The Adventures of
GILLION DE TRAZEGNIES

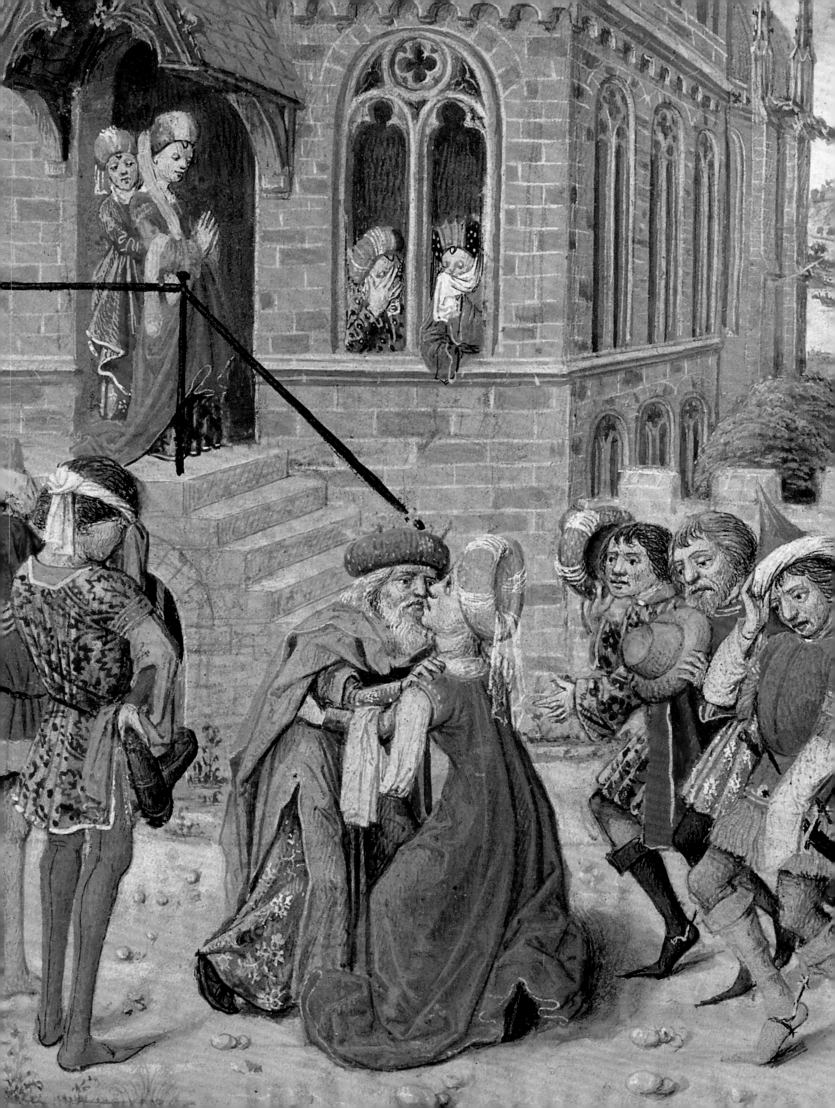

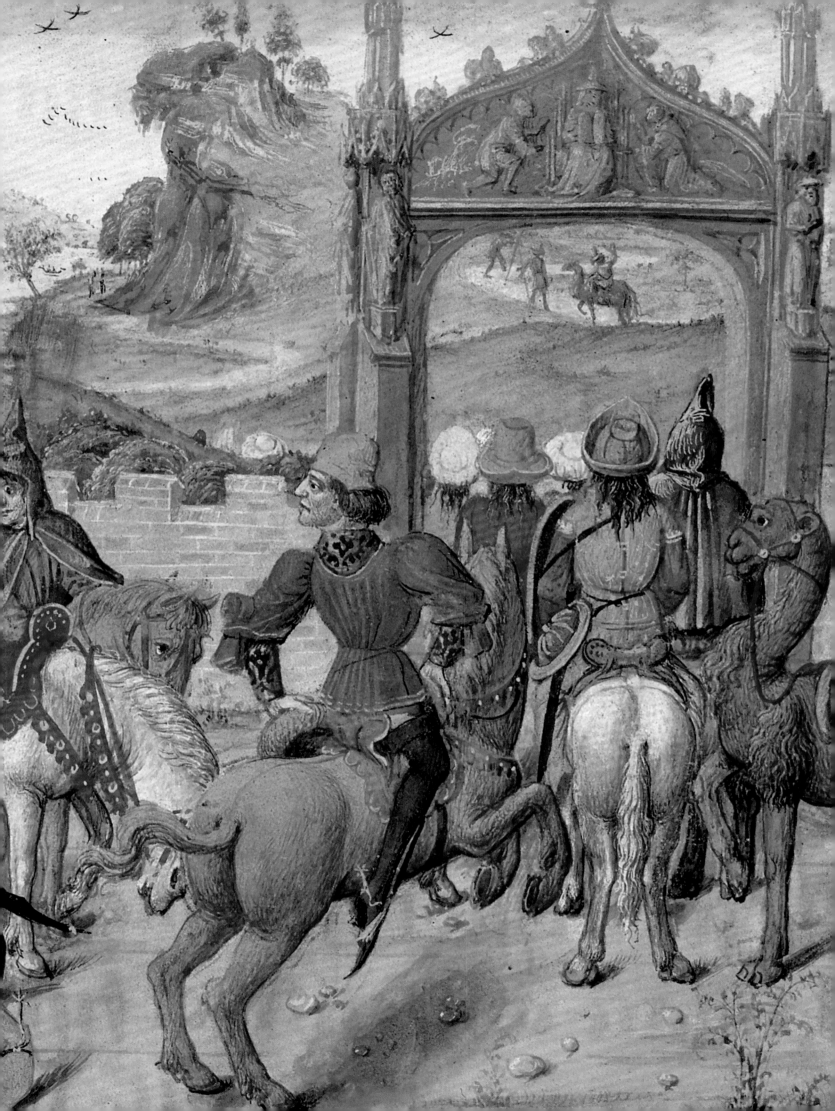

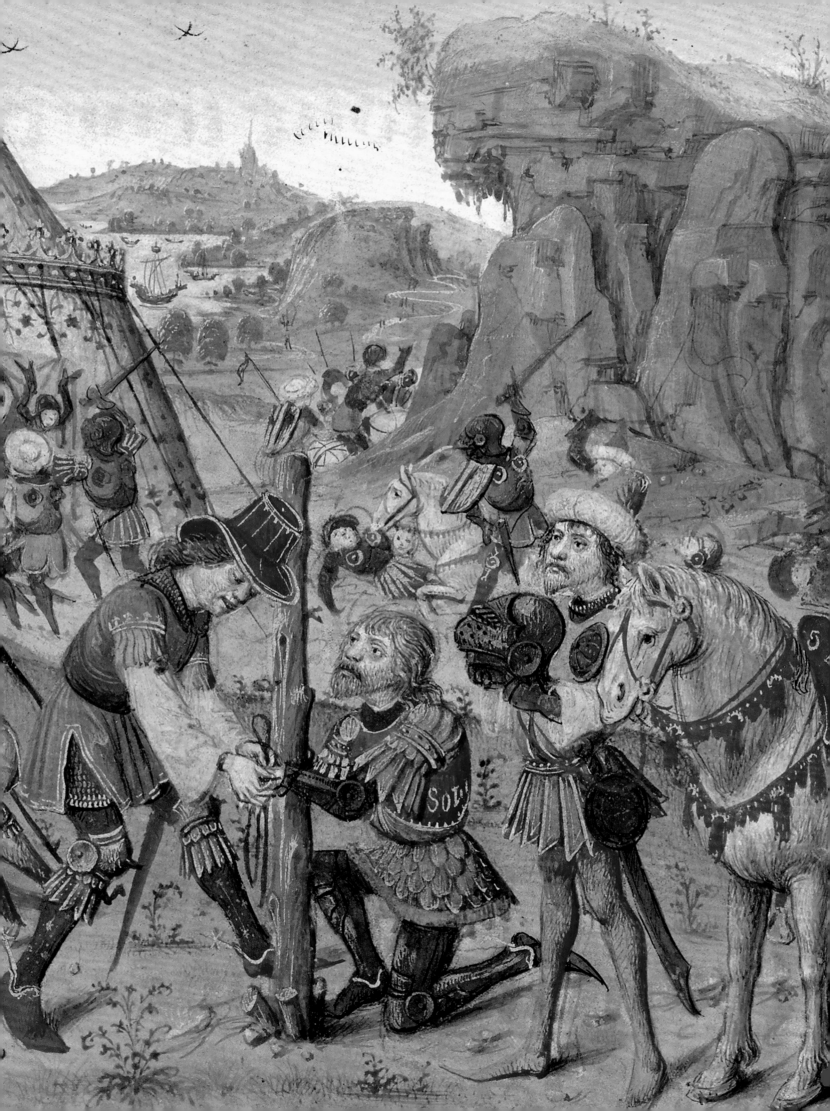

The Adventures of
GILLION DE TRAZEGNIES

CHIVALRY AND ROMANCE IN THE MEDIEVAL EAST

ELIZABETH MORRISON AND ZRINKA STAHULJAK

THE J. PAUL GETTY MUSEUM · LOS ANGELES

© 2015 J. Paul Getty Trust

Published by the J. Paul Getty Museum, Los Angeles
Getty Publications
1200 Getty Center Drive, Suite 500
Los Angeles, CA 90049-1682
www.getty.edu/publications

Ruth Evans Lane, *Project Editor*
Ann Grogg, *Manuscript Editor*
Kurt Hauser, *Designer*
Suzanne Watson and Amita Molloy, *Production*

Distributed in the United States and Canada by the
University of Chicago Press
Distributed outside the United States and Canada by
Yale University Press, London

Printed in Hong Kong

Library of Congress Cataloging-in-Publication Data

The adventures of Gillion de Trazegnies : chivalry and romance in the
medieval east / Elizabeth Morrison and Zrinka Stahuljak.
 pages cm
 Includes bibliographical references and index.
 ISBN 978-1-60606-463-4 (hardcover)
 1. Gillion, de Trazegnies (Legendary character)—Romances—
Illustrations. 2. Roman de Gillion de Trazegnies—Illustrations. 3.
J. Paul Getty Museum. Manuscript. 111—Illustrations. 4. Lathem,
Lievin van, active 1454–1493. 5. Brugge, Lodewijk van, heer van
Gruuthuse, approximately 1427–1492. 6. Illumination of books and
manuscripts, Flemish. 7. Illumination of books and manuscripts,
Renaissance—Flanders. 8. Illumination of books and manuscripts—
California—Los Angeles. 9. Chivalry in art. I. Morrison, Elizabeth,
1968– author. II. Stahuljak, Zrinka, author. III. Lathem, Lievin
van, active 1454–1493. IV. J. Paul Getty Museum, issuing body. V.
Roman de Gillion de Trazegnies. English. Selections. Container of
(expression):
 ND3399.R58
 [A48 2015]
 745.6'743932—dc23
 2015015212

All decorative details are taken from the subject of this book, the
Romance of Gillion de Trazegnies (JPGM, Ms. 111).
Front jacket, p. viii: details of plate 9
pp. i–iii: details of plate 43
pp. iv, vii, xiii, 102: details of plate 13
p. xiv: detail of plate 1
pp. 10–11: detail of plate 17
pp. 14, 62: details of plate 37
pp. 60–61: detail of plate 42
Back jacket: detail of plate 43

Illustration Credits

Every effort has been made to contact the owners and photog-
raphers of objects reproduced here whose names do not appear
in the captions or in the illustration credits listed below. Anyone
having further information concerning copyright holders is asked
to contact Getty Publications so this information can be included
in future printings.

Figs. 1, 9: Den Haag, Koninklijke Bibliotheek
Figs. 2, 3, 10, 13, 14, 25, 30, 37: Bibliothèque nationale de France
Fig. 4: bpk, Berlin / Dresden, Staatliche Kunstsammlungen /
Hans Peter Klut / Art Resource, NY
Figs. 5–7, 23, 24, 26–28, 33: Claudia Hoffmann
Fig. 8: Bibliothèque royale de Belgique
Fig. 11: Cliché CNRS-IRHT, Bibliothèques d'Amiens Métropole,
Ms. 483 F, fol 1
Fig. 12: © DeA Picture Library / Art Resource, NY
Figs. 31, 34, 35: © Petit Palais / Roger-Viollet / The Image Works
Fig. 32: Staatsbibliothek zu Berlin, Stiftung Preussischer
Kulturbesitz, Berlin, Germany
Fig. 36: bpk, Berlin / Staatsbibliothek zu Berlin / Art Resource, NY

Contents

ix Foreword
 Timothy Potts

xi Acknowledgments
 Elizabeth Morrison and Zrinka Stahuljak

1 Introduction
 Elizabeth Morrison and Zrinka Stahuljak

8 Map of Places Related to the *Gillion* Romance

Part 1: Images and Text

12 Plot Summary for the *Romance of Gillion de Trazegnies*
 Zrinka Stahuljak

15 Plates with Translations and Summaries
 Zrinka Stahuljak

Part 2: Essays

63 A Romance between the East and the West
 Zrinka Stahuljak

103 The Genius of Visual Narrative
 Elizabeth Morrison

140 Appendix 1: Description of the Manuscript

141 Appendix 2: Comparison of the Dülmen *Gillion* Miniatures
 with Illuminations in the Getty *Gillion*

142 Appendix 3: Diagram of Gatherings

147 List of Abbreviations

147 References

152 Index

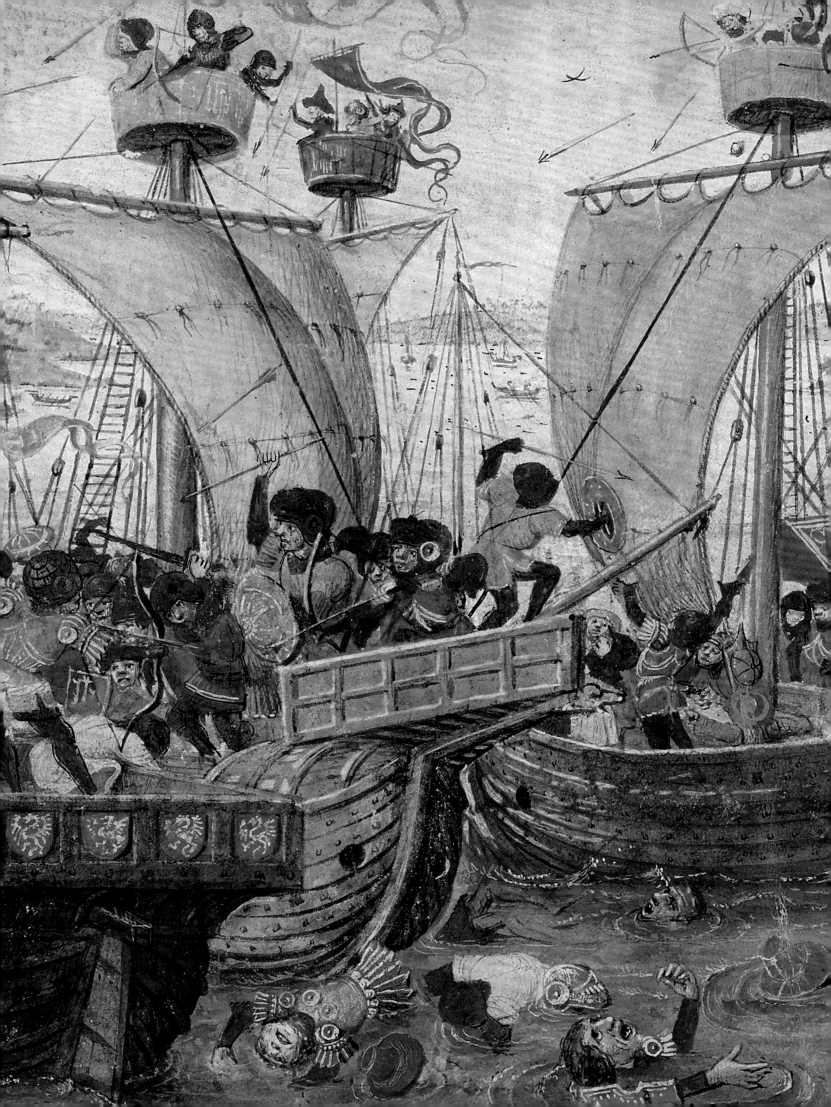

Foreword

The J. Paul Getty Museum has long been celebrated for its outstanding holdings in Northern Renaissance manuscripts, especially its small but exquisite collection of Flemish manuscripts, including a number of undisputed masterpieces. In December 2012, we were fortunate to be able to add another stunning representative of this exceptionally fertile and creative period to our holdings, the *Romance of Gillion de Trazegnies*, painted by the renowned fifteenth-century artist Lieven van Lathem (Ms. 111). With its eight half-page miniatures and forty-four historiated initials, this important monument represents one of the finest productions by the most accomplished and sophisticated painter of secular scenes in the golden era of Flemish secular manuscript illumination. The ambitious and lively images and French prose text tell the engaging story of a brave and daring Flemish knight, Gillion de Trazegnies, who journeys to the East and is confronted along the way with trials and tribulations ranging from capture at sea to unintentional bigamy. The Getty manuscript was created at the behest of one of the greatest book collectors of the era, Louis of Gruuthuse (ca. 1422/27–1492), a high-ranking nobleman at the powerful court of Burgundy. This secular masterwork now joins one of Van Lathem's greatest productions in the devotional realm, the Prayer Book of Charles the Bold (Ms. 37), acquired by the Getty in 1989. Together, these two objects testify to the genius of an illuminator known for his flair for visual narrative, dynamic compositions filled with animated figures, and magisterial ability to capture vignettes of the natural world.

From the moment of the arrival of the *Romance of Gillion de Trazegnies* at the museum, Elizabeth Morrison, Senior Curator of Manuscripts at the J. Paul Getty Museum and a specialist in Flemish manuscript illumination, began to plan a monograph on the text and illuminations of the manuscript, and enjoined as her collaborator Zrinka Stahuljak, Professor in the Departments of French & Francophone Studies and Comparative Literature at the University of California, Los Angeles, and a specialist in medieval French romance literature. Their complementary essays in this volume examine in depth the manuscript's creation, meaning, and place within a rich historical and artistic framework. Every image from the manuscript is here reproduced in full color, together with a translation or summary of the text, thus leading the reader through every thrilling moment of Gillion's adventures.

The Northern Renaissance, a time of extraordinary artistic innovation and productivity, was also a period of exploration and discovery. The *Romance of Gillion de Trazegnies* is a testament to the rich global context that European artworks of this era can provide.

One of the aims of the present book is to consider what the text and illuminations of the Getty *Gillion* can contribute to an understanding of the culture that created it, in particular European perceptions of the Muslim East. From Gillion's imprisonment by an Egyptian sultan, to the knight's travels through Jerusalem, Libya, and Egypt, to his eventual leadership of a Saracen army, the contemporary European reader was led on a thrilling journey at once safely displaced and exotically titillating.

The Crusading overtones of the manuscript's images were important in the social and political context of the day. The dramatic fall of Constantinople (1453)—and with it the end of the Christian Byzantine Empire—had taken place just a decade before the creation of the manuscript, inspiring the Burgundian duke, Philip the Good, to raise support for a military expedition to the East. By examining the Getty's *Romance of Gillion de Trazegnies* through the lens of other literary creations of the day, including the collecting habits of the Burgundian nobility, and above all, by exploring the lavish illuminations that accompany this tall tale of adventure and romance, this study provides an insight into the mind-set of Europeans at once attracted to and wary of an East separated by war, politics, religion, and culture. It is particularly appropriate, then, that this publication is appearing on the occasion of the exhibition *Traversing the Globe through Illuminated Manuscripts* (January 26–June 26, 2016), curated by Bryan C. Keene in the Department of Manuscripts, which highlights cross-cultural encounter and exchange in manuscripts, including the *Romance of Gillion de Trazegnies*.

We are delighted to welcome this important acquisition into the Getty's distinguished collection, and it is fitting that it should join a number of other important Getty manuscripts in receiving monographic treatment with full access to all its images. The authors of this study, Elizabeth Morrison and Zrinka Stahuljak, are to be congratulated for presenting the *Romance of Gillion de Trazegnies* with an ideal combination of enthusiasm for its lively contents and careful consideration of its importance for future research.

Timothy Potts
Director
The J. Paul Getty Museum

Acknowledgments

As the authors of this volume, we share a deep interest in the unique cultural achievements of the court of Burgundy in the second half of the fifteenth century, and our separate areas of expertise made our partnership for a volume on the Getty's *Romance of Gillion de Trazegnies* a most propitious and productive one. Along the way, our excitement for the project has only been exceeded by our passion for the manuscript itself. We became more and more absorbed by the problems and questions posed by the manuscript's text and illuminations, much to our mutual enjoyment. In our monthly meetings and several trips, we exchanged ideas, endlessly discussed the thorny aspects of dating, attribution, and textual recension, and often felt that we were vicariously sharing in the sense of adventure and humor integral to Gillion's story as we forged ahead on the project. The result, happily, is a pair of essays that are interdependent and intertwined, building together to something much more than they would have been apart.

Our endeavor has profoundly benefited from the generous help offered by scholars and curators at a variety of institutions across America and Europe. Anne D. Hedeman and Hanno Wijsman offered valuable commentary and suggestions on the first draft of the text, raising pertinent issues and sharing generously of their specialized knowledge, all of which has greatly improved the final product. Scot McKendrick, Head of Western Heritage Collections at the British Library, and Thomas Kren, Associate Director of Collections at the Getty, are both intimately familiar with the work of Lieven van Lathem and were unstinting in their willingness to share their observations and thoughts on his oeuvre and the Getty manuscript; their reflections greatly influenced sections of "The Genius of Visual Narrative." Marc Gil looked at Getty manuscripts as well as those in Brussels associated with David Aubert in order to provide an opinion on the script. Margaret Scott willingly examined detail after detail of various Van Lathem manuscripts to provide invaluable assistance with costume dating. Scholars François Avril, Godfried Croenen, Erin Donovan, Joris Heyder, Dominic Leo, Elizabeth Moodey, Lucy Mookerjee, Andrea Moudarres, Charles Noble, Tassos Papacostas, Christiane Patens, Richard and Mary Rouse, Lucy Sandler, Teresa Shawcross, and James Towe all generously contributed advice in their various fields of expertise. Stéphanie Vincent's edition of the text of *Le Roman de Gillion de Trazegnies* was integral to our study of both the Getty manuscript and the closely related copy in a private collection in Dülmen, Germany. We also are grateful to the owner of the Dülmen manuscript for permission to spend time with it and for help in obtaining new photography of its pages. In Paris, Charlotte Denoël, Curator of Manuscripts at the

Bibliothèque nationale de France, gave us the extraordinary opportunity to view the institution's manuscripts by Van Lathem on multiple occasions. Claire Martin at the Petit Palais enabled Elizabeth Morrison to spend time with its wonderful *Alexander* manuscript and helped with obtaining the reproductions of that manuscript for this publication. On two occasions, Bernard Bousmanne gave gracious permission to Zrinka Stahuljak to study copies of *Le Roman de Gillion de Trazegnies* housed at the Bibliothèque royale de Belgique in Brussels, and Ann Kelders welcomed her there with great collegiality and selflessness, while Pascal Trousse and other staff ensured a cordial and ideal work environment. Eef Overgaauw and Robert Giel facilitated a whirlwind visit to the Staatsbibliothek zu Berlin–Preussischer Kulturbesitz, where we were given liberal access to the famed four-volume copy of Jean Froissart's *Chronicles* illuminated by Van Lathem.

In Los Angeles, staff members at the Getty were integral in various ways. Department of Manuscripts curators Kristen Collins, Christine Sciacca, and Bryan Keene readily undertook additional duties in order to provide Elizabeth Morrison with the time to work on this volume and served as sounding boards for her ideas. Nancy Turner, Conservator of Manuscripts, was unsparing with her time and knowledge, devoting hours to poring over the manuscript with Elizabeth Morrison. We are grateful for Bryan Keene's enthusiasm for including the manuscript in his exhibition, *Traversing the Globe Through Illuminated Manuscripts*, during whose run this volume will appear. Staff assistant Andrea Hawken and intern Rheagan Martin provided invaluable administrative and technical assistance. Former intern Megan McNamee diligently helped with German translations, as did summer intern Andrea Guerrero, who also read over the English translations for the volume's plates. Volunteer Lily Spitz was tireless in the hours she spent gathering the vast bibliography for the volume, and volunteer Meagan Decker read and commented on an early version of Elizabeth Morrison's essay. At the University of California, Los Angeles, the Academic Senate generously enabled Zrinka Stahuljak's research trips, and the Dean of Humanities provided financial support for editorial work. Cristina Maria Politano, research assistant for Zrinka Stahuljak, is to be thanked for her superbly attentive and efficient editorial assistance on "A Romance between the East and the West" and translations. Zrinka Stahuljak's essay would not be the same without Laure Murat's loving support and unwavering encouragement.

The Getty Publications Department has been an eager collaborator in this project, and their help has been much appreciated throughout our journey. Kara Kirk was an early advocate of the volume, and Rob Flynn smoothed our way in its beginning stages. Ruth Lane took over as a staunch ally in her patience with questions, changes, and requests. Elizabeth Nicholson helped keep the project on track throughout. Early on, Elizabeth Morrison asked for the assistance of designer Kurt Hauser, whose sensitivity to the beauties of manuscripts and his deep understanding of how best to present them has resulted in the splendid volume before you. Freelance editor Ann Grogg offered her editorial insight to ensure the final text's consistency and readability. Suzanne Watson was instrumental in making sure the images printed in the volume were of the highest quality, and Pam Moffat was diligent in acquiring the best possible images from other institutions.

This publication also relies heavily on the quality of the images that grace it. At the Getty, Rebecca Truszkowski was meticulous in ensuring the quality of the digital photography, and Johana Herrera worked on correcting the files to make sure they sparkled. Bryan Keene arranged for the handling of the manuscript during photography and participated in the process, as well as Nancy Turner, Christine Sciacca, and Stephen Heer.

The two of us would also like to recognize each other's invaluable thoughts and insights during this process. Many of our best ideas emerged in conversation during the course of research for this book. Throughout our essays we have attempted to cite each other's work and give due credit. One of the great joys of this project has been to see how our work together has enriched our relationship as colleagues and friends.

. . .

It was the greatness of the *Romance of Gillion de Trazegnies* by Lieven van Lathem as an exquisite art object that prompted the idea for this book, but its acquisition by the Getty was only possible through the unwavering support of the Getty's Board of Trustees, President and CEO Jim Cuno, Director Timothy Potts, and Associate Director for Collections Thomas Kren.

Elizabeth Morrison
Senior Curator of Manuscripts
J. Paul Getty Museum

Zrinka Stahuljak
Professor, Departments of French &
Francophone Studies and Comparative Literature
University of California, Los Angeles

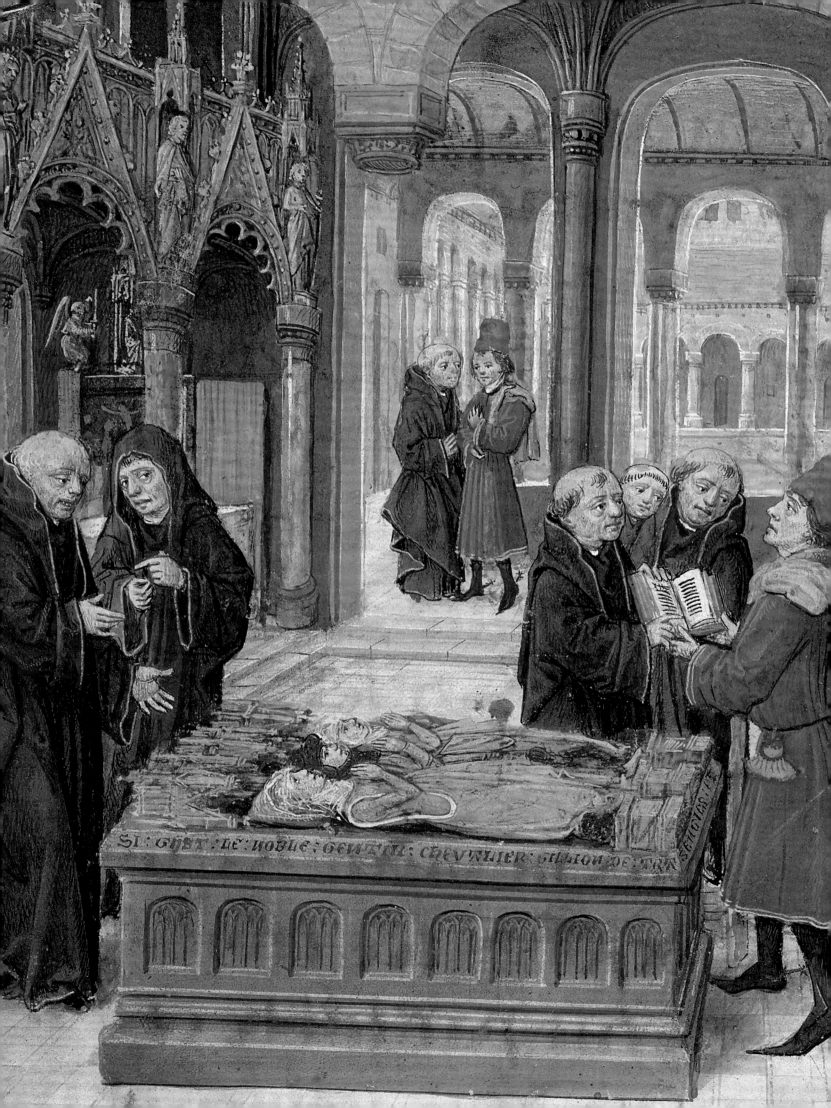

CI · GIST · DE · NOBLE · GENTIL · CHEVALIER · GILLION · DE · TRA

Introduction

ELIZABETH MORRISON AND ZRINKA STAHULJAK

I n 1817, the Reverend Thomas Frognall Dibdin undertook a journey across England to describe the most beautiful and important books of his country. Upon arriving at Chatsworth, the ancestral home to the Dukes of Devonshire, he found a manuscript containing the engaging story of Gillion de Trazegnies, a medieval knight from Hainaut (in present-day Belgium and northern France) who travels on a pilgrimage to Jerusalem, is captured in the exotic lands of the East, mistakenly becomes a bigamist, and dies in battle as a celebrated hero. So taken was Dibdin with this manuscript's stunning illuminations that he wrote, "The larger ones have a freshness and brilliancy almost unrivalled" that would bring even the harshest of critics into "an ecstasy of delight." At the end of his enthusiastic description, he wistfully concluded that "the reader sighs to take leave of such a volume."[1] These are the first published words known about the most famous copy of the *Romance of Gillion de Trazegnies* [*Le roman de Gillion de Trazegnies*], illuminated by one of the greatest artists of the fifteenth century, Lieven van Lathem. At a sale at Sotheby's on December 5, 2012,[2] the J. Paul Getty Museum was fortunate to acquire this masterpiece, now Ms. 111 in the Getty's collection.

This illuminated copy of the *Romance of Gillion de Trazegnies* has long been known to scholars, and, prior to its arrival at the Getty, it had been mentioned in almost fifty publications and exhibited in seven prestigious exhibitions.[3] Despite the fact that the manuscript is well known among scholars and has been seen by thousands of members of the general public, no full consideration of its text and illuminations has been undertaken (see Appendix 1 for a summary description of the manuscript). The story behind the Getty *Gillion* is the focus of this volume.

Setting the Scene

In the late Middle Ages, stories full of courtly romance, heroic derring-do, violent battles, political intrigues, and exotic settings were understandably prime candidates for illumination. This type of manuscript, often tens of thousands of lines long, was read aloud in an episodic manner, with skilled readers breaking off at a dramatic moment to leave the audience breathless for the next installment and the illuminations bringing the tales to life. By the middle of the fifteenth century, Flanders was well established as the preeminent site for the creation of secular illuminated manuscripts in Europe. Flanders, along with other portions of present-day Belgium, the Netherlands, and northwestern France, collectively

known as the Burgundian Low Countries, was governed by the powerful Dukes of Burgundy, among the wealthiest European rulers of the time as well as lavish and discerning art patrons. Manuscript production was in fact embedded in the economic and cultural life of the region, providing continuous work for authors, scribes, and artists while fulfilling the sophisticated needs of the area's richest patrons. Local rulers and the members of their courts provided the foundation for the successful industry and ensured a steady stream of commissions. The wealth, high standards, and discriminating tastes of these patrons encouraged artists to ever-higher levels of quality in illumination and led to the creation of some of the finest examples of manuscript art ever achieved.

At the highest level of bookmaking, any given manuscript was the product of a tightly intertwined complex of figures and events. At the beginning was always the text. Sometimes an author is known, and sometimes, as in the case of the *Romance of Gillion de Trazegnies*, the author is not. Many texts were copied over and over for centuries, with hundreds of copies attesting to their popularity; others were composed for select audiences and survive in only a few examples. Often these texts were written at the behest of a particular patron, or the author would undertake the project with a dedicatee in mind. Either that same person, or perhaps someone who was a friend, descendant, or even just a client decades or centuries later who was interested in that particular narrative, would then commission a copy of the text in manuscript form.[4] The patron would likely be involved in choosing the scribe and artist of the manuscript and would help decide the level of decoration. Scribes at this period were just as famed for their calligraphy as artists were for their illuminations. Multiple related versions of the text might exist, with small or significant changes marking individual textual traditions. Once the exemplar had been chosen and the scribe had written out the text, the illuminator would go to work, adding miniatures, historiated initials containing an identifiable scene or figure, ornamental initials, and decorated borders as directed. The finished product would then be bound and presented to the patron, serving as a key symbol of wealth, sophistication, and prestige. It is within this context and according to this process that the Getty *Gillion* was created.

Louis of Gruuthuse (ca. 1422/27–1492), a high-ranking member at the Burgundian ducal court and the patron of the Getty manuscript, is one of history's great manuscript collectors. Louis amassed a library of almost two hundred volumes, the majority of which were contemporary illuminated secular manuscripts, at a time when the English royal collection was composed of less than half that. The *Romance of Gillion de Trazegnies* appealed to Louis on a variety of levels. The text itself, celebrating one of the great legendary personalities of the Burgundian Low Countries, reflected glory on the noble descendants in the region. Adding to the manuscript's contemporary appeal, the figures are dressed at the height of fifteenth-century fashion and the scenes take place in Flemish churches and other buildings. The setting of the text's story in the lands of the East would also have had contemporary resonance, as in 1463–64, Philip the Good, Duke of Burgundy (1396–1467), was actively planning a Burgundian Crusade to regain Constantinople and Jerusalem; in 1454, Louis had vowed to follow Philip's Crusading endeavors. Lastly, Louis engaged the services of one of the most skilled secular illuminators of the day, Lieven van Lathem (ca. 1438–1493), to add images to his copy. The Getty volume, filled with lively illuminations of a regional hero vanquishing the Saracens (Arab Muslims) in the East, would have promoted Louis's political career as well as fulfilled his desire for an imaginative text illustrated by beautiful and entertaining images.

The Patron

Louis of Gruuthuse, also known as Lodewijk van Gruuthuse or Louis de Bruges, was a Flemish-Burgundian noble with a stellar career at the courts of Philip the Good and then his son, Charles the Bold (1433–1477), Dukes of Burgundy.[5] Louis's rise to the highest echelons of power started in 1449 when he became Philip's *échanson* (the honorary function of cupbearer). Louis had by then exercised his military skills in numerous tournaments in which he distinguished himself and won prizes, but he was almost instantly upgraded to major leadership roles in government and diplomacy. Philip appointed Louis governor of Bruges in 1452 to help maintain the loyalty of the city during the wars with Ghent, and, for Louis's able service, Philip knighted him a year later. An ambitious courtier, Louis did not waste a chance to show his total adherence to the duke's cause. At the magnificent Feast of the Pheasant in 1454, he made a vow to follow the duke closely as his shadow on a Crusade and serve him to death: "I vow to God, to Our Lady, to the ladies, and to the pheasant that, in case my most feared lord the duke should undertake the holy voyage, I will serve him in my body and my possessions."[6] Louis's star was clearly on the rise. Starting in 1458, the duke entrusted Louis with important diplomatic missions. Louis had already served as the duke's chamberlain and counselor since 1455, and, as reward for his loyal services, the duke inducted him into his prestigious Order of the Golden Fleece in 1461 (fig. 1), just after Louis's return from his first diplomatic mission to England (1460–61). Orders such as that of the Golden Fleece were founded as societies of knights sworn to uphold the honor of their liege lords (usually a king) in chivalric and Christian ideals, with military support if necessary. In 1463, the duke appointed Louis *stadhouder* (governor general) of Holland, Zeeland, and Frisia. Louis led another important diplomatic mission to England in 1465–67, to the court of King Edward IV, where he negotiated the marriage of Duke Philip's son Charles and King Edward's sister Margaret of York.

After Philip's death in 1467, Louis continued to be one of the most trusted advisers and military leaders under the new duke, Philip's son Charles the Bold. When, during the Wars of the Roses, King Edward IV was temporarily overthrown and fled England in 1470, Louis was his host in the Burgundian Low Countries and was later rewarded with the title Earl of Winchester in 1472. Charles died prematurely in 1477 during the siege of Nancy, and his only child, Mary of Burgundy, inherited the government of the duchy, with Louis as her first chamberlain. Although Louis was a member of the governing council after 1477, and thereby entrusted with important tasks, his fortunes waned after Mary's death in a horse-riding accident in 1482, for he opposed the policies of Mary's husband, Maximilian, regent of the duchy. Louis was imprisoned three times between 1485 and 1488, and his career ended in disgrace: at the chapter of the Order of the Golden Fleece in 1491, he was threatened with expulsion. He died in 1492.

An Ambitious Library

The more Louis rose in prominence, the wealthier he grew. He possessed a considerable fortune originally built from the tax levied on the production and commercialization of beer (*gruut* is the herb used in the beer's brew, hence the family name). His appointment as governor general of Holland, Zeeland, and Frisia came with a yearly pay of 300 Flemish pounds, and his English earldom was worth 200 pounds sterling. Some of this large personal fortune was spent on lavish entertainment that befitted his ruling-class status. His library, the most impressive of the entire ducal entourage, played an important part

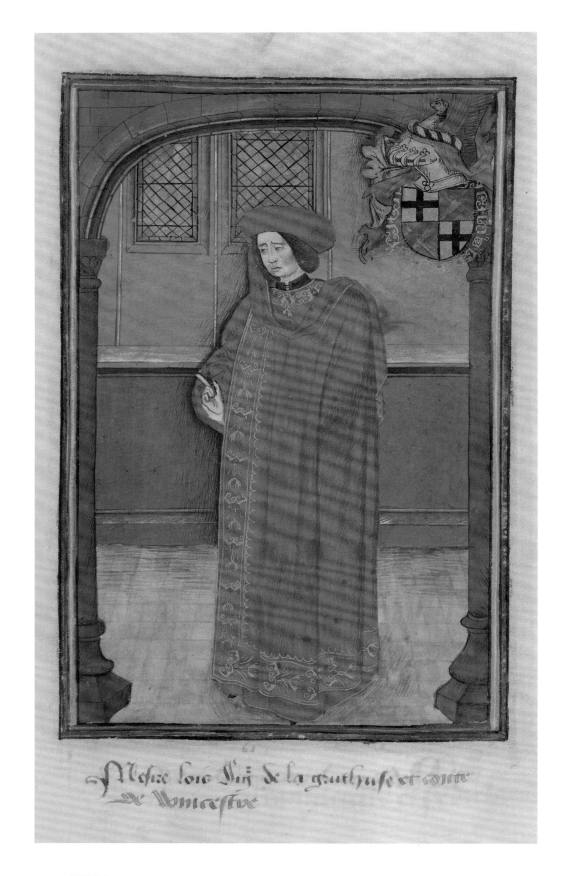

FIGURE I

Louis of Gruuthuse, from *Statutes, Ordonnances, and Armorial of the Order of the Golden Fleece*, ca. 1473–91.
The Hague, KB, Ms. 76 E 10, fol. 69

in Louis's self-fashioning as a courtier.[7] Indeed, he began seriously collecting after his fortunes began to rise, and the lavish books served as a sign of his class consciousness.[8] Few manuscripts would have come to Louis by inheritance; instead, the bulk of his library was built through acquisition, sometimes of books made previously and most often by commission, almost exclusively from Bruges workshops, although with some from Ghent and Antwerp. With almost two hundred individual volumes (some works extend to multiple volumes), Louis amassed the most splendid library after that of Philip the Good. Louis often patterned his acquisitions and commissions on Philip's library and built the largest surviving collection owned by a Burgundian noble. Around 1512, the library passed to King Louis XII (1462–1515), and the largest portion of the collection is today housed in Paris at the Bibliothèque nationale de France.

The vast majority of works from Louis's library are in French, with many translations from Latin. Although his maternal language was Flemish, he had only seven manuscripts written, at least partly, in Dutch, which is closely related to Flemish. The first part of the collection, about 48 volumes, dates from before 1450; at least 10 are from the fourteenth century, and about 8 are from the thirteenth century. The rest of the collection, 150 volumes, was comprised of contemporary illuminated manuscripts, and more than half of those had been commissioned by Louis in Flemish workshops. Almost all of his manuscripts were illuminated, and he liberally had his commissioned manuscripts marked with his coat of arms and personal symbol of a firing *bombard* (a short cannon; see plates 1, 13). Most often they also bore his motto, *Plus est en vous* (There is more in you).

Most of Louis's manuscripts are French translations of histories and juridical or didactic treatises by authors from antiquity. There are also medieval religious works, chivalric treatises, books of tournaments, military manuals, hunting manuals (*livres de chasse*), and texts concerning the art of government (*miroirs de prince*). Essentially, Louis's collection consisted of secular manuscripts written in the French vernacular, rather than in Latin. Louis's embassies to and connections in England and the general context of war, diplomacy, and international relations explain his interest in the chronicles of England, the Low Countries, and the Hundred Years' War, while the literature produced for and read by the members of the Order of the Golden Fleece expresses the ambitions of a courtier and member of the order. Although Louis's collection has a close relationship to the library of Duke Philip of Burgundy, Louis did not develop two areas important to Philip: pseudohistorical works legitimating Philip's expansion at home and Crusading ambitions abroad. In fact, of the three Crusade-themed works, the *Romance of Gillion de Trazegnies* is the only one lavishly illuminated.[9] It seems that Louis endeavored to imitate the Crusading intentions of his sovereign in the beginning, but after the failure of Philip's Crusade in 1464–65 and Philip's death in 1467, Louis's interest in the East faded.[10]

Within the context of Louis's collection, to call the Getty *Gillion* a "romance" is, in fact, somewhat of a misnomer. The author identifies it as *istoire*, a history or story of Gillion de Trazegnies's deeds that he "translated into our French language" from Italian. Our modern genre of "romance" derives from the first medieval vernacular narratives written in the second half of the twelfth century whose authors called these narratives romances because they were written in the Romance language (*romanz*), that is, in medieval French. The Getty manuscript is a pseudohistorical text, a work of historical fiction.[11] "Historical fiction" is again a modern genre, but the term nevertheless conveys the fundamental hybridity of this medieval genre. Had it found its place in the library of the Duke of Burgundy, the *Romance*

5

of Gillion de Trazegnies would likely have been listed in the 1467–69 inventory compiled after the duke's death in the category of *livres de gestes* (books of deeds).[12] Today the majority of these texts are identified as fiction, and often as romances, but at the end of the fifteenth century, this broad category also included some history, both real and fictional, and excluded other romances, which were classified under *livres d'amour* (books of love). There was hardly a fixed notion of romance as a genre; the term *gestes*, which translates as "deeds" or "feats," points instead to an action genre that also claims to be an educational model in matters of prowess and chivalry. This context explains the historical-realist setting of the fifteenth-century romances and the contemporary inclusion of certain narratives traditionally defined as histories in the same category as the educational-action genre.

Manuscripts of the Romance of Gillion de Trazegnies

The *Romance of Gillion de Trazegnies* may have not circulated widely, but the appeal it held for the courtiers to the Duke of Burgundy is intriguing and worthy of attention. We know of five manuscript copies in Middle French.[13] The copy thought to be the earliest, containing what is known as the short version of the romance to distinguish it from the later, longer version discussed below, belonged to Jean de Wavrin (Brussels, KBR, Ms. 9629, 1450–60).[14] Another copy of the short version was owned by Philippe de Clèves (Jena, Thüringer Universitäts-und Landesbibliothek, Ms. El. f. 92, second half of the fifteenth century).[15] The latest copy of the short version (Brussels, KBR, Ms. IV 1187) was made in 1529 for Jean IV de Trazegnies. This copy was produced much later than the manuscripts under consideration here; it is therefore not included in the discussion. Anthony, the Grand Bastard of Burgundy (Dülmen, private collection), and Louis of Gruuthuse (Los Angeles, JPGM, Ms. 111) each owned the long version of the romance, copied in 1463 and 1464, respectively. The long version amplifies the short version throughout, but the major change comes at the very end. The conclusion to Gillion's adventurous life—his return to Hainaut, dinner with his two wives, their entry into religious life, the sultan's call for help, and Gillion's return to Egypt and death—is a sequence that occupies only one folio in the short version but grows to fifty and fifty-one folios in the Dülmen and Getty manuscripts, respectively. These two are also the only illuminated copies of the romance in the textual tradition.

The short prose version of the *Gillion* romance was composed sometime between 1450 and 1460. It is one of the many Burgundian romances created or prosified (updated into prose from an earlier verse format) between 1450 and 1470, all featuring local, albeit pseudo-historical, regional heroes.[16] Whereas *Gillion* is an original prose romance, and it is unlikely that an earlier, now lost, verse version of the romance existed, the hero was known to the public through a Flemish play performed in the fourteenth and fifteenth centuries.[17] Although no precise date of composition for *Gillion* has surfaced, it was composed before the prose version of *Gilles de Chin*, which identifies Gilles as Gillion's godson, and before the *Book of the Deeds of Jacques de Lalaing* [*Le livre des faits de messire Jacques de Lalaing*] (both composed after 1453), which specifically mentions Gillion as an example of prowess and praises Hainaut as the land of chivalry.[18] Thus a short version of *Gillion* would have been composed at the earliest by 1453 and at the latest by around 1460, sometime before a longer version was completed and transcribed in 1463 for Anthony. An argument in favor of its composition before 1453 is the absence of a mention of the 1453 fall of Constantinople and end of the Byzantine Empire, which encompassed much of present-day Greece. Instead,

Cyprus, the main Christian stronghold after the loss of the last of the Crusader States in 1291, plays a major role in *Gillion*, especially in the beginning of the romance, when the sultan attempts an invasion, perhaps a reference to the Turkish invasion of Cyprus in 1426.[19]

. . .

The *Romance of Gillion de Trazegnies* is one of the most important manuscripts acquired by the Getty Museum since the establishment of the manuscripts collection in 1983. It is only fitting that this masterpiece should now be celebrated in a publication that explores in depth both its text and illuminations. The arrangement of this volume, with the first part dedicated to the textual and illumination elements and the second to scholarly interpretation, underscores the primacy of the original object in enabling our investigative analyses. As a museum, the primary reason, of course, for acquiring the manuscript was for its stunning images. The Northern Renaissance represents one of the greatest eras in the history of painting, and Lieven van Lathem was one of its seminal artists. His highly atmospheric landscapes and the startling naturalism in the way his figures move and interact with their surroundings are distinctive traits of his style that reflect the most important innovations of the period and helped define its overall aesthetic. Van Lathem was, moreover, a master at weaving disparate narrative threads together in scenes of matchless appeal and charm. But it was only when confronted with a text of the scope, originality, and narrative potential of the story of Gillion de Trazegnies that Van Lathem's powers could truly shine. The text and images taken together explain why the Getty's *Romance of Gillion de Trazegnies* represents one of the most impressive and dazzling creations of its time.

NOTES

1. Dibdin 1817, cciii–cciv; Edward Ham was equally struck by the manuscript when he saw it in 1932. Ham 1932.
2. London, Sotheby's, December 5, 2012, lot 51. Sotheby's 2012.
3. See the Getty's website for a complete listing of the manuscript's bibliography and exhibition history; many of these titles can also be found in the References section of this volume. One of these exhibitions was *Illuminating the Renaissance: The Triumph of Flemish Manuscript Painting in Europe*, held at the J. Paul Getty Museum in Los Angeles and the Royal Academy in London in 2003–4 (Kren and McKendrick 2003), when the manuscript first traveled to Los Angeles.
4. McKendrick in Kren and McKendrick 2003, 59–78, is a prime source for the process of the creation of secular manuscripts during this period. While the present publication is concerned with high-end, luxurious manuscripts such as the Getty *Gillion*, other secular manuscripts were produced for off-the-shelf consumption.
5. This biographical summary is based on Van Praet 1831; de Smedt 2000, 132–33; Vale 1995.
6. Quoted in Caron 2003, 141, trans. by Stahuljak.
7. The description of Louis's library is based on Lemaire and de Schryver 1981; Baurmeister and Laffitte 1992, 194–95; Martens 1992; Laffitte 1997, 248; McKendrick in Kren and McKendrick 2003, 69; Vale 1995, 118; Wijsman 2007; Wijsman 2010, 1–12, 356–69.
8. Scholars have tended to date the majority of manuscripts commissioned by Louis to the decade between 1470 and 1480. See Hans-Collas and Schandel 2009, 321–28. This assumption, which might bear reexamination given some of the conclusions drawn in this volume, is beyond the scope of this study. For the purposes of this book, all manuscripts discussed within the context of Louis's collection are dated to the period between 1460 and 1490 unless otherwise noted.

9. Hans-Collas and Schandel 2009, 11–18; Wijsman 2010, 366. See also Baurmeister and Laffitte 1992; Laffitte 1997; Lemaire 1996; Martens 1992; Quéruel 2006; Willard 1997.
10. Donovan 2013; Moodey 2012.
11. On the genre, see Morse 1980; Gaucher 1994; Brown-Grant 2012; Ferlampin-Acher 2012.
12. Barrois 1830, 182–91.
13. There are also three Latin translations, one each from the late fifteenth and sixteenth century, and one undated. Vincent 2010, 44–45.
14. Horgan 1985.
15. Wolff 1839. Philippe's manuscript is important because it is the only complete surviving copy of the short version; Wavrin's copy is damaged, as the text ends after only seventy-two folios.
16. Doutrepont 1909; Doutrepont 1939; Timelli et al. 2014. Examples include: *Gérard de Nevers* (ca. 1451–64); *Gilles de Chin* (ca. 1453–67); *Chatelain of Coucy* (ca. 1460–65?); *Romance of the Count of Artois* (ca. 1453–60); *History of the Lords of Gavre* [*Histoire des Seigneurs de Gavre*] (1456); Antoine de la Sale's *Jean de Saintré* (1456); and *Jean d'Avesnes* (ca. 1460–67). This group of pseudohistorical chivalric biographies is flanked chronologically by romanced histories of real historical knights, the Marshal Boucicaut (1364–1421) and the knight Jacques de Lalaing (1421–1453), whose lives were recounted in the *Book of the Deeds of Marshal Boucicaut* [*Le livre des fais du bon messire Jehan le Maingre, dit Boucicaut*] (ca. 1406/7–9) and the *Book of the Deeds of Jacques de Lalaing* [*Le livre des faits de messire Jacques de Lalaing*] (ca. 1453–63, completed by 1470).
17. Vincent 2010, 83–96.
18. Chalon 1837, 4, xviii. The *Gillion* romance mentions Gillion [*sic*] de Chin twice in the long conclusion as one of the young Hainaut knights who accompanies Gillion to Cairo (Getty *Gillion*, fols. 204, 217v; Vincent 2010, 341, 355).
19. Cf. Paviot 2003, 214.

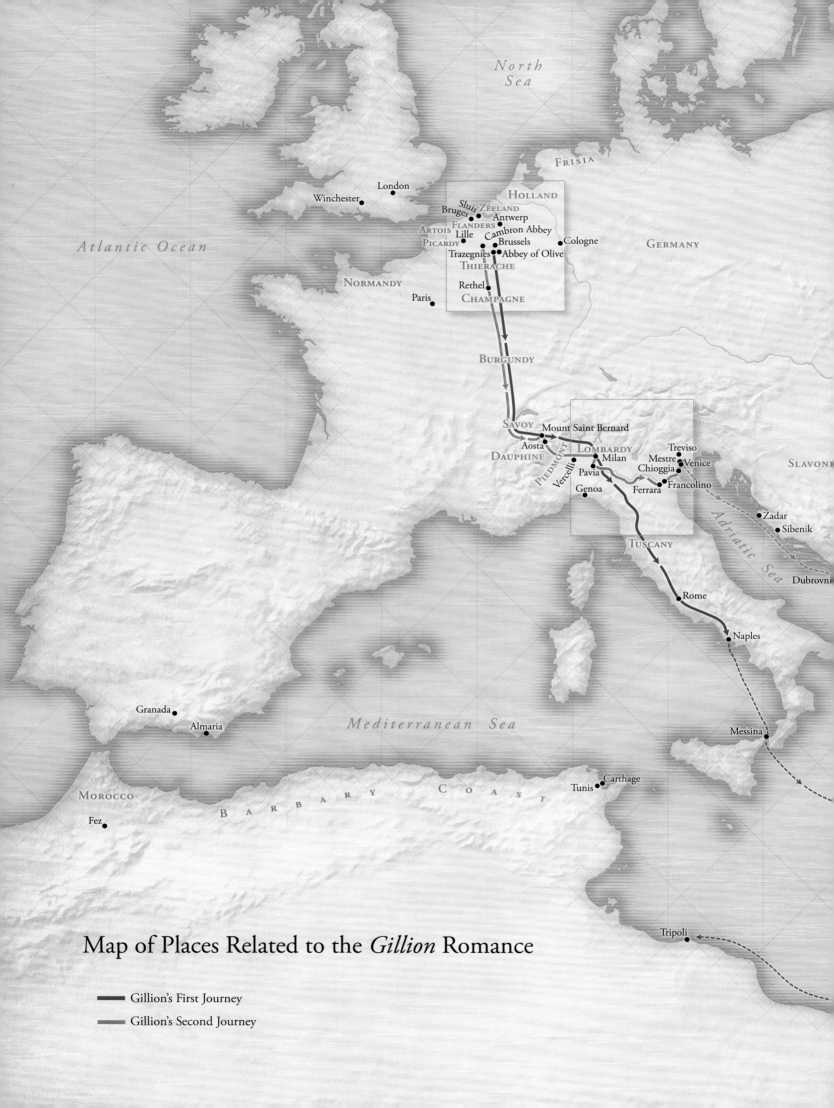

Map of Places Related to the *Gillion* Romance

— Gillion's First Journey

— Gillion's Second Journey

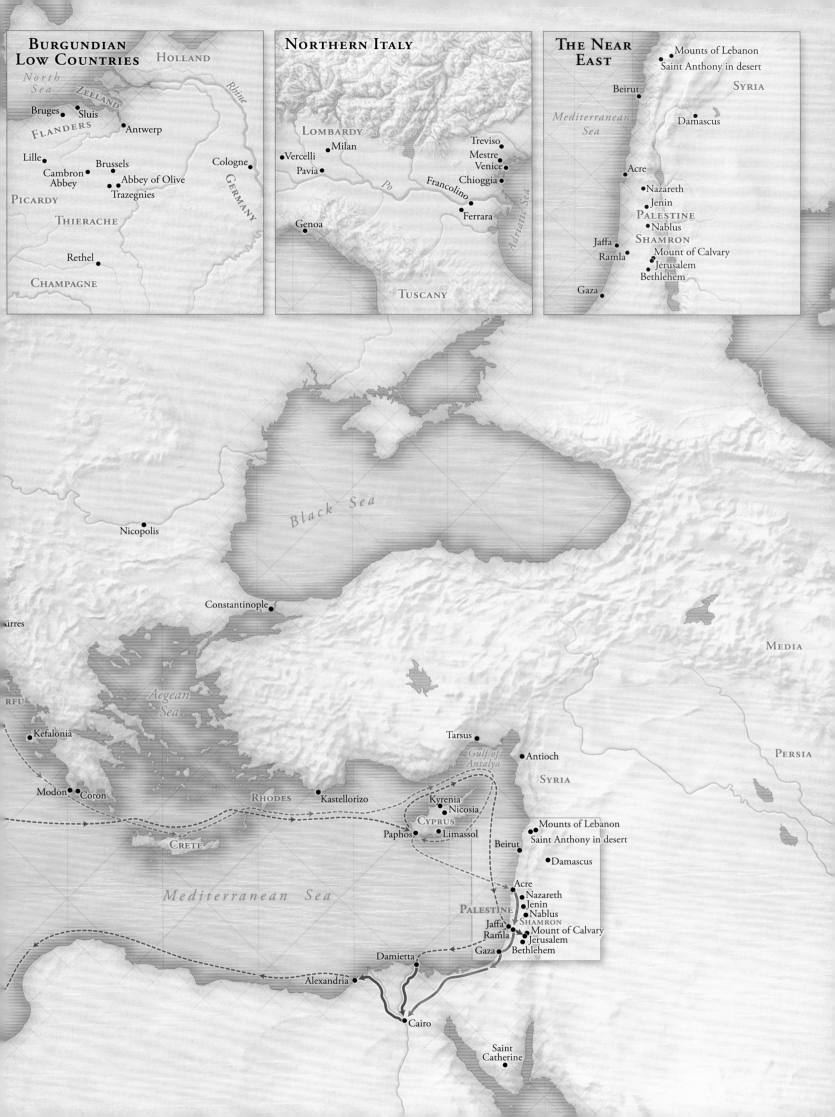

BURGUNDIAN LOW COUNTRIES

North Sea

HOLLAND

ZEELAND

FLANDERS

Bruges • • Sluis
• Antwerp

Lille •

Cambron Abbey • Brussels •
• Abbey of Olive
• Trazegnies

Rhine

Cologne •

GERMANY

PICARDY

THIERACHE

Rethel •

CHAMPAGNE

NORTHERN ITALY

LOMBARDY

Vercelli • • Milan
 • Pavia

Treviso •
Mestre •
Venice •
 • Chioggia
Francolino •
 • Ferrara

Po

Genoa •

Adriatic Sea

TUSCANY

THE NEAR EAST

• Mounts of Lebanon
• Saint Anthony in desert

SYRIA

Beirut •

Mediterranean Sea

• Damascus

Acre •

• Nazareth
• Jenin

PALESTINE

• Nablus

SHAMRON

Jaffa •
Ramla •

• Mount of Calvary
• Jerusalem
• Bethlehem

Gaza •

Black Sea

Nicopolis •

Constantinople •

ürres

Aegean Sea

RFU

Kefalonia •

Modon • • Coron

RHODES

CRETE

Mediterranean Sea

MEDIA

PERSIA

Tarsus •

Gulf of Antalya

• Antioch

SYRIA

Kastellorizo •

Kyrenia •
 • Nicosia

CYPRUS

Paphos • • Limassol

Beirut •

• Mounts of Lebanon
• Saint Anthony in desert

• Damascus

Acre •
 • Nazareth
 • Jenin
 • Nablus

PALESTINE

SHAMRON

Jaffa •
Ramla •
 • Mount of Calvary
 • Jerusalem
Gaza • • Bethlehem

Damietta •

Alexandria •

Cairo •

Saint Catherine

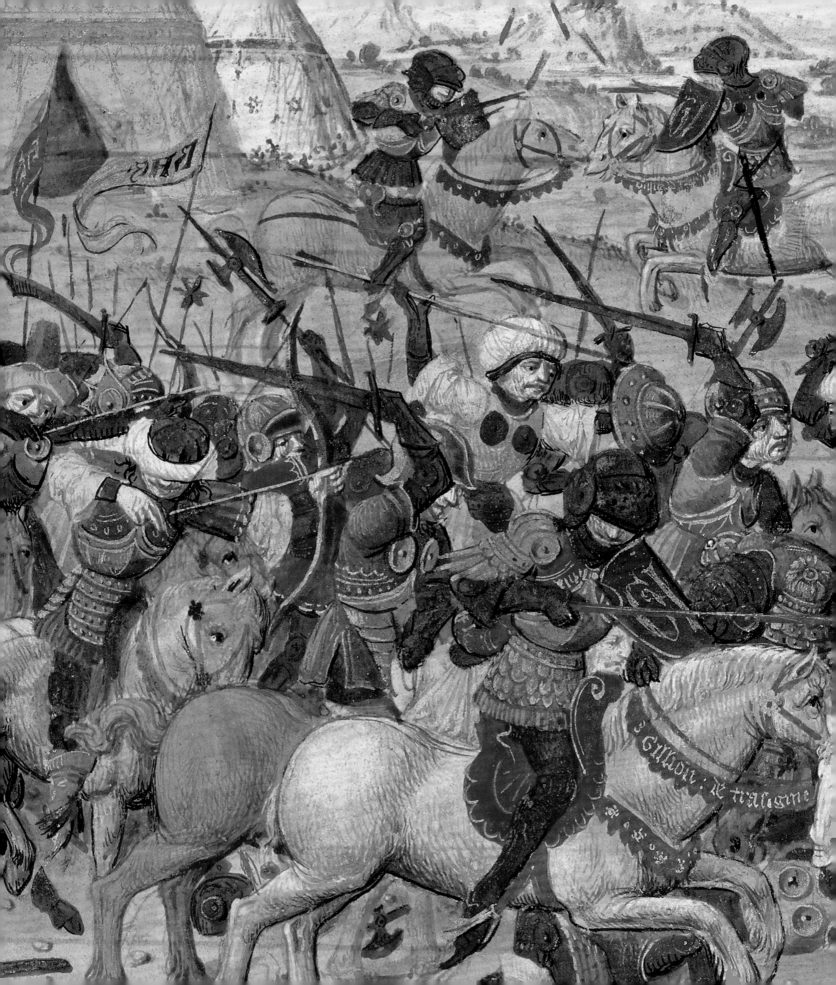

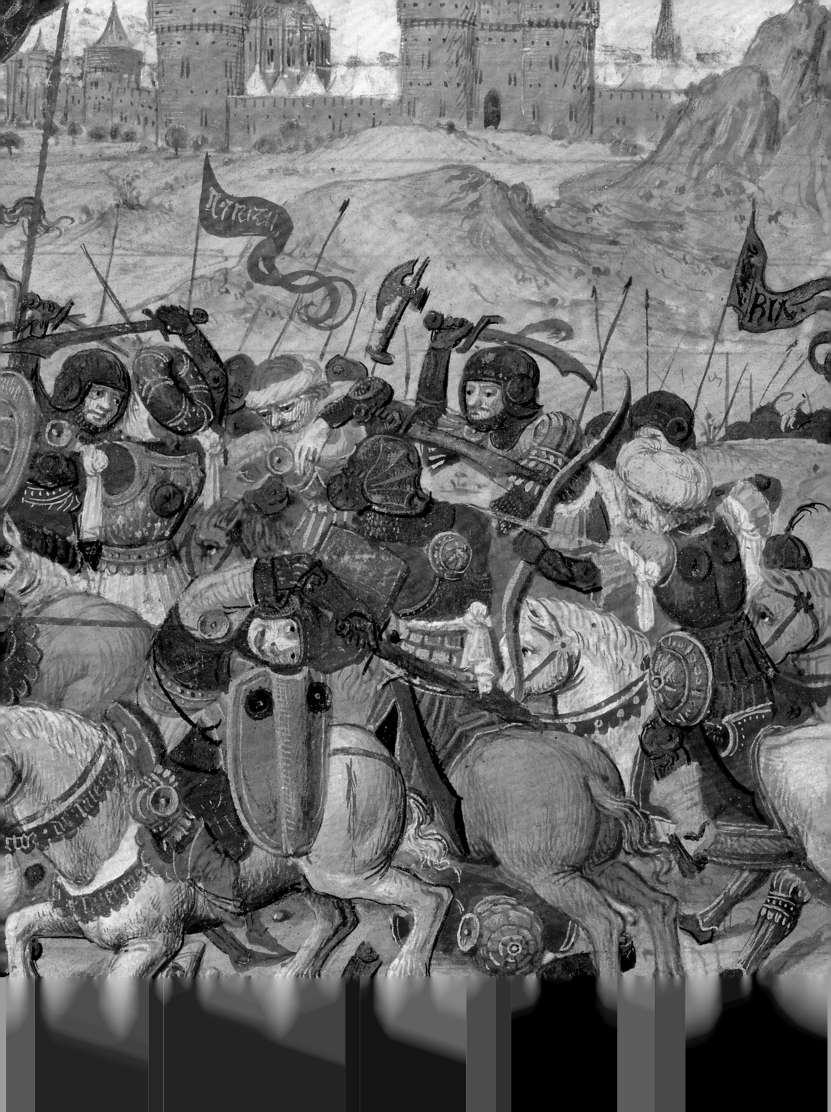

Plot Summary for the *Romance of Gillion de Trazegnies*

ZRINKA STAHULJAK

The author's prologue introduces the story of Gillion de Trazegnies, a noble knight from the county of Hainaut, in present-day Belgium and northern France. He was married to two women at once, one a Western noblewoman, Marie d'Ostrevant, and the other an Egyptian Muslim princess, Gracienne. This triangle, unorthodox for the Middle Ages, is openly displayed at the Abbey of Olive, where three recumbent statues, Gillion's in the middle, flanked by his two wives, lie on top of a single tomb. The story of Gillion's bigamy piques the interest of a writer passing through the abbey. He obtains from the abbot a copy of a small book in parchment, written in Italian, and translates it into French, creating the *Romance of Gillion de Trazegnies*.

The romance begins with Gillion's first marriage and a wrenching separation. In return for his loyalty and services, Count Baldwin of Hainaut gives his close relative Marie in marriage to Gillion. Although united in beauty and wealth, the couple is afflicted with childlessness. On the brink of despair, Gillion makes a vow to leave on a pilgrimage to Jerusalem at the first sure sign of a pregnancy. That very night Marie finally conceives. Faithful to his vow, Gillion leaves Marie and Hainaut before the child is born, despite his wife's anguish and tearful pleas from the Count of Hainaut and his entourage to see the pregnancy to term. As a token of their love and remembrance of her, Gillion gives Marie a ring with a ruby. As was then required of pilgrims, he first travels to Rome, seeking papal absolution and dispensation for his pilgrimage, and then to Jerusalem. But on his way back home, a terrible storm rises and his ship is thrown into the path of the Egyptian sultan's army sailing in the Mediterranean. The Christians prefer death to slavery and fiercely resist the Muslim attack. Soon they are outnumbered and massacred; Gillion, the sole survivor, is captured and taken to the sultan's dungeon in Cairo. Awed by his courage, the sultan finds him a fit sacrifice in Muhammad's honor. On the appointed day, Gillion is stripped naked and about to be executed by archers when, taken by his physical beauty and vigor, the sultan's daughter, Gracienne, tricks her father into postponing the sacrifice until the next major religious feast day. Just then the sultan is attacked by King Ysore of Damascus seeking vengeance for the sultan's and Gracienne's refusal of his marriage proposal. The king of Damascus is determined to conquer Gracienne by force, and during the first attack his troops capture the sultan. The sultan's dispirited army hastily retreats, and Cairo is about to fall to the enemy. Keeping her calm, Gracienne rescues Gillion from prison,

dresses him in sultan's armor, and sends him on a rescue mission. Her ploy works: the Muslim soldiers believe that the sultan was miraculously liberated and return to the battle, defeating the king of Damascus. In a move that will save his life, Gillion frees the sultan. Sometime later, the sultan orders the Christian knight's execution, but Gracienne has Gillion wear the armor he wore when he saved her father. The sultan immediately recognizes the armor but is stunned to find the Christian knight hiding in it. Still, Gracienne's new ploy works: instead of executing the Christian knight, the sultan offers to promote him to commander of his Muslim troops. In return for his freedom, Gillion has to vouch that he will not escape back to Hainaut without obtaining the sultan's leave, a promise that he will bitterly regret because he will be forced to spend the next twenty-four years in Cairo. But he finds some consolation in the fact that during his prolonged stay among Muslims, he can kill many enemies of Christ, alongside his companion-in-arms, Hertan, a Muslim knight with Christian leanings. Many more battles will follow, with Gillion defeating the sultan's enemies, Ysore's nephew, the emir of Orbrie, seeking vengeance along with his cousin, King Hector of Salerno; and, later, the army of the king of Mobrant.

While Gillion struggles daily to survive in the lands of the infidel, Marie gives birth to twin sons, Jean and Gerard, whom she raises alone while refusing to take another husband. Fourteen years after Gillion's disappearance, the Count of Hainaut decides to send a knight in search of him, hoping that news of Gillion's certain death will convince Marie to remarry. Desiring Marie's hand, the Hainaut knight Amaury leaves on the quest for Gillion and finds him in Cairo. Amaury brings Gillion the false news of Marie's and his progeny's death. Grief-stricken, Gillion blames himself and swears never again to return to Hainaut. Amaury rejoices, as he imagines—prematurely—that the path to winning Marie's hand is cleared. But before Amaury is able to leave, Cairo is besieged by King Fabur of Moriane, who wishes to avenge the death of his relative, the king of Damascus. Desiring martyrdom, Gillion leads the sultan's army into another battle with more zeal than ever. Before long, Gillion chases the invaders back to the Mediterranean shore, but he is captured by King Fabur and taken by ship to Tripoli. Amaury dies cowardly in the same battle.

Desperate, Gracienne begs Hertan to save Gillion. Hertan disguises himself as a black Moor and goes to serve Fabur as his new jailer. Eventually he liberates Gillion from the Tripoli dungeon, and the two escape on a merchant ship back to Cairo. On their return, the sultan elevates Gillion, the Christian knight who obstinately refuses to convert to Islam, above all Muslim courtiers. This situation is unacceptable for Haldin, a Muslim noble. He falsely accuses Gracienne of adultery and apostasy in order to disgrace Gillion. But Hertan defends Gracienne's suit and honor in a judicial duel (trial by combat) against Haldin, and he is certain to win: God grants Hertan victory because Gillion and Gracienne have maintained chaste relations despite their growing mutual love. To put a stop to any future rumors and to permanently secure Gillion's formidable military skills in defense of his kingdom, the sultan has Gillion marry Gracienne. The plot follows a strange twist: still a Christian, Gillion becomes heir to the sultan's throne, while Gracienne converts to Christianity in the privacy of their bedchamber before they consummate their marriage.

Back in Hainaut, Gillion's sons Jean and Gerard have grown up, and they are their father's sons: their trajectory mirrors Gillion's. Since Amaury failed to return to Hainaut, they now leave on the quest for their father. They arrive in Jerusalem via Rome, serve the king of Cyprus for a while, and are then captured by Muslim pirates. Jean is taken to Tripoli, Gillion's old prison, and Gerard to Dubrovnik, the seat of the Slav king, Morgan.

There, Gerard duels for the honor of Morgan's sister Natalie, who is enamored of him and who was falsely accused by Emir Lucion of trying to poison Morgan and usurping the royal throne. The brothers are reunited when Morgan besieges King Fabur in Tripoli. The two Muslim kings agree to decide the outcome of their war with a judicial duel between their champions; Jean is ordered to fight for Fabur, and Gerard for Morgan. But Jean recognizes his younger brother, and Gerard surrenders to him, following the rule of primogeniture (precedence given to the first-born male child). Fabur thus wins the war, and the twins become his captives. Fabur then attacks the sultan in Cairo for the second time, and Jean and Gerard fight for him as mercenaries. During the battle, Gillion recognizes the coat of arms and the battle cry of Trazegnies and asks Hertan to do all he can to retain the twins. When Hertan captures them, they show Gillion the ring with the ruby that Marie gave them. Gillion is suddenly faced with the fact that he has two sons and that he is a bigamist!

The romance ends with a reunion that might have surprised quite a few of its medieval readers. The sultan grants Gillion leave to return to the county of Hainaut, on the condition that he return to Cairo immediately if another war breaks out. Accompanied by his sons, Gracienne, and Hertan (who dies in Rome an hour after he is baptized by the pope), Gillion returns home, only to face the dilemma of what to do with his two wives. They decide to expiate their worldly sins; Marie and Gracienne take the veil at the Abbey of Olive, and Gillion retreats to the Cambron Abbey. Within the same year, Gracienne dies. The bond between the two women is so strong that Marie dies just two days later. Even as Gillion mourns, the sultan calls him back to save Cairo once more. Gillion leaves the title and the lands of Trazegnies to Jean, the elder of the twins, and returns to Cairo accompanied by Gerard and sixty young knights from Hainaut. In a final, epic battle, Gillion receives a mortal wound from which he dies in the Muslim lands where he spent most of his life. His final wish is to be reunited with his two wives, and Gerard takes his heart back to Hainaut and places it in the tomb to rest between Marie and Gracienne.

Plates with Translations and Summaries

ZRINKA STAHULJAK

NOTE TO THE READER Each of the Getty manuscript's eight miniatures is accompanied by its rubric (in bold) and a translation of the related sections of the romance (in italics). The forty-four historiated initials are accompanied by summaries (in roman type) based on the text of the romance. Some initials are close to the gutter of the center of the manuscript, and in those cases, a sliver of the facing page is visible. Because of the choice of format, presenting the miniatures facing a full page of translation of the associated text, some initials appear alone on a page; Plate 36, coming between two miniatures, is presented both as a detail and as a full page. To provide full continuity for the visual and textual narratives, rubrics from the Getty manuscript's table of contents (fols. 1–6v) are translated for seventeen missing images (six miniatures and eleven historiated initials). These rubrics would have been repeated in the body of the text before each image.

All the extant images are marked with two types of folio numbers, the original number and the modern number. The manuscript was originally foliated in red Roman numerals at the upper right of each page (only the front of each folio receives a number, as opposed to pagination, in which both the front and back of each page receive a number). Sometime after thirty-three folios were removed, the manuscript was foliated again in pencil in Arabic numerals in the upper right. Because this modern foliation does not account for the missing pages, the foliations in red ink and pencil do not match. All Getty published and online materials follow the modern foliation, so that foliation is indicated first in the translations and summaries, followed by the Roman numerals of the original foliation. For the missing images, folio numbers are copied from the Getty manuscript's table of contents (Roman numerals).

Most place names have been given modern spellings or their modern equivalents (Crete for Candia, Dubrovnik for Ragusa, Gibraltar for Jubaltar, Kyrenia for Sermes) and can be located on the Map of Places Related to the Gillion *Romance*. The place name "Babilonne" is consistently translated with the modern equivalent "Cairo" and, occasionally, "Egypt" ("the sultan of Egypt," "Cairo in Egypt"); "Babilonnois" is translated with "Cairene." "Barbarie" is the Barbary coast of northern Africa, more narrowly the Berber region; "Morienne" denotes broadly the land of the Moors in northern Africa and refers more narrowly to today's Libya; "Esclavonie" refers to the land of the Slavs, and more specifically to Slavonia, the area south of Hungary, between the rivers Drava and Sava (in today's Croatia). These place names, compiled by Zrinka Stahuljak, are also used for the map on pp. 8–9. "Saracen," the standard medieval term for "Arab Muslim," has been retained as the translation for "Sarrazin."

The dedicatory prologue to the *Romance of Gillion de Trazegnies* discussing the manuscript's patron is followed by a second prologue that opens with the author's statement of purpose, unique to the Getty manuscript. This second prologue segues into a description of the author's discovery of the manuscript, depicted in the frontispiece.

15

PLATE I
Fol. 9 [fol. ii], MINIATURE, *The Author Hearing the Story of Gillion de Trazegnies*
"Prologue by the book's author"

Second prologue

The high and exalted deeds that inspired the noble hearts of our ancient predecessors are worthy of praise, recommendation, and perpetual memory, especially among princes and noblemen. Upon hearing or reading the stories of righteous men of lore who used and employed the arms and conditions of chivalry, even on the infidels, ancient enemies of the Catholic faith, they can thereby greatly gain from fleeing all vice and loving good virtues.

As it happens, about two years ago I traveled through the county of Hainaut, where there once was and still exists a noble and valiant chivalry, as this ancient history, among others, makes manifest. I have been since my youth and remain eager to know the noble and high deeds achieved by the valorous and valiant men of lore and, since I was passing by a rather ancient abbey called Olive, where I saw three high raised tombs, I inquired at the abbey and sought out the names of the dead who lay buried in them. The abbot and those of the monastery therein told me that the bodies of two noble and courageous ladies and their husband in their midst were buried there. They told me their names and bynames, which I saw inscribed around their tomb. And having seen and read the epitaph to the dead, I learned that the most valiant knight, my lord Gillion de Trazegnies, lay buried there in the midst of two noble and virtuous ladies, who were both his companions and spouses during his lifetime, one of whom was daughter to the sultan of Egypt, which astonished me to no end. I then immediately bid the abbot and the monks to pray tell me at length how the lord of Trazegnies had had a sultan's daughter for a wife and had brought

her to the land of Hainaut. Seeing my great desire to know the truth, the good abbot thereupon had one of the monks bring a small book in parchment, written in Italian, in very ancient and obsolete writing. Having read and understood the matter that seemed noble, poignant, and highly commendable, I was glad to work on translating the content of the said little book into our French language, so that the high deeds and chivalrous feats of my brave lord Gillion de Trazegnies and his two sons, Jean and Gerard, do not vanish from memory but rather increase in perpetuity. Because of this I am certain that the story will please you, my most high, most excellent, and most powerful Prince Philip, by the grace of God, Duke of Burgundy, Lothier, Brabant, and Limbourg, Count of Flanders, Artois, and Burgundy, Palatine of Hainaut, Holland, Zeeland, and Namur, Marquess of the Holy Empire, Lord of Frisia, Saline, and Malines. And even though I am not skilled or talented enough to firmly eschew Lady Idleness, mother of all vices, I have dedicated myself to the task, begging you, my most feared lord, and all others that you amend the errors, should there be any, which I notwithstanding leave to your good correction.

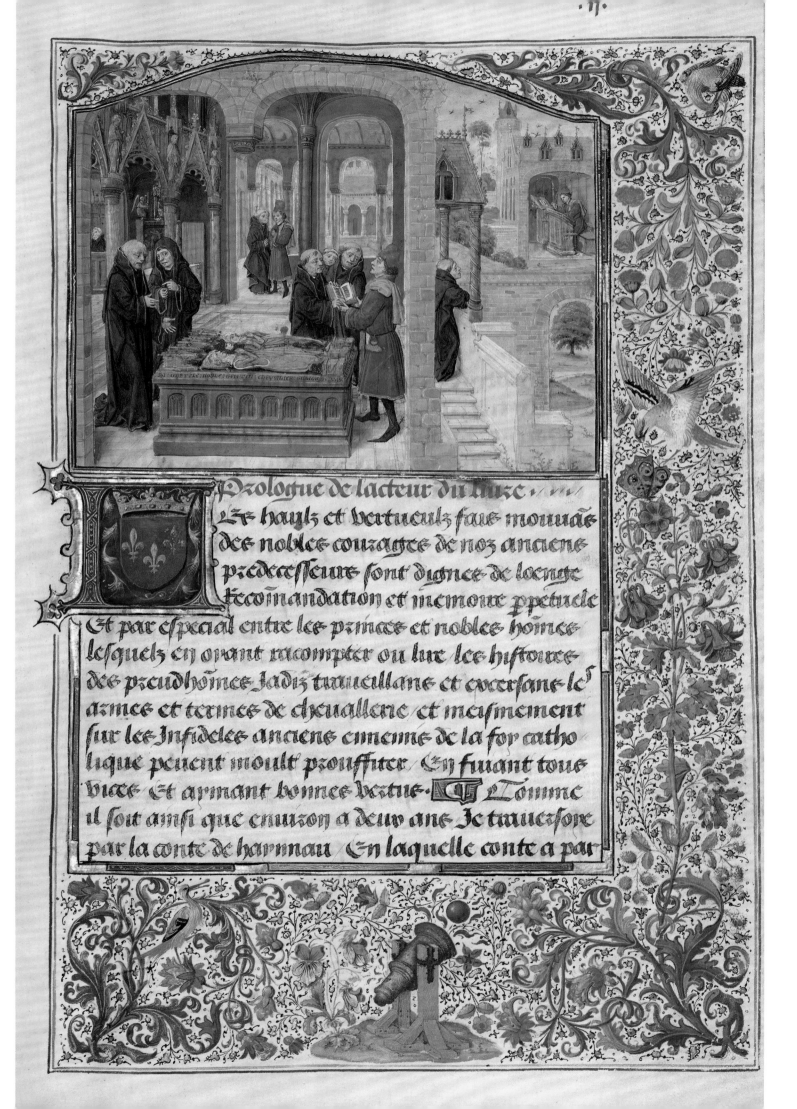

Prologue de lacteur du liure.

Les haulz et vertueulz fais mouuans
des nobles couraiges de noz anciens
predecesseurs sont dignes de loenge
recommandation et memoire ppetuele
Et par especial entre les primces et nobles hommes
lesquelz en oyant racompter ou lire les histoires
des preudhommes Jadiz trauaillans et exerceans les
armes et termes de cheuallerie et mesmement
sur les Infideles anciens ennemis de la foy catho
lique peuent moult prouffiter En fuyant tous
vices Et aymant bonnes vertus Comme
il soit ainsi que enuiron a deux ans Je trauersoye
par la conte de haynnau En laquelle conte a par

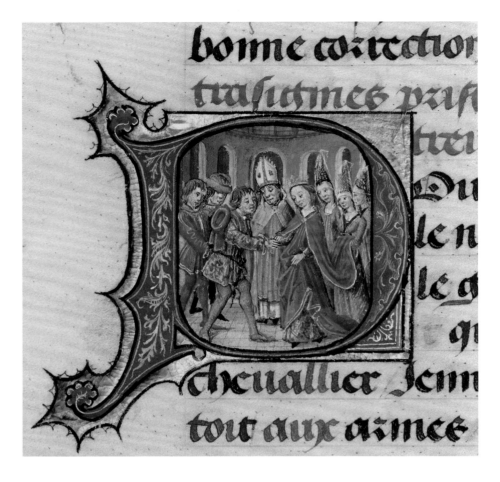

PLATE 2

Fol. 10v [fol. iii], **Initial *D*: *The Wedding of Gillion and Marie***

Count Baldwin of Hainaut has given his close relative, Marie, daughter of the Count of Ostrevant in marriage to a young but most valiant and reputed knight, Gillion, lord of Trazegnies, in reward for his services. The image shows them inside the chapel of the castle of Avesnes. A bishop, recognizable by his white miter and green cope, joins Gillion's and Marie's hands to signify their union. Gillion carries a sword, denoting his knightly status, and Marie wears a crown to signal her high nobility. The narrator describes them as adorned with beauty and goodness and perfectly matched in their high morals, and the artist painted them with gentle and humble expressions. Based on the text, the man dressed in blue and standing behind Gillion could be Count Baldwin. He is wearing a collar closely resembling that of the chivalric Order of the Golden Fleece, established in 1430 by the Duke of Burgundy.

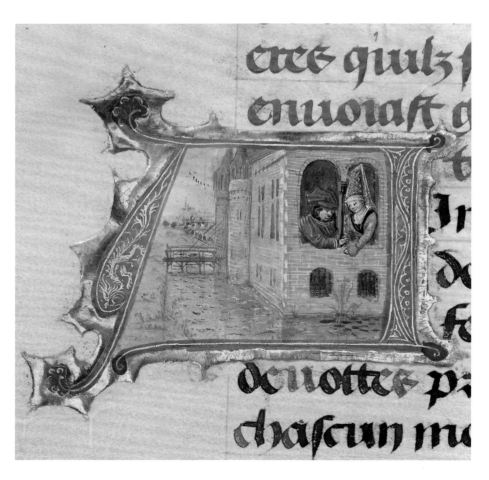

PLATE 3

Fol. 11v [fol. iiii], **Initial *A*: *Gillion and Marie Gazing at a Mother Carp and Her Offspring***

Gillion and Marie are deep in conversation at the windows of the great hall of the castle of Trazegnies, overlooking a moat. They gaze downward, and Marie gestures with her left hand toward a school of fish, a carp with her hatch. Marie is crying: despite the fact that God endowed Gillion with such force, beauty, and common sense, shaped her so no woman can surpass her, and graced them both with riches and lands, he has not yet blessed them with a male heir. An heir gives comfort and joy to the mother, she laments, as does the brood playfully swimming around their mother carp. There is no greater love than the mother's for the offspring she conceives and carries, but God has forgotten to grant them that gift of nature.

PLATE 4

Fol. 13 [fol. vi], **Initial** *Q*: *Gillion and Marie Gazing at Carp and Gillion Praying*

In the left half of the picture, Gillion moves to take Marie's hand to console her: neither of them is to be blamed for the absence of progeny, since such is God's will; at his pleasure, he will grant them a numerous brood. Taking one last look at the carp swimming away with her hatch, Gillion, absorbed in thought, retires to the castle's chapel. Kneeling before the Crucifix, he most humbly prays to God to grant him the power to engender an heir in his wife. He promises that as soon as he learns that his wife has conceived, he will set out on a pilgrimage to the Holy Sepulcher in Jerusalem.

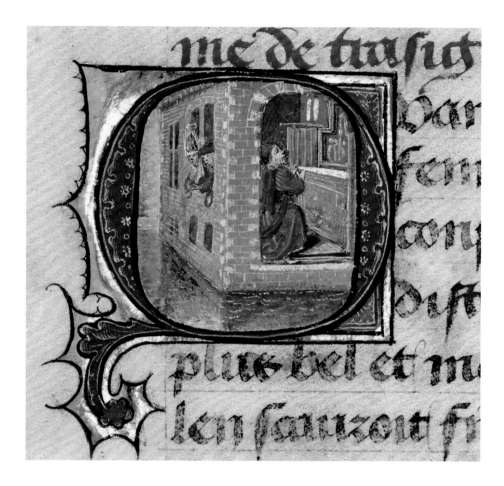

PLATE 5

Fol. 14 [fol. vii], **Initial** *A*: *The Count and Countess of Hainaut Setting Out on Horseback*

That very night, Marie conceived, and as her certainty grew, she shared the news with Gillion. On the day following her announcement, Gillion set out to the court of Count Baldwin to invite him to visit the young household. Count Baldwin, still young of age and desiring to please the lord of Trazegnies, commands that his departure be prepared for the next morning. The count, dressed in blue, is wearing a gold collar, perhaps meant to suggest anachronistically the collar of the Order of the Golden Fleece, and the countess has mounted behind him. The count's retinue departs eagerly toward the castle of Trazegnies, in the company of the lords of d'Antoing, d'Enghien, de Ligne, de la Hamaide, and de Bossut.

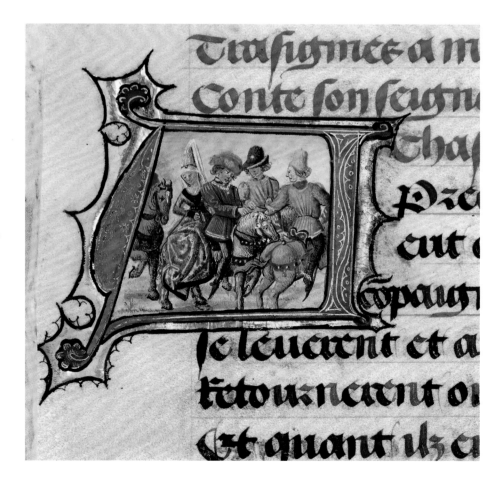

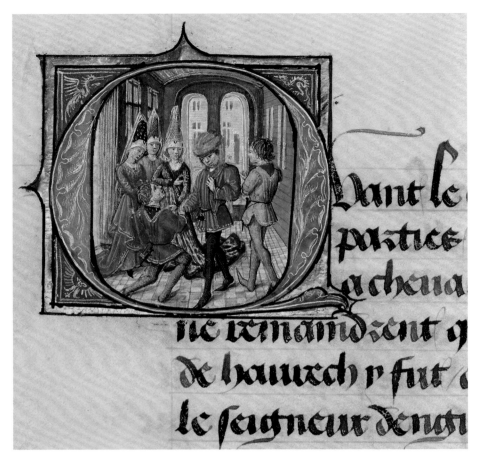

PLATE 6

Fol. 15v [fol. viii], **Initial *Q*:** *Gillion Asking the Count of Hainaut for Permission to Go on Pilgrimage*

Gillion is on his knees, holding Count Baldwin's hand. Before his relatives, knights, friends, and ladies, he exposes his request: his plea to God has been answered when, four or five months ago, Marie conceived. Now that there are manifest signs of her pregnancy, it is his turn to fulfill the vow he made to God to cross the sea and never to tarry more than one night in the same place until he reaches the holy city of Jerusalem and prays at the Holy Sepulcher. He commends his wife, his possessions, and the child to be born—boy or girl—to the care of the count, the countess, and his relatives and friends. Expressing emotion at this surprise request, the count, the countess (in the same dress as in the preceding image), and another knight (dressed in green with a sword) are shown gesturing, whereas another lady dressed in blue, perhaps Marie, looks dumbstruck by this request.

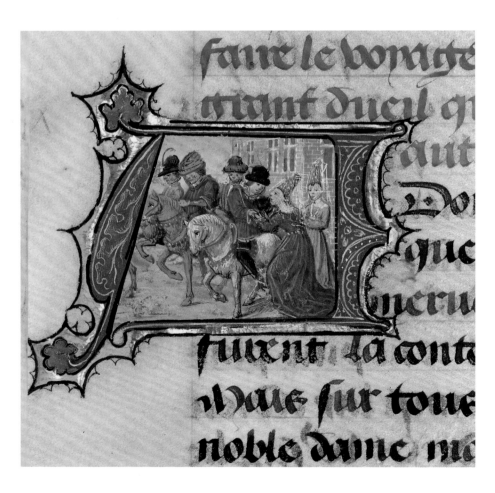

PLATE 7

Fol. 17 [fol. x], **Initial *A*:** *Gillion Taking Leave of His Wife Marie*

Despite the collective plea and cries to postpone his pilgrimage until his wife gives birth, Gillion gets ready to depart, unshaken in the belief that his vow must be fulfilled immediately. To his right, in blue, is the count, whose eyes are hidden from our view. The artist painted the rest of the entourage with downcast faces and frozen expressions, suggestive of the degree of devastation at Gillion's departure. In one of the most moving moments in the text, the narrator talks about how great joy has turned into immense grief. In a tender scene between the spouses, who have just kissed each other lovingly, Marie, crying, requests the gift of a ring with a large ruby that Gillion wears on his finger. Gillion grants it to her to serve as a reminder to pray to God for his swift return from across the sea.

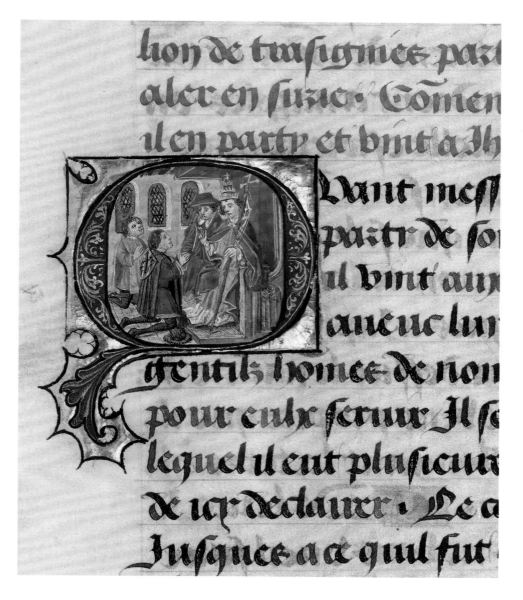

PLATE **8**

Fol. 19 [fol. xii], **Initial** *Q*: *Gillion Receiving the Pope's Blessing*

On his way to Jerusalem, Gillion goes first to Rome, by way of Champagne, Burgundy, Savoy, Lombardy, and Tuscany, accompanied by his men. Gillion is depicted kneeling on both knees. On his back, the artist has painted for the first time the Trazegnies coat of arms—the black lion of Flanders on an azure background, with golden trim and three transversal golden bars. In the presence of a cardinal, dressed in red, and the Holy Father, painted with the distinctive papal crown and staff, Gillion has just made his confession. The pope has absolved him of sin and is blessing Gillion.

PLATE 9

Fol. 21 [fol. xiiii], MINIATURE, *Gillion's Ship Attacked by the Sultan's Army*

"How my lord Gillion de Trazegnies left Jerusalem and was captured at sea by the Saracens and held captive in Cairo in Egypt"

The sultan [of Egypt] was in one of his ships, surveying the sea around him, when he spotted the pilgrims' ship. He ordered his sailors to steer with haste in order to board the pilgrims' or merchants' ship that he saw traveling ahead of him, for it very well seemed to him that it was loaded with Christians. On the other hand, the captain of the Christian ship immediately recognized the Saracen ships that were rapidly closing in on them in order to do battle and destroy them. On account of this, a great fear seized his heart and he said: "Lord pilgrims who are on this ship, behold the enemies of our Lord before you. Consider what is for the best: either to defend yourselves to the death or to surrender and spend the rest of your lives as serfs and slaves in great misery and poverty." Upon hearing the captain, the brave knight, my lord Gillion, replied for himself and his men and said that they would much prefer to die, if need be, in defending themselves to the death, than to surrender into the hands of Saracens as slaves and serfs....

The Saracens started to hook up to the pilgrims' ship. They swarmed and assailed it quickly and the good Christians took to defending it vigorously. Then began the shooting from both sides, so vicious and gruesome that it was a horrific sight to see. From the ship's masts up above, stones, arrows, and very large iron bars were thrown. And the attack was fierce, massive, and ferocious.... The sultan advanced quickly and believed he would smite the knight [Gillion], but he failed because the bachelor-knight [young aspiring knight], like an enraged tiger, struck the sultan with the sword with all his might. Had the Saracen not known

how to avoid the blow, he would have sliced him down to the chest. Nevertheless, because the powerful blow was delivered quickly, the sultan, willy-nilly, was forced to fall flat on the floor of the ship, legs in the air.

The Saracens who saw this thought the sultan was dead. They raised him to his feet as soon as they could. The sultan had never been more sorry than to see himself brought down in this way. He therefore shouted most fiercely to his men, saying: "What is this, you cowardly and unfaithful Saracens! May you be cursed by Muhammad's mouth when one Christian's body forces you to retreat and falter! And yet you can see that there is but one ship and few men who can harm you, while we have three large, well-manned ships over them. You have neither the force nor the courage to dare conquer them." Thereupon, the Saracens attacked the Christian ship from all sides, more fiercely than before. And my lord Gillion unfailingly stood his ground on the ship's deck, where the pagans assailed him from all sides. But he punished them severely, for he killed or maimed as many as he could reach with a solid blow. And he began to cry out "Trazegnies" to fortify his men who defended themselves most courageously with all their strength. On one occasion when the Saracens came on board their ship and then were pushed back, there was such a massive carnage that the sea all around the ships was tinted and turned ruby red with the blood of the dead. But it is a common saying that where force reigns justice finds no place. For there was such a multitude of Saracens compared to our men that the Christian ship had to yield by sheer force

and all its defenders were cut to pieces, except my brave lord Gillion who was captured and tightly bound because the sultan did not want him to die quickly on account of his formidable defense and valiance in arms. He ordered for Gillion to be taken to Cairo in Egypt where he was to be placed under a good guard and given enough to eat and drink.

[Fol. xvii], MISSING HISTORIATED INITIAL
"How the lady of Trazegnies gave birth to two beautiful sons and named the elder Jean and the younger Gerard"

[Fol. xviii], MISSING HISTORIATED INITIAL
"How the sultan of Egypt intended to alight in Cyprus but was unable because of the very great resistance put up by the king of Cyprus. And how he returned to Cairo where he received a messenger in his palace while he sat at the table"

[Fol. xxii], MISSING HISTORIATED INITIAL
"How my lord Gillion de Trazegnies, imprisoned in the sultan's dungeon in Cairo, said his prayers to our Lord. And how the sultan sent for him and ordered him brought before him in order to have him stoned to death"

[Fol. xxiii], MISSING HISTORIATED INITIAL
"How my lord Gillion de Trazegnies killed the jailer and three other Saracens. And how the beautiful Gracienne, the sultan's daughter, was the reason Gillion's life was spared this time"

[Fol. xxv], MISSING HISTORIATED INITIAL
"How the life of my lord Gillion de Trazegnies was spared thanks to the intervention of the maiden Gracienne, the sultan's daughter. And how he was brought back to the dungeon"

[Fol. xxvi], MISSING MINIATURE
"How the maiden Gracienne visited and consoled my lord Gillion de Trazegnies in the sultan's dungeon. And how the knight thereafter exhorted the maiden to believe in the religion of Jesus Christ"

Et me fay ceste grace que le fruit quelle apportera
voeulles saulver et garder a celle fin que auant ma
mort le puisse veoir et que telle oeuure piust tousiours
faire qui bien soit tres plaisante et agreable

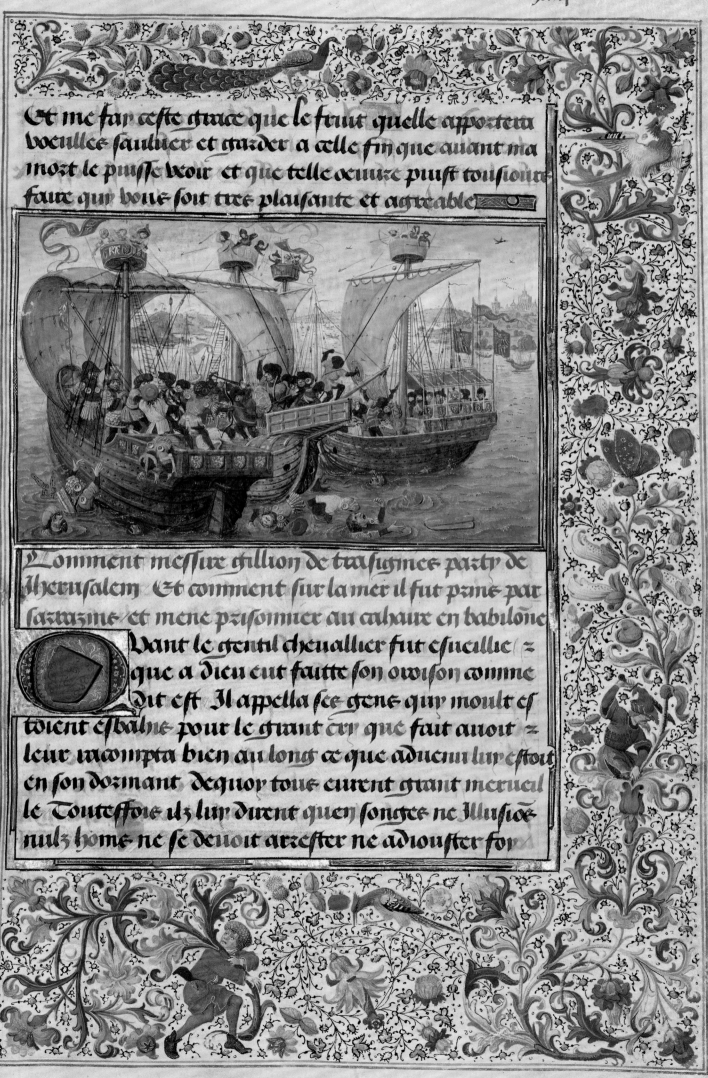

Comment messire chillon de traisignes party de
Iherusalem Et comment sur la mer il fut prins par
sarrazins et mene prisonnier au cahaire en babilone

Uant le gentil cheuallier fut esueillie z
que a dieu eut faitte son oroison comme
dit est Il appella ses gens qui moult es
toient esbahis pour le grant cry que fait auoit z
leur raconpta bien au long ce que aduenu luy estoit
en son dormant dequoy tous eurent grant merueil
le Touteffoie ilz luy dirent quen songes ne illusioe
nulz home ne se deuoit arrester ne adiouster foy

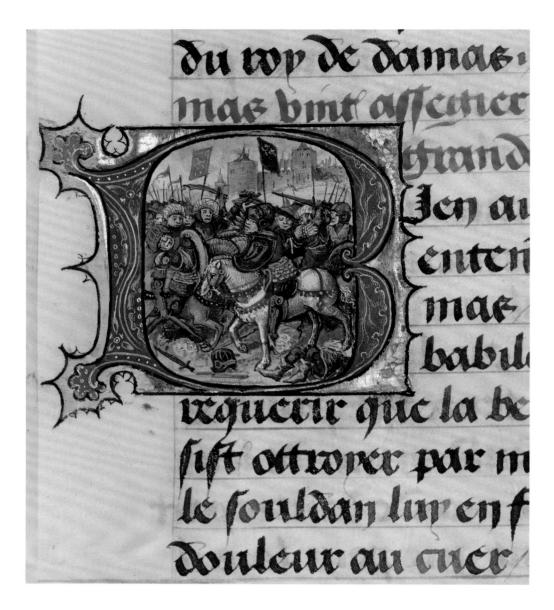

PLATE 10

Fol. 27 [fol. xxx], **Initial *B*: *A Battle before the Walls of Cairo***

This historiated initial depicts the first battle between the armies of the sultan of Egypt and King Ysore of Damascus before the walls of Cairo. King Ysore is seeking vengeance for the injury he suffered when Gracienne refused his marriage proposal and wishes to conquer her by force. Gillion prominently occupies the center of the image and can be identified by the initials "GI" on his shield, his standard (a golden lion on a blue background) held high above his head. The battle rages, and corpses on the ground are being trampled under horses' hooves. But in

the story, during this initial violent clash of the armies of the sultan and King Ysore, Gillion remains imprisoned inside the city. Because the artist imaginatively depicts him participating in the battle, this image could be a foreshadowing of Gillion's imminent role as savior of the sultan and commander of his army.

[Fol. xxxiii], MISSING HISTORIATED INITIAL "How the noble lady Gracienne freed my brave lord Gillion de Trazegnies from prison and had him and Hertan armed. And how she sent them to the rescue of the sultan, her father, and the adventures they had"

PLATE II

Fol. 31v [fol. xxxv], **Initial** *V: King Tarsus Capturing the Sultan*

The two Muslim armies, one led by King Ysore, the other by the sultan, have clashed violently. Although the image is partially effaced, we see the sultan standing in the middle of the image; his armor bears the letters "Sou'dan'" (*Souldan*). The sultan has just been unhorsed in a joust by the king of Tarsus; his lance, shattered to pieces, lies on the ground. Defending himself fiercely, he has cracked skulls and cut arms and legs, which are strewn across the battlefield. But now, unable to resist any longer, the sultan is captured by an ally of King Ysore, the king of Tarsus. He is still mounted, while, to the right, we see the sultan's men, who have tried to rescue the sultan, being pushed back. The sultan's standard, shown by the artist as blue with a gold lion—as if adopted by the sultan once Gillion became head of his army—lies on the ground, trampled under horses' hooves.

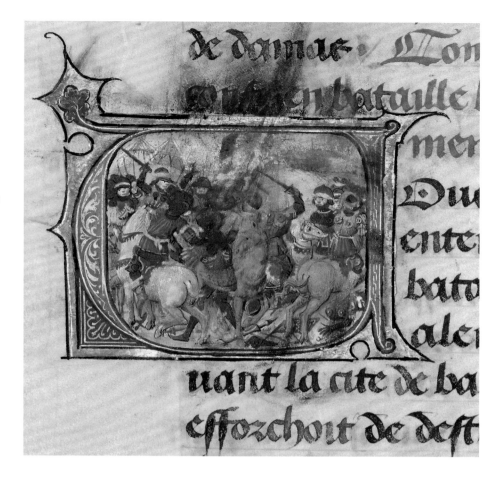

PLATE 12

Fol. 34v [fol. xxxviii], **Initial** *L: Gillion and His Companion Hertan Riding to Rescue the Sultan*

On the upper left, the battlefield is covered with corpses of Cairenes. In the foreground, Gillion exits the fortifications, followed by Hertan. Gillion is identified twice as "Gillio," on his armor and the horse's harness, but is in fact disguised in sultan's armor: upper body in gold and red, with a green trim at the waist, arms and legs in black, with a black helmet. Gracienne thought of this trick with the aim of reversing the fortunes of the Cairene army, which had retreated in defeat after the sultan's capture. Even as he marches forward, Gillion is turning back toward the Cairenes hidden from our sight behind the city walls. Playing the role of the sultan, he tells them that if they do not follow him back into battle, Muhammad will punish them for disregarding the miracle of his liberation and for not taking vengeance on the king of Damascus.

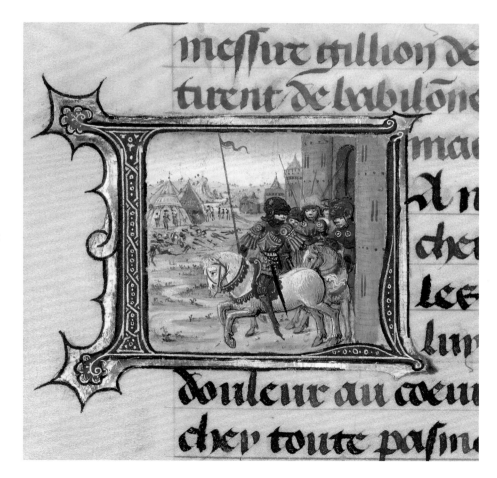

nestoient demourez ne bieulz ne jesnez que tous ne
fussent venuz aux champs pour le grant myracle
quilz cuidoient certainement que mahom eust fait
sur la personne du souldan leur seigneur Et tant
exploitterent que ilz se retrouverent sur la champa
igne ou la crinmelle bataille auoit este et illec trou
uerent leur maistre estandart gesant par terre ilz le
releuerent puis le baillerent a porter a vng roy sar
uuzin lequel estoit preudhome en sa loy et vaillant
en armes A tant se taist pour le present listoire
de messire gillion de trasignies de hertan et des bah
loinois pour parler du roy ysore de damas et de ses
roys et adniziaulx qui estoient pres de leur mort.

Coment messire gillion de trasignies et hertan occirent
et desconfirent le roy ysore de damas et son ost Et
coment le souldan fut reconquis sur ses ennemis.

PLATE 13

Fol. 36v [fol. xl], MINIATURE, *Gillion Slaying King Ysore and Freeing the Sultan*
**"How my lord Gillion de Trazegnies and Hertan killed and defeated King Ysore of Damascus
and his host. And how the sultan was won back from his enemies"**

King Ysore sat down on a portable throne and sent for kings and emirs of his host and his counselors to come to his pavil-ion.…When all had gathered and were come to his large and spacious pavilion, after an exchange recounted herein, the king asked the opinion and counsel of them all in order to fairly decide how he should proceed with his captive, the sultan of Egypt. Some condemned the sultan to be skinned alive, others to be dismembered into pieces, others still to hang. Upon hearing the opinions and advice of his council, King Ysore told them: "Fair lords, I think the matter should be conducted otherwise and that the sultan should not be treated thus given that during the length of his reign he has been a noble and valiant prince and that he had many handsome victories over his enemies, notwithstanding that all princes should be merciful with one another. In-deed, I would advise that we chain him to a stake in front of my pavilion, then send for his daughter, the beautiful Gracienne, to come to us by safe-conduct. And I will tell her of the great and perfect love that I have always felt for her. I reckon that, if she is good and loyal to her father and when she sees him in danger, she will be more inclined to hear my reasons in order to deliver him from the peril in which he finds himself, which she will be able to witness. And if it so happens that she not wish to take me for a husband, I will have the life of the sultan, her father, end in such a death as will terrorize and hor-rify all who see it." Thereupon, all agreed in unison that his counsel was good and consented to its execution.

…While King Ysore sat at the table and was being served his first dish and everyone in his host was rejoicing at the handsome victory that they had obtained, my lord Gillion and Hertan, accompa-nied by the Cairenes, rode swiftly toward the host.…

They did not stop once until they all, in one wave, hit the tents of the men from Damascus, whom they found completely disarmed, seated at their meal. The cries and the noise started and rose up amid the host, so great that it seemed that everyone had assembled there. The Cairenes spread through the tents of their enemies, putting to the sword everyone they came across. They felled so many tents and pavilions by cutting the cords that none was left standing. In the meantime, the brave knight, my lord Gillion de Trazegnies, who with all his heart desired to put his enemies down and cut them to pieces, looked around and saw the sultan tied up and chained in front of King Ysore of Damascus's pavilion. Presently and swiftly, sword in hand covered in the blood of Saracens he had killed, he cut the ropes that bound him to the stake and thus freed him, then gave him armor and a good charger to mount. The sultan, who did not know him, thanked him profusely.

…Gillion then went into the tent of King Ysore, who was still at the table among kings and emirs mentioned above, having a great celebration. He entered and soon recognized King Ysore among the others because he had heard stories of him. And Hertan, sword in hand, followed him closely. But when they were inside, my lord Gillion started to shout

and said: "Ha, Ysore of Damascus, the hour has struck for vengeance on your body, neither flight nor fight will do."

…He then swiftly raised his good sword, smiting King Ysore on the head with such a marvelous blow that he sliced him open to the chin. Instantly, Ysore fell on his back to the ground, dead.

When kings and emirs, Ysore's rela-tives, found themselves surprised in this way, they jumped to their feet intending to flee the pavilion. They thought they could leave but they found Hertan in the company of the Cairenes, facing them with their unsheathed swords in hand, all bloodied.

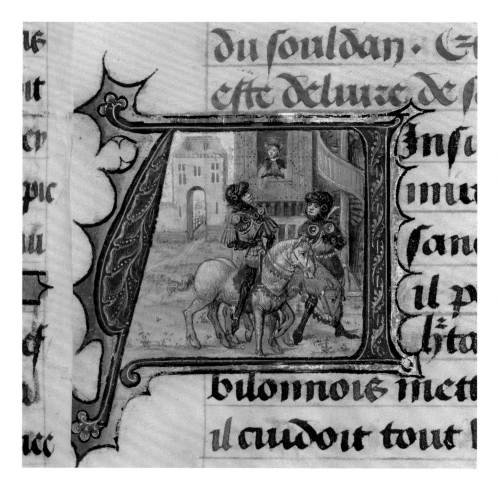

PLATE 14

Fol. 41 [fol. xlv], **Initial** *A: Gillion and His Companion Hertan Secretly Returning to Cairo*

Having liberated the sultan, killed King Ysore, and hunted down and chased out their enemies, Gillion and Hertan have just stolen back inside the city via a side entrance, tucked away between the city walls and the river Nile. Clasping her hands in a prayer of thanks, Gracienne watches them dismount in the gardens of the palace. Gillion's and Gracienne's gazes meet. At this moment, Gillion is full of pride at fulfilling his mission and keeping the promise made to Gracienne that he would not flee even if he succeeded in liberating the sultan. But the meeting of their eyes is also the artist's first indication of their growing affection and complicity.

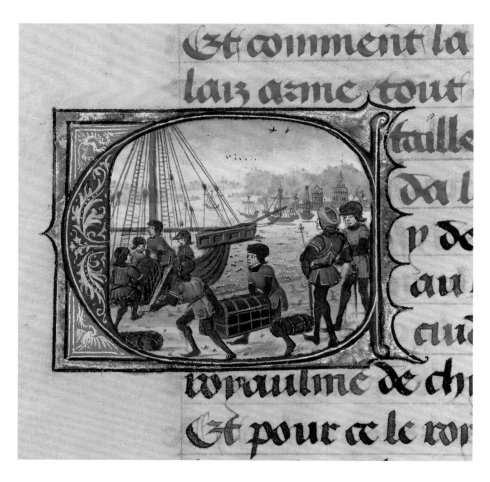

PLATE 15

Fol. 44v [fol. xlviii], **Initial** *C: Troops Loading Provisions onto a Ship*

Big ships are being loaded and prepared for a military campaign. The image may serve as a double reference to the simultaneous war preparations by the emir of Orbrie, to avenge the death of his uncle, King Ysore, and by the king of Cyprus, to avenge an earlier raid on Cyprus by the sultan. Unintentionally, the Muslim and Christian armies will converge on Cairo at the same time. Since the soldiers and sailors do not wear beards or turban-like hats, both commonly used to represent Muslims, it is more likely that the artist chose to represent here the Christian army boarding the ships to attack Muslims.

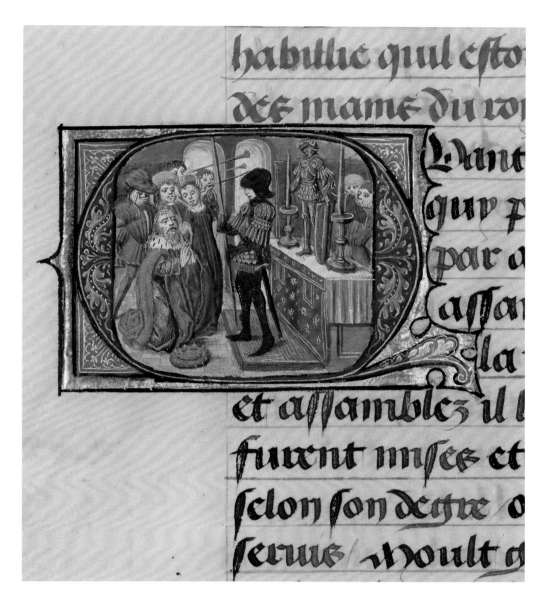

PLATE 16

Fol. 45v [fol. xlix], **Initial *Q*: *The Sultan Kneeling before Gillion***

Wishing to thank Muhammad for his liberation, the sultan has ordered Gillion, the Christian knight, brought out of the dungeon and executed. In anticipation of this sacrifice, musicians sound their trumpets. Gillion stands in the middle, in full armor, with a sword and a lance. Gracienne has dressed him in the same sultan's armor that he wore into battle, and the sultan, recognizing the appearance of the one who rescued him, falls to his knees in prayer, bareheaded. He believes that he was saved by Muhammad himself. The sultan had asked for a statue of Muhammad, placed on the altar behind Gillion, to be brought in witness of the execution, but the artist highlights the sultan's erroneous belief that Gillion is Muhammad by painting Muhammad's armor in imitation of Gillion's. Hertan, dressed in green, covers his mouth with his hand to repress his laughter at the foolish belief of the sultan and his emirs that Gillion is Muhammad himself.

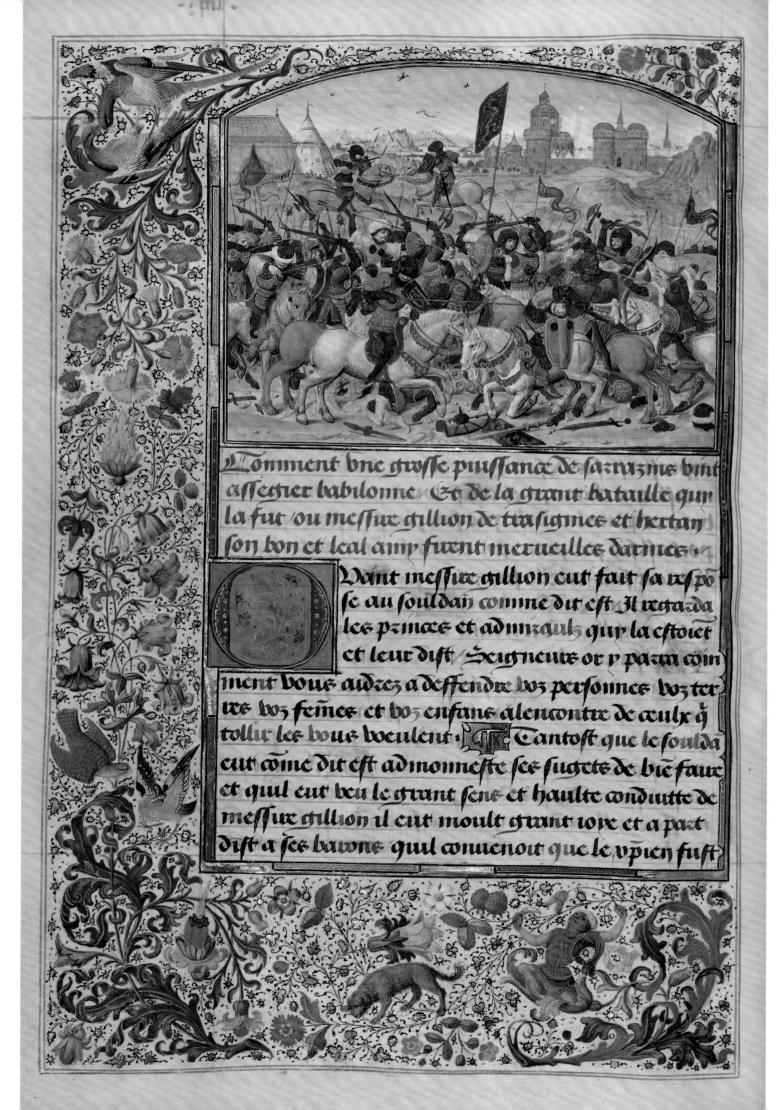

Comment vne grosse puissance de sarrazins vint
asseguer babilonne. Et de la grant bataille gui
la fut / ou messue gillion de trasignies et hertan
son bon et leal amy furent merueilles darmes.

Uant messue gillion eut fait sa respon
se au souldan comme dit est Il regarda
les princes et admiraulz gui la estoient
et leur dist / Seigneurs or y parra com
ment vous aidrez a deffendre voz personnes voz ter
res voz femmes et voz enfans alencontre de ceulx qui
tollir les vous voeulent. Tantost que le souldan
eut comme dit est admonneste ses sugetz de bien faire
et gui eut veu le grant sens et haulte conduitte de
messue gillion il eut moult grant ioye et a part
dist a ses barons guil conuenoit que le vpien fust

PLATE 17
Fol. 49v [fol. liii], MINIATURE, *Gillion Defeating King Hector and Gillion Fighting with the Emir of Orbrie*
"How a great Saracen force besieged Cairo and how in a great battle that took place there my lord Gillion and Hertan, his good and loyal friend, performed marvelous deeds of arms"

When my lord Gillion was about one mile outside the city, he spotted in a vale the emir of Orbrie who was ordering his troops. They barely advanced farther when the two hosts observed each other. Seeing the enemy approach his host, the Saracen emir exhorted his men to do well, enjoining them to remember to avenge the death of his uncle, King Ysore of Damascus, and of their relatives and friends that the Cairenes had put to the sword a short time ago.…My lord Gillion strongly urged on the Cairenes, entreating them to make every effort to destroy and crush their enemy, so that he would have a reason to boast of their courage to the sultan, their natural lord.

Thereupon my lord Gillion couched a very solid lance and hurled himself among his enemies.…At that point the battle intensified on both sides, because my lord Gillion, sword in hand, covered in the blood of Saracens he had killed, spotted King Hector of Salerno who was exacting a severe punishment on the Cairenes. He grabbed a very firm lance, held by a Saracen of his enemy party. He struck this King Hector with such a great blow that neither the king's shield nor his armor could protect him from the iron and the wood that passed through his body. And when Gillion pulled out the lance, King Hector fell dead between the horses' hooves.…

The emir of Orbrie, seeing the lofty conduct in arms of my brave lord Gillion, was very grieved, and not without reason. He thought to himself that if the Christian lasted for a while longer, he would defeat him completely in a short time. He advanced so that my lord Gillion could hear him well and spoke in these words: "You, Saracen, have caused me so much displeasure and damage by previously killing my uncle, King Ysore of Damascus, and today King Hector, my cousin. Should you be possessed with such great audacity as to engage in hand-to-hand combat with me, I will make my men retreat and you yours." To which my lord Gillion replied and said to him: "Emir of Orbrie, by the God who died for us on the cross, I have not yet had such great joy as I will when by this sword I will make you breathe your last. I am glad to duel with you as you say, but may it never please God that I stop the battle for as much. For today I intend to see all the pagans that you led to this land dead and cut into pieces on the field. But I wish to tell you one thing, and if you are willing, I agree to it: you and I will move away from the battle the length of an arrow's shot and there we will test by the sword's edge which one of us is worthier to gird it and we will do battle until one of us dies." The emir of Orbrie was glad to accept.…

And when the brave and valiant knight and the admiral moved away as described, they assailed each other with lowered lances, spurring their good chargers. Their charge was so rapid that it seemed to be lightning from the sky. They struck each other with such violence that their lances broke and flew into large pieces.

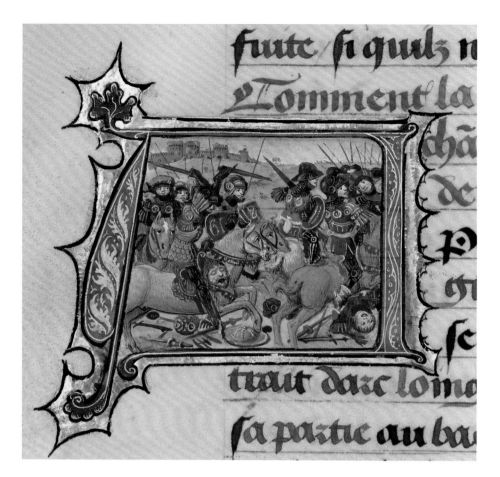

PLATE 18

Fol. 54v [fol. lviii], **Initial** *A: Gillion Defeating the Army of the Emir of Orbrie*

Directly under the watchful eye of Gracienne, who is perched in Cairo's highest tower (upper middle of the image, last tower on the right of the fortifications), Gillion and Hertan are in hot pursuit of the emir of Orbrie's army. Gillion, identified by "GI" on his shield and "Gilli" on his armor, is again wearing the sultan's armor. He has just defeated the emir of Orbrie in a joust and cut off his head. The emir's head is swinging on the horse's saddle as the last remnants of the emir's army are being hunted down and killed. Gillion will present the emir's head to Gracienne and the sultan.

[Fol. lxii], MISSING HISTORIATED INITIAL
"What kind of life lady Marie, his wife, led in Hainaut, while my lord Gillion de Trazegnies was in Cairo. And how a knight named Amaury desired to have the lady in marriage"

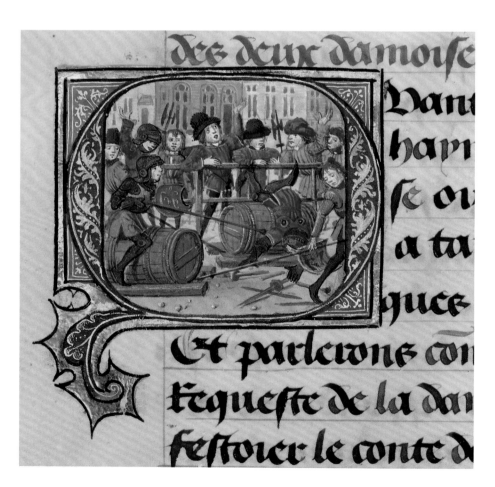

PLATE 19

Fol. 60v [fol. lxv], **Initial** *Q: Gillion's Sons in a Mock Joust*

While Gillion fights at the head of the sultan's army, back in Hainaut, his twin sons are nearing adolescence and learning the art of chivalry. They have called a prize tournament, inviting the children of neighboring nobles to a barrel joust. On the left, the artist has painted the younger twin brother, Gerard (identified with the initials "GE" on the shield), throwing Jean, the elder twin (right), off the barrel and to the ground. In contrast to the illumination, the story tells that Gerard, the more impulsive and tempestuous of the two brothers, refuses to joust for practice, dismissing it as child's play, and swears to joust only if mounted on a charger horse. In the text, it is Morant of Carnières who throws Jean off the barrel for a third time, as the spectators raise their hands and cry "victory" for Morant.

PLATE 20

Fol. 64v [fol. lxix], **Initial** *V: The Knight Amaury Kneeling before Gillion and the Sultan*

At Count Baldwin's request, Amaury, "the most disloyal and treacherous knight" according to the narrator, sets off on a quest to find Gillion. If he can find proof of Gillion's death or disappearance, he secretly hopes to marry Marie. The sultan hires him as a mercenary and presents him to Gillion. We see the sultan gesturing toward Amaury as he explains his desire to have another Christian knight keep Gillion company. Gillion reaches for Amaury's left arm to invite him to stand up and asks him for the news from the kingdom of France and its neighboring marches. Pretending not to recognize Gillion, Amaury plans to lie to him and tell him the story of the lord of Trazegnies, whose pregnant wife died soon after her lord's departure and before giving birth.

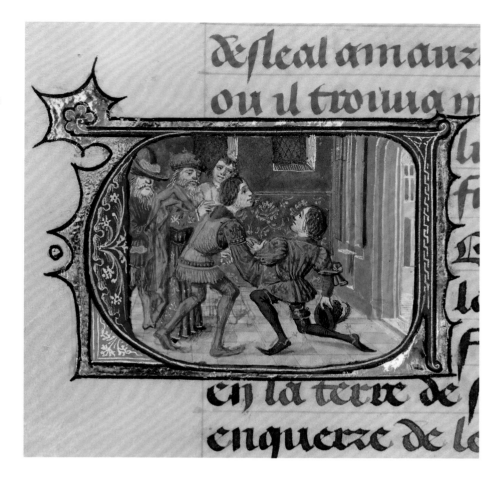

PLATE 21

Fol. 69 [fol. lxxiiii], **Initial** *Q: Gillion Reacting to the News of Death of His Wife and Progeny*

Gillion swoons on hearing the news of Marie's and his unborn heir's untimely deaths, as Gracienne (in blue) and Hertan (in green) rush to hold him up. Amaury's body language indicates his glee. Gillion is devastated and swears never to return to Hainaut, for his love for Marie was his sole motivation to ask for leave and safe-conduct from the sultan in return for his faithful services. Overcome with emotion and guilt, Gillion blames his prolonged stay and contact with the Saracens for her death.

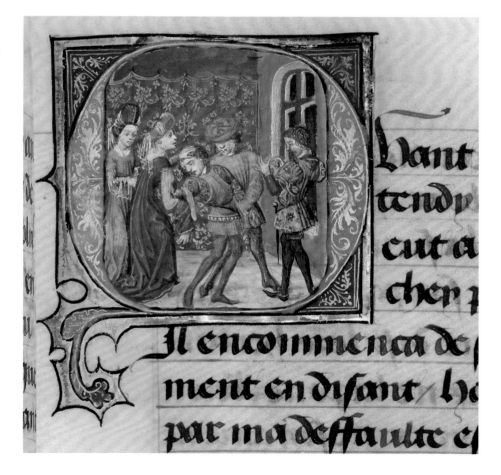

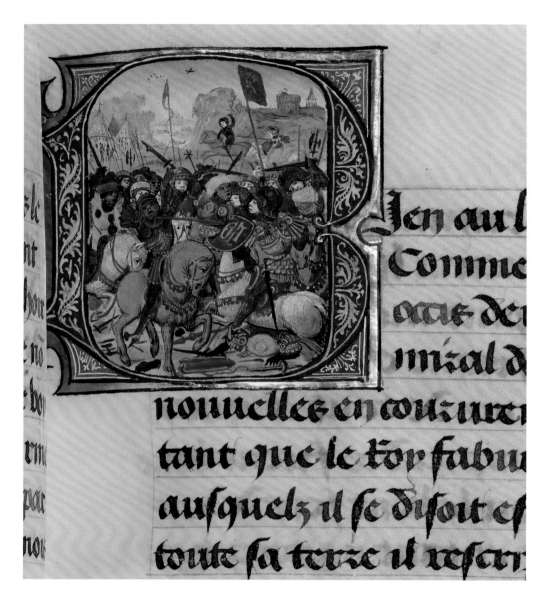

PLATE 22

Fol. 72 [fol. lxxvii], **Initial *B*:** *Gillion Defeating the Emir of Tripoli*

King Fabur of Moriane, the land of the Moors, near kin to both King Ysore and the emir of Orbrie, whom Gillion had killed, has laid siege to Cairo together with the king of Fez and the emir of Tripoli to avenge their deaths. In the heat of the battle, Gillion (identified on his armor and shield) pierces the emir of Tripoli with his lance. Bodies of others that Gillion had killed or maimed lie on the ground and are being trampled by horses. In the background, the cowardly and treacherous Amaury is fleeing the battlefield, hoping to reach the riverbanks of the Nile and catch a boat back home. A Saracen is in hot pursuit, as Amaury tries to outrun him rather than put up resistance. But the Saracen catches up and kills him with a lance. On top of the highest tower of Cairo, Gracienne watches; the narrator describes her as torn between her fear for her father's and Gillion's life.

PLATE 23

Fol. 78v [fol. iiii^{xx} iii], **Initial *L*: *Gillion Captured While in Pursuit of King Fabur***

As the enemy army retreats, Gillion pursues his target, King Fabur. Unconscious of his surroundings, he does not realize that Hertan and his soldiers have fallen behind. In the heat of the action—killing and maiming—Gillion has jumped on King Fabur's boat, anchored on the Nile. As he sounds out the battle cry of "Babylon" (Cairo), the enemy soldiers and sailors cut the boat loose, while soldiers left behind drown among corpses of men killed by Gillion. At the same time, in desperate search of Gillion, the sultan and Hertan look toward the Nile, only to watch helplessly and reach out in vain toward the boat sailing away with Gillion captive. The sultan is dressed in the armor that Gillion had previously worn when impersonating the sultan. Gracienne observes the whole scene from her tower (in the upper right corner).

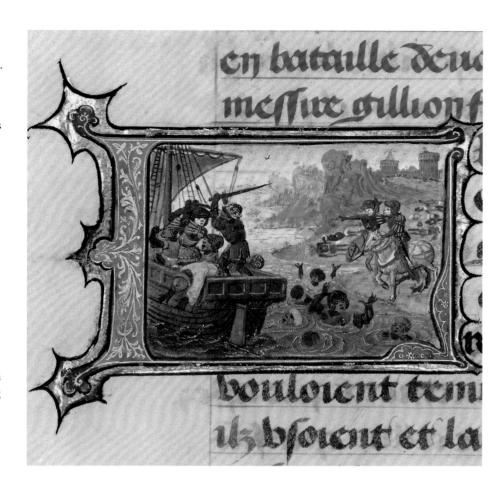

PLATE 24

Fol. 82 [fol. iiii^{xx} vii], **Initial *A*: *Gillion Dragged to Prison in Tripoli***

Unable to fend off all the assailants and weakened by his multiple wounds, Gillion faints. King Fabur spares his life and, upon arrival in Tripoli, orders him imprisoned. Gillion, his armor marked with "Gill," is shown from the back, beaten and shoved into the dungeon by his jailers. Throughout, the kings of Moriane and of Fez are painted by the artist as dark skinned and are often referred to as the "Africans" (*Auffriquans*) by the author.

[Fol. iiii^{xx} ix], MISSING HISTORIATED INITIAL "How the maiden Gracienne complained to Hertan of the capture of my lord Gillion, her good friend. How Hertan set out on the quest to find him and how he arrived to Tripoli in Barbary"

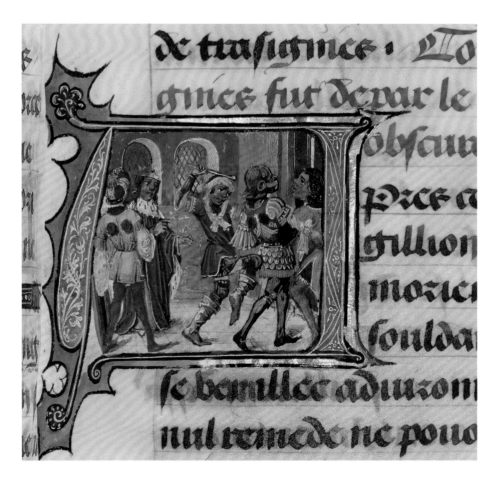

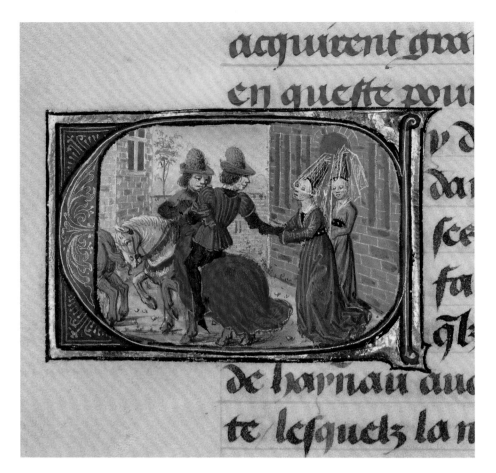

PLATE 25

Fol. 84v [fol. iiii^{xx} x], **Initial** *C*: *Gillion's Sons Taking Leave of Their Mother Marie*

Jean and Gerard are taking leave of their mother to start the quest for their missing father. Marie, accompanied by a lady-in-waiting, holds on to Jean's hand for as long as she can, as the brothers spur their horses. She has just given Jean the ruby ring of Gillion's that she was wearing. They are all struck mute, their hearts too heavy at this separation and uncertainty.

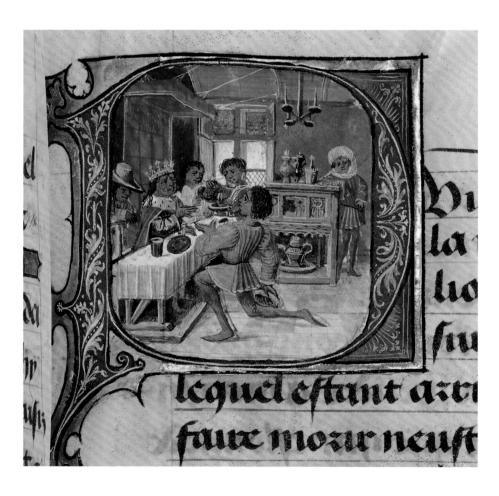

PLATE 26

Fol. 95 [fol. ci], **Initial** *P*: *Gillion's Companion Hertan in Disguise Kneeling before King Fabur*

On the day of the Feast of Saint John the Baptist, Hertan is kneeling before King Fabur. Hertan has blackened his face and hands with an herb to look like the Africans. He has also adopted their dialect, which he knows well because he once lived there. He presents his credentials as a former prison guard in service of King Ysore of Damascus, who lost everything he had in the battle when Ysore was killed. King Fabur appoints him as his new jailer, placing him in a position that will ultimately enable Gillion to escape from captivity. Together with Hertan, Gillion will return to Cairo on a merchant ship.

PLATE 27

Fol. 101v [fol. cvii], **Initial** *P*: *Gillion Embracing the Sultan's Daughter Gracienne*

As the merchant ship carrying Gillion and Hertan approached the port of Cairo, Gracienne was watching from her tower. Not a single day since Hertan's departure has gone by without Gracienne visiting the harbor in search of news of Gillion and Hertan. As she rushes to the harbor, Gillion recognizes her from afar and waves, then he and Hertan jump to the riverbank. As Hertan is still raising his arm in a greeting, Gracienne takes Gillion into her arms and kisses him more than twenty times before letting him go.

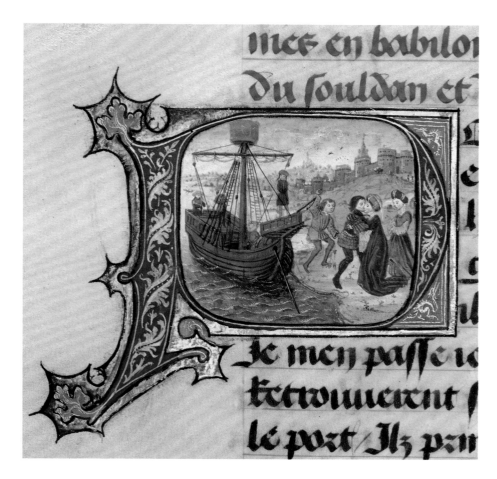

PLATE 28

Fol. 105 [fol. cxi], **Initial** *C*: *Gillion's Sons Kneeling before the King of Cyprus*

Trying to pick up a trace of their missing father, Jean and Gerard follow his steps across Europe and the Mediterranean, first to Rome, then to Jerusalem, but without any success. In Jerusalem, a pilgrim directs them to Cyprus, to serve its Christian king fighting the Saracens. Jean and Gerard, carrying the Trazegnies coat of arms, kneel before the king of Cyprus, who has just finished watching two knights from Brittany play a game of chess. He is flanked by his nobles and a bishop. The twins tell the story of their quest for their father. Since the king of Cyprus is at war with the sultan of Egypt, they offer their military services, hoping that they may hear news of their father, who, they believe, is in Cairo.

[Fol. cxiiii], MISSING MINIATURE
"This chapter tells of the great battle that took place before the city of Nicosia in Cyprus where the brothers, Jean and Gerard de Trazegnies, performed marvelous feats of arms and rescued the constable of Cyprus whom the Saracens wanted to hang and strangle"

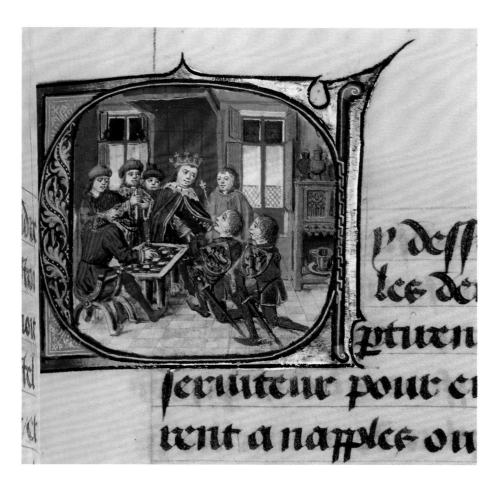

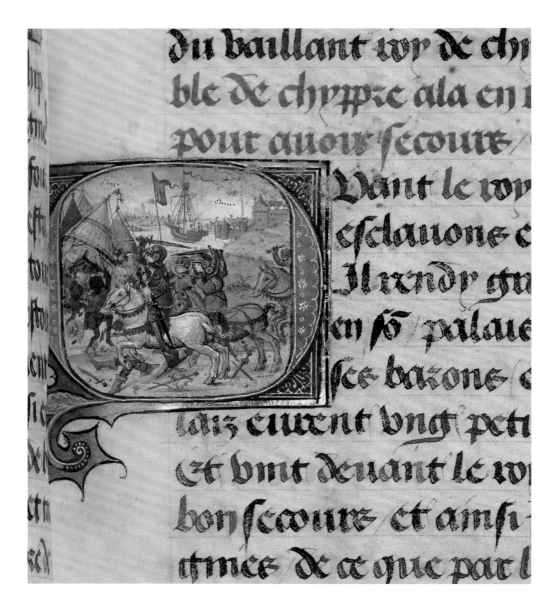

PLATE 29

Fol. 113 [fol. cxx], **Initial** *Q: Gillion's Sons Attacking the Encampment of King Bruyant*

Bruyant, king of the Slavs (*Esclavons*), is besieging the Cypriot city of Nicosia. Despairing of military aid, the constable of Cyprus must find a way to sail to Rhodes to seek the help of the Great Master of the Knights Hospitaller (referred to in the text as "Templars"). In the middle of the night, Jean and Gerard create a diversion, leading five hundred of the most experienced and hardened fighters to the enemy tents. They cause chaos, cutting down tents and pavilions, and putting the enemy to the sword. Then they retreat as quickly as possible to minimize the risk of losses. During that time, the constable has reached the port of Famagusta undetected. In the background, his brig sails out of Famagusta toward Rhodes.

PLATE 30

Fol. 115 [fol. cxxii], **Initial *Q*:** *Military Aid Arriving in Cyprus*

The military aid from Rhodes has arrived at the port of Kyrenia in Cyprus. The Christian army, along with reinforcements from Crete and the Isles of Pelago (the islands of the Aegean Sea), has discharged its cargo of wine, wheat, meat, flour, and other provisions and then loaded it onto dromedaries, horses, donkeys, mules, and chariots. They set out on their way to Nicosia, stopping three miles short of the enemy siege.

[Fol. cxxv], MISSING MINIATURE
"How King Bruyant and his entire army were put to the sword before the city of Nicosia in Cyprus, where they came with a large host of Saracens"

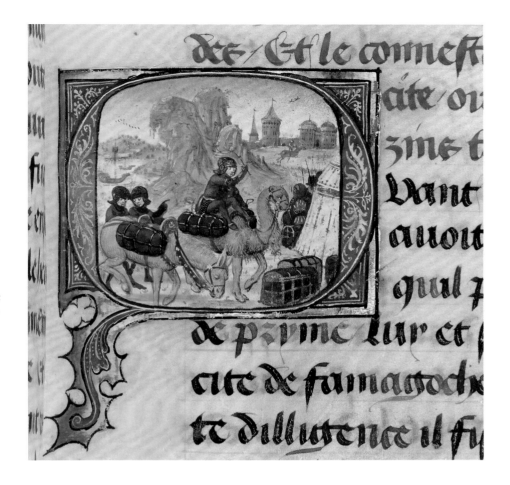

PLATE 31

Fol. 120 [fol. cxxviii], **Initial *A*:** *Gillion's Sons Attacked by Saracen Pirates*

Just as Gillion's pilgrim ship was attacked by the sultan's army, Muslim pirate vessels assault Jean's and Gerard's merchant ship on their way to Spain, one from Slavonia (*Esclavonie*), the land of the Slavs, the other from Moriane (*Morienne*), the land of the Moors. Despite being outnumbered, each brother, identified by the Trazegnies coat of arms on his shield, takes up a defensive position on either side of the boat. Whoever comes near them cannot escape death. Their fierce and deadly resistance makes the Saracens retreat. To counter, the Saracens lower a small boat into the water, with two men (of the six mentioned in the text) in it, one with a drill in his hand, the other holding an oar. They pierce large holes in the ship's hull, which begins to take on water. Although the sailors manage to plug some of the holes, ultimately they run out of options and surrender.

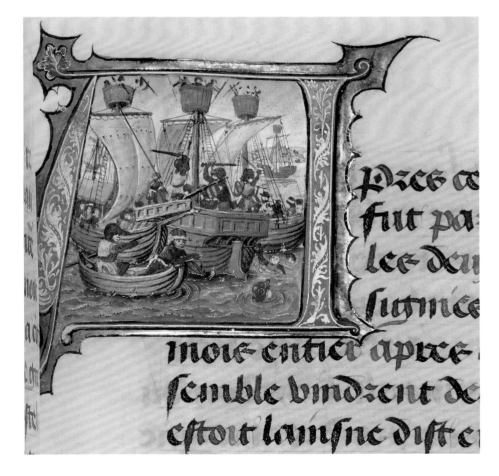

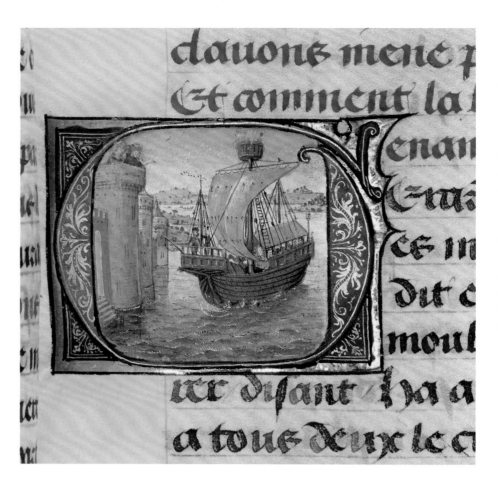

PLATE 32

Fol. 124 [fol. cxxxii], **Initial** *G*: *Gillion's Son Gerard Taken Prisoner by Ship to Dubrovnik*

Gerard and Jean have been separated. Pirate Slavs are taking Gerard to Dubrovnik. Morgan and Natalie, brother and sister, have climbed to the tower of the high castle of Dubrovnik to see if any of the messengers, recently dispatched, may bring back news of their father, King Bruyant of Slavonia. They have been without news since the king left to attack Cyprus. They watch the arrival of the foreign ship and descend to the harbor in search of news, but instead find Gerard and other captives, whom the pirates offer as a gift.

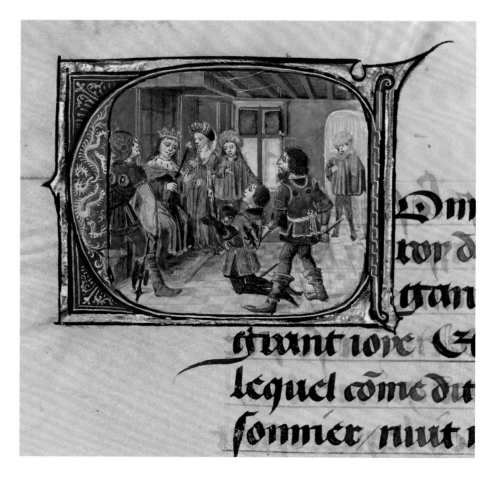

PLATE 33

Fol. 128v [fol. cxxxvi], **Initial** *C*: *Gillion's Son Gerard Kneeling before King Morgan of the Slavs*

Messengers brought back to Dubrovnik news of King Bruyant's total defeat and death. His son Morgan has just been crowned king. Gerard is kneeling before him, shoved by his jailer, and tells him the story of his and Jean's origins and quest for their missing father. He ends the story with the admission of his participation in the battle in Cyprus. Morgan's grief for his dead father stirs him to summarily condemn the Christian to death. Still, he asks Gerard if he has heard anything about his father, Bruyant. As Gerard confesses that he killed Bruyant with his own sword, Natalie, standing to the left of Morgan's throne and gesturing toward Gerard, intervenes and asks her brother to postpone the Christian's execution until all the nobles gather at the court for the Feast of the Nativity, in three months' time.

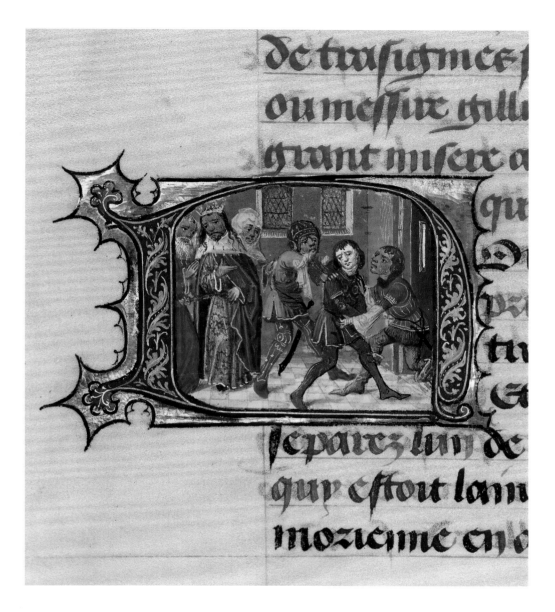

PLATE 34

Fol. 132v [fol. cxl], **Initial** *N*: *Soldiers Dragging Gillion's Son Jean to Prison*

Jean is being taken to King Fabur's dungeons in Tripoli, where his father had been held. Fabur threatens Jean that he will repay with his body and life the great damage that Fabur suffered when the other Christian captive escaped from his prison. Jean is overcome with the certainty that this long-gone Christian is his father and that he will never see him or his brother again. The guards catch him as he falls into a faint.

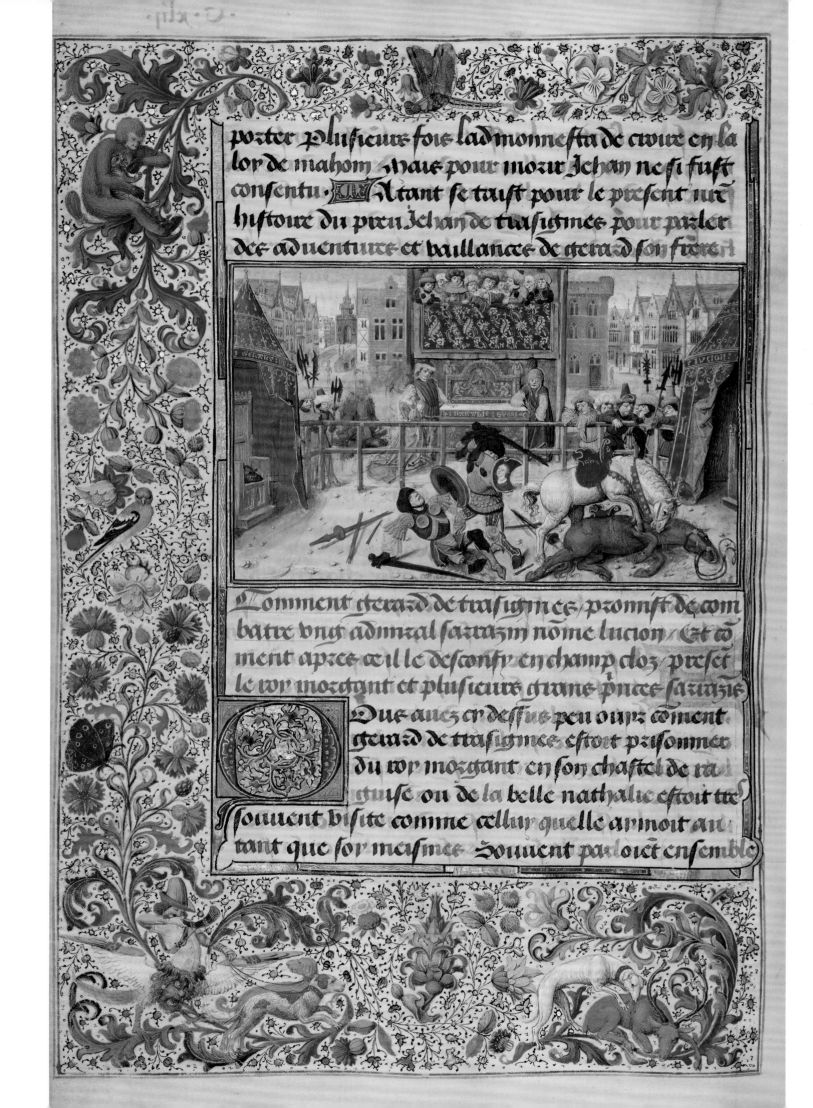

porter plusieurs fois ladmonnesta de croire en la
loy de mahom. mais pour mozir Jehan ne si fust
consentu. Atant se tu[st] pour le present n[r]e
histoire du pren Jehan de trasistmes pour parler
des aduentures et vaillances de gerard son frere

Comment gerard de trasistmes es promist de com
batre vng admiral sarrazin nomme lucion. Et co
ment apres ceil le desconsit en champ clos present
le roy morgant et plusieurs grans princes sarrazis
Ous aues er dessus peu ouyr coment
gerard de trasistmes estoit prisonner
du roy morgant en son chastel de ra
guise ou de la belle nathalie estoit tre
souuent bisite comme celluy quelle armoit au
tant que soy meismes. Souuent parloict ensemble

PLATE 35

Fol. 134v [fol. cxlii], MINIATURE, *A Judicial Duel between Gillion's Son Gerard and the Emir Lucion*

"How Gerard de Trazegnies promised to do battle with a Saracen emir named Lucion and how afterwards he defeated him in the lists in the presence of King Morgan and several other great Saracen princes"

The noble maiden [Natalie] told the valorous Gerard how an emir called Lucion had accused her publicly of grand treason, in full court in the great hall of the palace, in the presence of King Morgan, her brother. He charged her with wanting to assassinate Morgan by poison so that after his death she would be the lady and the queen of the land. He agreed that to clear and defend herself she should find a champion within the next forty days to do battle with him and to prove that his charge and indictment of the maiden were an untrue and treacherous lie and grand treason. "And if it so happens that I do not find a champion, I will be condemned to burn at the stake or, if the champion defending my right against Lucion should be defeated, the king, my brother, will hang him and strangle him on the gallows."

When Gerard de Trazegnies had heard the maiden, he said laughing: "My most dear lady, do not worry about finding a champion. On account of the great good and courtesy that you have shown me, I will aid and assist you within my humble power in defending your suit and right, which I know to be righteous and honest.…"

The noble maiden had the valiant Gerard armed with the beautiful and rich armor that she had procured for her champion. She then had a shield brought to him, on which she had had an image of the face of a maiden painted lavishly. In presenting it to him, she spoke these words: "My good and loyal friend, I offer you the gift of this shield. It has a full trim of fine gold, which signifies prowess, valiance, strength, and virtue, and that toward all men, you should be humble,

gentle, and courteous. And the head of the maiden on the blue background in the shield's middle means that for the love and memory of my person you shall be constantly endowed with valiance and daring, and that you shall never be lacking in these or else your undertaking will be void. Moreover, I beseech you to keep the shield out of love for me.…"

…Thereupon, the two champions couched their good lances, each mounted on a strong charger on his side of the lists and measuring the other with a formidable gaze. They spurred their horses and started on their run with such speed that it was a marvel to watch them for they moved as fast as lightning. When they approached, they struck such blows on their shields that their lances flew to pieces. And when they saw their lances were broken, they most furiously drew their fine swords and took to smiting each other so fiercely that with each blow it seemed that they must have cut down and sliced each other open. With each blow they delivered, the edges of their fine and sharp swords made sparks fly from their helmets. Lucion was a handsome knight, well built and strong of body, while Gerard was no less strong, and moreover he was young, quick, skillful, expert in arms, and a good Christian to boot.…

As Gerard fought with the Saracen, he glanced at the stake where the wood was ready and saw the beautiful Natalie praying on both knees. And he remembered how he kissed her at their separation. At that point, great courage filled him with force and vigor, and he started to ride most fiercely toward his enemy, sword in hand. He delivered such a great and powerful blow on his helmet that

he threw Lucion from the horse down to the ground in a daze. When Gerard saw Lucion fall, he dismounted and approached him, sword in hand. As soon as Lucion saw Gerard jump to his feet, he took courage and came to meet him. There they began a great duel with the edges of their swords. In the meantime, Gerard's charger assailed Lucion's and they fought with hooves and teeth so ferociously that Gerard's horse strangled the Saracen's. The pagans, and the king himself, said that this was a very bad sign for Lucion, who was very grieved at heart to see his horse strangled and he cursed Muhammad several times.…

Thereupon, Lucion came so close to Gerard that with the sword he struck mightily straight down the middle of his shield and seriously damaged it. But Gerard remembered that the beautiful Natalie offered him the shield, painted with the face of a maiden, which meant he should remember her. Greatly desiring to take revenge against the Saracen traitor, Gerard lifted his sword intending to strike Lucion on the helmet from above, but Lucion raised the shield to block the blow. Gerard, deft and skilled with the sword, noticed that the Saracen's lower body was unprotected. He brought down the sword, striking Lucion on the left thigh so prodigiously and vigorously that he severed it completely. The Saracen was forced to fall to the ground, letting out a shrill scream. Gerard then told him: "Master, if you lent me something since this morning, I took the pains to soon return it to you. A good payer makes a good lender."

43

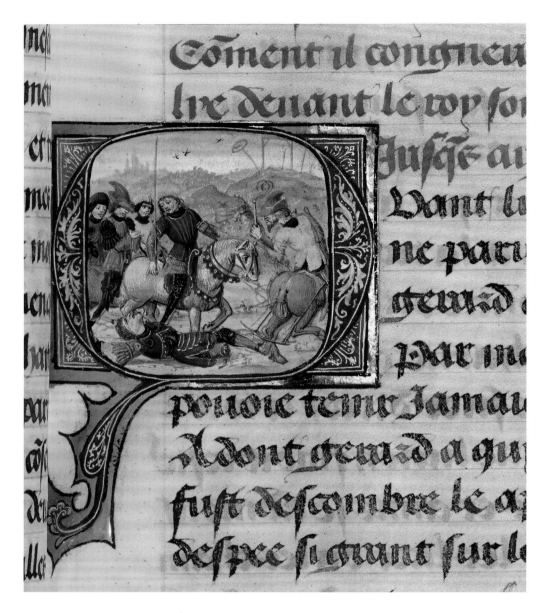

PLATE 36

Fol. 147 [fol. clv], **Initial** *Q: The Emir Lucion Being Dragged to the Gallows*

Powerless and filled with rage, Lucion threatened Gerard, who, in lieu of a response, cut off Lucion's right arm (the artist depicts him with his left arm missing) and then his ear and cheek. Seeing he was done for, Lucion called for King Morgan and admitted to falsely accusing Natalie. Royal vengeance is swift: Lucion is to be dragged to the gallows (visible in the background) and hung and strangled to death. The executioners have grabbed him by his right foot (left foot is shown) and attached it to the horse's tail, and Lucion is dragged on the ground until his skin and flesh start coming off. Witnesses are horrified as Lucion curses Muhammad in the most abject of ways.

nathalie sa seur Je te conseille de le gehir et il aura
pitie de toy Adont lucion dist vpien tu as bone cau
se et tresbien mas conseillie come leal et preu en ar
mes et tel tir ie troue et experimente Et du mal q̃
Jay fait et come Je me repens grandement Et po~
tant ie te prie que deuers moy tu voeulles venir a celle
fin que tu me aydes a leuer Jusques a ce que deuant
le roy ie auray declare et gehir mon pechie Je te bail
leray mon espee come cellui quy par sa prouesse ma
vainquu et desconfi en champ clos Par ma foy tre~
desleal traittre tu nas garde quen toy ne en tes bour
des ie doye prendre aucune fiance Je ne lay pas en
toy troue Jusques a present ¶Coment ladmiral
lucion se rendi vainquu a gerard de trasignies·
Coment il congneu son cas en descoulpant natha
lye deuant le roy son frere Et comēt il fut dillec trayne
Jusq̃s au gibet ou il fut pendu et estragle

Vant lucion ver guen nulle maniere il
ne paruendroit a son Intention de tenir
gerard aux mains Il luy dist Crestien
Par mahom se a mes deux mains ie te
pouoie tenir Jamais plus beau iour tu ne verroies
Adont gerard a quy moult tardoit que du traittre
fust descombre le approcha et luy donna vng coulp
despee si grant sur lespaule que le bras destre luy
enuoya par terre Et de la grant angoisse q̃l sentir
Il ietta vng grant et merueilleux cry a ors ses pro

audier et conforter le boulsist · Mzn telle fa
chion quentendre pouez estoit gerard de trasignes
prisonnier ou chastel de richiuse duquel pour le
present nous bous lairons le parler Jusques heure
soit dy retourner Pour bous racompter des fais
et baillances de messire gillion de trasignes sõ pe

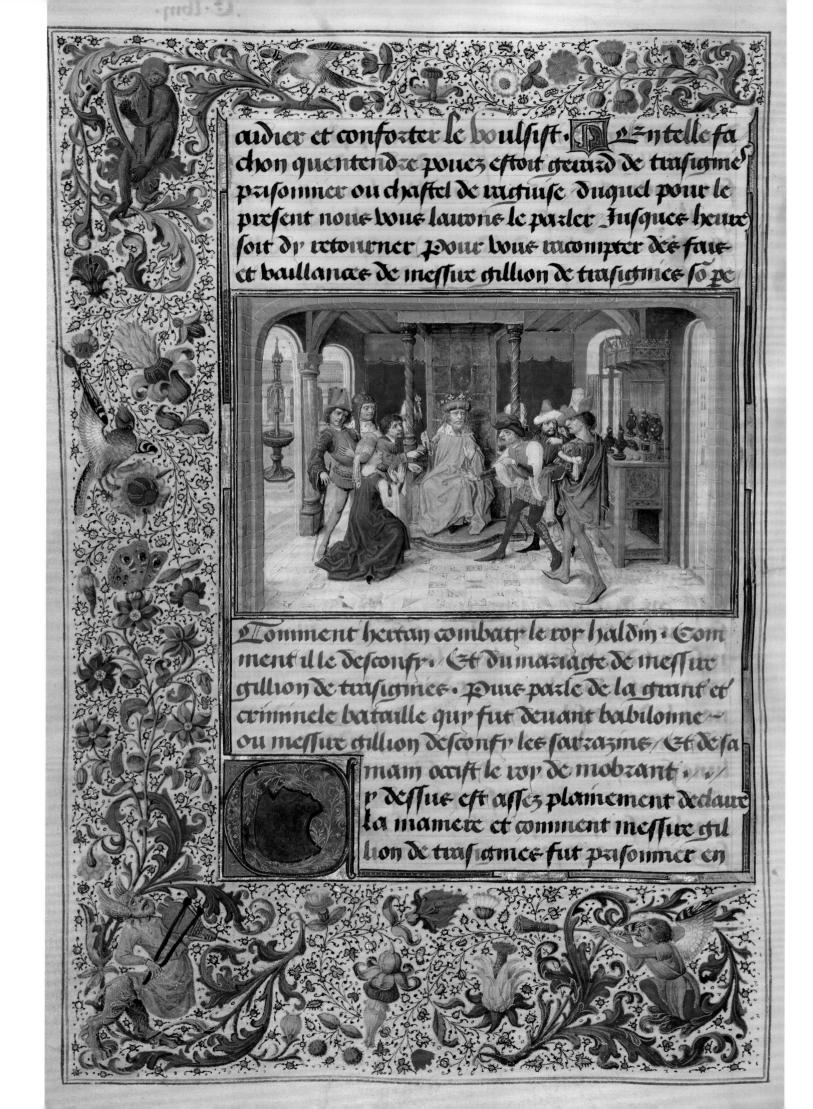

Comment hertan combatir le roy haldin · Com
ment il le desconfir · Et du mariage de messire
gillion de trasignes · Puis parle de la grant et
crimnele bataille quy fut deuant babilonne —
ou messire gillion desconfit les sarrazins / Et de sa
main occist le roy de mobrant · · ·
y dessus est assez plainement declaire
la maniere et comment messire gil
lion de trasignes fut prisonnier en

PLATE 37

Fol. 150v [fol. clviii], MINIATURE, *King Haldin Accusing the Sultan's Daughter Gracienne of Dishonorable Behavior*
"How Hertan did battle with King Haldin and defeated him. Of the marriage of my lord Gillion de Trazegnies.
Then the chapter tells of the great and criminal battle before Cairo where my lord Gillion defeated the Saracens
and with his own hand killed the king of Mobrant"

The Saracen king [Haldin] of whom I speak was well esteemed, strong of body, well built in all his body parts, daring, tenacious, and skilled in arms. But he was greatly pained and envious to see my lord Gillion promoted and raised above all the Saracen princes, given that he was not of their religion but a Christian. One day he saw that the sultan stood alone at the windows of his palace. He approached him and, upon greeting him, spoke thus: "Sire, it is quite true that I am your man, by which I owe you fealty and loyalty and I am obliged to speak the truth. Given that this matter concerns your honor greatly, not for anything would I wish to conceal it from you. And yet I attest and assert that Gracienne, your daughter, is so enamored of Gillion the Christian, your captive, that seldom are the days when she does not leave the city to go to the castle you gave him. You know that he is a Christian and very clever, and he could lure your daughter into believing in his faith. Never a greater misfortune could come about. And therefore, sire, take notice in order to avoid such a great misfortune. What I have said is the truth and do not think that I should alert you any differently for any reason...."

Upon hearing the sultan, her father, make the accusations mentioned above, the maiden Gracienne responded in a loud voice, most wisely, so as to be heard by all. She said: "Indeed, sire, for as long as you spare my corporal life from receiving death, I will tell you only the truth. Sire, it is quite true that I have gone to my lord Gillion several times and often. But by the faith that I owe Muhammad in whom I believe, never once in his life did Gillion ask me to dishonor or shame myself any more than would my own brother, if I had one." Thereupon Haldin replied: "Lady, by my faith, the contrary of what you say is true and I am ready to prove this in battle against a Saracen who is of Muhammad's religion. But I do not wish to have any fight with Gillion, who is a Christian."

Upon hearing King Haldin refuse to combat against the Christian knight [Gillion], the noble princess Gracienne's thoughts turned to Hertan. And as they thus spoke before the sultan, my lord Gillion and the brave man Hertan entered the hall. And as those who were unaware of it, they were astonished to see such a great assembly gathered. They broke through the crowd and came forth until they came before the sultan....

Upon hearing King Haldin who refused to combat or do battle with my lord Gillion, Hertan pushed through the crowd until he soon found himself before the sultan. When he saw himself before him, he began his speech in a loud voice so that all who were in the hall could hear him clearly, and he thus spoke to the sultan: "Sire, according to what I was able to hear, King Haldin has falsely and without reason accused the honor of your daughter, whom I see here. He charges her with a thought, will, and intention that she never had a single day of her life. This is why I promise to God and to Muhammad that, in order to safeguard the true right and suit of Gracienne, I will take to the battlefield against King Haldin. I will force him, with the aid of the edge and point of my sword, to avow publicly that he wrongly and for evil reasons accuses the noble lady and that he falsely invented what he says about her and lied. I wish to add without hesitation that Gillion has never induced her to dishonor or spoken to her in a base language."

As soon as the sultan heard that Hertan would take the battlefield against King Haldin to defend the right of Gracienne, his daughter, he was overtaken by a feeling of gratitude.

47

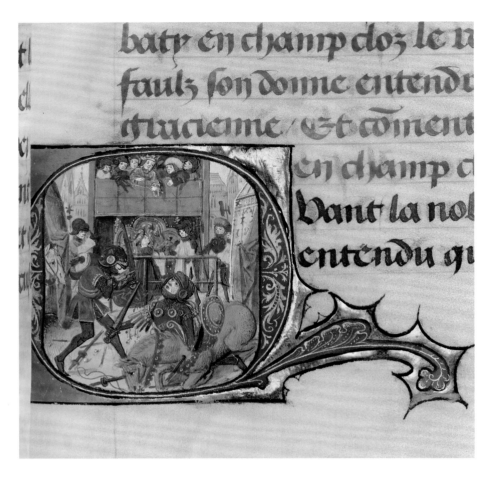

Fol. 153 [fol. clxi], **Initial *Q*: *Gillion's Companion Hertan in a Judicial Duel with King Haldin***

The sultan and his entourage are on the viewing stand, while Gracienne prays aloud to Muhammad at the altar (and under her breath to her true lord, Jesus Christ). The duel began with a joust in which Haldin threw Hertan off the horse. In a hurry to finish Hertan off, Haldin dropped his lance and charged at him with the sword. But Hertan picked up Haldin's lance and pierced Haldin's horse with it. In the fall, Haldin's leg gets trapped under the horse; he is helpless. Hertan strikes a terrible blow that severs Haldin's arm holding the sword, quickly defeating him. In the aftermath of the judicial duel, Gillion marries Gracienne.

[Fol. clxxiii], MISSING MINIATURE
"How King Morgan of Slavonia laid siege to King Fabur of Moriane. And of the duel between two brothers, Jean and Gerard de Trazegnies, who in battle recognized each other when Gerard surrendered to Jean"

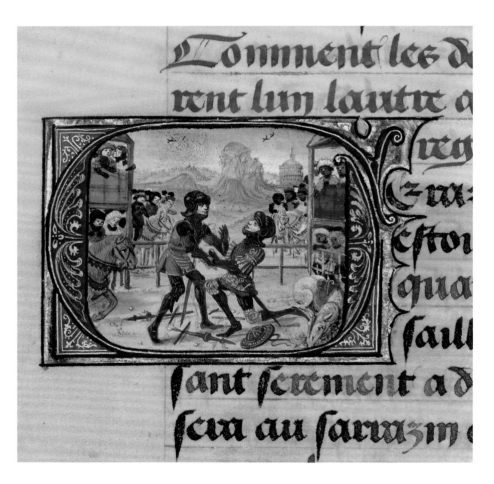

Fol. 164v [fol. ciiii^{xx}], **Initial *G*: *Gillion's Sons Recognizing Each Other***

King Morgan, shown in the stands (upper left), has laid siege to King Fabur (upper right) in Tripoli because of a dispute over pirates' raids. With provisions dwindling, Fabur proposes a judicial duel to resolve the conflict. He asks Jean to be his champion against an enemy Saracen, and Morgan sends for Gerard to be the champion of his army. Both kings wish to save the lives of their Saracen knights. Jean and Gerard fight for a long time, but say not a word out of contempt for the opponent whom each believes is a Saracen. When Jean finally subdues Gerard, Gerard starts to lament, invoking his mother, father, and brother of Trazegnies. Upon hearing him, Jean lowers his sword and reveals his identity, while Gerard falls on his knee and declares himself defeated. The artist has shown the twins with their visors lifted to illustrate the moment of their mutual recognition.

PLATE 40
Fol. 168v [fol. ciiii^xx^iiii], **Initial *B*:**
A Battle Scene

This historiated initial does not match the text. After Gerard's surrender, King Fabur and King Morgan have made peace and decided to lay siege to Cairo together. Both Jean and Gerard are now Fabur's captives. In the image, Gillion is depicted on the left, identified with the letters "GI" on his shield, piercing with his lance an enemy knight, identified with "ES," alluding to "Fes." But Gillion's opponent cannot be the king of Fez, who is still alive in the next scene. Gracienne is shown keeping watch over Gillion in Cairo's tallest tower (upper right corner), as is her custom. Because this chapter in the Getty manuscript stops before any military engagement, it is more likely that this scene foreshadows the battle between the armies of the sultan and King Fabur, and the duel between Gillion and the king of Fez. It is also possible that the artist made a mistake in this instance.

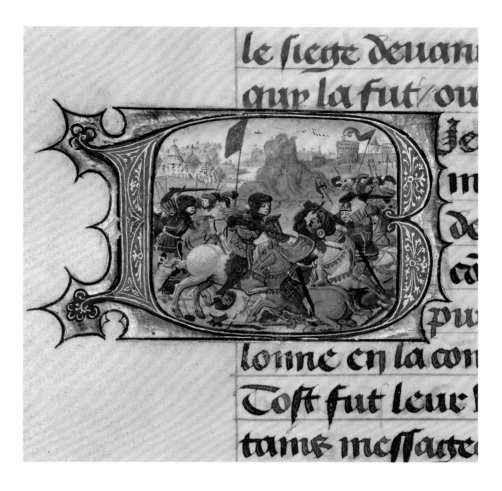

PLATE 41
Fol. 170v [fol. ciiii^xx^vi], **Initial *A*:** *Gillion Defeating the King of Fez*

King Fabur, King Morgan, and the king of Fez continue their siege of Cairo. In a decisive battle, Gillion is riding in from the right on a white horse, identified on his shield and the horse's harness. From the left, the king of Fez charges. They joust, and their lances shatter as both are unseated. Their armies rescue them from the melee, and the battle rages on.

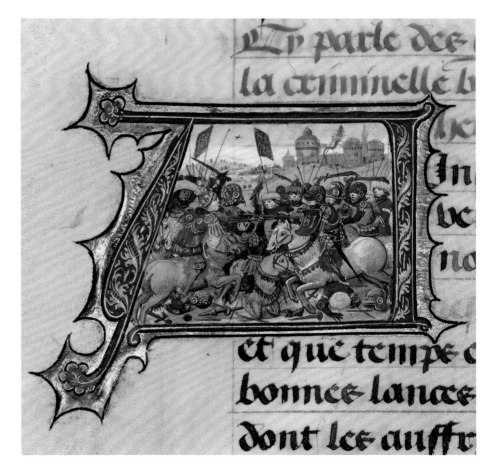

PLATE 42

Fol. 177 [fol. ciiii^{xx}xiii], MINIATURE, *Gillion Defeating King Fabur during the Siege of Cairo*

"This chapter tells of the great battle that took place before Cairo where the two brothers of Trazegnies were captured for their high deeds. And how in the battle Gillion de Trazegnies, their father, recognized them"

King Fabur, learning of the deaths of the king of Tunis and king of Belmarin, was overcome by fear. Jean de Trazegnies shouted to him, loud and clear. He spoke thus: "Ha, sire, why do you delay, why do you keep us in the rear, we should be in the first rows of the battle in order to succor our men." "Sire," said Gerard to King Fabur, "grant my brother and myself permission to go kill our enemies and we will keep watch over you so that, if need be, we can assist you in haste."

Upon hearing the arguments of the two bachelor knights, King Fabur granted them leave on the condition that they return if he was in need. Gerard then called to his brother Jean and told him that he did not know from which side they should best attack their enemies, who were all Saracen. "Truly, brother," said Jean, "were it not for the fear of the danger in which we are, I would be glad to fight them without sparing one or the other side. But given that we are here with King Fabur, it behooves us to assist his party...."

Thereupon the two Trazegnies brothers hurled themselves into the melee where they performed marvels in arms and acquitted themselves in such a manner that in little time the Cairenes recognized the edge of their swords. There was not one among them so audacious to confront them unless he held death dear. All men fled them, and those who fell into their hands were certain to lose their lives.

The valiant knight, their father, was on the other side of the battlefield, slicing through the troops and killing all those he could lay his hands on....

Not long thereafter my lord Gillion crossed paths by chance with his two sons, each carrying around his neck a shield painted with the coat of arms of Trazegnies.... "Hertan," said Gillion, "truly, I do not know which parts they hail from or where they may come from, but both of their shields bear the coat of arms of Trazegnies, of whose branch I am the head. I would very much like them to tell me why and for what reason they carry them and how they could have come by them, and I ardently wish to know the truth of it."

...He then ordered Hertan to capture alive, to the best of his ability and by any means available, the two vassals and bring them to Cairo.... And Hertan did so much that the two brothers were surrounded right there where they were, exacting a severe punishment on their enemies....

Thereupon the two bachelor knights surrendered themselves to Hertan, who had them held and led to Cairo by twelve Saracens. He ordered those in the escort that the brothers be delivered on his behalf to the beautiful Gracienne and that they clearly explain to the lady that they were his gift to her but that if she held her husband, my lord Gillion, dear then she was not to allow any discourtesy or rough treatment inflicted on them....

The king of Fez, full of resentment and wrath, at seeing his men be taken out and lose ground, smote a Cairene, under the gaze of my lord Gillion, with such a heavy sword blow on the helmet that he felled him dead from the horse down to the ground. As soon as my lord Gillion saw this, he approached the king of Fez and, letting go of the bridle and raising the sword with his two hands, he brought down on the king of Fez such a horrific and powerful blow that he severed the head from the shoulders....

Then, my lord Gillion who desired greatly to take revenge on King Fabur seized a large lance from a Saracen's hand. He couched it and struck Fabur in the upper part of the body with such speed and force that the lance pierced through the other side of his body by more than two feet. Gillion's blow knocked King Fabur down to the ground, where he perished in misery among the dead, trampled by the horses.

bien au long tout ce que par le souldan luy auoit
este chargie de dire · ¶ Adont le roy sabur ayat
entendu lexposition des messages a luy enuoyes
depar le souldan Il fist assambler son conseil deuat
lequel il declaira ce que depar le souldan luy auoit
este mande Tous furent dun accord que ainsi en
seroit fait et que au vi. iour le souldan les trouue
roit prestz pour luy et son pouoir combatre en ac
cordant que les huit iours durans il y auroit treue
dentre lune partie et lautre sans faire quelque rop
ture ¶ Ainsi quentendre pouez le roy sabur z
son conseil firent la response au message du soulda
lequel a tant partir du tref de sabur et retourna
deuers le souldan son seigneur qui desiroit son retour

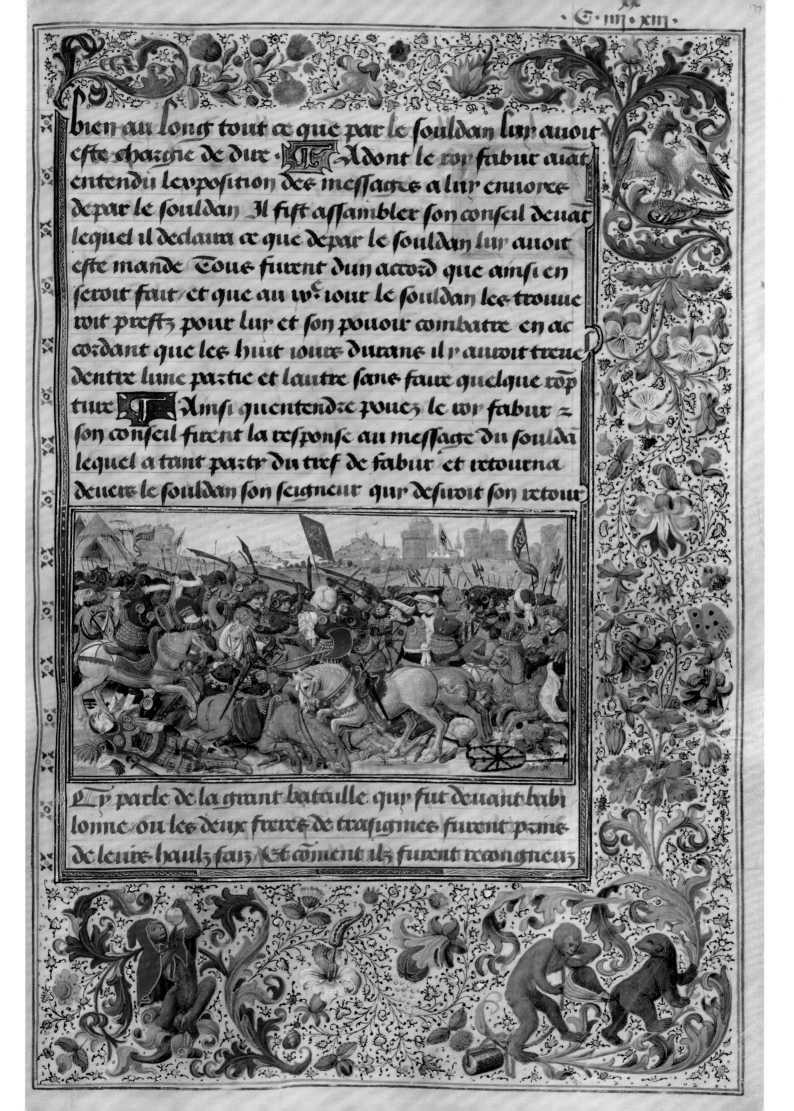

¶ Cy parle de la grant bataille qui fut deuant babi
lonne ou les deux freres de trasignies furent prins
de leurs haulz faiz Et comment ilz furent recongneuz

que de bous elle deult enfanter meifmement difoit
que lenfant mozu lors que il vint fur terre poqnor
teuz telle douleur an cuer que ie fis ferement de no
iamais retouner pdela Si aduint affez toft apres q
au pres de cefte cite le fouldan liura bne moult fiere
bataille alencontre des farrazif lefquelz furent defco
fis et octis Ceftuy amaurry dont bous me parles
p laiffa la bie Par ma for fire de ces nouuelles ne
doit nul bon cuer eftre dolant mais ioreulx Selon
fa defferte il a receu fon guerzedon come ruifo eftoit

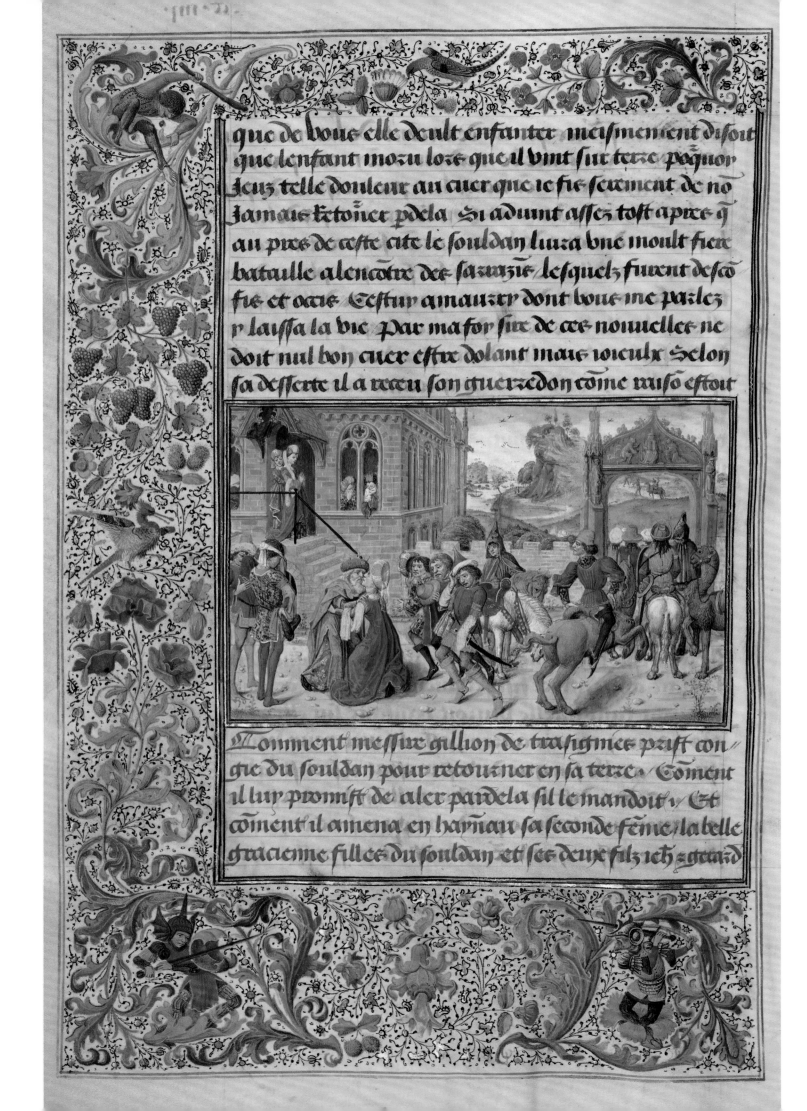

Comment meffire gillion de trafignies prift con
gie du fouldan pour retourner en fa terre Coment
il luy pmomift de aler pardela fil le mandoit Et
coment il amena en haynau fa feconde femme la belle
gracienne filles du fouldan et fes deur filz ieh z gerard

PLATE 43

Fol. 188v [fol. cciiii], MINIATURE, *Gracienne Taking Leave of Her Father the Sultan*

"How my lord Gillion de Trazegnies took leave of the sultan to return to his land. How he promised to come back if the sultan sent for him. And how he brought to Hainaut his second wife, the beautiful Gracienne, the sultan's daughter, and his two sons, Jean and Gerard"

When the good knight had heard his two sons tell a fraction of their adventures, he could not be more astonished on account of their still very young age....

...My lord Gillion and his two sons stayed together at the sultan's court for about six months after that last battle. It happened one day that the sultan was standing at the window of his palace, when my lord Gillion came to him and most humbly addressed him: "Sire, it is true that today there is no prince of your religion who possesses such great worldly power to dare wage war or somehow rally against you. Your entire empire and kingdoms, as well as those of your neighbors and friends, live in a solid and stable peace. And I hold it true that there is no living prince today who should dare disquiet you or stir against you. Sire, because at present I know for sure that all your power is in steady peace, I pray of you most humbly, reminding you of all the joys I was able to give you, that your benign grace grant me and my sons leave to take our leisure to the land of Hainaut from whence we come. And I promise you on my faith that I believed that my wife, their mother, had passed away from this mortal life a while back, as Amaury, the French knight, had assured me, of which I remind you. And on his assurance, although the contrary was true, I had resolved to spend the remainder of my days here. I have served you loyally, to the best of my ability. I would like to take my wife Gracienne and Hertan with me, and I promise you on my faith and the religion of Jesus Christ, my god, that if war or other matters arise and you send for me, I will not stop for a day or an hour until I come back here to serve you as I've done until now."

...[The sultan] called my lord Gillion and told him that he had taken counsel with whom he concluded and agreed that he, his wife, his two sons, accompanied by Hertan, could freely return to his native land on the condition that he swore an oath on his faith to forsake all and return to Cairo to serve him, if the sultan sent for him on account of some matter. My lord Gillion promised to do so without fail.

After my lord Gillion had thanked the sultan profusely, he promptly prepared his departure. The sultan offered many beautiful gifts to him and to his daughter, and likewise to Jean and Gerard. Indeed, he gave them so much gold, silver, and other great riches, it would be a marvel to enumerate them all. As soon as their affairs were ready and they were equipped with guides and ass and camel drivers, they had their treasures and riches packed and charged onto horses, mules, camels, and dromedaries. And when they were completely ready, they took leave of the sultan who, seeing them depart from his court, was deeply moved, commending his daughter Gracienne to the good knight. Upon departure, he kissed her most tenderly, while crying, then embraced my lord Gillion and his two sons and commended them to the care of Muhammad. At that time they took leave of the princes and noblemen who were there and who accompanied them for four miles outside the city. All the people of Cairo were in mourning when they learned of the departure of my lord Gillion and his wife Gracienne.

[Fol. ccxii], MISSING HISTORIATED INITIAL
"How the two ladies of Trazegnies took the vow of chastity and thereby lived harmoniously together in good fellowship"

[Fol. ccxv], MISSING HISTORIATED INITIAL
"How the two ladies of Trazegnies took the veil at the Abbey of Olive in Hainaut and how my lord Gillion, their husband, retired to the Cambron Abbey"

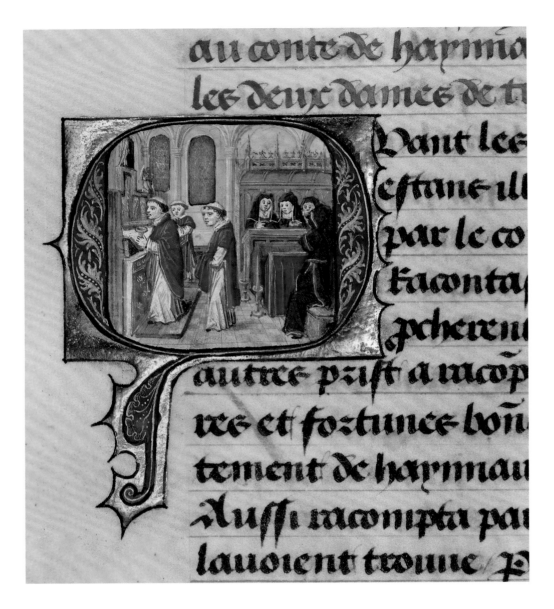

PLATE 44

Fol. 200v [fol. ccxviii], **Initial** *Q: Gillion's Wives Marie and Gracienne during Mass at the Abbey of Olive*

In this chapter, Gillion, having taken a monk's habit at the Cambron Abbey, tells his life's story to the Count of Hainaut. Within the same year, at the Abbey of Olive, to which they had retired by common agreement, Gracienne dies, and Marie survives her by only two days. The image shows monks celebrating a private Mass with nuns at the Abbey of Olive, and the two women to the right of the center are probably Gillion's two wives, in harmonious communion of shared prayer.

[Fol. ccxxii], MISSING HISTORIATED INITIAL
"How several Saracen kings together agreed and pledged to make war and engage in combat against the sultan of Egypt"

PLATE 45

Fol. 204 [fol. ccxxviii], **Initial *A*: *Gillion and His Son Gerard Preparing to Set Sail for the East***

While Jean stays behind as the new lord of Trazegnies, up to sixty young noblemen have left Hainaut in the company of Gillion, rushing to the rescue of the besieged sultan in Cairo. Gillion has promised their fathers and the Count of Hainaut to treat them like his own children. In Milan, they have armed and equipped themselves for the sea passage and have just arrived in Pavia. Gillion (to the far left), wearing still the same armor bearing his name, oversees the young men loading their arms and provisions onto a boat that will sail down the river Po, taking them to Ferrara and then to Venice. Gerard stands behind him.

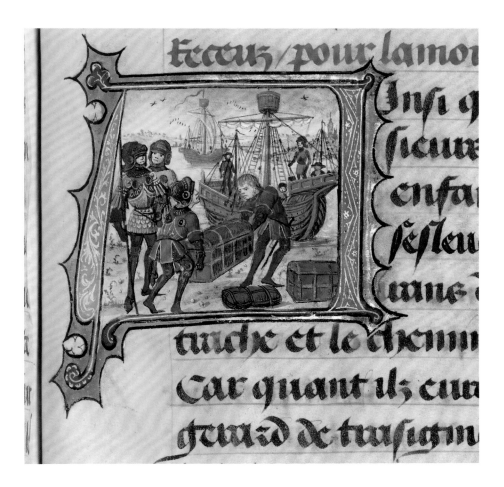

PLATE 46

Fol. 208 [fol. ccxxxii], **Initial *Q*: *Gillion and His Son Gerard Passing Dubrovnik***

Gillion's galley, with two Trazegnies standards flying high on the stern, is sailing down the Adriatic coast. As they row past Dubrovnik, Gerard, wearing the same green armor as in the previous image, is pointing toward the city with his right hand. He tells Gillion, in his red and golden armor, and his companions of his captivity in Dubrovnik and the great love and courtesy shown him by Natalie, King Morgan's sister. The galley is flying a Venetian banner and is immune from attack because of the republic's truce with King Morgan, so no boats approach them. As it moves past the city walls unharmed, Gerard regrets not seeing Natalie again. But the good wind pushes them onward and away.

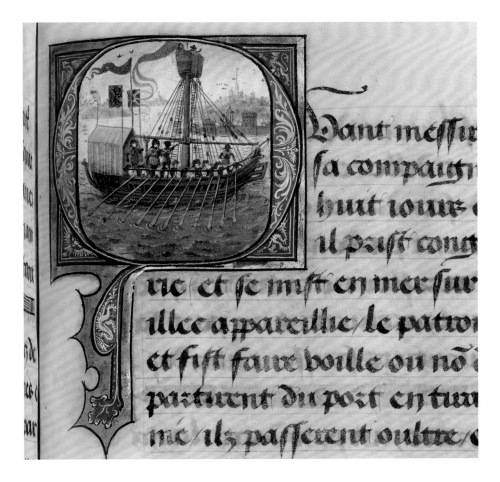

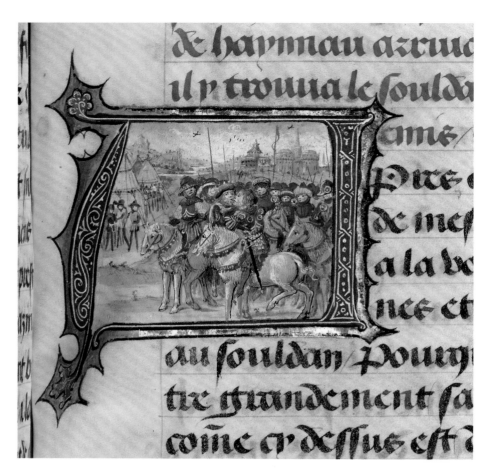

PLATE 47

Fol. 210 [fol. ccxxxiiii], **Initial** *A*: *The Sultan Embracing Gillion*

Gillion landed in Acre and then met the Saracen army of twenty thousand men in Gaza, led by the emirs of Jerusalem, Gaza, Acre, Ramla, Antioch, and Palestine. Together with the young nobles from Hainaut, they have just arrived before the walls of Cairo, where the sultan stands battle ready. Even before Gillion has had time to greet the sultan, the sultan comes before him, displaying great joy and surprise. He throws his arms around Gillion and wishes him the warmest welcome, calling him "the force of Egypt, the pillar and haven of Eastern nations subjected to us." Gillion humbly responds, while from all sides kings and emirs come to bow before him. Then, overjoyed, they let out a cry so great that the enemy army is convinced that the sultan's attack will be imminent.

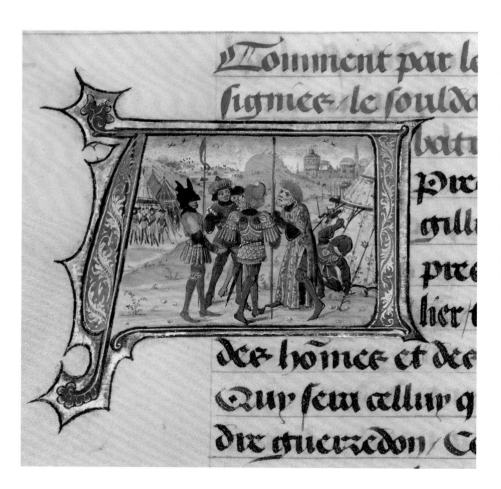

PLATE 48

Fol. 214v [fol. ccxxxviii], **Initial** *A*: *Gillion Advising the Sultan on Battle Strategy*

The messenger, who had reached Hainaut with the sultan's message and traveled back ahead of Gillion bearing the news of the knight's return to Cairo, was killed before he could deliver the good news to the sultan. Unaware of the messenger's fate, the sultan is convinced that Gillion's appearance is due to Muhammad's miraculous intervention. Gillion almost laughs out loud but instead simply advises the sultan to postpone the battle until the next day.

[Fol. ccxxxix], MISSING MINIATURE
"How the sultan of Egypt set the battle against his enemies for the next day and how his enemies decided likewise. How the sultan charged my lord Gillion to order his troops and how Gillion did it. And how on all accounts he conducted himself chivalrously"

PLATE 49

Fol. 218v [fol. ccxliii], **Initial** *Q: Gillion Defeating the King of Gibraltar*

The king of Gibraltar, tall and strong as a giant, has massacred the flower of the Hainaut chivalry. Arnaut de Roisin, Jacques de Werchin, Bernard de Ligne, Guilbert d'Antoing, and Guillaume de Bossut have already perished under his battle-ax, when Gillion approaches and swings his sword, severing his enemy's left arm holding the shield. In agony and caring little for his life, the king of Gibraltar attacks Gillion with his halberd, breaking Gillion's shield in two and killing his horse on the spot. Quickly back on his feet, Gillion lifts his sword and cuts off the Saracen's leg at the hip. The Saracen falls down and is trampled to death under horses' hooves.

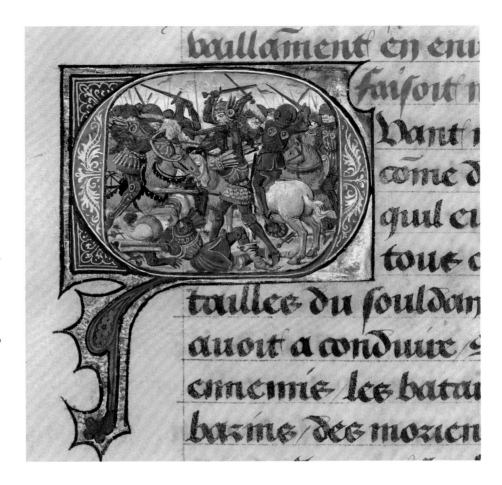

PLATE 50

Fol. 224v [fol. ccxlix], **Initial** *Q: Gerard Rescuing His Father Gillion during Battle*

The king of Gibraltar lies dead (lower middle of the image), and Gillion is still on his feet. He defends himself bravely, like an enraged boar, from the mass of the Saracens approaching him from the left. He wields his sword and shield (painted with the letters "GI"), but he is still without a horse, and many a javelin and arrow wound him. But the terrible clamor attracts the attention of the sultan, who hurries to Gillion's rescue. Gerard arrives, carrying the shield with the Trazegnies coat of arms, with several knights from Hainaut. They push back the Saracens, and Gillion is able to mount a horse.

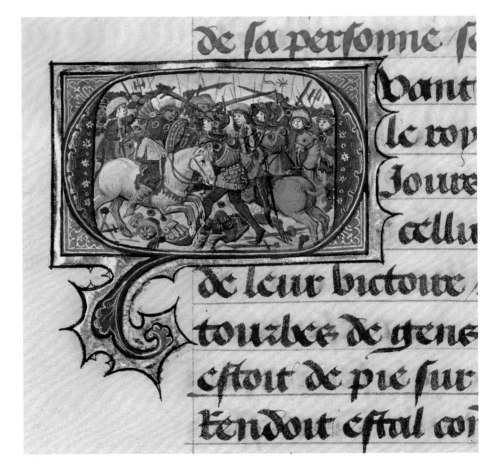

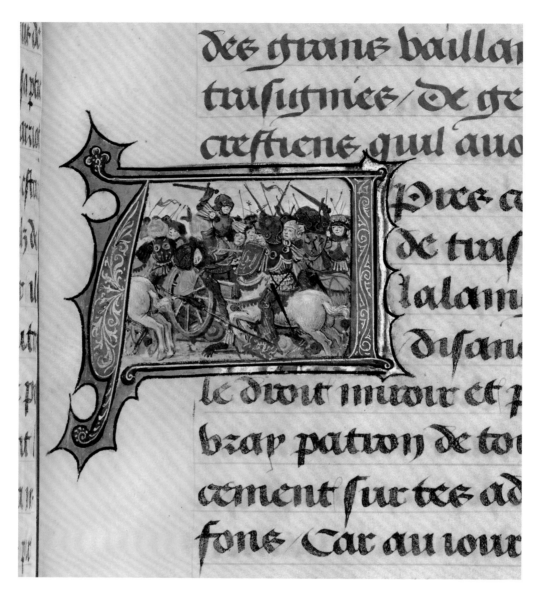

PLATE 51

Fol. 228 [fol. ccliii], **Initial *A*: *Gillion and His Son Gerard Defeating a Saracen Army***

The terrible and deadly melee continues, as the enemy retreats. Gillion, carrying the shield with the letters "GI," has just killed the enemy's standard-bearer; the emir and the banner are falling to the ground. Gerard follows suit, with the shield displaying the Trazegnies coat of arms, as they attack the chariot guarding the master battle standard deep in the enemy side of the battlefield.

[Fol. cclvii], MISSING MINIATURE
"How after accomplishing several high deeds honorably, my lord Gillion de Trazegnies took ill to his bed. And how he rendered up his soul to the Lord"

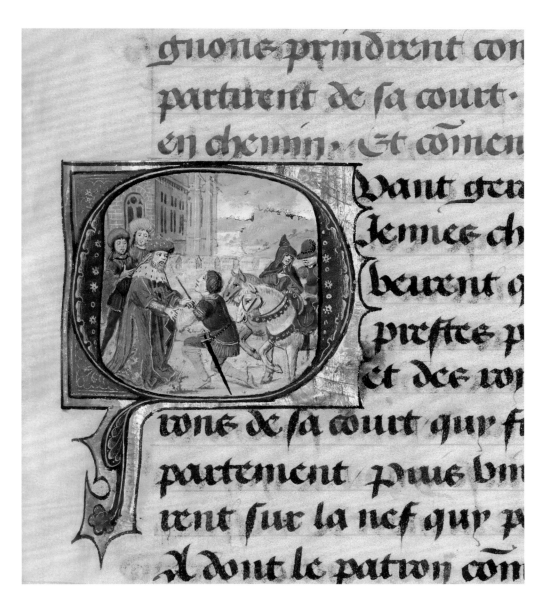

PLATE 52
Fol. 235 [fol. cclxi], **Initial** *Q*: *Gillion's Son Gerard Taking Leave of the Sultan*

Gerard kneels before the sultan as he gets ready to depart from the sultan's court. Before passing away, Gillion begged the sultan to give leave and safe conduct to his son Gerard and his company of knights to return to Hainaut. Seeing their determination to return to their native lands, the sultan grants them leave and offers them beautiful and rich gifts that they load on the boats, taking them down the Nile to the Mediterranean Sea and to Venice.

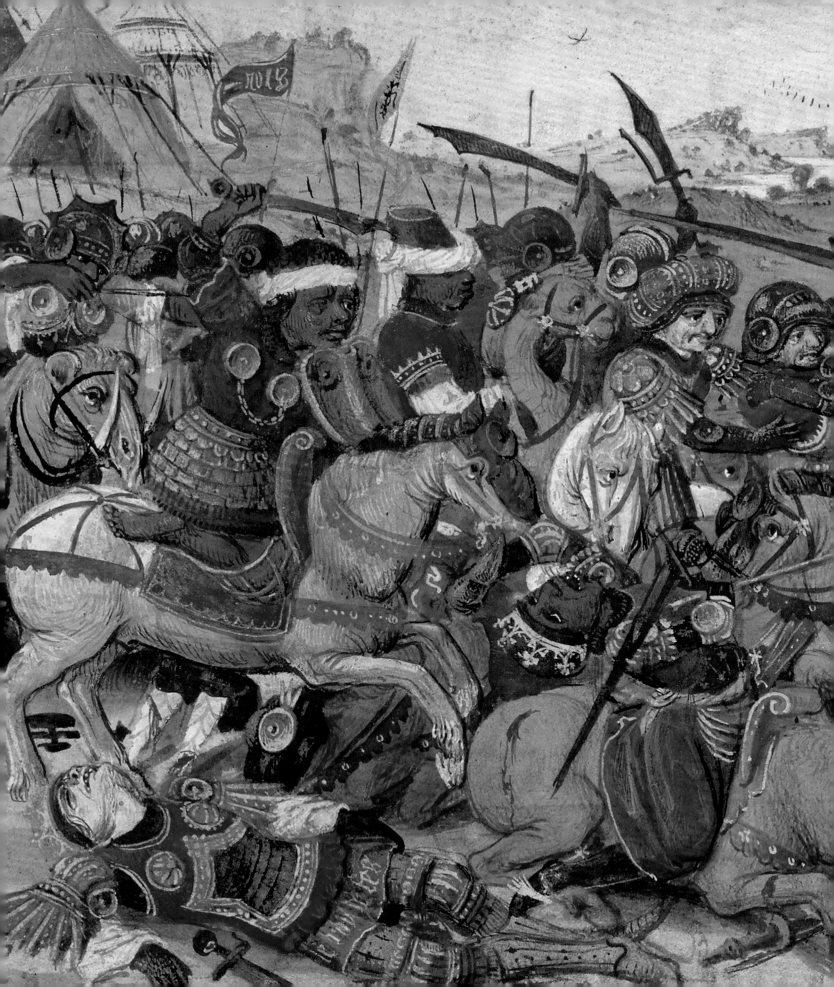

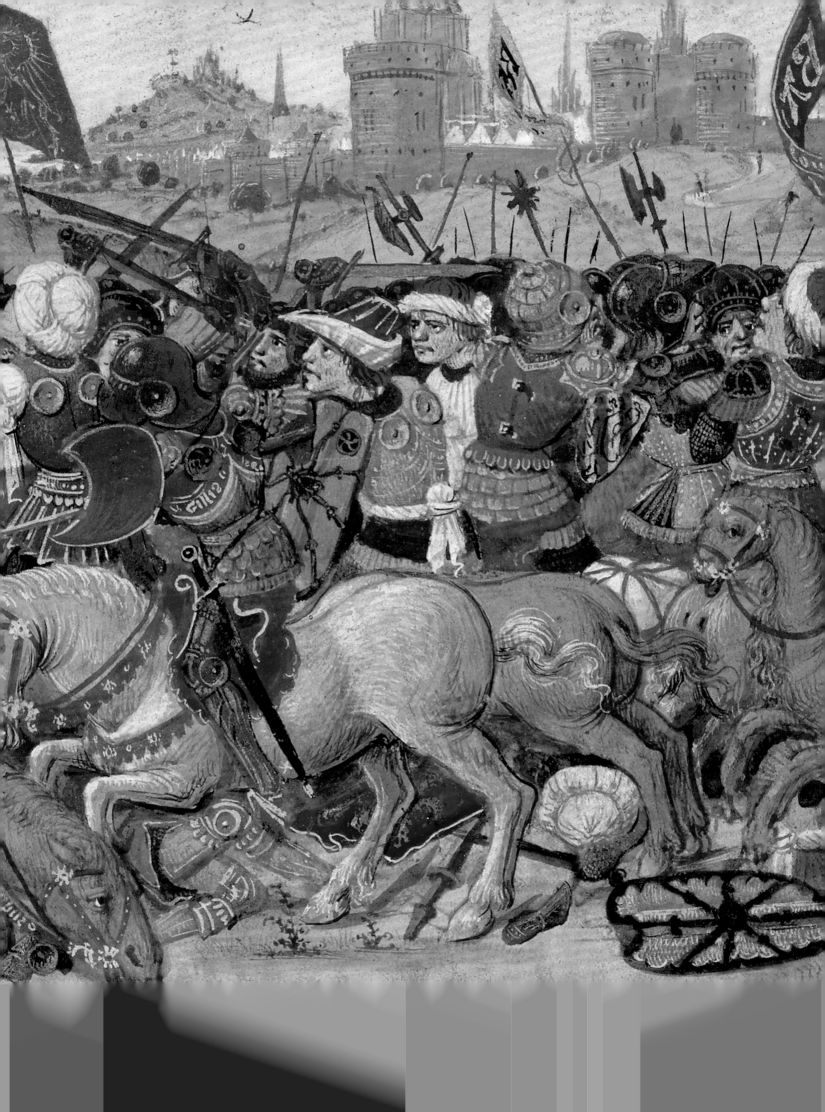

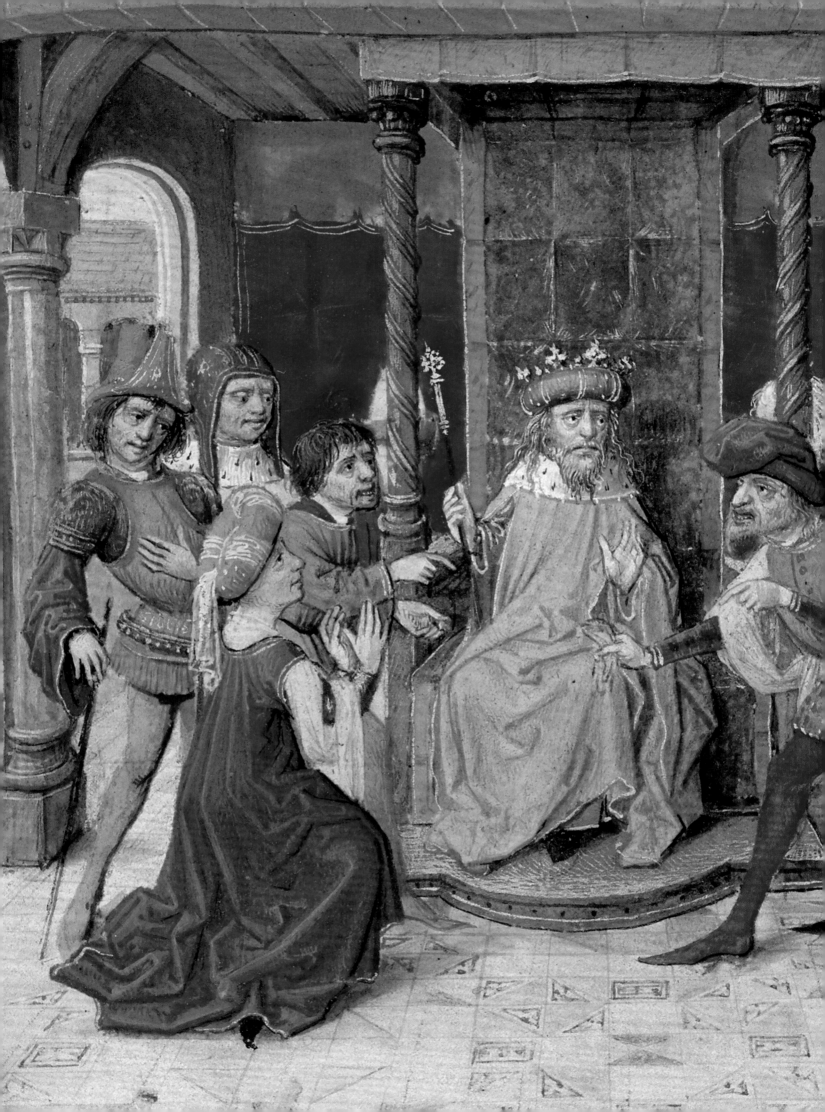

A ROMANCE BETWEEN THE EAST AND THE WEST

ZRINKA STAHULJAK

The life of Gillion de Trazegnies is a story poised between the East and the West, his love interests divided between Marie, a Western noblewoman, and Gracienne, a Muslim princess. The first miniature of the Getty *Gillion* manuscript showcases this in-between position, with Gillion's recumbent tomb statue comfortably ensconced between that of his two wives (plate 1). But what in this exciting story full of twists and suspense was true or plausible in the fifteenth century when the romance was written? Who was Gillion de Trazegnies? Why did the story particularly appeal to the Burgundian high nobility of the period, to the point that the owner of the Getty manuscript, Louis of Gruuthuse, invested substantial sums in its lavish production? Why did it occupy such a prominent place, as we will see, in the libraries of courtiers to the Duke of Burgundy, but not in Duke Philip the Good's impressive library that numbered almost nine hundred volumes at his death?[1] Who wrote this stirring narrative of extraordinary adventures, and why? Let us pursue the answers to these questions as we unravel the many elements that make up the rich plot of this unusual romance.

The Geopolitics of the Romance

The *Romance of Gillion de Trazegnies* begins and ends in the West, in the region of Hainaut (in present-day Belgium and northern France), and in between it creates a web of connections among major centers in the Mediterranean: the Adriatic, the Maghreb (northwest Africa), especially Tripoli in today's Libya and Fez in Morocco, Cairo in Egypt, Jerusalem, Damascus in Syria, Cyprus, Rhodes, Rome, and Venice (see Map of Places Related to the *Gillion* Romance). The geography of the romance corresponds to some of the main geopolitical arenas that preoccupied Philip the Good, Duke of Burgundy (r. 1419–67), as the Hundred Years' War (1337–1453) between England and France drew to a close and the Burgundian expansion and unification of the Low Countries was completed. In quick succession, Philip first acquired the territories of Hainaut, Holland, Zeeland, and Frisia from his cousin, Jacqueline of Bavaria, and, in April 1433, he incorporated them into his

63

two other northern possessions, Flanders and Artois. Then, in 1435, he signed the Treaty of Arras with Charles VII of France (r. 1422/29–61), abandoning the English alliance that he had forged in the aftermath of the assassination of his father, John the Fearless, which had been orchestrated by the French in 1419.[2] As peace returned to the West, the duke could set his sights on enhancing his European stature and polishing his international image. The pillar of his strategy was his Mediterranean policy, which would ultimately lead to his proposal for a new Crusade.

Philip's third marriage, to Isabel of Portugal, and the support of a Portuguese Crusade against the kingdom of Morocco may have been the initial motivation for the construction of the Burgundian naval fleet that began in 1438.[3] But, in response to papal encouragements, Philip expanded his plans to the eastern Mediterranean, sending a fleet of seven ships under the command of Geoffroy de Thoisy from the North Sea port of Sluis (French: L'Écluse) to provide military support to the Knights Hospitaller of Rhodes. In 1444, Philip named his chamberlain and counselor, Waleran de Wavrin, as "commander of the army and fleet of the Levant."[4] Sporadic raids produced no significant gains and failed to materialize into a full-scale Crusade, despite a decade of intense diplomatic activity with the papacy and the East, that is, with Rhodes, Cyprus, and the Holy Land itself.

Aiming to position himself as the defender of Christianity, the duke changed his tactics around 1450.[5] His first public commitment to a Crusade was made at the chapter of the Order of the Golden Fleece held in May 1451 in Mons and was spearheaded by Bishop Jean Germain, the chancellor of the order. The duke had founded the chivalric order in Bruges in 1430, on the occasion of his marriage to Isabel. It was certainly the most successful and coveted of numerous similar princely initiatives, rivaled only by the Order of the Garter (founded by King Edward III of England, ca. 1348) and the Order of the Collar (founded by the Count of Savoy, Amédée VI, in 1363–64).[6] After the twenty-four initial inductions in 1430, the duke brought the membership to thirty knights by 1433.[7] The rationale offered for the order's foundation was to honor "the knights of old," to encourage those "who at present are strong and vigorous of body," and to legitimize the aspirations to membership of "knights and noblemen." But the order was also established "to pay due respect to God and to defend the holy Christian faith."[8] Accordingly, at Mons, the duke proposed to take the cross in the near future and lead a new Crusade to the East.

The duke's plan received a lukewarm welcome from the European rulers and was especially discouraged by Charles VII, who preferred to direct his resources toward evicting the last of the English from the Continent, and by the king of Aragon, who denied the duke the leadership of the Crusade, claiming it for himself because he was titular king of Jerusalem. But when in 1453 Constantinople fell to the Ottoman Turks, Pope Nicolas V (r. 1447–55) called for another Crusade, and the duke took the cross. The vow was made at the famed Feast of the Pheasant (*Le Banquet du faisan*), held in February 1454 in Lille, a sumptuous illustration of the duke's Crusading project as a pious but unattainable goal and a product of his teeming chivalric imagination. After the 1451 rebuke of his Crusade by the European monarchs, the Burgundian states remained the duke's only resource for mounting it. Since leadership and Crusading vows would be instrumental to the expedition's success, the duke prepared the feast with the members of the Order of the Golden Fleece present alongside many nobles and notables. The entertainments (*entremets*) were full of fantastical ancient and Orientalist motifs: the play of Jason (the hero of the Golden Fleece) and Medea, tapestries narrating the story of Hercules, the legend of the woman-serpent Melusine and the castle

of the Lusignan (Francophone rulers of Cyprus), a wild man riding a camel, a painting of a desert with a tiger battling a dragon, an Indian jungle with strange beasts, a large sailing ship (carrack) with sailors, and a living lion protecting a statue of a naked woman covered in Greek letters. The Crusading intention was conveyed in a dramatic closing entertainment featuring the Holy Church and the Pheasant carried by the king of arms, herald and officer of the order, who was named Golden Fleece. First, a nun, representing "our mother, the Holy Church," was carried in on an elephant led by a giant dressed as a Moor from Granada. She made an appeal to the duke and to the knights of the order. In response, the duke promised publicly to keep his vow against the Great Turk, which he had already put in writing. He handed the vow to Golden Fleece, who read it aloud over the head of the Pheasant. The Holy Church then thanked the duke and exited.[9] A total of 112 vows were made, but only 12 by knights of the order. Among the 100 nonmembers who made vows, there were probably some nobles who aspired to its membership and who wanted to impress the duke with their willingness to serve; indeed, 6 were later inducted into the order, including Louis of Gruuthuse and Anthony of Burgundy, bastard son of Duke Philip. The Feast of the Pheasant was probably the duke's most impressive and brilliant display of chivalric pomp, luster, and ceremonial, the apex of the Burgundian enactment of its own importance and wealth.[10]

However, internal Burgundian problems—the Ghent wars (1449–53) and dissensions and conflict between the duke and his son Charles (1457–February 1464)—obstructed any serious action. Finally, in 1463–64, a Crusade was mounted, but the new French king, Louis XI (r. 1461–83), did not grant leave to the duke, his vassal, under the pretext of formally reestablishing peace with England. To keep the Crusade promise made to Pope Pius II (r. 1458–64), the duke appointed Anthony of Burgundy as commander, but Pius's death in August 1464 canceled the Crusade once again. The duke died in June 1467, one month shy of his seventy-first birthday, his Crusading dream unfulfilled.

The *Gillion* romance was born out of the Crusading effervescence of the years between 1451 and 1464. Anthony, the Grand Bastard of Burgundy, and Louis of Gruuthuse each owned the long version of the romance, copied in 1463 and 1464, respectively. Anthony's manuscript (Dülmen, private collection) is dated on the last folio, followed by the scribe's signature, "*David Aubert, manu propria*" (p. 373); Louis's manuscript (JPGM, Ms. 111) is dated at the beginning (fol. 8v), in the dedicatory prologue that describes the book's patron and owner (for the manuscript tradition, see Introduction).[11] The Dülmen and Getty manuscripts are the prime examples of the textual tradition under discussion. Three significant moments in the romance commend the ideals of Crusade, exhorting the reader to join the effort and aligning with the climate of excitement at the Burgundian court. In the opening sentence of the prologue, the Getty manuscript explicitly mentions Crusading against the "infidels": "The high and exalted deeds that inspired the noble hearts of our ancient predecessors are worthy of praise, recommendation, and perpetual memory, especially among princes and noblemen. Upon hearing or reading the stories of righteous men of lore who used and employed the arms and conditions of chivalry, even on the infidels, ancient enemies of the Catholic faith, they can thereby greatly gain from fleeing all vice and loving good virtues" (Getty, fol. 9). This is a variant unique to the Getty manuscript. In the second instance, Burgundy is extolled by the king of Cyprus as one of the two main forces fighting the infidels: "But I promise you as a loyal Christian that I will spare no effort to solicit and entreat my good friends and allies, in France as in Burgundy, so that before one year and a half should come to pass, I will assemble so many men that the fields, mountains,

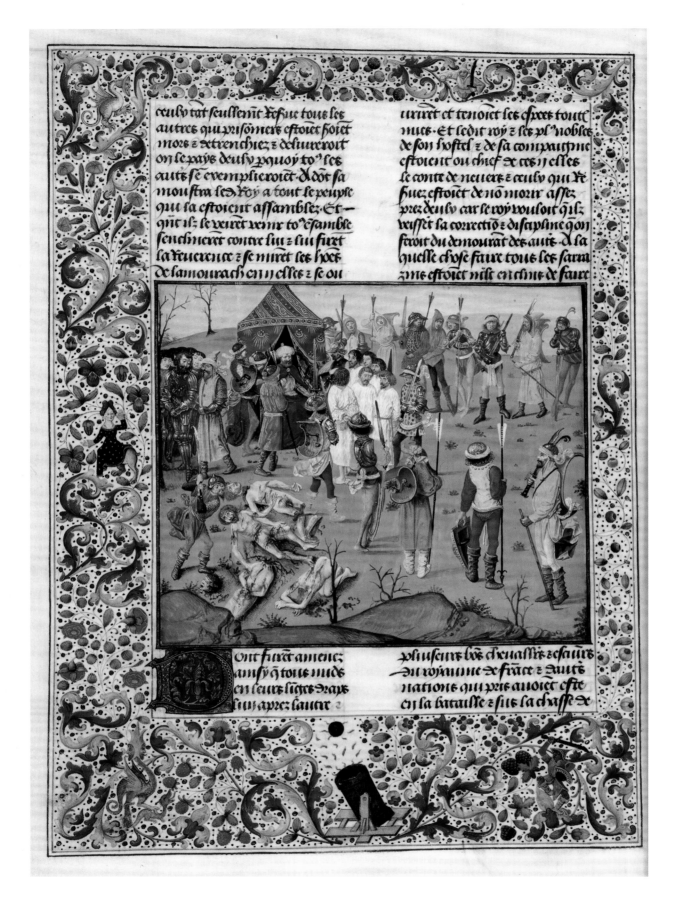

FIGURE 2

Master of the Dresden Prayer Book, *The Massacre at Nicopolis*, from Jean Froissart, *Chronicles*,
ca. 1475. Paris, BnF, Ms. fr. 2646, fol. 255v

and valleys around the city of Cairo will swarm with Christians" (Getty, fol. 56v/Dülmen, p. 181).[12] The third example describes a Crusade-like expedition from Hainaut in more than fifty folios: sixty young noblemen (fol. 204v/p. 342), "of the best lineages of Hainaut" (Getty, fol. 202v), are led by Gillion to Egypt. Over the length of one folio, the author develops the idea of the apprenticeship of chivalry in Saracen (Arab Muslim) lands "in order to increase their honor and renown" (fol. 204v/p. 342); he then exemplifies it in the next chapter when the Count of Hainaut presses his vassals to grant leave to their sons "to go on this voyage" (fol. 204v/p. 342).

The preeminence of Burgundy and France in the king of Cyprus's speech and the departure of male heirs to fight in the East against the infidels may be a reference to the well-known example of the Count of Nevers, the future Duke of Burgundy, John the Fearless (r. 1404–19). He led the Burgundian-French forces in the Battle of Nicopolis (September 25, 1396) and was captured by the Ottomans. More than three hundred nobles and knights perished in the battle and the massacre ordered by Sultan Bajazet I. However, the Count of Nevers and twenty, or at most twenty-three, other nobles, among them the French Marshal Boucicaut, were saved thanks to the intervention of a Turkish-speaking knight, Jacques de Heilly de Créquy, who had served in the army of Sultan Murad I, Bajazet's father (fig. 2) and was able to identify the highly prized captives. Duke Philip the Bold, the Count of Nevers's father, ransomed John and the nobles at the staggering amount of 200,000 florins; John returned to Dijon in Burgundy in February 1398. Philip the Good, John's son, was born in July 1396, three months after the count's departure eastward.[13] The traumatic Christian defeat and the Count of Nevers's near-miraculous escape from death would thus mark Philip from infancy.

Who Was Gillion de Trazegnies?

Gillion de Trazegnies was strong of body and upright in character, courteous and generous, intolerant of flatterers, and an excellent counselor and loyal vassal to his lord, Baldwin, the Count of Hainaut (fols. 11v–12/p. 129; for more, see Plot Summary). His marvelous strength gave him an air of the supernatural: "His enemies could hardly believe he was human" (fol. 225v/p. 362), thinking him "a fairy man" (fol. 76v/p. 199). His moral incorruptibility is exemplified throughout the romance. He unhesitatingly deploys his prodigious force against the Saracens, in defense of the holy Catholic faith (fol. 225/pp. 361–62), as "an infuriated tiger" (Getty, fol. 23) or "an enraged lion" (Getty, fol. 226). He steadfastly clings to his word of honor, to his own detriment: despite fervent pleas by his pregnant wife, Marie, and the Count of Hainaut, he leaves before she gives birth because he made a vow to go on a pilgrimage at the first sure sign of pregnancy (fol. 13v/p. 130); when Gracienne liberates him from prison to rescue her father, the sultan, he swears to return to captivity (fol. 41v/p. 166); and he promises not to escape from the sultan's court without his leave, "by which he was greatly disappointed because he spent twenty-four years overseas before he could obtain leave to return" (fol. 47v/p. 172). He never swerves from his Christian faith to convert to Islam, although "he was asked several times to renounce the religion of the Crucifix and enjoined to believe in the religion of Muhammad to which he had never acquiesced" (fol. 48/p. 172). Instead, he converts both Gracienne and his companion-in-arms, Hertan. In short, Gillion embodies "the valiant Christian knight," a descriptive employed countless times in the text.

But this Gillion de Trazegnies did not exist. Or, rather, he may have existed under several different names that were blended into one pseudohistorical portrait. Gillion's single-minded

battle against Saracens allows us to identify him with several historical persons: three lords of Trazegnies who had participated in the Crusades.[14]

The title of the lord of Trazegnies was first used in the twelfth century. Trazegnies is a town and fief located in Hainaut, in present-day Belgium, and its lords were loyal vassals and administrators to the Counts of Hainaut, as the initial portrait of Gillion suggests. Otto II de Trazegnies (d. ca. 1192) had connections to the Cambron Abbey—where Gillion retired at the end of his life—and was the first of the Trazegnies family to take the cross in any Crusade (the Third Crusade). He died in the Holy Land.[15] But there are two better candidates for a model for Gillion. Gilles II de Trazegnies (d. 1204?), constable of Flanders, participated in the Fourth Crusade, not with the main army in Constantinople but in the Holy Land.[16] A third possibility is Gilles le Brun (d. 1276), who came from the Trazegnies lineage but never carried the title of lord of Trazegnies. Gilles le Brun may have contributed to the story in two ways. His first wife, Ida de Sotrud, brought the fief of Ostrevant into the Trazegnies lineage; Gillion's wife Marie is of Ostrevant lineage. Moreover, Gilles le Brun went on the Seventh Crusade with Louis IX (Saint Louis), spent some time in Cyprus, and was taken prisoner with Louis in Egypt and accompanied him later to Acre. During their sojourn in the Holy Land, Louis made him constable of France, and Gilles married the sister of Jean de Joinville, seneschal of Champagne, Louis's counselor and, later, chronicler.[17] This close link to Louis is highlighted in the first chapter of the latest French manuscript (Brussels, KBR, Ms. IV 1187), made in 1529 for Jean IV de Trazegnies, which situates the events as taking place during Louis's reign. The fact that a family copy is the only one to draw such a clear connection between a legendary ancestor and a real Crusading king creates a phantasmagoric landscape typical of genealogical histories: the Getty manuscript frequently speaks of Gillion's "lineage." Unencumbered by historical accuracy, genealogies more often than not rearranged family histories into legends that best suited the family's purpose, unhesitatingly combining multiple stories and twisting chronologies to its advantage.

But a more general view of the Crusading and Eastern contexts that inspired the creation of the romance is also possible. During this whole period from the 1440s to 1460s, the duke maintained intense contacts with the East, and his court teemed with Easterners: Eastern Christians, Greeks, Moors, and Turks.[18] It is easy to imagine the character of Gillion, the perfect Christian knight who successfully assimilated for years in the Muslim lands, as a fictional rendition of someone like Bertrandon de la Broquière, the duke's spy in Syria and Egypt (1422–23). De la Broquière's return to Burgundy was captured in an illumination dated after 1455 (fig. 3): de la Broquière is kneeling before the duke and his Turkish dress contrasts sharply with the duke's armor, suggestive of his possible acculturation even as it reminds the reader of how he had to blend with the population in order to carry out his mission.

Is the *Romance of Gillion de Trazegnies* a True Story?

The opening of the Getty manuscript situates the events in the time of Childebert, king of France, and Baldwin I, Count of Hainaut (Getty, fol. 10v). Childebert was a Frankish king of the Merovingian dynasty, who ruled from 511 to 558. Baldwin I, Count of Hainaut, ruled from 1051 to 1070. He also ruled Flanders, as Baldwin VI, from 1067 to 1070. Thus their names are used not to situate the romance in a precise historical moment but to signify events taking place in a distant past.

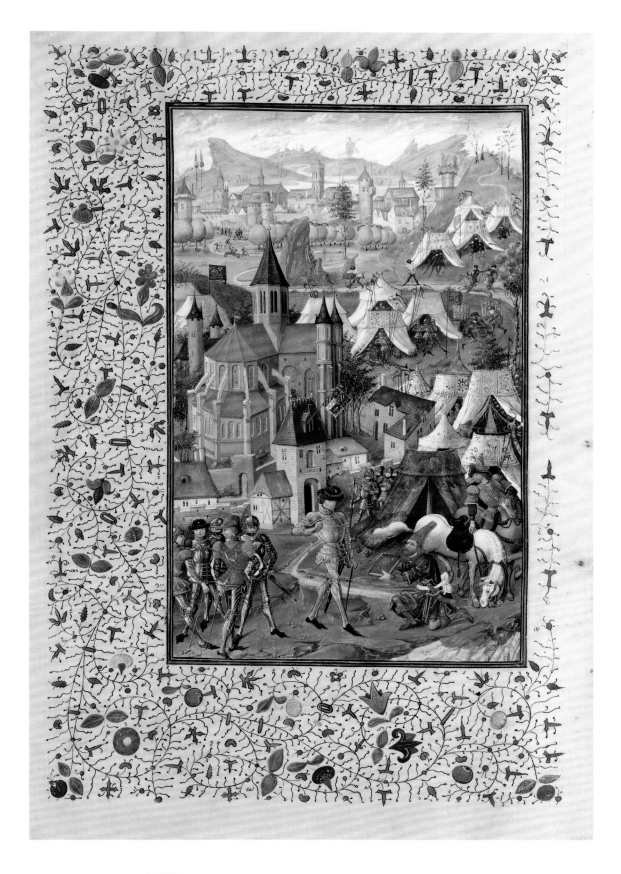

FIGURE 3

Jean le Tavernier, *Presentation Scene with Duke Philip the Good*, from Bertrandon de la
Broquière, *Voyage in the Land of Outremer*, after 1455. Paris, BnF, Ms. fr. 9087, fol. 152v

Although the romance gestures to a time before the Crusades, the plot has resonance with contemporary events. Jerusalem had been the object of centuries of Christian attempts at conquest and subsequent failures. In the fourteenth and fifteenth centuries, the reconquest of the Latin Kingdom of Jerusalem was the objective of the papacy and of numerous Western great and lesser rulers, such as Philip VI of France, Pierre I of Cyprus, the house of Anjou, and Duke Philip the Good. Conquered in 1099 in the First Crusade (1096–99), Jerusalem fell in 1187 to Saladin, the Muslim sultan of Egypt and Syria. The last Christian foothold on Syrian soil, Acre, was lost in 1291, while Christian forces withdrew to the island of Cyprus, ruled by King Henry of Lusignan. In the romance, Cyprus, the easternmost Christian outpost facing Muslim Syria, is ruled by an unnamed Christian king; in reality, this was the house of Lusignan. According to the text, the Knights Hospitaller of Saint John of Jerusalem (erroneously called the Templars in the text) live on the island of Rhodes, which they indeed occupied from 1309–10 until 1522.

The romance also replicates the traditional power of Venice as the city from which the Crusades were launched. Two well-known examples include the Venetian transport of the Crusader army in the Fourth Crusade that infamously captured Constantinople (1204) instead of Jerusalem, and the Venetian departure of Pierre I, king of Cyprus and Jerusalem, which netted a celebrated raid on Alexandria in 1365. In the romance, Gillion's final Crusade-like expedition to Egypt, with his son Gerard and sixty young knights of Hainaut, also departs from Venice, where he received an impressive welcome from the patricians as he entered the port of the city (fol. 206v/p. 344) and at the Piazza San Marco "found the Duke and the lords who awaited [his] arrival" (fol. 207/p. 344). It is interesting that the Getty manuscript differs from the Dülmen version, which overenthusiastically associates Gillion with Venice: although Gillion's initial pilgrimage and return started and ended in Naples, the Dülmen scribe writes that Venetians flocked to greet Gillion, "some because they had seen him in Cairo, others because they had seen [him] in Venice and elsewhere" (Dülmen, p. 344). Since this is Gillion's first time in Venice, the Getty version corrects and specifies that all recognized him, "some because they had seen him in Cairo and others on account of the favorable reports about him received by the duke and the lords" (Getty, fol. 206v).

The romance borrows heavily and self-consciously from fourteenth- and fifteenth-century travelogues and pilgrimage narratives (see Map of Places Related to the *Gillion* Romance). The Mediterranean travel itineraries of Gillion, and his sons Jean and Gerard, follow one well-traveled pilgrim route: by land through Champagne, Savoy, and Lombardy to Rome, then from Naples to the port of Jaffa in medieval Syria (in present-day Israel), with an optional stop in Cyprus. Father and sons sail on merchant ships (fol. 19v/p. 136; fol. 105/p. 225). On his return, Gillion and his sons travel the same itinerary in reverse, from Acre in medieval Syria (in present-day Israel) to Naples on "a nave from Genoa" (fol. 192/p. 321). The other travel itineraries across the Mediterranean mirror Venetian dominance in the pilgrim business: Amaury, the Hainaut knight who goes to find Gillion and purposefully tells him that Marie and his progeny have died, leaves from Venice to Acre "with several merchants" (fol. 64v/p. 189), and the messenger who delivers the sultan's call for help to Gillion in Hainaut follows the route from Damietta to Venice. Venetian administrative records indicate that the republic authorized the activities of agents who helped pilgrims secure all the provisions and services they needed at the trip's starting point and connected them with inn owners, ship captains, money changers, and interpreters.[19] The Venetian mercantile machine created premodern group tours; by 1480, the contract with the ship's

captain was all-inclusive: "A contract has to be signed with a ship captain who generally asks between fifty and sixty ducats. For this sum, he is required to provide round-trip transportation, food (except during stopovers at ports of call), animals for land transportation in the Holy Land, and payment of all tributes and tolls."[20] Gillion's and, later, his sons' landing in Jaffa reproduces, moreover, the standard disembarkation procedure for pilgrims arriving in fourteenth- and fifteenth-century Syria under Muslim rule. They were greeted and registered by the sultan's dragomans (officials who also served as interpreters and guides), then given donkeys and mules for the transit to Jerusalem (fol. 19v/pp. 136–37; also fol. 106/p. 226). Amaury even hires a personal guide in Acre, a more expensive but more expedient option (fol. 65/p. 189).

Since the romance is mapped on pilgrim itineraries, it is not by chance that Gillion's first journey opens, and also ends, with a pilgrimage to the Church of the Holy Sepulcher, a highlight of all pilgrimages to Jerusalem (fol. 20/p. 137; also fol. 192/p. 321).[21] At the end of the romance, during his second journey in Egypt and Syria, Gillion and the Crusaders from Hainaut visit another staple destination on the pilgrim itinerary, "the holy pilgrim sites that lay beyond, like Saint Catherine of Mount Sinai, Saint Paul and Saint Anthony of the desert, and several other holy places" (fol. 232/p. 368). The author models their travels by land in Syria and Egypt on the established routes from Cairo to Gaza to Jerusalem and describes the standard equipment and precautions: "[Amaury] made preparations and provisions for the crossing of the desert and hired a dragoman to guide him" (fol. 66v/p. 190; also fol. 191v/p. 321).

Trade routes were the backbone of travel in the Mediterranean and Muslim lands, and merchants and pilgrims formed information networks: in Jerusalem, Amaury "had found a pilgrim who had told him that, when the sultan found men who wanted to serve him in war, he retained them as mercenaries. There was a merchant there who told him this was true" (fol. 66v/p. 190; also fol. 106v/p. 227). After Amaury crosses the desert between Gaza and Cairo with merchants, the sultan indeed hires him.

The *Gillion* romance is not based on the true story of one person but is woven from many elements of the lives and experiences of numerous people; it is a collective experience distilled into one exemplary, and pseudohistorical, biography of a hero. It signals to the modern reader the freedom from historical accuracy and fact-based approach that the Middle Ages commonly exercised and allows us to understand Gillion's world as a universe composed of many disparate, noncontinuous historical elements. The result is a rich web of the plausible and a multidimensional projection screen that, for fifteenth-century readers, was the purview of the best historical fiction (on genre, see Introduction).

The Appeal of the *Gillion* Romance: Louis of Gruuthuse, Anthony of Burgundy, and the Crusade

Four ducal courtiers owned fifteenth-century copies of the romance under consideration here: Louis of Gruuthuse (JPGM, Ms. 111), Anthony of Burgundy (Dülmen, private collection), Jean de Wavrin (Brussels, KBR, Ms. 9629, 1450–60), and Philippe de Clèves (Jena, Thüringer Universitäts- und Landesbibliothek, Ms. El. f. 92, second half of the fifteenth century). However, the *Gillion* romance seems to have been of particular significance for Anthony and Louis, who personalized their *Gillion* manuscripts to an extent rarely seen and whose manuscripts were the only ones to be illuminated.[22]

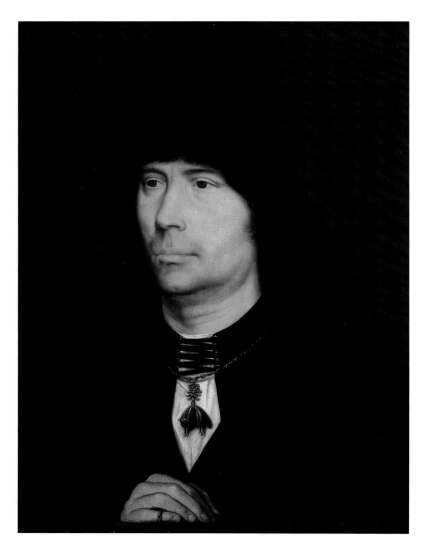

FIGURE 4
Copy after Hans Memling,
Portrait of Anthony of Burgundy,
ca. 1500. Dresden, Staatliche
Kunstsammlungen, Gemäldegalerie
Alte Meister, Inv.-Nr. 1283

The Introduction summarizes the brilliant career of Louis of Gruuthuse, but that of Anthony of Burgundy (ca. 1421–1504), one of sixteen bastard sons sired by Philip the Good (fig. 4), was not any less successful. He took the title of the Grand Bastard (*le Grand Bâtard*) after the death of his elder half-brother, Corneille, in 1452. Anthony led many important military campaigns and diplomatic missions for Philip (e.g., to Ghent, 1452–53) and was governor of the duchy of Luxembourg after 1452. He was inducted into the duke's chivalric Order of the Golden Fleece in 1456. After his capture in 1477 by the French at the Battle of Nancy, where Charles the Bold died, he switched allegiance to the kings of France.[23]

Jean, bastard of Wavrin (ca. 1394/1400–ca. 1472/75), was a military commander descended from an old provincial noble family in the Lille region whose status had diminished by the fifteenth century. He fought on the losing French side at the Battle of Agincourt (1415) and then entered the service of the English and Burgundians. Following the change in Anglo-Burgundian relations established by the Treaty of Arras in 1435, he retired from military service after Philip's failed siege of the English-held city of Calais in 1436 and obtained the governorship of the town of Lillers in 1437, an office he kept until 1445. By 1462, he had become the duke's chamberlain and, by 1465, his counselor. He went on an important diplomatic mission to Pope Pius II in Rome in 1463, in preparation for the 1464 Crusade. With Anthony and Louis, he also went on a diplomatic mission to England in 1467.[24] Wavrin is best known as the author of the six-volume *Chronicles of England* [*Chroniques d'Angleterre*] (1445, updated in 1469–71).[25]

In contrast, Philippe de Clèves was the youngest of the four courtiers (1456–1528), and he would have known Philip the Good, who died in 1467, only as a child. But he was Philip the Good's godson and relative (his grandfather Adolphe de Clèves was Philip's brother-in-law) and served as courtier to Archduke Maximilian of Austria, regent of Burgundy, before opposing him in the revolt of the Flemish towns between 1488 and 1492.[26]

Jean, Anthony, Louis, and Philippe all played major political roles, whether in civic or military service, to the Dukes of Burgundy. But they were likewise avid manuscript collectors and patrons, with important libraries. Wavrin had at least 32 manuscripts; Anthony, 44 surviving manuscripts; Louis, 150 titles in almost 200 volumes (some texts were so long that they required more than one volume); and Philippe, 152 titles in 168 volumes (of which about 60 survive). Of the four collections, only Philippe's has an extant contemporary inventory, compiled after his death by order of Margaret of Austria, regent of the Habsburg Netherlands.[27]

This intersection between political life and bibliophilia deserves attention. The general Crusading context of the Burgundian court alone would suffice to justify the lavish and

audacious visual program in Anthony's and Louis's manuscripts of the long version of the *Gillion* romance. Both men took the cross at the Feast of the Pheasant in 1454, though they were not yet members of the duke's prestigious Order of the Golden Fleece. But they were ambitious, up-and-coming members of the Burgundian-Flemish high nobility, and young enough to depart on a Crusade. However, the links between the manuscript they each commissioned—the long version (see Introduction)—and their personal involvement in the duke's political and military projects were far more personal.

Anthony's manuscript was made in 1463, as the explicit states: "Here ends the true story of the valiant knight my lord Gillion de Trazegnies that was copied [*grossee*], illuminated [*historiee*], and planned [*ordonnee*] in its entirety as is seen at the command and bidding of the most feared and well beloved prince Anthony, bastard of Burgundy, lord of Bevre, Beuvry and Tournehem, and captain general of Flanders and Picardy. In the year 1463 of the Lord's grace"; the dating is followed by the scribe's signature, "*David Aubert, manu propria*" (Dülmen, p. 373). In fact, Anthony's manuscript was being completed as advanced preparations for Philip's Crusade reached their apex, as discussed briefly above. Between November 1463 and February 1464 Philip was in Bruges, keeping watch as his fleet was assembled and armed in the nearby port of Sluis.[28] But in a meeting in Lille, on February 23, 1464, the French king Louis XI "requested and commanded" that the duke postpone his departure by one year in order to finalize peace negotiations between England and France.[29] On March 5, 1464, the duke announced that Anthony would take his place and command the fleet of fifteen ships from Sluis to Marseille, where twelve more ships would be commissioned. They departed for France on May 20 or 21, 1464, the duke intending to join them in March 1465 in Marseille. On its way to Marseille, the expedition helped in lifting the siege of the Portuguese town of Ceuta on the African coast, but the Crusade was canceled when Pope Pius II died in August 1464. In January 1465, Anthony was in Avignon on his return trip to Burgundy.[30]

If the manuscript of *Gillion* was finished in 1463, Anthony would have commissioned it before knowing that he was to lead the advance Crusade; however, his commission would have been directly linked to the acceleration and concretization of Crusade projects. The long version of his manuscript must have been inspired by these activities, which explains the author's single-folio intervention lamenting the lack of the Crusading spirit "against enemies of the Christian faith" and the indolence of knights of his day: "At present, times are such that each man seeks his comfort and, instead of virtues, vices rule" (fols. 203–203v/ pp. 340–41). While Anthony's patronage would not have reflected his status as Crusade commander, it would demonstrate his support of his father's project. The dedicatory prologue to his Dülmen manuscript names him "a Cesar Augustus in prowess, largesse, and kindness" and states that Anthony commissioned a copy of the story because it was "a beautiful mirror to direct and instruct noble hearts in honorable and chivalric prowess" (Dülmen, p. 125). At the time of the manuscript's making, Anthony's was an imminent Crusade; only later would he end up leading its botched effort.

There is another aspect of the Dülmen manuscript that argues strongly for Anthony's vicarious identification with his father's project: his virtual identification with Gerard, the younger of Gillion's twin sons. The Dülmen manuscript's nine miniatures favor the scenes with Gillion's twin sons, Jean and Gerard (see Plot Summary and Appendix 2). After the frontispiece where Gillion appears in the two right frames (fig. 5), only three miniatures illustrate his actions in the East: Gillion and Hertan leaving to rescue the sultan (see fig. 26), Gillion's defense of Cairo against the emir of Orbrie (see fig. 24), and finally their duel and the

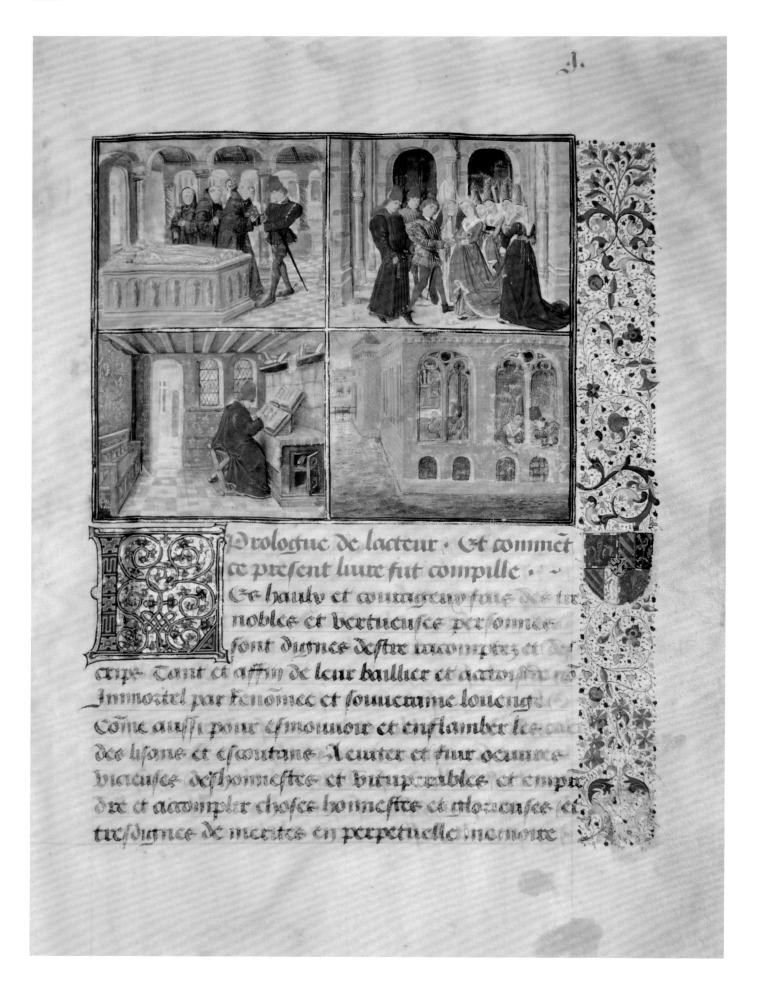

.J.

Prologue de lacteur · Et commēt
ce present liure fut compille · ·
Ce haulv et courageux faie des tre
nobles et bertueuse personnes
sont dignes destre racomptez et de
cripe · Tant et affin de leur baillier et acroissez en
Immortel par kenōmee et sounctame louenge
Cōme aussi pour esmouvoir et enflamber les cue
des lisans et escoutans A euiter et fuir oeuvre
vicieuses deshonnestes et biruperables et empre
dre et accomplir choses honnestes et glorieuses et
tresdignes de merites en perpetuelle memoire

FIGURE 5 (opposite)
Workshop of Lieven van Lathem, *The Author Hearing the Story of Gillion*; *The Author Translating the Story*; *The Wedding of Gillion and Marie*; *Gillion Praying and Gillion and Marie Gazing at Carp*, from *Romance of Gillion de Trazegnies*, 1463. Dülmen, private collection, fol. 1

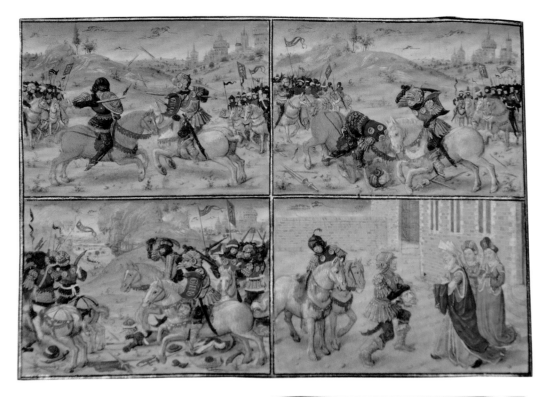

FIGURE 6
Workshop of Lieven van Lathem, *Gillion Duels with the Emir of Orbrie*; *Gillion Kills the Emir*; *The Army of the Emir Flees*; *Gillion Brings the Head of the Emir to Gracienne*, from *Romance of Gillion de Trazegnies*, 1463. Dülmen, private collection, fol. 54v (detail)

FIGURE 7
Workshop of Lieven van Lathem, *The Constable of Cyprus Is Led to His Hanging and Gillion's Sons Rescuing the Constable*; *The Sons of Gillion Attack the Encampment of King Bruyant and the Constable Sails to Rhodes*; *The Arrival of the Grand Master of Rhodes into Cyprus*, from *Romance of Gillion de Trazegnies*, 1463. Dülmen, private collection, fol. 117v (detail)

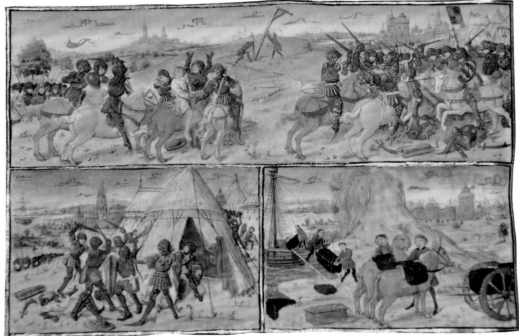

defeat of Orbrie's army (Dülmen, fol. 54v; fig. 6). The remaining five miniatures all depict the brothers' actions: the king of the Slavs' siege of Cyprus (see fig. 27; the brothers are in the upper right and lower right frames, identified by the Trazegnies gold and blue standard, shield, and armor), the rescue of the constable of Cyprus and the surprise attack led by the brothers on the Slavs (Dülmen, fol. 117v; fig. 7; the brothers are on the right of the upper frame, identified by the Trazegnies gold and blue coat of arms, and in the lower left frame), the defeat of the Slavs and pirate attack on the brothers' galley (see fig. 23; they are identified in the upper frame by their gold and blue standard and in the lower frame by their coat of arms),[31] a judi-

cial duel (trial by combat) between Gerard and Lucion (see fig. 33), and finally the judicial duel between Jean and Gerard (see fig. 28). In total, Gillion appears in four miniatures, compared to the five for Gerard and four for Jean (four out of five miniatures feature both brothers).

Although Jean is the elder of the two brothers, both the textual and the visual narratives give him a smaller role than Gerard's. The text of the long conclusion, moreover, excludes Jean from the final action. As heir and new lord of Trazegnies, he remains in Hainaut, while Gerard is accorded the privilege of accompanying his father on the final Crusade-like expedition. The artist highlighted Gerard's presence, most notably in the miniatures on fols. 152 and 177. On fol. 152 (see fig. 33), where Gerard is clearly identifiable for the first time, he is dressed in red and golden armor resembling that of Gillion (the one difference is the green undercoat, the color green identifying perhaps a young knight).[32] On fol. 177 (see fig. 28), in the final lower right frame, when the brothers recognize each other and refuse to continue their judicial duel, Jean is shown surrendering to Gerard. In the Dülmen image cycle, Gerard thus overshadows his brother (and arguably his father). It is not improbable to conclude that Anthony, the first of the duke's bastard sons, but second to the duke's legitimate son and heir, Charles, saw himself in the younger Trazegnies. Like Gerard, Anthony would not be able to inherit, but he could present himself as militarily braver, more accomplished, and more heroic than his younger half-brother. In fact, the narrative promotes Gerard's combativeness and prowess, while Jean is presented as more temperate (fol. 91v/p. 213). The twin brothers do not look alike, nor do they have the same character, and there is a stronger resemblance between father and sons than between brothers. Their adventures at first replicate Gillion's. They follow in their father's footsteps from Hainaut via Rome to Jerusalem, and later they are captured by two groups of Muslim pirates in the Mediterranean. Jean is then taken to King Fabur's dungeon in Tripoli (in present-day Libya) where his father had been imprisoned earlier, while Gerard finds himself in Ragusa (Dubrovnik, in present-day Croatia), where Morgan, a Slav king described as Muslim, reigns. But as the narrative progresses, it is the younger Gerard, not the elder Jean, who has a love affair with a Saracen princess, Natalie, a corollary to his father's love for Gracienne. And it is Gerard, not Jean, who accompanies his father on the final expedition against the infidels in Egypt. This bias toward the younger son is so strong in the Dülmen manuscript that the artist inverts the narrative on fol. 177 (see fig. 28). According to the text, the two brothers are reunited in Tripoli when Morgan attacks King Fabur there. The two Muslim kings agree to decide the outcome of their war with a judicial duel between their champions; to spare Muslim lives, each king selects a Christian knight. But when Gerard, on the verge of defeat, begins a lament in French, Jean is able to identify himself as "your brother" (fol. 166v/p. 299). Immediately, the younger Gerard, following the rule of primogeniture, surrenders to the elder Jean, the heir. But the artist of the Dülmen manuscript has instead painted Jean surrendering to Gerard. Since the Dülmen artist did not make any similar errors in the cycle, but rather showed an intimate knowledge of the text, it is plausible that this inversion of roles was purposeful to personalize the manuscript for the patron. It is noteworthy that in the Getty *Gillion*, Lieven van Lathem made no such inversion in the historiated initial depicting Gerard's surrender (plate 39) and took it even a step further by changing the color of the brothers' horses from the Dülmen manuscript. While the Dülmen image (fig. 28) shows a dark horse on the ground (the horse of the surrendering Jean), Van Lathem's image in the Getty copy has a white horse lying wounded on the ground, the horse of the surrendering Gerard (plate 39).[33] Following the story line, Van Lathem switched the

protagonists and their horses, making it more likely that the Dülmen manuscript served him as a model.[34]

Van Lathem's miniatures for Louis of Gruuthuse in the Getty manuscript emphasize not the brothers' but rather the father's trajectory: except for the frontispiece (plate 1) and the duel between Gerard and Lucion (plate 35), six extant large miniatures feature Gillion. In her essay in this volume, Elizabeth Morrison establishes that, of the seventeen missing images, six were large miniatures. According to the rubrics in the Getty manuscript's table of contents, the subjects of the six missing large miniatures would have been equally split between Gillion's (three) and his sons' (three) adventures: (1) Gillion is visited and comforted by Gracienne in prison (fol. xxvi); (2) the twin brothers join in the defense of Cyprus and gain fame in a battle against the Saracens (fol. cxiiii); (3) the Saracen defeat in Cyprus featuring the brothers (fol. cxxv); (4) the brothers' judicial duel before Tripoli (fol. clxxiii); (5) Gillion's return to Egypt to assist the sultan and preparations for the final battle before Cairo (fol. ccxxxix); and (6) Gillion's death (fol. cclvii). Thus, Louis's Getty manuscript dedicates a total of nine miniatures to Gillion and four miniatures to the brothers (the frontispiece stands apart). It is instead the historiated initials of the Getty manuscript that develop the brothers' narrative as mirroring the father's trajectory: (1) separation scene from Marie (compare plates 7, 25); (2) attack on the Christian ship and capture (plates 9, 31); (3) Gillion's and then Jean's captivity in Tripoli (plates 24, 34); (4) defense of the Muslim maidens, Gerard of Natalie and Hertan of Gracienne (large miniatures, plates 35, 37, and historiated initial, plate 38); and (5) departure from the sultan's court (large miniature for Gillion, plate 43, and historiated initial for Gerard, plate 52). There is additional evidence that these two long-version manuscripts were intentionally personalized to suit the interests of their patrons: the Getty manuscript presents Jean's and Gerard's feats of arms in Cyprus in a single chapter (fols. 108–13) written out on one folio, while in the Dülmen manuscript, made for Anthony, the episodes extend to four chapters (fols. 113–19). The Getty manuscript thus consistently privileges Gillion's story over that of either of his sons.

Neither interested by nor vulnerable to fraternal competition, Louis would no doubt have preferred to focus in his manuscript on the single heroic figure, with whom identification was easier. The dedicatory prologue to his manuscript includes an idea similar to that found in Anthony's manuscript, namely, that Gillion's story is an exemplum to follow, "because following reason, all noble hearts desire seeing and hearing deeds and feats of high esteem, and especially when they can reap rewards in chivalric praise and renown" (Getty, fol. 8). Whereas Louis has his heart set on a copy of "this present story" (Getty, fol. 8), without singling out the hero or his sons, Anthony chooses, "among many beautiful histories," "the deeds and adventures of a valiant knight from Hainaut, called Gillion de Trazegnies, and his two sons Jean and Gerard" (Dülmen, p. 125). Louis's manuscript is dated 1464 in the dedicatory prologue describing its patron and owner (Getty, fol. 8v). Even though Louis had vowed to depart on the Crusade in 1454, by 1464 he was governor general of Holland, Zeeland, and Frisia and unlikely to be asked or encouraged to leave his important post. In fact, there is no record of Louis's travel outside of Flanders and England; to the contrary, his commission coincides with, and perhaps even celebrates, his appointment by Philip in 1463 to the post of governor general, with 300 Flemish pounds for his yearly expenses.[35] This allowance could certainly have covered the production of the Getty *Gillion*, which was one of his first original commissions; it is estimated that 3 Flemish pounds was a normal payment per miniature at that time.[36] The dedicatory prologue in fact stresses this recent appointment

in the list of Louis's titles that begins, "monseigneur Louis, lord of Gruuthuse, prince of Steenhuyse, lord of Avelgem, of Espierre, of Oostkamp, of Tielt and of Berchem, etc.," and ends, "and by the command of my most feared lord Philip, by the grace of God Duke of Burgundy and Brabant, etc., governor general of his lands of Holland, Zeeland, and Frisia" (Getty, fol. 8). Since only ten nobles had signed up to leave on the 1464 Crusade,[37] Louis's commission was perhaps meant to stir other knights to action through Gillion's story, which was intended to be read aloud to them. The dedicatory prologue is explicit in describing Louis's conviction "that among princes and especially before those of young age, in order to direct their hearts and acts to valiance and virtuous deeds in everything, [the story] had to be read, very diligently heard and learned" (Getty, fol. 8). The prologue thus demonstrates Louis's sincere support of the duke's Crusade as much as it highlights his important position.

Indeed, one more argument favors Louis's lavish commission as a celebration of his appointment as governor general. The prologue that identifies Louis as the patron is unique among his other significant commissions. Nothing resembling the Getty manuscript's dedicatory prologue on fols. 8–8v appears in his first two commissions, the *Mirror of History* [*Miroir historial*] (Paris, BnF, Mss. fr. 308–11, ca. 1455), a translation of Vincent de Beauvais, and the *Moralized Bible* [*Bible moralisée*] (Paris, BnF, Ms. fr. 897, ca. 1455–60), both of which have extensive picture programs, although the manuscript of the *Mirror of History* had been mostly written out when Louis commissioned the images and thus may not count as his commission.[38] Neither does any such prologue appear in his expensive commissions from the early 1470s of Raoul Lefèvre's *History of Jason* [*Histoire de Jason*] (Paris, BnF, Ms. fr. 331, after 1472),[39] Lefèvre's *Collected Histories of Troy* [*Recueil des histoires de Troie*] (Paris, BnF, Ms. fr. 59, ca. 1470), Pseudo-Aristotle's *Secret of Secrets* [*Secret des Secrets*] (Paris, BnF, Ms. fr. 562, ca. 1470–75), Jean Froissart's *Chronicles* [*Chroniques*] (Paris, BnF, Mss. fr. 2643–46, ca. 1470–75), a translation of Valerius Maximus's *Memorable Deeds and Sayings* [*Faits et dits mémorables*] (Paris, BnF, Mss. fr. 288–89, ca. 1470–80), nor in Jean de Wavrin's *Chronicles of England* [*Chroniques d'Angleterre*] (Paris, BnF, Mss. fr. 74–85, after 1471–before 1490), exceptional since it is the sole extant complete manuscript of the work.[40] Two other commissions by Louis shed additional light on the exceptionalism of the Getty *Gillion*'s dedicatory prologue. In 1472, Louis received the title of Earl of Winchester from Edward IV of England. The scribe of Jean de Courcy's *La Bouquechardière* (Paris, BnF, Mss. fr. 65–66), dates the manuscript to 1473 and lists Louis's titles of "earl of Winchester, lord of Gruuthuse, prince of Steenhuyse" but only at the end of the author's prologue, without a separate dedicatory prologue (fol. 5). Louis also commissioned *Pénitance d'Adam* [*Penitence of Adam*] (Paris, BnF, Ms. fr. 1837, ca. 1473–84), a translation from Latin into French by Colard Mansion who calls Louis "my lord of Gruuthuse, earl of Winchester" (fol. 1). This was a new translation, Louis's original literary commission that he chose to mark specifically with the title of earl. It has only one illumination by the Bruges Master of 1482 whose work is usually dated to the decade of 1480. Louis is portrayed with Mansion and another smaller figure behind them, whose height and seeming youthfulness indicate that it is probably Louis's son, Jean, depicted as a teenager (ca. 1458–1512). The inclusion of Louis's teenage son would likely have occurred prior to Jean's marriage in 1478, making it more likely that this new commission celebrates Louis's title in the period between 1472–77.[41]

Indeed, it seems that Louis's dedicatory prologue in the Getty *Gillion* manuscript is modeled on Anthony's; both list the patron's extensive titles and extol his virtues.[42] Anthony and Louis both made Crusade vows in 1454; at the time they each commissioned their copy

of *Gillion*, their vows were still binding and not yet carried out. When Anthony commissioned his manuscript, he was months away from being named the Crusade commander; when Louis commissioned his, he could have been fairly certain that his services would be required at home and not away from it. Yet his commission could serve as proof that, despite his inability to depart, his vow was deeply lodged in his heart. The duke's Crusade was a great cultural discourse that needed extra scaffolding, and both Anthony and Louis built it in different ways with their copies of the *Gillion* manuscript.

It would not be an exaggeration to say that Louis's projection onto *Gillion* stands out even though he is thought to have been impressively generous in marking his manuscripts with his coat of arms, devices (the firing *bombard*, or short cannon), and mottoes.[43] Still, in the Getty *Gillion*, he inserts himself with his *bombard* and a lion wearing his helm into the margins of the miniature that is a starting point in Gillion's twenty-four-year-long sojourn in the East (plate 13). The presence of the lion representing Louis may even be enhanced by a play on Gillion's name, "Gil-lion." This miniature, the third extant in the Getty manuscript, shows the knight's liberation of the sultan and his first bloody victory, dressed in the sultan's armor, over the Saracens. Certainly, Louis was more interested in an illuminated *Gillion* than he was in the more historical and didactic *Book of Heraclius* [*Livre d'Eracles*] (Paris, BnF, Ms. fr. 68), a French translation and continuation of William of Tyre's twelfth-century chronicle, *History of Deeds Done beyond the Sea* [*Historia rerum in partibus transmarinis gestarum*], which he commissioned after 1472 and before 1480. *Heraclius* was a much cheaper and more rapidly produced copy, with mostly generic scenes and traditional subjects.[44] But the *Romance of Gillion de Trazegnies* "is the most elaborate eastern-focused illumination cycle in his library."[45] As in Anthony's case, *Gillion* afforded greater room for self-fashioning than a more straightforward history from the past glory days of the First Crusade. Could Louis have wished, on the one hand, to support the duke's project with the patronage of a virtual Crusade and, on the other, to highlight his patronage that had been made possible by his recent appointment as governor general? Patronage buttressed the duke's political actions and the overall Crusade culture, and at the same time, rich and expensive manuscripts acted as individual status symbols, denoting a noble's initiation into the most select group. Such an interpretation of markers of social ascension rings especially true since Anthony's *Gillion* is the first commission in his collection, and Louis's *Gillion* is probably only his third commission and the first (and one of the few) that displays originality. Their liberal marks of ownership and patronage in many colophons of their manuscripts make sense, considering there are few surviving examples of colophons that explicitly name the patron who commissioned both the transcription and the illustration.[46]

Louis of Gruuthuse's manuscript is dated in the dedicatory prologue. In other words, the date appears at the manuscript's inception, unlike Anthony's, which is dated and signed by the scribe David Aubert at its completion, on the last folio. It is possible that the table of contents and prologue were added after the completion of the rest of the manuscript, but regardless, the prologue states that the manuscript was copied and illuminated in 1464: "Monseigneur Louis commissioned me to copy [*grosser*], following word for word the true and very old original, this present volume in the form and manner that follow and then, as you can see, he had it entirely illuminated and its layout planned [*l'a fait decorer et ordonner*], in the year of the incarnation of Our Lord Jesus Christ, 1464" (Getty, fol. 8v).[47] The prologue thus indicates that the production of the manuscript may have begun during the preparations for the Crusade, while the duke and his entourage were in Bruges (from November 16,

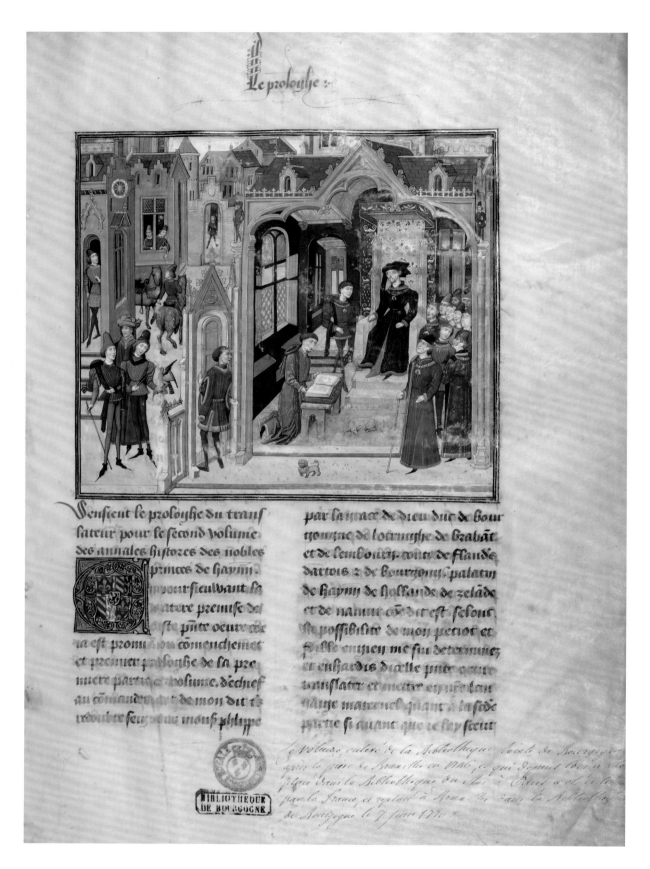

FIGURE 8

Willem Vrelant, *Duke Philip the Good Listening to a Text Read Aloud*, from *Chronicles of Hainaut*, 1449. Brussels, KBR, Ms. 9243, fol. 1

1463, through February 18, 1464, and for two weeks in May 1464, at the time of the fleet's departure from Sluis).[48] Aubert, Philip's clerk and scribe, who copied Anthony's manuscript and likely Louis's (see below), would have been in Bruges at these times, because he accompanied the duke's peripatetic court.[49]

Moreover, the convergence of itineraries and activities would explain an interesting detail in the dedicatory prologue. Anthony's says that the origin of his commission was "in having heard the reading of deeds and adventures of a valiant knight of Hainaut, called Gillion de Trazegnies and his two sons Jean and Gerard" (Dülmen, p. 125). We know that communal reading was common for both Dukes Philip and Charles: the frontispiece to the second volume of the *Chronicles of Hainaut* [*Chroniques de Hainaut*] (Brussels, KBR, Ms. 9243, 1449) (fig. 8), the first history that Philip is known to have commissioned himself, shows just such a scene of public reading at the court, and the prologue to the *Abridged Chronicles of Emperors* [*Chroniques abrégées des empereurs*], copied by Aubert, describes Philip as "having been accustomed for a long time to have ancient histories read for him daily" (Paris, Bibliothèque de l'Arsenal, Ms. 5089, 1462, fol. Q).[50] But Louis's commission originated in his "having seen this present history" (Getty, fol. 8). Given the similarities in the compositions of the image cycle between the Dülmen and Getty manuscripts, which Morrison explores in her essay, is it possible that Louis saw Anthony's copy in Bruges in 1463, made and coordinated by the duke's scribe Aubert? Louis could have seen it in Aubert's atelier during the duke's two sojourns in Bruges (February 23–July 5, 1463, and November 16, 1463–February 18, 1464), during which the preparations for the departure of the Crusade were completed.[51] The dedicatory prologue emphasizes, unusually strongly, the degree to which Louis was implicated in the commission of the copy and illumination. That manuscripts were disseminated within networks of nobility and friendship would further validate the idea that noble networks of patronage encouraged communal readings as much as communal viewings.[52]

Gillion de Trazegnies in the Courtiers' Libraries

Wavrin, Anthony, Louis, and Philippe each owned a copy of the *Gillion* romance. Philippe de Clèves seems to have made only four original commissions out of 152 known titles in his library.[53] As his collection was constituted mainly through inheritance and acquisitions and after Philip the Good's death, the place of the *Romance of Gillion de Trazegnies* in it does not bear upon our consideration of political life and bibliophilia in the period covering the duke's Crusading projects. This is not the case for the other three patrons: while *Gillion* in Wavrin's library adds to its overall cohesion, its presence in Anthony's and Louis's libraries is more surprising.

Wavrin, who was retired from military service by 1437, had never become a knight of the Order of the Golden Fleece, nor had he taken the cross. But his nephew, Waleran de Wavrin, was in charge of the duke's naval expeditions in the Mediterranean from 1444 to 1446 and served as counselor for the 1464 Crusade. More important, Jean de Wavrin was on the 1463 embassy to the pope in Rome during Philip's preparations for the 1464 Crusade. In this context, the focus of Wavrin's collection is remarkable: among the known thirty-two manuscripts (eight of which are probable attributions), sixteen are romances of chivalry in fifteen volumes.[54] Moreover, all the romances in Wavrin's collection transport the reader to the Mediterranean basin, especially the lands menaced by Muslims (Spain, Greece, and the Holy Land). Represented are local chivalric heroes tied to the regions of Flanders, Artois, and Hainaut (*Gillion de Trazegnies, Gilles de Chin, Chatelain of Coucy, Count of Artois, The*

Lords of Gavre, and Antoine de la Sale's *Jean de Saintré*), chivalric heroes of Greek, Roman, or Trojan antiquity (Raoul Lefèvre's *History of Jason*, *Romance of Thebes*, *History of Troy*, *Apollonius of Tyre*, *Romance of Florent and Octavian*, and *Romuleon*), and chivalric heroes fighting or living among Muslims (Philippe Camus's *History of Olivier de Castille and Arthus d'Algarbe* and *Paris and Vienne*). Although they do not bear the usual marks of ownership, such as armorial or ex libris, this list includes two romances of local chivalric heroes, *Gérard de Nevers* and *Jean d'Avesnes*, because they were illustrated by the Master of Wavrin, Wavrin's favorite illuminator.[55] The Mediterranean focus of Wavrin's library is emphasized by one additional manuscript made in 1459–60 containing three titles on Crusading politics and strategy by William of Adam, Bertrandon de la Broquière, and Giovanni Torzelo.[56] Wavrin's interest in the lands ruled by Muslims that serve as privileged theaters for chivalric action seems clear. The *Romance of Gillion de Trazegnies* does not stand out in Wavrin's library; indeed, its presence is reinforced by the coherence of the entire collection.

Forty out of forty-four surviving titles in Anthony's library were didactic works or chronicles. *Gillion* was one of only two works of literary nature; the other was Christine de Pizan's *Letter of Othea to Hector* [*Epistre d'Othea*]. Thirty manuscripts were contemporary illuminated copies. Anthony began his manuscript patronage with the *Gillion* romance, and *Gillion* was also only one of three manuscripts whose incipit explicitly mentions Anthony's commission.[57]

The *Gillion* romance seems to fit uncomfortably into Louis's library as well. It was probably only Louis's third important commission. His commission in 1464 makes sense in the context of Philip's Crusade that year and was likely propelled by his eagerness to show support for it as well as to acknowledge his recent appointment as governor general of Holland, Zeeland, and Frisia (1463) and his recent induction into the Order of the Golden Fleece (1461). Louis's original commissions peaked between 1470 and 1490, but by then *Gillion* appears to be a jarring example of an overly enthusiastic courtier who, in the face of political realities, abandoned the pursuit of similar works. The *Book of Heraclius* and the *Chronicle of Baudouin d'Avesnes* [*Chronique dite de Baudouin d'Avesnes*] (Paris, BnF, Ms. fr. 279, ca. 1470) are the only other Crusade-themed works in Louis's collection, and the addition of a history, *The Siege of Rhodes by the Turks* [*Le Siège de Rhodes par les Turcs*] (Paris, BnF, Ms. fr. 5646, after 1482), was in response to the unsuccessful Turkish siege of Rhodes in 1480.[58] While *Gillion* was likely lavishly illuminated in 1464,[59] neither the *Book of Heraclius* nor *Baudouin d'Avesnes* was a major investment when they were made after 1470. It would seem that Louis sought to imitate the Crusading intentions of his sovereign but that after the failure of Philip's Crusade in 1464, and especially after the duke's death in 1467, his commitment to a real Crusade and interest in the East faded.[60] He nevertheless continued to cultivate his image of ducal courtier and commissioned literature produced for and read by the members of the Order of the Golden Fleece (Statutes of the Order, Lefèvre's *History of Jason* and *Collected Histories of Troy*, Guillaume Fillastre's *History of the Golden Fleece* [*Histoire de la Toison d'or*], two copies of Jacques de Longuyon's *Vows of the Peacock* [*Vœux du paon*], and Christine de Pizan's *Letter of Othea*). In comparison with Wavrin's library, which teemed with chivalric biographies of local pseudohistorical heroes, *Gillion* is unusual in Louis's library, as he did not commission any other chivalric pseudohistories. Likewise, because it is the only romance of a regional hero in the East, *Gillion* stands apart from the romances of the Arthurian world found in Louis's library: *Tristan and Isolde*, *Lancelot of the Lake* [*Lancelot du Lac*], *Perceforest*, *History of the Holy Grail* [*Histoire du saint Graal*], *Merlin*, and *Artus de Bretagne*.

It would be too hasty to conclude, however, that Louis was not interested in the East. To do so would be to ignore geography and follow our modern—and anachronistic—notions of genre. In terms of geography, Louis's collection is divided: texts focused on the European Northwest and texts situated in the Mediterranean and the East. *Gillion* falls in with several other romances, including an *Alexander* romance, as well as the stories of Jason and Troy (Raoul Lefèvre; Guillaume Fillastre; Christine de Pizan), the travels of Mandeville and Marco Polo (two copies), and the few histories mentioned above. The stories of Jason and the Golden Fleece link the East and antiquity into one. If Jason is the founding figure associated with the chivalric Order of the Golden Fleece, whose task is also the defense of the Christian faith, then stories of antiquity set the stage for the contemporary Muslim East where Christian holy sites are occupied.

There is one notable gap that must be addressed. Aubert, the duke's scribe, claimed in the 1462 dedicatory prologue to the *Abridged Chronicles of Emperors* that Philip was "without any reservation the Christian prince who is the best purveyed with an original and sumptuous library" (fol. Qv). And yet, as far as we know, the *Romance of Gillion de Trazegnies* was copied only for the members of the duke's entourage despite being dedicated to Duke Philip the Good: "I am certain that the story will greatly please you, my most high, most excellent, and most powerful prince Philip, by the grace of God, Duke of Burgundy" (fol. 10/p. 127). This lacuna in Philip's library is less surprising when we consider the duke's predilection for histories that he himself commissioned, especially regional histories in the second half of the reign,[61] and that literary works were instead offered to him by his entourage.[62] For example, *Gérard de Nevers*, *Florimont*, *Jean d'Avesnes*, and *Apollonius of Tyre* in his library were likely gifts from Jean de Wavrin.[63] The *Chronicles and Conquests of Charlemagne* [*Croniques et conquestes de Charlemagne*] (Brussels, KBR, Ms. 9066, 1458–60) were originally commissioned by Jean V de Créquy, then continued by Philip. While the duke was very active in commissioning prose versions or translations of histories and epics (e.g., Jean Wauquelin's *Chronicles of Hainaut* or Wauquelin's *Girart de Roussillon*), prosification of romances (prose versions of earlier verse compositions) seems to have been a pastime of Burgundian high nobility. A copy of *Gillion* nevertheless did end up as part of the heritage of the duke's library: Wavrin's unilluminated text was acquired in a lot of seventy-eight volumes between 1516 and 1523–24 by Margaret of Austria from a descendant of Wavrin and is housed today at the Bibliothèque royale de Belgique (Brussels, KBR, Ms. 9629) with the bulk of Philip's manuscripts.[64]

Who Wrote the *Gillion* Romance?

We do not know who created the original Middle French short version of *Gillion de Trazegnies* about 1453–60 (for dating, see Introduction). Scholars have speculated that the author might be Jean de Wavrin, Philip's chamberlain and counselor, or Guillebert de Lannoy (1386–1462), knight of the Order of the Golden Fleece and Philip's chamberlain and ambassador.[65] While many romances were copied for Wavrin or commissioned by him as gifts in the same workshop and illuminated by the same artist, the Master of Wavrin, there is little evidence for Wavrin's original literary activity other than that of his *Chronicles of England*.[66] His military activity, nevertheless, sheds light on his literary interest in the chivalric feats of regional knights fighting in the Mediterranean, the main focus of his library. Guillebert de Lannoy is well known as the author of a report on his travels to Syria and Egypt in 1421–23 as English King Henry V's and Duke Philip's spy, *Travel Reports on Several Cities, Ports, and Rivers in Egypt and Syria* [*Rapports sur les voyages de plusieurs villes, ports et rivières tant en*

Egypte comme en Surie] (1423).[67] Another work, *Education of a Young Prince* [*Instruction d'un jeune prince*] (1436–39), is attributed to him, based on the frontispiece in which the author presenting the work to Philip the Good is wearing the collar of the Order of the Golden Fleece (or attributed to his brother Hugues, also a knight of the order).[68]

The text of the *Education of a Young Prince* starts with a scene similar to *Gillion*'s prologue. A knight stranded in Norway on his way home to Picardy from Prussia is shown a manuscript that his clerk found in a crack in the wall of a priory. The clerk, "who knew well the language of the land," "said to his master that he had found a fragment of a chronicle." The knight commands the clerk to translate it from German to French. In the prologue, Lannoy thus portrays himself not as the author or translator of the discovered "fragment of a chronicle" but as a knight who commissions its translation from "a parchment quire written in poor and faded writing."[69] This situation differs from the opening of *Gillion*, in which the author is not a third person at the command of a knight but speaking in the first person and taking full credit for his agency: "Since I was passing by a rather ancient abbey called Olive, where I saw three high raised tombs, I inquired at the abbey and sought out the names of the dead who lay buried in them. . . . I was glad to work on translating the content of the said little book into our French language" (fols. 9v–10/pp. 126–27). Van Lathem painted the author in the scholar's robe in the upper right corner (plate 1). It is interesting that the earlier Dülmen manuscript shows the author, in the first frame of the first miniature (see fig. 5), wearing a short blue *cotte* with the sword of a knight, but in the next frame, below, he is clothed in the same clerk's gown as in the Getty manuscript and writing in his scriptorium. His authorial agency and presence are further figured in the third frame of Dülmen's first miniature as he witnesses Gillion's and Marie's marriage. This kind of transposition of the same figure creates continuity in the Dülmen image, even though it unfolds over a three-frame sequence; the change of clothing from the first to the second frame, from knight to clerk, is suggestive of the author's connection to knighthood.

Two other knights are possible candidates for the original commission of the short version of the *Gillion* romance. The commission could be linked to the Trazegnies family, whose head, Arnould de Hamal, had bitterly fought Philip the Good's policy of unification of the Low Countries under Burgundian rule.[70] Upon Arnould de Hamal's death in 1456, the Trazegnies title passed to his son Anselm II via the maternal line; Anselm's mother was Anne de Trazegnies. The new lord of Trazegnies could have wished to see a romance rehabilitating the lords of Trazegnies in the Burgundian court as the glorious and loyal servants of the Counts of Hainaut and Dukes of Burgundy.[71] While this speculation seems persuasive, there is no evidence presently available linking the Trazegnies to the patronage of texts and manuscripts. But there is instead another knight who can be associated with the writing of *Gillion de Trazegnies* and who had a long history of patronage: Jean V (ca. 1395/1400–1472), lord of Créquy in Artois and Canaples in Picardy, chamberlain to Philip the Good since 1426, his military commander and ambassador, and knight of the Order of the Golden Fleece, inducted at the order's foundation in 1430. Jean de Créquy was a famous jouster, successfully participating in many tournaments with his nephew, Jacques de Lalaing. His pronounced love of literature was evident in a joust against the bastard of Béarn in Bruges in 1445, when his horse wore the arms of Lancelot of the Lake. He is named as the narrator of tale 14 of the *One Hundred Merrie and Delightsome Stories* [*Les cents nouvelles nouvelles*]. He went on a pilgrimage to the Holy Land in 1448–49, and at the Feast of the Pheasant, when he took the cross, he read the script appealing for a "holy voyage."[72]

There are many reasons to believe that Jean de Créquy may have been responsible for the original commission of the *Romance of Gillion de Trazegnies*, probably in honor of Philip. Créquy was not only a political counselor to Philip but also his literary adviser. His influence on Philip's library was considerable. The *Chronicles and Conquests of Charlemagne* was an original commission made by Jean before 1458. Volume 1 was made under his patronage and was perhaps from the outset copied by Aubert, by "the strict bidding of my most feared lord, monseigneur de Crequy."[73] Volumes 2 and 3 were commissioned directly by Philip and completed in 1458 by Aubert.[74] The story of Jason, the hero of the Order of the Golden Fleece, forms a second connection from Créquy to Philip. The *History of Jason* was written around 1460 by Raoul Lefèvre, who was most likely Créquy's chaplain. Another of Créquy's scribes, Isidore du Ny, is thought to have copied Jean Mansel's *Flower of Histories* [*Fleurs des histoires*] for Philip,[75] and Créquy's copy of the *Flower of Histories* is actually mentioned in the prologue to the *Chronicles and Conquests of Charlemagne*.[76] Finally, Philip's copies of *Renaut de Montauban* seem to be based on Créquy's. It is noteworthy that Créquy's Fressin castle was only three miles from the duke's castle of Hesdin.[77]

The prologue of the *Chronicles and Conquests of Charlemagne* states that Créquy was an avid reader and patron: "Naturally he is inclined to see, study, and own books and chronicles on a variety of subjects; and . . . he saw many new ones appear in several locations and he has prodigally commissioned the writing of others."[78] He was, with Wavrin, one of the first to have a library of at least twenty-four volumes with a clear focus on historical and literary texts,[79] and he actively commissioned translations and prosifications. In addition to the *Chronicles and Conquests of Charlemagne*, he commissioned the prose versions of at least four, if not five, romances previously composed in verse (*Romance of Florent and Octavian*, *Blancandin and the Lady-Proud-in-Love* [*Blancandin et l'Orgueilleuse d'amour*], *Bevis of Hampton* [*Beuve de Hantone*], *Gilles de Chin*, and, less likely, the *History of the Three Sons of Kings* [*Histoire des trois fils de rois*]) and a prose version of the epic *Renaut de Montauban*.[80] He owned a *Book of Heraclius*, with a very original illumination cycle,[81] a two-volume *Old Pilgrim's Dream* [*Songe du Vieil Pelerin*] by Philippe de Mézières, and Wauquelin's three-volume *Chronicles of Hainaut*.[82] In 1451, he acted as intermediary for Martin le Franc's *Champion of Women* [*Champion des dames*] and was patron to Vasco de Lucena, translator of Quintus-Curtius's *History of Alexander* [*Histoire d'Alexandre*] for Charles the Bold.[83]

The romances Créquy commissioned were, like *Gillion*, situated in the Mediterranean basin. *Gilles de Chin* was prosified for Créquy, as its two prologues reveal: "I wanted to modify from rhyme to prose this present treatise" "at the request and entreaty of the noble and powerful lord, monseigneur Jean, lord of Créquy and Canaples."[84] Jean de Wavrin also owned a copy of *Gilles de Chin*, but its prologue omits any mention of the original Créquy commission. The author declares only, "I wanted to prosify, change from verse into prose, this present treatise."[85] It seems that *Gilles de Chin* was originally made for Créquy, then lent to Wavrin for the production of his copy. But Wavrin likely never returned it to Créquy, and Créquy's copy in Wavrin's collection later came into Margaret of Austria's library, according to its 1523 inventory.[86] The fact that all mention of Créquy's commission was erased in Wavrin's copy is crucial. Jean de Créquy was always careful to include a dedication to Philip;[87] he did so in the prologue to the *Chronicles and Conquests of Charlemagne* and the *History of Jason*. The author's prologue in *Gillion* dedicates the romance to Philip, although we are missing the identity of the original patron who commissioned the short version. Could Créquy have commissioned a copy of *Gillion* but the record of his original commission was erased and

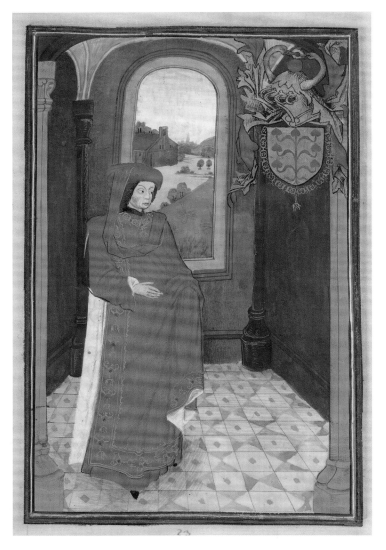

FIGURE 9

Jean de Créquy, from *Statutes,
Ordonnances, and Armorial of the
Order of the Golden Fleece*, ca. 1473–91.
The Hague, KB, Ms. 76 E 10, fol. 50

replaced with prologues to Anthony and Louis? Given the close relationship of the two romances—Gillion is said to be Gilles's godfather—could *Gillion de Trazegnies* have gone through the same process as *Gilles de Chin*? In other words, Créquy could have commissioned the romance and dedicated it to Philip, the romance's dedicatory prologue could have been suppressed in later copies, as was the case in the copy of *Gilles de Chin* for Wavrin, and then Anthony and Louis, proud owners of their all but first illuminated books, added their own marks of patronage and ownership.

There is an even more convincing argument for Créquy's patronage of *Gillion*: the interweaving story of the ring with a ruby that ties different parts of the romance together. In order to fulfill his vow to God—that he would leave on a pilgrimage to Jerusalem at the first sure sign of Marie's pregnancy—Gillion refuses to postpone his departure until after the birth of his child, despite fervent pleas from his bereft and pregnant wife and from Baldwin, the Count of Hainaut. As Gillion gets ready with his retinue, his wife asks for a token of remembrance, "a golden ring that he wore on his finger and in which was encased a very large ruby. 'By my faith, lady, I grant you this request and would have granted an even greater one had you asked so that you remember to pray to God that I can return well soon from overseas'" (fol. 18v/pp. 135–36; plate 7). At the age of seventeen, just after Jean and Gerard win their first major tournament, Jean has a vision of his father. The brothers make a pact never to return to Hainaut before learning with certainty their father's fate; they will wear their "coat of arms and emblems whereby he will be able to recognize us and we him, as it may please God" (fol. 93v/p. 215). In anguish at the prospect of losing her sons after having lost her husband, Marie gives Jean the ring as a token of good luck (fol. 94/p. 215; plate 25). The ring makes one final appearance in the recognition scene between Gillion and his sons, when it fulfills its role as the incontrovertible proof of filiation: "And, lord, so that you lend more faith to what is said, at our separation from her, she handed me a golden ring that you had given her when you left from Trazegnies. Here it is!" (fol. 188/p. 318). In this way, the ring with a ruby ties together the plot of the romance and the generations of a family: from a token of remembrance it becomes a sure sign of recognition between father and sons.

The Créquy armorial consists of a helm, topped by a ring with a large ruby (figs. 9, 10). The crest is elaborated with two swans, whose necks grow out of the helm to hold, each from one side, the ring in their beaks. From the lower portion of the helm hangs the collar of the Order of the Golden Fleece. It surrounds the blazon with the wild plum tree (*créquier*), symbol of the Créquy family (fig. 11). The swan was a sought-after chivalric badge and the heraldic symbol of the Counts of Boulogne. According to legend, Eustace of Boulogne married the daughter of the Swan Knight. A child born from that union, the Crusader and the

86

FIGURE 10

Jean de Créquy, from *Grand Equestrian Armorial of the Golden Fleece*, 1430–61. Paris, Bibliothèque de l'Arsenal, Ms. 4790, fol. 155

FIGURE 11

Créquy Master, *Armorial Escutcheon of Jean de Créquy*, from *Book of Heraclius*, ca. 1440–45. Amiens, Bibliothèque municipale, Ms. 483, fol. 1 (detail)

supreme hero of the First Crusade, Godfrey of Bouillon, was the Swan Knight's grandson.[88] Evidence from family seals indicates that the representation of one swan in 1375 developed into two swans between 1392 and 1412.[89] Although two swans were rarer than one as references to the Swan Knight, they were also sported by the Dukes of Clèves. But it was the ruby ring that inspired a late narrative of a family story, the *Romance of the Sire of Créquy* [*La Romance du Sire de Créqui*], first published in 1782 and attributed to Baculard d'Arnaud (1718–1805). The romance is written in 107 decidedly unmedieval quatrains and in a distinctly fake Gothic language, in a fashion popular in the eighteenth and early nineteenth centuries. It anachronistically situates the action in France[90] as it tells the story of the Créquy family ancestor, Raoul de Créquy, who, before his departure on the Second Crusade, broke in two a ring with a ruby and gave one half to his wife so she could recognize him on his return. The French king and his own brother Baldwin believe that Raoul died in the Battle of Mount Cadmus, and Baldwin urges his widowed wife, Mahaut, to remarry. After many adventures, including captivity among Turks, Raoul returns on the day of her wedding. No one recognizes him, but he produces his half of the ring, while the two swans fish out Mahaut's lost half from the pond:

> *Two swans under the bridge were playing on the water*
> *And with their beaks retrieved the half of the ring*
> *That gleamed with a ruby; the Lady having seen it*
> *Exclaimed: this is the lost half of my ring.*[91]

The two parts join seamlessly. This is a belated and, in all likelihood, retrospective eighteenth-century interpretation of the Créquy armorial. It is interesting that the family legend presents analogies with the Gillion story. Whereas Gillion has two wives, Mahaut almost has two husbands; Raoul left before the birth of his son, like Gillion; the ring with a ruby broken in two reunites husband and wife, just like the ring with a ruby brings Gillion back home to his first wife. Still, we should take as evidence of Créquy's patronage not this belated family fiction but the fact that the armorial and the *Gillion* romance prominently display the ring with a large ruby.

Jean de Créquy had an interest in the Crusades and in the East. He commissioned the romances *Gilles de Chin*, *Blancandin*, and *Bevis of Hampton*. He also owned Jean d'Arras's romance *Melusine*, the medieval family legend of the Lusignan rulers of Cyprus; the historical *Book of Heraclius* with a very original illumination cycle; Mézières's two-volume allegorical treatise *Old Pilgrim's Dream*; and Hayton's Crusade treatise *Flower of Histories of the East* [*Fleur des histoires d'Orient*]. Créquy also went on a pilgrimage to the Holy Land in 1448–49. But the strongest connection with the East is not personal to Jean de Créquy only but also to the Créquy family, in the figure of Jacques de Heilly de Créquy, the knight who saved the Count of Nevers, the future Duke of Burgundy John the Fearless, at Nicopolis in 1396. Thanks to his knowledge of Turkish, Jacques secured John's liberation when he negotiated the nobles' ransom between Sultan Bajazet and Duke Philip the Bold. As we will see, Gillion plays a similar role in the East.

Jacques de Heilly was from a cadet branch of the Créquy family. He died without offspring in 1415, at Agincourt, imprisoned and then massacred by the English; he was the last descendant of the cadet branch started by his great-grandfather Philip. Jean V's great-great-grandfather, Jean I, and Jacques's great-grandfather Philip were brothers.[92] Jacques's role in rescuing the young Count John of Nevers was spectacular and memorable. It must be remembered in this context that Philip the Good's Crusading predilection was likely due not only to the general circumstances of the Turkish threat to Constantinople but also to the memory of his father's traumatic defeat and narrow escape from death. Likewise, Jacques's role could have been remembered in the Créquy family for his bravery and loyalty to the Duke of Burgundy. In fact, Jacques was named chamberlain to the then-Duke of Burgundy, Philip the Bold, soon after his mission was accomplished.

The late fourteenth century is rich with examples of Christian knights who traveled to Muslim courts to test their chivalry and acquire glory and riches. Perhaps the most famous is Boucicaut (1366–1425?), marshal of France. Boucicaut was, together with Philip of Artois, Count of Eu and constable of France, the main military commander of the Franco-Burgundian Crusade led by Count John of Nevers. Captured at Nicopolis, Boucicaut was saved only by the Count of Nevers's intervention.[93] In his youth, Boucicaut had spent three months at the court of Sultan Bajazet's father, Murad I: "They offered him their services in case he went to war against some Saracens."[94] Jacques de Heilly, from a cadet branch, followed a similar trajectory in search of glory. He served for more than three years as a mercenary in Murad's army and learned to speak Turkish: "He remained and lived in Turkey with them and served Murad... for more than three years."[95] His acquaintance among the Ottomans was so extensive that, after the battle, he "had such good fortune on his side that he was recognized by the men and guards of Murad's body and household."[96] And while he was familiar to the Turks, Jean Froissart, the main chronicler of the events of the Hundred Years' War, highlights Jacques's foreignness at home among the French, who at first do not recognize him on his

return from Nicopolis because "he had frequented and haunted the far-away lands overseas much more than the nearby lands of his origins."[97]

The *Romance of Gillion de Trazegnies* raises the issue of Christian knights fighting as mercenaries for Muslims. The knight Amaury, a vassal of the Count of Hainaut whom the count sends overseas on a search for Gillion fourteen years after his disappearance (fol. 58v/p. 183), learns that "the sultan kept mercenaries regardless of their religion" (fol. 67/p. 191; also fol. 66v/p. 190). Mercenaries were paid soldiers not naturally in service of that lord. When he hires Amaury as a mercenary, the sultan assigns him under Gillion's command, "with a Christian knight" (fol. 67v/p. 191). Does this immediate association on the sultan's part make Gillion a mercenary? His case is more ambiguous, because he was the sultan's prisoner before being liberated on his word not to escape without the sultan's leave (fol. 47v/p. 172). His successful command of the sultan's army did not earn him the freedom to return to Hainaut. However, after Amaury brings the (false) news of Marie's death, Gillion thinks himself a free man, no longer under the obligation to attempt to return to Hainaut. He decides to settle in Egypt, in the sultan's service: "My true God, I recognize and see well enough that it will not come to me to cross the sea and return to Hainaut. But since it is so…and if it please the beautiful Gracienne, I am decided to take her as wife according to the religion of Jesus Christ, not otherwise, in case that the sultan, her father, grants her to me willingly" (fol. 102/p. 222; also fol. 95/p. 216). His knowledge of Arabic, his marriage to Gracienne, by which he becomes the sultan's heir, and the rich gifts and payment he receives later confirm that Gillion's character was at least partially based on the model of Western mercenaries like Boucicaut and Jacques de Heilly, who could achieve the goals of killing Christ's enemies in a very individualized and personalized form of a Crusade. Indeed, Gillion's mercenary status is justified by the logic of killing Saracens: "I can honorably save my soul overseas by putting pagans and Saracens to death, just as I could do likewise through worthy and salutary acts, if I were in my lands" (fol. 159v/p. 286; also fol. 202/p. 339). Even though the romance repeatedly insists that Gillion keeps his Christian faith, we know from historical documents that only a converted mercenary, a renegade, would have deserved the welcome that the sultan reserves for Gillion when he returns to Cairo: "From all sides kings and emirs and the whole army assembled there came to bow to him in obeisance" (fol. 213/p. 350).

These three elements—Créquy's patronage interests, the Créquy armorial, and the history of Jacques de Heilly de Créquy—all point to Jean de Créquy's possible original commission of the short version of the *Gillion* romance. And while it is unlikely that the name of the romance's original author will ever be known, we can speculate about the identity of the scribe who copied the long versions of the Dülmen and Getty manuscripts. The Dülmen colophon dates the completion of the manuscript to 1463, followed by the scribe's signature, "*David Aubert, manu propria*" (Dülmen, p. 373). Ducal archives name Aubert as "receiver of the domain and taxes of Pontieu in 1453" (*receveur du domaine et des aides de Ponthieu en 1453*), the duke's "scribe [*escrivain*] in 1463," and "secretary" (*clerc*) in the 1467–69 inventory made in Lille after the duke's death.[98] Aubert names himself in 1459 as the duke's "secretary" in the *Norman Chronicles* [*Chroniques normandes*], as "scribe" in *Perceforest*, and again as "secretary" in his version of Philippe Camus's *History of Olivier de Castille*, copied before 1467.[99] As ducal secretary, Aubert accompanied the duke's peripatetic court; his frequent change of location explains the different town names that appear in the copies Aubert produced between 1462 and 1465: Hesdin, Brussels, and Bruges.[100] As we saw, the duke spent the last two months of 1463 and the first two months of 1464 in Bruges,

Louis's principal residence. Since it is dated at the beginning, the Getty manuscript was begun in 1464, after Anthony's copy was produced. But the Getty copy is not signed by Aubert. Anthony and Louis both used Aubert's services: he copied Froissart's *Chronicles* (Berlin, Staatsbibliothek, SPK, Ms. Dep. Breslau 1, vols. 1–4, ca. 1468–69) for Anthony, and Lefèvre's *History of Jason* (Paris, BnF, Ms. fr. 331, after 1472) and Pseudo-Aristotle's *Secret of Secrets* (Paris, BnF, Ms. fr. 562, ca. 1470–75) for Louis. The Getty manuscript does bear a strong resemblance to the scribal hand of the Dülmen manuscript; however, the script known as *bastarda* had become common by that time, and the elegant style of Aubert was particularly sought after and emulated. Between manuscripts signed by Aubert and those attributed to him with a fair degree of certainty, he would have copied six manuscripts in 1463 and 1464. One possible explanation for this elevated volume of production is that he supervised the copying of more manuscripts than he could have written himself; if that is so, Louis's manuscript could be a seventh copied in 1463–64 by Aubert and his collaborators.[101] It is possible that Aubert occasionally served as a "producer" or "coordinator" (*libraire*) responsible for coordination of several phases in the production: copy (*grosser*), layout (*ordonner*), and illumination (*historier* or *decorer*).[102]

In addition to the paleographic evidence that favors the attribution of the Getty copy to Aubert's hand and to his collaborators,[103] there is an interesting syntactical and semantic difference that emerges between the two long versions that may speak in favor of the thesis that Aubert copied both the Getty and Dülmen manuscripts. Until the start of the new long conclusion, the Dülmen manuscript very closely follows the short version, of which Philippe de Clèves's copy (Jena) is the only complete extant manuscript.[104] Changes in the Dülmen copy are confined to the occasional different division of chapters and to the insertion of a few sentences or words. But the Getty copy is somewhat less closely related textually to the Jena and Dülmen manuscripts; while it follows the chapter divisions of the Jena manuscript, making Dülmen a unique example, the Getty copy is textually somewhat longer, showcasing numerous ornamental interventions by the scribe in almost every paragraph. He makes no substantial changes in the subject matter, but his language aims for more precision and abounds in adjectives. The modifications are thus confined to superficial interventions, syntactical twists, and extra flourishes in the vocabulary. Similar ticks in Aubert's signed copy of a different text, Camus's *History of Olivier de Castille* (Paris, BnF, Ms. fr. 12574, before 1467), further support the conclusion that Aubert not only wrote out the Getty copy but was also responsible for its extended text.[105]

It is additionally possible to speculate about Aubert's authorship of the two long versions of *Gillion*. Aubert would have been known to Anthony and Louis for his compilations written for Créquy and Duke Philip (*Chronicles and Conquests of Charlemagne*; *History of Charles Martel* [*Histoire de Charles Martel*]). Given Aubert's experience, Anthony could have tapped him for an expanded version that focuses on Gerard and the Hainaut expedition of sixty young knights, a venture similar to the 1464 Crusade preparations. Louis would then have followed suit. And while Anthony's manuscript would have been illuminated under the supervision of Lieven van Lathem, Louis would have hired the artist himself.[106] Both Anthony's and Louis's manuscripts are likely to have been copied in the same place within two years. Both have also been illustrated by the same workshop of Lieven van Lathem (the Getty by himself, the Dülmen under his influence). The two manuscripts are written out in similar hands (the Dülmen signed by Aubert and the Getty made at least in Aubert's workshop, if not by his hand), however in versions that differ superficially but consistently. These

are precisely the marks of a situation in which the scribe was very close to the author and, in fact, likely to be the same person.[107] However, although Aubert is arguably the author of the two expanded long versions, he is otherwise known only as a translator, compiler, and amplifier (*History of Olivier de Castille*) but not as a writer of original texts. Créquy's commission of the *Chronicles and Conquests of Charlemagne* from Aubert was also a translation and compilation. Without any new evidence favoring Aubert's original authorship, it is unlikely that Aubert would have authored the original short version of *Gillion* that Créquy possibly commissioned.

Is the *Gillion* Romance a Translation?

Among many romances created between 1450 and 1470 that feature regional, pseudohistorical heroes, *Gillion*, like *Jean de Saintré, The Lords of Gavre,* and *The Count of Artois*, is an original fifteenth-century romance composed directly in prose. Yet the author stages his work as a translation: "Seeing my great desire to know the truth, the good abbot thereupon had one of the monks bring a small book in parchment, written in Italian, in very ancient and obsolete writing. Having read and understood the matter that seemed noble, poignant, and highly commendable, I was glad to work on translating the content of the said little book into our French language" (fol. 10/p. 127). The two other anonymous authors of *The Lords of Gavre* and *The Count of Artois* resort to the same gesture of presenting themselves as translators.[108] Staging an original work as a translation was a time-honored and highly conventional strategy for instilling authority in the Middle Ages; the work's value and importance derived from the fact that others considered it worthy of transmission. An original creation without this genealogy of sorts had no such claim to historical value.

The choice of Italian as the purported original language of the romance is surprising for several reasons. For centuries, Latin had been the language of authority and transmission of knowledge; the very mention of a translation from Latin into French conferred an ancient and exemplary status on the text. The mention of an archaic script, "in very ancient . . . writing" that has become "obsolete," lends some credibility to the text's historicity. It may even be possible that the term "obsolete" gestures further to thirteenth-century Italian, which was full of Latin loan words and Gallicisms.[109] "Obsolete" may also refer to the Franco-Italian or Franco-Venetian, the composite written literary language of thirteenth- and fourteenth-century northern Italy, and especially Venice.[110] Finally, the choice of Italian is unusual in a Crusading romance, since Italian-speaking characters were usually not engaged in overseas war but in overseas trade.

However, the romance's choice of Italian as the purported original language fully reflects the political horizon that Italy occupied for fifteenth-century Burgundian and Flemish French speakers. In the fifteenth century, Venice and Genoa had the two most powerful merchant navies, ferrying commodities and people across the Mediterranean, to and from European, African, and Asian shores. In the fourteenth and fifteenth centuries, Venice also outperformed all its competitors as the main pilgrimage port to the Holy Land. For centuries, Venice had been the port of embarkation for Crusader armies. Italy was thus a natural bridge between Francophone northern Europe and the East, as travelers—pilgrims and Crusaders—to the Holy Land almost always passed through Italy. Accordingly, all the protagonists in the *Romance of Gillion de Trazegnies* travel to and from the East via Italy, and they furthermore depend on the Genoese and Venetian merchants to get across the Mediterranean. Italian as the linguistic horizon of expectation for travelers to the East was

also linked to another important cross-cultural production: the interaction between artists of Burgundian Flanders and northern Italy, especially Bruges and Florence.[111] The choice of Italian as the language of transmission of Gillion's story reflects the idea that travel and trade are associated with a specific language in the Mediterranean context. If the romance narrates how Gillion and his sons were transported several times across the Mediterranean by the Italians, its author has every reason to imagine Italian as the original language in which Gillion's story was first recorded.

Painting Translation

The choice of Italian in the *Gillion* romance grows organically out of the role of merchants and trade routes and the dominance of Italian cities in the pilgrim and Crusade transportation business. Indeed, it can be said that exchange and trade underwrite the whole of the romance and its transmission, and that Lieven van Lathem focused on translation in particular. Furthermore, it appears that Van Lathem participated in a new trend for compositions of frontispieces in a group of manuscripts produced in the ambient of Philip the Good's court in this period.

In the frontispiece accompanying the prologue (plate 1; p. xiv), the Getty manuscript has a visual narrative featuring several repetitions of a figure dressed in a blue *cotte*, red hat, and pink hood. This technique, in which more than one event happening to a single character is shown, is called continuous narrative. In this miniature the figure appears three times: in the first two he has a purse and spurs, and in the final one he appears to wear a long scholar's robe. Van Lathem portrayed the author, who identifies himself in the text as a translator (on authorship, see above), as both a traveler and a scholar, albeit not simultaneously. The spurs and the purse, as well as the legible inscription on the tomb of Gillion and his wives Marie and Gracienne, "Here lies the noble and gentle knight Gillion de Trazegnies and . . ." (*Si gijst le noble gentil chevalier Gilion de Trasengies et . . .*) are part of the stunning exactitude of visual detail that Van Lathem deployed in his work and that Morrison explores in her essay. In the Dülmen manuscript image of the same sequence, the artist portrayed a knight with a sword dressed in a short *cotte* receiving the book from the abbot, and in the frame below, the translator is at work, having donned his scholar's robe (see fig. 5). While the Dülmen image has four separate frames,[112] in the Getty version the narrative continuity is not segmented. Van Lathem thus suggested that translation is a continuous process of transmission, driven by curiosity and old books: the author-translator of the romance stopped at the abbey, and the triple tomb piqued his curiosity, leading to the presentation of the book. But translation is also an act of exchange. Inside the abbey, the author-translator approaches the tomb in the company of the abbot. The original book is offered to him in the central foreground, and in the final, upper right section of the frontispiece, the author as translator at work is watched from afar by a monk in anticipation of the outcome. The translator's activity takes place in a secular world, outside the walls of the abbey (the gate and the road lead out in the lower right corner), possibly in a castle, but his translation appears to be without a patron, indicated by the fact that unlike most frontispiece miniatures, no one is shown receiving the finished object (cf. figs. 3, 12–14). Van Lathem's choice not to include the presentation scene of the book to the patron is all the more surprising because this manuscript's prologue emphasizes the patronage of Louis of Gruuthuse. His choice makes sense, however, when considered in a larger context of translation as gift-exchange: a book is a gift, and its payment a countergift.

FIGURE 12

FIGURE 12

Jean le Tavernier, *Urban Scene with the Presentation of a Book to Duke Philip the Good*, from *Chronicles and Conquests of Charlemagne*, 1458–60. Brussels, KBR, Ms. 9066, fol. 11 (detail)

The aforementioned purse hanging at the translator's waist is not a rare feature of presentation scenes in secular manuscripts, but its inclusion by Van Lathem in the Getty frontispiece is perhaps purposeful and significant.[113] It seems to function here as a referent for the idea of translation as trade. Many, although by no means all, presentation scenes to Duke Philip include a figure carrying a purse, dressed in a long robe: Chancellor Nicolas Rolin, a member of the bourgeois class who rose to become one of Philip's closest confidantes and the equivalent of Burgundy's prime minister.[114] If the predominant case of Rolin is any indication, the purse could be worn by someone of the nonnoble bourgeois class of citizens associated with the duke's court; nobles, however, would often be painted with a sword. Translation as a commercial transaction is made explicit in the presentation scene of *Chronicles and Conquests*

FIGURE 13

Lieven van Lathem, *Presentation Scene with the King of Arabia*, from Pseudo-Aristotle,
Secret of Secrets, ca. 1470–75. Paris, BnF, Ms. fr. 562, fol. 7

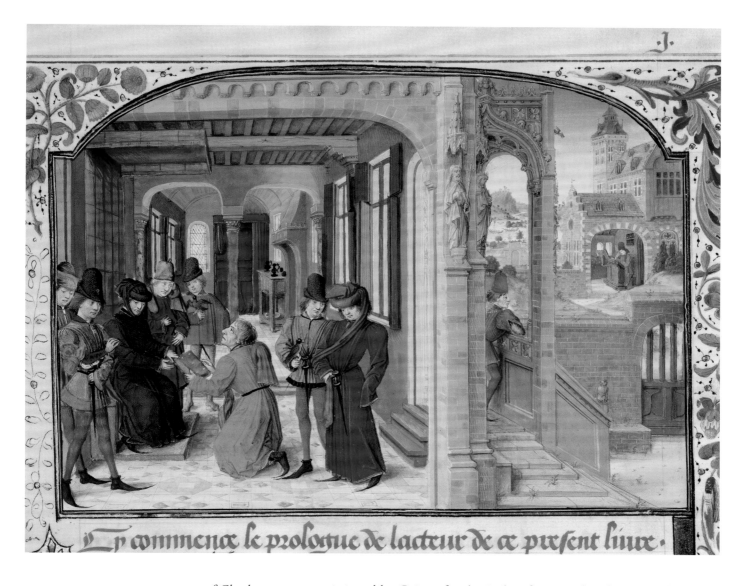

FIGURE 14

Lieven van Lathem, *Presentation Scene with Duke Philip the Good*, from Raoul Lefèvre, *History of Jason*, after 1472. Paris, BnF, Ms. fr. 331, fol. 1 (detail)

of Charlemagne, commissioned by Créquy for the Duke of Burgundy, where a market at the city gates occupies the foreground (fig. 12). In the upper right-hand corner is a more standard presentation scene, showing the manuscript being offered as a gift by the patron Jean de Créquy, who is identified by the collar of the Order of the Golden Fleece and the short *cotte* worn by nobles.[115] Yet this presentation scene is pushed into the background while trade is foregrounded in the urban marketplace at the city gates, where food, drink, clothes, and jewelry are all present. Other elements in the image marshal the idea of exchange: the middle section shows courtiers engaged in a conversation, one of them holding a falcon, and the duke's dwarf approaching the group, while the upper left section presents two men exchanging something over the balcony. The inner courtyard sets the scene in a courtly tone. The artist, Jean le Tavernier, removed the inner wall of the duke's palace, thereby suggesting that the duke overlooks and enables the city and courtly exchanges, one adjacent to the other. All three areas communicate through the open gate and open facade of the palace. While the duke's "good government" encourages vigorous commercial activity and courtly exchange, the bustling urban marketplace offers a select arena for the courtiers to purchase gifts for the sovereign.[116] Le Tavernier thus saw translation as a circulation between the city market and the court, spurred by the middle section of courtiers. But in the Getty *Gillion*, Van Lathem

completely eliminated the patron and the typical presentation scene, placing instead at the center the intermediary figure of the translator, who is the pivot of just such a circulation: a citizen associated with the duke's court, he is both the creator and the gift giver. He will, upon completion of his work, most likely engage in "trading" his book: as the dedication of *Gillion* signals, he will offer it as a gift to the duke, for which, in exchange, he can expect a countergift in the form of ducal payment, a fact perhaps underscored by the presence of a purse prominently hanging at his waist. Van Lathem's frontispiece is particularly interesting as there is no record of the original short version's commission and patron, making the focus on the translator more immediate and compelling.[117]

Lieven van Lathem may have been particularly interested in the figure of the translator as middleman, although in later illuminations he softened the unique staging seen in the *Gillion* romance. In two other manuscripts illuminated for Louis of Gruuthuse, he again painted the translator, albeit in a more standard presentation scene. The frontispiece of Pseudo-Aristotle's *Secret of Secrets* shows the translator presenting his work in Arabic to the king of Arabia; the translator states in the prologue that he translated from Greek to Chaldean, then to Arabic, and the scene takes place under a crescent painted in the middle of the archway (fig. 13).[118] Here, Van Lathem pointed to translation as a primary scene further removed in time. In Lefèvre's *History of Jason* he painted a continuous image like the frontispiece of the Getty *Gillion* (fig. 14). It combines a typical presentation scene, the completed work presented to Philip the Good (seated, in black, his collar of the Order of the Golden Fleece visible under the black overpainting),[119] with a narrative frontispiece, where the author-translator, presumably translating from Latin, is seen at work in the upper right-hand corner. But the order is here reversed from the Getty *Gillion*, as the presentation scene of the book does not begin a translation, but rather concludes it.

All three of Van Lathem's frontispieces for Louis of Gruuthuse display a high degree of textual consciousness and sensibility to translation, and they subvert or nuance the customary presentation scene in which the completed manuscript is presented to the patron. While this kind of artistic consciousness gestures to the topos of precedent, though not necessarily an authoritative one, as the original is in Italian in the *Gillion* romance, it also challenges the standard frontispiece composition. The Getty *Gillion*'s frontispiece is the most singular and original, perhaps a reflection on the least authoritative of languages, Italian. Since Italian was not an authoritative language, Van Lathem departed from the model and created an image of continuous transmission to lend it authenticity. The *History of Jason* and *Secret of Secrets* each deal with languages of great cultural prestige—Latin, Greek, and Arabic—and so they only mildly subvert the presentation scene. The authority of the narrative here hinges on the perfect compositional model, the presentation scene with the patron combined with the image of the textual precedent that gives the text its authenticity. In the Getty *Gillion*, Van Lathem chose to include the precedent, the old book as an open book at the very center of the visual narrative; his painting was a performative act whereby the image conjured up the historicity of the precedent.

A Romance between the East and the West

Not only did Van Lathem paint translation as a process in the frontispiece to the Getty *Gillion*, but he also painted the open book twice: in the central scene of the original presented to the author, and then again in the writer's scriptorium. The open books stand for a revelation of the true story of Gillion's double life, as it were, and, perhaps also for an elusive,

mirage-like invitation to its viewers to embrace the East. The manuscript presents the love story between Gillion and his two wives as truly a romance between the East and the West, with Gillion acting as a hyphen linking the two in a relationship of ambivalence and ambiguity. While the West felt an enchantment with the East that may well be called medieval Orientalism, it reacted to contact with an entrenchment in values. The placement of Gillion's recumbent statue between his two wives embodies his position as the tie that binds the two worlds, the East and the West (plate 1). This contact, however, is not smooth, because it requires an act of passing, such as we saw in Bertrandon de la Broquière's clothing (see fig. 3): a fleeting, or perhaps permanent, metamorphosis or conversion. This ambivalent pull that the East exerts on the characters is redeemed on each occasion by a stance of Western superiority and staunch ideology; any ambiguity about Gillion's assimilation into the Muslim world is systematically sidestepped.

The infatuation with the East starts with the author's prologue. Marie is introduced not as an individual or as Gillion's wife but only as a part of a female couple that she forms with Gracienne: "The bodies of two noble and courageous ladies and their husband in their midst were buried there." The author foregrounds the identity of the sultan's daughter: "Two noble and virtuous ladies, who were both his companions and spouses during his lifetime, one of whom was daughter to the sultan of Egypt" (fol. 9v/p. 126). The enchantment rests with the Eastern wife; the author does not mention Marie as the mother of Gillion's sons. Rather, Marie is an object of exchange between the lord and his loyal vassal, a reward for Gillion's services: "He accomplished so much by his valor that the noble Count Baldwin gave him into marriage his close relative named Marie, daughter of the good Count of Ostrevant" (fol. 10v/p. 127). The text makes no mention of courtly love between the two, as their thoughts turn immediately to their marital frustration, the absence of a "male heir" (fol. 13v/p. 130), the inability to continue a lineage: "We are unable to produce a lineage" (fol. 13/p. 130). Once their prayers are answered, Marie's pleas that Gillion see the pregnancy to term before fulfilling his vow are shut down with authority: "I ask that you speak no more of this matter" (fol. 18/p. 135). She meets with refusal the Count of Hainaut's encouragements to remarry in accordance with canon law after seven years of Gillion's absence and lack of news (fol. 58/p. 183). Instead, she finds fulfillment in maternal love, but her sons' departure in search of their father devastates her, and her character is literally cast aside.

Instead, love resides in the East. It is at the moment when Gracienne sees Gillion naked, as he is about to be executed by archers at the command of the sultan (perhaps a subtle play on the legend of Saint Sebastian), that God "inspires" her to love him and to incline her to believe in Jesus Christ: "She believed that she had never seen a more beautiful or better shaped body of a man" (Dülmen, p. 147; missing fols. xxiii–xxv in the Getty *Gillion*). This divine sanction is nothing but a cover for the erotic foundation of love. Gillion himself is said to be in love with Gracienne, in distinct contrast to his passionless, albeit tender and dutiful feelings for Marie: "The knight began to gaze at the maiden until his heart started to quiver and he no longer knew what to do because a love's arrow burning with ardent desire pierced all the way to his heart" (fol. 30/pp. 155–56).[120] Marital responsibility calls Gillion's thoughts back to Marie each time—"As soon he remembered his most noble companion, the lady of Trazegnies" (fol. 30/p. 156)—until Amaury brings false news of her death to Cairo. Even as Gillion is torn by remorse because he abandoned his wife and unborn child, Marie's death is the legitimation of his desire for Gracienne: "Ha, noble maiden Gracienne, it was my hope to take you for a wife and marry you according to the Christian religion, and I also

never intended to return to the land of Hainaut since I lost the one [Marie] whom I loved so faithfully" (fol. 95/p. 216; also fol. 102/p. 222). The thought of marriage to Gracienne emerges organically from the loss of Marie. But this is not a new thought; it has haunted Gillion for a long time, repressed each time. What had been transgressive is now openly articulated: "The Christian knight...watched the one he had desired for so long arrive" (Dülmen, pp. 286–87; missing fols. clxviii–clxxiii in the Getty *Gillion*). From the beginning, this meeting of the Western knight and Eastern princess—the Getty manuscript favors calling Gracienne a "princess," unlike the Dülmen, which prefers "maiden"—is a matter of romance, in contrast to the marriage with Marie. The narrative is at pains to purify each carnal thought with talk of Christ: "And as the knight and the maiden were together conversing [of love],...the noble and good knight preached to the noble maiden with so many beautiful and virtuous speeches that she entirely converted her love to Our Lord" (fols. 26–26v/p. 151).[121] But it remains tainted by the suspicion of premarital sexual contact, as Gillion associates his remorse over Marie's death with a punishment for his sin: "I see clearly that my sin caused this since I have long remained in the Saracen land and had commerce with those who are not believers in God and his law" (fol. 69v/p. 193).

This East-West romance comes at a price: bigamy and Gillion's suspected conversion to Islam. Gillion controversially becomes "the force of Egypt, the pillar and haven of Eastern nations subjected to us" (fol. 212v/p. 350; also fol. 230v/p. 366), even a "father" of the Egyptian nation (fol. 73v/p. 197). Fols. 153–59 of the Getty *Gillion* (plate 37; Dülmen, chap. 52) encapsulates this delicate negotiation of his status between the East and the West. The sultan offers Gracienne ostensibly to reward Gillion for his past services (fol. 159v/p. 286), but in reality to retain his services forever (fols. 159–159v/p. 286). Gillion becomes the sultan's heir—"After my death you will hold all my lands and dominions" (fol. 159v/p. 286)—and marries Gracienne under Islamic law: "The caliph married them according to the law of Muhammad" (Dülmen, p. 287; missing fols. clxviii–clxxv in the Getty *Gillion*). The suspicion of Gillion's conversion to Islam is all the greater given that in the first battle, when he saves the sultan, he is wearing the sultan's armor so that all will think that Gillion is in fact the sultan. His new inheritance of the sultan's throne is merely a successful outcome of what was hinted at from the beginning. But the romance pushes the willing suspension of disbelief to its limits when Gillion publicly avows, surely to the delight of Western audiences, that he will never give up his Christian faith and that he will, moreover, convert Gracienne: "'I keep [Gracienne] and thank you most humbly, on the condition nonetheless that you never force me to relinquish my religion, to which, since this is within my power, I will convert completely your daughter Gracienne by kindness, if I am able and such is her pleasure.' This the sultan granted him, thinking that his daughter would never renege her religion" (Dülmen, p. 286; missing fols. clxviii–clxxv in the Getty *Gillion*).

Early on in the romance, when the sultan liberates Gillion from prison and appoints him commander of his army, the author claims, "He was asked several times to renounce the religion of the Crucifix and enjoined to believe in the religion of Muhammad to which he never acquiesced" (fol. 48/p. 172). Gillion's staunch refusal to convert is not a historically credible proposition; in Mamluk Egypt of the fourteenth and fifteenth centuries, men of similar high status would have been renegades, converts to Islam who took Muslim wives. The change from the status of slave or prisoner to officer of the state could be accomplished only by conversion to Islam. Still, Gillion's refusal is not far-fetched, as many Christian pilgrims to Egypt and Syria chose to believe that, if given a chance, renegades would return to

their original faith.[122] Pilgrims preferred to think that renegades continued "secretly believing" in Christianity (Dülmen, p. 149; missing fol. xxv in the Getty *Gillion*), as Hertan and Gracienne, although outwardly Muslim, secretly believe in Christ.

Stalwart espousal of Christian faith, despite contemporary evidence to the contrary, legitimizes the romance between a Western noble and an Eastern princess, a romance of the West fascinated with the East. The question of Gillion's likely conversion to Islam as unavoidable and necessary is evacuated with Gracienne's and Hertan's conversion to Christianity, confirmed later by the pope in Rome. Gracienne's desire for Gillion is her first inspiration to convert. And what a better way to condemn Islamic law than from the mouth of a future Christian; as Hertan says: "The Muhammadan religion is false, hateful, and damnable, and it leads to hell all those who die in it" (fol. 25/p. 150). An even better method is to laugh away all ambiguity caused by Gillion's twenty-four years in Muslim lands and to turn Muslims and their sultan into the butt of a joke. When Gillion liberates the sultan from Ysore, the king of Damascus, Gillion impersonates the sultan dressed in his armor and arms (plates 12, 13). After the sultan's savior vanishes without a trace (because Gillion returns to his prison guarded by Hertan), the Cairenes think Muhammad performed a miracle. When Gracienne brings Gillion to the court in the sultan's dress, the sultan believes Muhammad has come back to honor him and falls to his knees in veneration. Hertan can barely suppress his laughter (plate 16). Muslims' belief in heathen miracles is ridiculed again for the benefit of the Christian audience on the occasion of Gillion's return to Cairo (plate 48).[123] Yet another method of conjuring up the idea of Gillion's acculturation and assimilation is through unwavering Crusade-like rhetoric. As the head of the sultan's army, Gillion agrees to do battle only against Saracens, refusing to fight against the king of Cyprus (fol. 49/p. 173). The paradox of killing Saracens in order to secure the reign of another Saracen is resolved by the goal of salvation: "I can honorably save my soul overseas by putting pagans and Saracens to death, just as I could do likewise through worthy and salutary acts, if I were in my lands" (fol. 159v/p. 286; also fol. 202/p. 339).

The romance compromises on the status of love and the institution of marriage, but it is absolutely uncompromising on the status of religion. In the world of the romance, it is possible to imagine mistaken bigamy, but it is impossible to imagine that a Christian would convert (even if only outwardly). Conversely, a Muslim's conversion to Christianity is eminently feasible; still, when the romance proposes a porous, tolerant Muslim world that allows a Christian to prosper in it, it also creates an impermeable world of entrenchment even for a converted male Muslim.[124] Thus Hertan, baptized as Henry by the pope in Rome, dies only an hour after his baptism. Gracienne survives the baptism, but not for long. When Gillion returns to Hainaut, he is at a loss for how to deal with his bigamous situation, and although he has just been in Rome, he has never asked the pope for help.[125] To his surprise, Marie and Gracienne have a ready-made solution: each is ready to give up her place as wife at Gillion's side, with the same argument: "Without desiring to oppress her [Gracienne] or me with any carnal contact by night or by day" (fol. 196/p. 326; also fol. 195/p. 324). The women propose to enter a convent together, and it is the Abbey of Olive where the romance's author will find their tombs and obtain the original book in parchment.[126] The women form an indivisible entity, one that will no longer suffer the invasion of a male body. Their oneness ties back to the author's prologue, in which the female couple, anonymous and united in the same function, is separated "in the middle" by the man. Within one year of their entry into religion, the women die one after another, two days apart. Gillion, who had retired to a monastery, mourns their death, but when the sultan

calls him back, he invests his elder son Jean with the title of Trazegnies and returns to Egypt. Gillion is mortally wounded in the last battle defending the sultan and dies where he has passed his whole life: in Cairo. His son Gerard, who accompanied him, takes his heart back to Hainaut to rest between his two wives.

A romance between the East and the West can result only in bigamy, a doubling that is ultimately sterile and leads to (female) chastity and (male) sacrifice. The *Romance of Gillion de Trazegnies* is not simply a mirror of the West's ambivalent infatuation with the East. The meeting of two worlds that share fundamental values yet remain separated by essential differences is depicted as a romance between the East and the West. But this romance also contains a misunderstanding that leads to bigamy, to an impossible duplication that ends with an impasse. From bigamy to chastity, from double to nothing, the fifteenth-century audiences lived between enchantment and entrenchment, which may be just another description of the medieval romance.

NOTES

1. Philip's library grew from the 248 volumes that he inherited, compiled in the 1420 inventory, to 865 in the 1467–69 inventory. More than 600 manuscripts were acquired through commissions and gifts. Lemaire in Bousmanne and van Hoorebeeck 2000, 13–17; Doutrepont 1906; Barrois 1830.
2. Vaughan 1970.
3. Summary for years 1438–49 based on Paviot 2003, 81–115; Paviot 1995, 105–26; Vaughan 1970, 270–73.
4. Naber 1987, 284.
5. Summary for years 1451–64 based on Paviot 2003, 117–76; Paviot 1995, 126–34.
6. Pastoureau 1996.
7. De Gruben 1996.
8. Quoted in de Smedt 2000, 1–2.
9. Olivier de la Marche in Beaune and d'Arbaumont 1884, 340–80; Mathieu d'Escouchy in Buchon 1826, 83–118. The vow made upon the head of a bird was inspired by Jacques de Longuyon's work *Vows of the Peacock* (1312). See Gaullier-Bougassas 2011.
10. Paviot 2003, 127–35; Caron and Clauzel 1997; Caron 2003; Moodey 2012, 125–48.
11. For quotations, folio numbers refer to the Getty manuscript, and the corresponding page numbers to the printed edition of the romance by Vincent (2010). Vincent's edition is based on the manuscript in a private collection in Dülmen, Germany. Where the texts of the Getty and Dülmen manuscripts differ, the manuscript name accompanies modern foliation in the Getty or page numbers of the Vincent edition of the Dülmen (e.g., Getty, fol. 8, or Dülmen, p. 344). All translations from Middle French and modern French into English are mine.
12. When the texts of the Dülmen and Getty manuscripts correspond (most often with only slight variations), folio numbers refer to the Getty manuscript, and the corresponding page numbers to the printed edition of the romance by Vincent (2010), which follows the Dülmen manuscript.
13. Delaville le Roulx 1886, 282–92, 300–334; Froissart in de Lettenhove 1967, 15:327; Gardette 2003; Richard 2003; Contamine and Paviot 2008, 9–96.
14. I agree with Vincent (2010, 79) that Gillion is modeled on multiple historical sources. For a summary of the Trazegnies legend, see Bayot 1903.
15. Plumet 1959, 94–106.
16. Ibid., 108–17. There is some disagreement about the date of Gilles II's death. See de Barthélemy 1884, 2:188.
17. Plumet 1959, 150–68.
18. Paviot 2003, 257–90.
19. Newett 1907.
20. Sancto Brasca quoted in Tucco-Chala 1972–73, 85.
21. For the return journey, only the Dülmen manuscript mentions the Holy Sepulcher, while the Getty version notes in more general terms "devotions in the holy city of Jerusalem."
22. For an account of the textual and manuscript tradition of the *Romance of Gillion de Trazegnies*, see Introduction.
23. De Smedt 2000, 129–31; van den Bergen-Pantens 1993, 331.
24. Naber 1987, 289; Schandel 1997; Visser-Fuchs 2002; Marchandisse 2006.
25. Wijsman 2010, 477.
26. See Haemers 2007, 25–26.
27. Wijsman 2010, 274, 296, 357, 475–76; Korteweg 2007, 184–85.

28. Van der Linden 1940.
29. Paviot 2003, 170.
30. Paviot 1995, 126–34; Paviot 2003, 163–76.
31. Throughout the Getty and Dülmen manuscripts, the male Trazegnies family members carry the same shield (azure, with golden trim and three transversal golden bars). This is still today the coat of arms of the Trazegnies family.
32. For comparison, see plates 45, 46. Gerard wears all green, while Gillion's armor is closely modeled on the armor Gerard sports in the Dülmen images. See also plates 17, 42.
33. I thank Hanno Wijsman for pointing out this interesting detail.
34. See Morrison, "The Genius of Visual Narrative," 116.
35. Van Praet 1831, 7.
36. Alexander 1992, 32; McKendrick in Kren and McKendrick 2003, 62–63; Johan 2009, 2:234.
37. Paviot 1995, 132.
38. Laffitte (1997, 247) argues that a copy of the *Mirror of History* made in Bruges in 1455 may have been his first original commission; Wijsman (2010, 361) agrees. Louis may have commissioned Jean Wauquelin's translation of the *Chronicles of Hainaut* [*Chroniques de Hainaut*] (Paris, Bibliothèque Sainte-Geneviève, Mss. 809–11), dated before 1461, based on the fact that his coat of arms is painted without the collar of the Order of the Golden Fleece, which he acquired in 1461. See Sordet in Cockshaw 2000, 234–36. This dating would need to be reconciled with the prevalent dating of after 1470 for the Master of the *Chroniques d'Angleterre*.
39. See Morrison, "The Genius of Visual Narrative," 120–21, on dating.
40. For manuscript dating, see Hans-Collas and Schandel 2009. I have retained these generally accepted dates. However, based on the example of the Master of the *Chroniques d'Angleterre* (see note 38) and Morrison's argument in this volume in favor of dating the Getty *Gillion* to 1464, Louis's commissions should be globally reconsidered within the wider range of 1460–90 instead of the commonly held 1470–80 range for the majority of his manuscripts.
41. Hans-Collas and Schandel 2009, 201–3. Margaret Scott generously shared in private correspondence with Elizabeth Morrison that by 1480 the fashion dictates would have imposed a gown so tight that it would have had to have slits in the sleeves and it would not have closed across the chest. The fashion shown in the manuscript's sole illumination would thus have been outdated well before 1480. Hubert le Prévost's *Life of Saint Hubert* (Paris, BnF, Ms. fr. 424) and an anonymous translation of Henry Suso's *Clock of Wisdom* (Paris, BnF, Mss. fr. 455–56) have frontispieces showing Louis with his family, wife, son, and (one or two) daughters. The children's height and faces indicate younger age. The manuscripts are dated 1470–80, but the children's ages would encourage dating them to the first half of the decade.
42. See p. 73 of this essay. As Morrison shows, Louis's early commissions were closely allied to Anthony's. "The Genius of Visual Narrative," 133–34.
43. Wijsman 2010, 356–69; McKendrick in Kren and McKendrick 2003, 59–78; Hans-Collas and Schandel 2009.
44. I thank Scot McKendrick for sharing precious information on bookmaking costs. While it is difficult to determine comparative costs because of lack of evidence, Louis's *Heraclius* has only twenty-six one-column illuminations in grisaille, which would have undoubtedly cost less than Van Lathem's suite of illuminations in the Getty *Gillion*. Donovan 2013, 126; also Donovan 2011.

45. Donovan 2013, 126; also Donovan 2011.

46. McKendrick in Kren and McKendrick 2003, 72, also 67n79.

47. Delaissé (1959, 132) thought that this date referred to the creation of the new, long version, not to its transcription.

48. Van der Linden 1940. We do not have a precise record of Louis of Gruuthuse's whereabouts, although he was in Bruges in May 1463 and more than likely during the duke's stay from November 1463 to February 1464.

49. See p. 89 of this essay.

50. Bousmanne in Bousmanne, van Hemelryck, and van Hoorebeeck 2009, 171–83; Straub 1995, 83–84; Bouchet 2009; Coleman 1996.

51. Van der Linden 1940.

52. McKendrick in Kren and McKendrick 2003, 71–73.

53. Wijsman 2010, 300; Korteweg 2007, 188, 194.

54. Wijsman 2010, 472–76; Naber 1990b.

55. It is thought that *Gérard de Nevers* (Brussels, KBR, Ms. 9631) was made for Jean de Wavrin and passed to the duke's library. Schandel in Bousmanne, van Hemelryck, and van Hoorebeeck 2006, 133–38. Wijsman also explains that *Jean d'Avesnes* (Paris, BnF, Ms. fr. 12572) was in the 1467–69 inventory of the Duke of Burgundy, with other manuscripts offered by Wavrin. Wijsman 2010, 478; Naber 1990b, 27; see also Naber 1990a; Schandel 2002–3.

56. Wijsman 2010, 475. The attribution of the first of the treatises, *Advis directif pour faire le passage d'outremer* (Treatise on the Overseas Crusade), to William of Adam has not been met with general scholarly approval. Constable 2012, 5–8.

57. McKendrick in Kren and McKendrick 2003, 69; van den Bergen-Pantens 1996, 198.

58. Hans-Collas and Schandel 2009, 11–18; Wijsman 2010, 366; Wijsman 2007; Laffitte 1997, 249–50; Martens 1992; Baurmeister and Laffitte 1992.

59. See Morrison, "The Genius of Visual Narrative," 112–24, on dating.

60. Donovan 2013; Moodey 2012.

61. Small in Bousmanne, van Hemelryck, and van Hoorebeeck 2009, 10–23; Small in Cockshaw 2000, 17–22; Paviot 2003, 201, 226.

62. Paviot 2003; Wijsman in Bousmanne, Johan, and van Hoorebeeck 2003, 18–37.

63. Wijsman 2010, 478. See note 55, above.

64. Naber 1990b, 25. Philip did not own a copy of *Gillion de Trazegnies* during his lifetime (contrary to Moodey 2012, 70–72).

65. Horgan 1985; Vincent 2010, 22–27. The thesis by Bayot 1903 that one author composed *Gillion de Trazegnies*, *Gilles de Chin*, and *Jacques de Lalaing* is based on general observations of style and theme, and scholars have rejected it.

66. Stuip 1993, xliv–xlv; Gaucher 1994, 226; Vincent 2010, 20–22.

67. De Smedt 2000, 42; Potvin 1878.

68. Lannoy in Potvin 1878, xxxvii–xxxix, 335–439; Sterchi 2004; Visser-Fuchs 2006.

69. Lannoy in Potvin 1878, 338.

70. Vincent 2010, 75; Plumet 1959, 241–44, 246–49.

71. I thank Hanno Wijsman for bringing this possibility to my attention.

72. De Smedt 2000, 64–65; Paviot 2003, 113; Wijsman 2010, 309–14.

73. *Croniques et conquestes de Charlemagne* in Guiette 1940, 1:13.

74. Bousmanne and Palumbo in Bousmanne, van Hemelryck, and van Hoorebeeck 2009, 127–58. Créquy may have had his own copy (lost today) and intended *Croniques et conquestes de Charlemagne* as a gift for Philip. Charron and Gil 1999.

75. Gil 1994, 75, 74.

76. Willard 1996, 59; *Croniques et conquestes de Charlemagne* in Guiette 1940, 1:14.

77. Gil 1994, 94, 77.

78. *Croniques et conquestes de Charlemagne* in Guiette 1940, 1:14.

79. McKendrick in Kren and McKendrick 2003; Wijsman 2010, 314.

80. Gil 1994; Wijsman 2010, 310–15.

81. Donovan 2013, 54.

82. Gil 1994; Willard 1996; McKendrick in Kren and McKendrick 2003, 70–71; Donovan 2013, 29–70.

83. Willard 1996, 60; Gil 1994, 71, 72.

84. Quoted from Brussels, KBR, Ms. 10237, in Gil 1994, 83, 91n71, 91n73; also Chalon 1837, 1.

85. Quoted from Lille, Bibliothèque municipale, Godefroy 50, in Gil 1994, 92n74.

86. Gil 1994, 84; McKendrick in Kren and McKendrick 2003, 71.

87. McKendrick in Kren and McKendrick 2003, 243.

88. Wagner 1959, 130; Pastoureau 2009, 213.

89. Leman and Watelle 2009; Leman 2010.

90. *La Romance du Sire de Créqui* in Debrie and Garnier 1976, v. 218. For a translation, see http://www.crequy.com/la_romance_de_raoul.htm (accessed March 15, 2015).

91. Deus cingnes subs lie point s'esbatoient deseur liau,
 Et de leurs becqs tiroint [*sic*] eune moitié d'anniau
 Treis luisant deun roubi; le Dame l'eyhant veue
 Criea: chey le mitan de men anniau perdue.
 La Romance du Sire de Créqui in Debrie and Garnier 1976, vv. 381–84.

92. The exact number of generations between Philip and Jacques is uncertain. See http://racineshistoire.free.fr/LGN/LGN-frameset.html (accessed March 15, 2015); http://famille.de.crequy.com/sommaire.htm (accessed March 15, 2015).

93. Froissart in de Lettenhove 1967, 15:328.

94. *Le livre des fais du bon messire Jehan le Maingre, dit Bouciquaut* in Lalande 1985, 62; Lalande 1988, 26–28; Delaville le Roulx 1886, 1:159–65.

95. Froissart in de Lettenhove 1967, 15:319, 334.

96. Ibid., 15:324.

97. Ibid., 15:333.

98. Gil 1994, 74; Charron and Gil 1999, 81.

99. Charron and Gil 1999, 81; Paviot 1999, 11; Gil 1994, 74.

100. McKendrick in Kren and McKendrick 2003, 63; Charron and Gil 1999.

101. Delsaux and van Hemelryck 2014; Straub 1995; Straub 1997; Straub 1986–87; cf. Charron and Gil 1999, 98.

102. Straub 1995; cf. Charron and Gil 1999, 98; McKendrick in Kren and McKendrick 2003, 63–65, 76n36; Hans-Collas and Wijsman 2009, 39.

103. Delaissé 1959, 131–32; see also Morrison, "The Genius of Visual Narrative," note 30.

104. Wavrin's copy (Brussels, KBR, Ms. 9629) is damaged, as quires after fol. 72v are missing.

105. Régnier-Bohler 1999.

106. See Morrison, "The Genius of Visual Narrative," 112–16.

107. I thank Hanno Wijsman for encouraging me to explore this point.

108. Stuip 1993; Seigneuret 1966. *Jean de Saintré* does not feature the literary topos of presenting an original work as a translation. Unlike the other romances, it is not anonymous but signed by Antoine de la Sale.

109. Cornish 2011.

110. Roncaglia 1965.

111. Kren in Kren and McKendrick 2003, 412–13; Nuttall 2013; Nuttall 2004.

112. See Morrison, "The Genius of Visual Narrative," 115–16.

113. I thank Anne D. Hedeman for encouraging me to think through all the ramifications of the purse.

114. E.g., Paris, BnF Ms. fr. 9342, f. 5; Brussels, KBR Ms. 9043, fol. 2; KBR Ms. 9092, fol. 1; KBR Ms. 9242, fol. 1; KBR Ms. 10778, fol. 1; Vienna, ÖNB Cod. 2549, fol. 6.

115. Bousmanne and Palumbo in Bousmanne, van Hemelryck, and van Hoorebeeck 2009, 128.

116. Buettner 2001, 618.

117. Cf. Martin le Franc, *The Champion of Women* (Paris, BnF, Ms. fr. 12476, fol. 1v, 1451), in which Martin, wearing a purse, presents an unsolicited gift to the duke.

118. http://www.sites.univ-rennes2.fr/celam/cetm/S2.htm#4 (accessed March 15, 2015); Van Buren 2008.

119. Hans-Collas and Schandel 2009, 79.

120. Brown-Grant 2008, 155–62; Gaucher 1994, 361.

121. Gaullier-Bougassas 2003, 274–84.

122. *Visit to the Holy Places of Egypt, Sinai, Palestine, and Syria in 1384* in Bagatti 1948, 53.

123. On medieval European perceptions of Muslims, see Akbari 2009; Tolan 2002.

124. On social mobility of converts and renegades, see Dakhlia 2008, chaps. 3 and 4.

125. On bigamy and Christianity, see McDougall 2012.

126. On Olive as a convent with an abbess, see Dülmen, p. 329 (Getty missing fol. ccxv). Elsewhere, the Dülmen manuscript describes Olive as an abbey (p. 126/Getty fol. 9v; p. 333/Getty missing fols. ccxix–ccxxiiii; p. 370/Getty fol. 233v; p. 373/Getty fol. 237), and an abbey and monastery (p. 330/Getty fol. 199; p. 335/Getty missing fols. ccxix–ccxxiiii). Of the two references in the long conclusion of the Dülmen manuscript to Olive as an abbey and monastery, the single surviving reference in the Getty *Gillion* describes Olive only as an abbey (fol. 199). The manuscript copy owned by Jean IV de Trazegnies changes the prologue to harmonize the story. In this 1529 version, the abbot is an abbess of the convent of Olive who provides the author-translator with the small book on parchment (Brussels, KBR Ms. IV 1187, fol. 1).

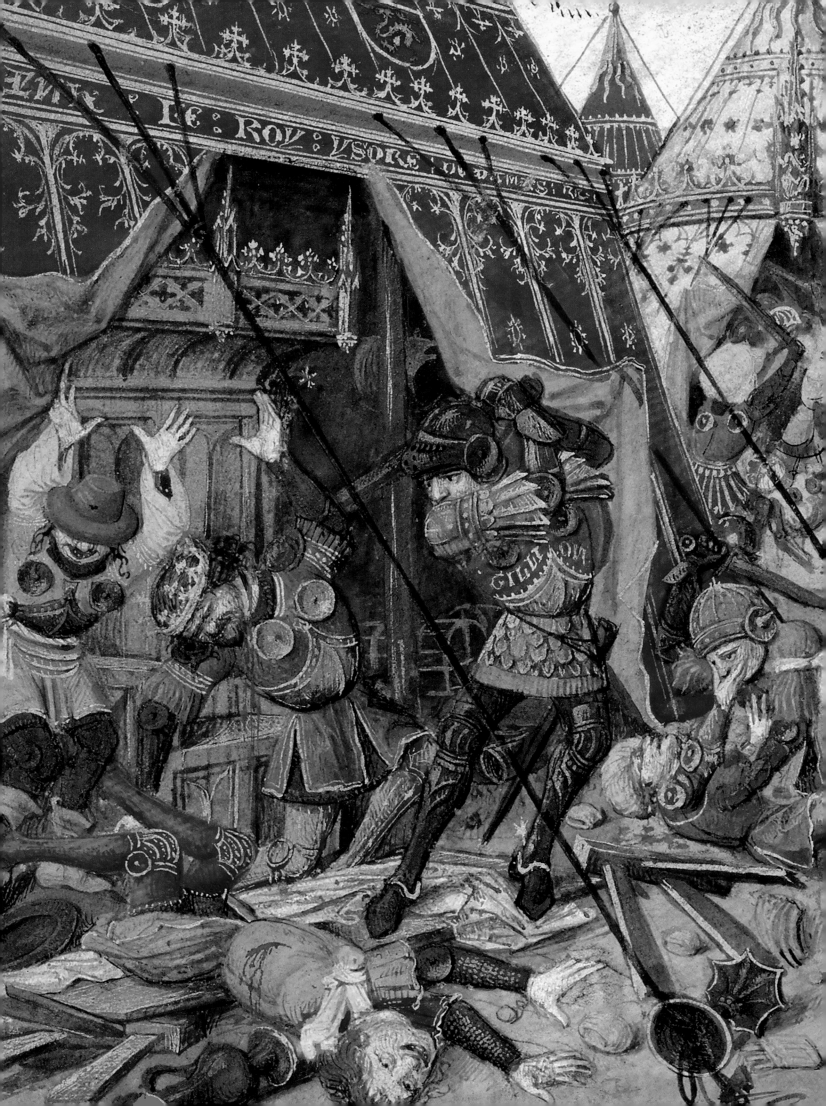

THE GENIUS OF VISUAL NARRATIVE

ELIZABETH MORRISON

Part travelogue, part romance, and part epic, the story of Gillion de Trazegnies encompasses the most thrilling elements associated with chivalric tales—faithful love, nefarious villains, family loyalty, and violent battle, with the added exotic elements of dangerous travel and Eastern customs. The text is full of lively descriptions and imaginative details that cry out for visualization. In the Getty's copy of this tale, the artist Lieven van Lathem took full advantage of the dramatic possibilities posed by the text in the manuscript's extensive complement of miniatures and historiated initials. The remarkable nature of Van Lathem's images centers on their clever construction as visual narratives, full of active, lively figures mirroring a range of emotional states and set within convincingly depicted towns or expansive, naturalistic landscapes.

Just as Zrinka Stahuljak's analysis of the rich and complicated influences on the creation and dissemination of the text of the *Gillion* romance can expand understanding, so careful consideration of the images in the Getty manuscript can shed new light on its origins and the way it would have been experienced by its contemporaries. Delving deeply into the codicology of the manuscript—how it was physically designed and put together—will indicate not only that the scheme of illumination was changed in the midst of its creation but also that a number of illuminated leaves were removed from the manuscript at some point later in its history. Based on a certain amount of "book detective work," this essay identifies the missing pieces and reconstructs what the lost illuminations may have represented. In this process, comparison of the Getty manuscript's suite of images to those of the only other surviving illuminated copy of the text, now in a private collection in Dülmen, Germany, has been critical. These closely related manuscripts were created for two of the most prominent collectors of the era—Anthony of Burgundy (Dülmen) and Louis of Gruuthuse (Getty)—who were, moreover, close associates at the court of Burgundy. The illuminations of the earlier manuscript, made for Anthony of Burgundy in 1463, were almost certainly known to Lieven van Lathem, who was likely, in fact, to have been closely involved with the creation of both manuscripts. A new understanding

of these elements will lead to a consideration of how the images in the Getty *Gillion* helped to structure the reader-viewer's perception and understanding of the text, providing a basis for contextualizing its program of decoration within the larger framework of Van Lathem's career as an illuminator, especially in relation to his other contributions to secular manuscripts. This discussion will clarify the role of the manuscript in the cultural and historical moment of its creation, particularly in the context of Louis of Gruuthuse's ambitions and his political and economic role in Burgundy.

The Artist

Lieven van Lathem's work is distinctive for its graceful, spirited figures, subtle handling of the emotional tone of scenes, brilliant color palette, complex compositions filled with incredible detail, and ambitious landscapes. It was the meticulous archival work of Antoine de Schryver, undertaken in the mid-1950s, that linked a well-known corpus of stylistically distinctive work to the name Lieven van Lathem.[1] Detailed payment documents from the Burgundian archives identified Van Lathem as the artist of the Prayer Book of Charles the Bold (Los Angeles, JPGM, Ms. 37, 1469 and ca. 1471).[2] As his only documented work, the prayer book serves as the primary reference for all other manuscript paintings attributed to him. Based on the characteristic style seen in the prayer book, illuminations in at least twenty manuscripts are now attributed to Van Lathem's hand, including the Getty *Gillion*.

Born in the village of Latem in Flanders to a family of artists in about 1438, Lieven van Lathem had joined the painter's guild in Ghent by 1454. Just two years later, he was in the employ of Philip the Good, Duke of Burgundy. Although Van Lathem was not always officially attached to the Burgundian court, he enjoyed the patronage of the Dukes of Burgundy throughout his career. He illuminated a prayer book for Philip (Paris, BnF, Ms. n.a.fr. 16428, ca. 1462–65) and then the prayer book for Philip's son Charles the Bold, mentioned above. He also contributed to a famous book of hours probably made for Mary of Burgundy, Charles's daughter (Vienna, ÖNB, Cod. 1857, ca. 1470–75), as well as serving as the *valet de chambre* and *peintre du roi* for Archduke Maximilian of Austria (later Holy Roman Emperor Maximilian I), Mary of Burgundy's husband. Van Lathem's long and prolific career ended with his death sometime in 1493. His artistic activities were not limited to illumination, however. He also was one of the most highly paid artists commissioned to work on the grand decorations for the meeting of the Order of the Golden Fleece in 1468 organized by Charles the Bold, as well as those for his wedding celebration the same year. There is also evidence to suggest that Van Lathem painted on panel as well, but no paintings by his hand have been firmly identified.[3]

Although Van Lathem was an accomplished and highly sought after painter of devotional books, he is equally well known for his illuminations in some of the most celebrated secular manuscripts produced in the period. Besides the Getty *Gillion,* he painted an ambitious *History of Jason* [*Histoire de Jason*] (Paris, BnF, Ms. fr. 331) and the frontispiece for a copy of Pseudo-Aristotle's *Secret of Secrets* [*Secret des secrets*] (Paris, BnF, Ms. fr. 562), all for Louis of Gruuthuse, who was clearly an admiring patron.[4] Van Lathem also contributed to an ambitious four-volume copy of Jean Froissart's *Chronicles* [*Chroniques*] for Anthony of Burgundy featuring more than two hundred miniatures (Berlin, Staatsbibliothek, SPK, Ms. Dep. Breslau 1, vols. 1–4). Van Lathem's artistic vision was so widely admired that his works were emulated by an entire generation of artists to follow, with illuminators influenced by his compositions, figure types, and narrative flair.[5]

Van Lathem's unique style is instantly perceptible in the Getty *Gillion*. The last half-page miniature in the romance (plate 43; pp. ii–iii) shows his extraordinary range of powers. It depicts Gillion's wife Gracienne taking leave of her father the sultan as she embarks on her new life. Gillion stands between his twin sons, both of whom tip their hats in respect as Gracienne embraces her elderly father.[6] To the right, Gillion's entourage readies for the journey ahead, the restive horses jockeying for position. The distance they must travel from Cairo to Hainaut is suggested by the winding paths, steep cliffs, and twisting river that leads the viewer into an expansive background. Touches of color add brilliancy to the image—the clear blue of the distant hills, the flashes of bright yellow and red in the clothing, and the fresh greens of the near landscape. The castle, crenellated wall, and garments are lovingly visualized and would have been familiar to contemporary viewers of the manuscript as echoes of their own fifteenth-century surroundings. It was common in manuscripts of the period to depict the events described, even ones taking place in the distant past, cloaked in details associated with the present. In this way, viewers could more easily make a connection between their own experiences and the stories portrayed.[7] In the case of the *Gillion* romance, an additional draw of the story was its setting in the exotic East, so Van Lathem also incorporated references that would have captured the imagination of his audience, such as the camel to the far right and the alluring turbans and other headgear of the members of the Egyptian court.[8] The artist's magisterial borders, known for their exceptional grotesques, also play an integral role in the impact of the page. Knights and a barefooted peasant seem to be almost overwhelmed by lush greenery as they battle with the outsize leaves and flowers that twist around them, while birds pluck at the encircling vines. The entire page becomes a tour de force of dramatic tension.

In addition to the eight elaborate larger images in the manuscript, there are also forty-four historiated initials. Despite their small size, the narratives in these initial scenes are often nearly as ambitious as the larger scenes. Near the beginning of the manuscript, a scene of Gillion with his wife is depicted in a historiated initial *A* (plate 3). Gillion and Marie appear at a double window, tenderly touching hands.[9] Below them a tiny family of fish inspires a sense of jealousy in the couple who cannot conceive. To the left is the wall of their castle and extending beyond it is a landscape of great breadth and distance, vanishing into a hazy horizon. These details seem all the more astounding when considering that the entire scene is just over 1 inch (2.5 cm) in height. Although the finesse and exceptional execution of this initial indicate that it was painted by Van Lathem himself, it is difficult to compare the style of the initials directly to his work in the miniatures of the Getty *Gillion* because of the difference in scale. It is perhaps fairer to compare the initials to the images found in the Prayer Book of Charles the Bold, which are more equivalent in size (figs. 15, 16). The figures in these two images are very close in actual dimensions. They show the same visible paint strokes in the ruddy-cheeked faces, elegant hand movements, and overall aspect of finish. Therefore, it seems likely that the highest-quality initials in the Getty *Gillion*, such as the two discussed above, are the work of Van Lathem. However, other initials exhibit less subtlety and ability, making it complicated to determine whether Van Lathem painted only some of the initials himself, and left others to his workshop, or the exigencies of time and the ambition of the project resulted in the artist producing initials of mixed quality, the latter being the scenario I consider most likely. If Van Lathem was not responsible himself for all of the initials, he doubtless was personally involved in their planning and execution.

Codicology of the Manuscript

The Getty *Gillion* contains one of the most extensive narrative sequences of illumination Lieven van Lathem ever created for a secular project.[10] However, several anomalies that come to light upon close examination of the manuscript indicate that the plan was originally less extensive than what was eventually executed at the time and that the completed plan was more extensive than what remains in the manuscript today. Study of the various aspects of the codicology of the manuscript (the physical evidence of its creation) will make it possible to determine a great deal about the manuscript's program of illumination, how it changed at the time of its painting, and how it was altered over the centuries since.

One of the unusual aspects of the Getty manuscript is the incorporation of historiated initials into the scheme of decoration. Certainly historiated initials are familiar in Van Lathem's work in general. They are, in fact, present in two early works associated with him: a book of hours decorated probably sometime between 1455 and 1460 (Cambridge, Fitzwilliam Museum, Ms. 143)[11] and a prayer book completed around 1460 (Stuttgart, Württembergische Landesbibliothek, Cod. Brev. 162).[12] In both books, full-color initials appear opposite full-page illuminations.[13] The Getty *Gillion* is, however, the only secular manuscript in which Van Lathem included historiated initials. In this time period it was unusual for narrative

FIGURE 15

Lieven van Lathem, *All Saints*, from the Prayer Book of Charles the Bold, 1469. Los Angeles, JPGM, Ms. 37, fol. 43 (detail)

FIGURE 16

Lieven van Lathem, Initial *Q: Gillion Receiving the Pope's Blessing*, from *Romance of Gillion de Trazegnies*, 1464. Los Angeles, JPGM, Ms. 111, fol. 19 (detail)

historiated initials to appear in secular manuscripts,[14] and they were, in fact, not part of the original plan of the Getty *Gillion*. This idea, first introduced by Scot McKendrick,[15] receives confirmation from careful investigation of several aspects of the pages. It seems clear that, originally, the manuscript was planned to have a series of large miniatures surrounded by borders for select chapters of the story, with the chapters not chosen for this treatment to receive a gilded and painted initial three or four lines high to mark the beginning of the new section. For example, the reverse of fol. 14 (plate 5, fig. 17), where a four-line-high historiated initial *A* now introduces chapter 4, retains evidence of a three-line-high initial *A* that did not extend nearly so far into the gutter of the book. Two sets of gilding can be seen quite clearly as shadows, one set within the other. The inner one was the original, smaller decorated initial that was painted over, while the outer one is the outline of the initial in gold now visible on fol. 14. There is evidence of these ghost initials throughout the beginning of the manuscript, with the last one seen on fol. 19. The manuscript is constructed as a series of gatherings, or stacked sets of folded sheets of parchment (see Appendix 3 for a description of the structure of the manuscript). Fol. 19 is found within the third gathering of the thirty-three that compose the manuscript. That the smaller gilded initials evident beneath the current historiated initials cease to appear after fol. 19 suggests that the plan for the manuscript was altered to include narrative historiated initials rather than simple decorated initials relatively early in its creation.

What is interesting to note is that the change in plan, while coming early in terms of its illumination, was decided upon only after the text had been fully completed: the text of manuscripts was almost always written out before the illuminations were painted, with empty space left for images at the appropriate locations. That the text for the Getty *Gillion* was completed before it was decided to incorporate historiated initials can be inferred from changes made in the written text, such as the one on fol. 14 (plate 5). Here, to make room for a historiated initial four lines high in a space originally left for a three-line-high decorated initial, the text originally occupying the fourth line had to be placed elsewhere. The scribe therefore added additional letters at the end of the previous line and then squeezed the letters "*co[m]*" in front of "*paigne*" on the next line to complete the word "*compaigne*." This kind of letter jockeying occurs until the very last historiated initial on fol. 235, always implemented by someone other than the original scribe. Sometimes a scribe would try to match the original script; sometimes little attempt was made to blend the old and new. In the example of fol. 170v, not only are the letter forms clearly different, with extra curls and a different slant to the script, but the ink itself appears much blacker, with the original lettering faintly visible underneath (fig. 18).

There were therefore two distinct phases in the production of the Getty *Gillion*. The first was for a manuscript with large miniatures at selected chapter openings, and then after the text was written out, in a second phase, historiated initials were added at all other chapter openings, considerably extending the narrative impact and luxurious feel of the manuscript. It may indeed be that when the decision was made to expand the illumination program of this secular manuscript, historiated initials came quite easily to Van Lathem's mind because he had already worked with them in earlier, devotional manuscripts.

FIGURE 17

Text page, from *Romance of Gillion de Trazegnies*, 1464. Los Angeles, JPGM, Ms. 111, fol. 14v (detail)

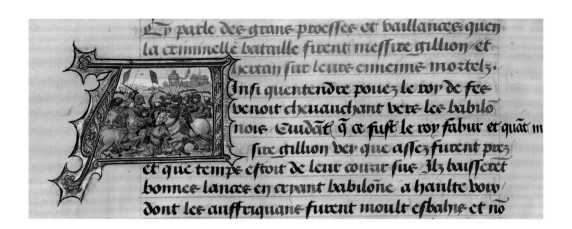

The addition of historiated initials to the Getty *Gillion* greatly enlarged the visual narrative content of the manuscript. However, the extant eight large miniatures and forty-four historiated initials do not represent the full extent of the expanded plan. Because the original foliation of the manuscript survives in the upper right corner of each page, it is a simple matter to determine how many folios are missing:[16] thirty-three. In addition, because the table of contents, essentially a chapter list,[17] is complete, and because every chapter division originally received some kind of illumination, it is also a simple matter to determine how many images are missing: seventeen. Sometimes a single leaf with an image is missing, and sometimes additional surrounding leaves of text are missing as well (see Appendix 3). What is not immediately evident is how many of those missing images would have been miniatures and how many would have been historiated initials. There are, however, several sets of clues that can help reconstruct the original program.

The first indicator is to account for the missing text. To determine how much text of the Getty *Gillion* is missing at various points, it can be compared to the Dülmen copy of the text.[18] As Stahuljak discusses in her essay, the Getty *Gillion* differs from the Dülmen copy of the text in extent. Although the story line and division of chapters are very similar, the choice of words and word order are often different, so that, generally, the Getty text is longer by a few words in every sentence. Therefore, a calculation of the number of words missing from the Getty manuscript must take this difference, into account, as there are likely more words missing from the lost leaves of the Getty manuscript than are represented in the corresponding portions of the extant Dülmen text. What is important is the *comparative* number of words missing for each folio of text. In general, where there is a single missing folio of text in the Getty manuscript, there is usually either around 350 (or less) or 450 (or more) missing words according to the Dülmen manuscript. As each miniature tends to take up about twelve lines of text, which works out to around 100 total words, it seems logical to deduce that for the folios where about 350 words of text (or less) are missing, there would have been a miniature, and where about 450 words of text (or more) are missing, there would have been a historiated initial. This approximation theory can be tested. Fol. 215 begins with a four-line decorated initial, and there is no jockeying with the words at the end of the lines, indicating that it was always intended to be a four-line decorated initial. The only place where large decorated initials appear elsewhere in the manuscript is immediately following a large miniature (cf. plate 35), so it can be concluded that a large miniature must originally have faced fol. 215. A comparison to the Dülmen text indicates that 355 words are lacking at this point. Therefore, a missing folio with a miniature corresponds to

about 350 missing words of text. This approximation theory can be applied in other places where a single folio is missing. Using it, we can account for five missing historiated initials[19] and three miniatures.[20] In some places, however, multiple leaves in a row are missing (see Appendix 1), and on one occasion, the Getty text differs so widely from the Dülmen copy[21] that it is not possible to use the missing numbers of words to determine what might have been there. In these cases, other methods will be necessary to help establish what is missing.

The next clue in differentiating between missing miniatures and historiated initials is the indication provided by offset, traces of pigment or impressions of decoration transferred to the facing page over time. An existing example can be found at fols. 36v–37 (plate 13, fig. 19). The shadow of the decorated border is clearly evident on the facing page in the margins. Especially distinct are the border lines at the bottom and the offsets of dots that were gilded. Faintly visible along the right-hand side of fol. 37 is the cross that would have originally decorated the shield that the lion holds on fol. 36v (there are actually two crosses, just as on Louis's arms, but only one is clearly visible without magnification). The cross was part of the coat of arms of Louis of Gruuthuse (see fig. 1) that was overpainted by a later owner, but not before the silver leaf of the cross oxidized, leaving an imprint on the facing page. If fol. 107v (fig. 20) is then considered, the same faint cross is visible, along with other evidence of offset, including traces of blue paint in the margin near the offset cross that were transferred from a decorated border opposite. Facing this page, then, would have originally

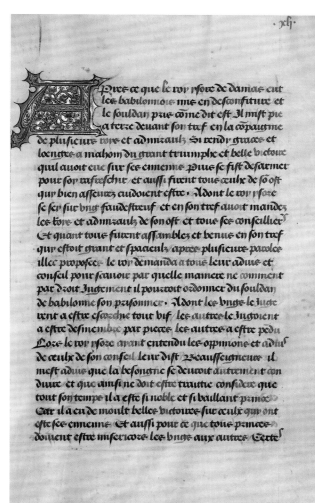

FIGURE 21

Table of contents page, from *Romance of Gillion de Trazegnies*, 1464. Los Angeles, JPGM, Ms. III, fol. 4

FIGURE 21A

Table of contents page, from *Romance of Gillion de Trazegnies*, 1464. Los Angeles, JPGM, Ms. III, fol. 4 (detail)

FIGURE 21B

Table of contents page, from *Romance of Gillion de Trazegnies*, 1464. Los Angeles, JPGM, Ms. III, fol. 4 (detail)

been a large miniature with a border featuring the arms of Louis of Gruuthuse. Similar offsets (although without evidence of the coat of arms of Louis of Gruuthuse, because only selected miniatures were accompanied by his arms) can be seen on fols. 24, 117v, and 232, where, we can deduce, large miniatures once appeared opposite.[22] The folios where a historiated initial was posited show no evidence of offset on the facing page in the margins, a finding that accords with the knowledge that the folios with historiated initials did not have surrounding borders.

Finally, information gleaned from the table of contents can be brought to bear (fig. 21). It is constructed so that the rubric for each chapter (a kind of resume of the text of the chapter, which is also repeated in red introducing the actual image in the manuscript) is copied out in its entirety and followed with the folio number where it is to be found in the manuscript, written in red. In the margins to the right of the rubrics are small faintly visible Roman numerals written out in a light brown ink in an informal script (fig. 21a). These acted as guides to the rubricator, who copied them in red in a formal script into the text block to indicate the chapter number associated with each rubric. In the margins to the left, small boxes are occasionally visible (fig. 21b), which I posit were used to indicate where a large miniature was placed.[23]

The boxes seem to be traced in the same ink used for the small Roman numerals in the right margins, so they may well have been recorded at the time of the manuscript's creation. Some are visible only through magnification (fig. 22, very faint at far left), as they were clearly not intended to form part of the visual design of the page but were a private notation system. In

FIGURE 22

Table of contents page, from *Romance of Gillion de Trazegnies*, 1464. Los Angeles, JPGM, Ms. III, fol. 5 (detail)

a few places boxes are missing although we know a miniature appears; notably this occurs on the first page of the table of contents.[24] Of the eight extant large miniatures, six have a box associated with them. The folio missing between fols. 214 and 215, where a large miniature is known to be missing (see above), has a box indication next to its chapter in the table of contents. Four additional boxes appear in the table of contents where there are missing leaves, all but one of them where either the number of words missing or an offset already indicated there was a large miniature.[25]

None of these three methods can be used independently as a definitive indicator of the presence of large miniatures or historiated initials in the original manuscript, but by combining the information provided by all three sets of clues within the manuscript, we can with some confidence conclude that the program would have been augmented by six additional miniatures and eleven historiated initials.[26] The original complement of the manuscript would then have been fourteen miniatures and fifty-five historiated initials, a remarkably ambitious program of illumination. With this information about the placement of the miniatures both surviving and postulated, we can take a moment to consider the original scheme of illumination for the manuscript, before the decision was taken to incorporate historiated initials. The visual story as told solely by the miniatures created a logical narrative arc that hit on the most important elements of the story: (1) the author-translator finds the text (fol. 9, author's prologue); (2) Gillion is captured by Saracens (fol. 21, chap. 8); (3) Gillion is visited and comforted by Gracienne in prison (missing, chap. 14); (4) Gillion saves the sultan (fol. 36v, chap. 19); (5) Gillion heads the Saracen armies (fol. 49v, chap. 23); (6) Gillion's twin sons join in the defense of Cyprus and gain fame in a battle against the Saracens (missing, chap. 37); (7) Gillion's twin sons participate in the Saracen defeat in Cyprus (missing, chap. 40); (8) Gerard fights Lucion for Natalie (fol. 134v, chap. 45); (9) Gracienne is accused of improper relations with Gillion (fol. 150v, chap. 47); (10) during a judicial duel before Tripoli, the twins recognize each other after having been separated (missing, chap. 49); (11) Gillion finds the twins during battle (fol. 177, chap. 53); (12) Gillion, his sons, and Gracienne leave the East (fol. 188v, chap. 54); (13) Gillion's return to Egypt to support the sultan and preparations for the final battle before Cairo (missing, chap. 63); and (14) Gillion's death (missing, chap. 67). Reconstructing the missing miniatures lets us see how the original plan was a visual summary of the plot. Indeed, the intent of miniatures was to draw attention to particular moments, but the addition of illumination was also meant to help the reader-viewer navigate the different sections of the manuscript with ease. Given the subjects of the miniatures, it would have been possible to simply scan the large images across the manuscript to understand the major elements of the story from beginning to end.

One additional note concerning codicology can be made by looking at the gathering map (see Appendix 3), where a pattern emerges once the distribution of missing miniatures and historiated initials has been determined. For the most part, the large miniatures were cut out as single folios, but where historiated initials are missing, they were often on conjoint bifolia or within larger missing sections of the manuscript.[27] It is relatively easy to remove the central bifolio of any gathering from a bound manuscript without disturbing the rest of the gathering. Removing any of the other bifolios, however, or sets of leaves that extend across multiple gatherings, would be quite a difficult maneuver. Nancy Turner, conservator at the J. Paul Getty Museum, has suggested that the manuscript was likely disbound when the leaves were removed. Unfortunately, we do not know at what point in the manuscript's history the leaves were removed, but we do know that the current binding dates from the

early nineteenth century, so it must have been before then.[28] The manuscript was in the collection of the kings of France after Louis of Gruuthuse's death, but it disappears from the royal inventories after 1518[29] and does not reappear until it was recorded in the beginning of the nineteenth century in the collection of the sixth Duke of Devonshire (1790–1858). It seems probable that the images were removed during the process of rebinding, sometime after it left the royal French collection.

Comparison with the Dülmen *Gillion*

Physical examination of the manuscript has provided information about the missing leaves and the likely size of the lost images, but further information about the Getty *Gillion* can be gleaned from a comparison of its illuminations with those of the Dülmen manuscript, the only other extant illuminated copy. They were written within one year of one another by the same scribe, David Aubert (or workshop),[30] utilized aspects of the same compositions (see Appendix 2), and are related stylistically. It will become clear from comparing the two manuscripts that Lieven van Lathem was intimately aware of the copy made for Anthony of Burgundy (Dülmen manuscript) when he created the illuminations for the Getty *Gillion*. However, a close comparison of figure types, compositional structures, and other stylistic features indicates that while the images in the two manuscripts are closely linked artistically, Van Lathem was not in fact responsible for the illuminations in the Dülmen manuscript. Nevertheless, the narrative approach taken in the Dülmen manuscript can shed light on the corresponding images in the Getty *Gillion*. Because the program of illumination is complete in the Dülmen manuscript, and some of the images there occur at exactly the points where illuminated pages are missing from the Getty *Gillion*, the Dülmen example can also help fill in some of the lost pieces of the Getty manuscript.

The Dülmen manuscript has long been associated with Van Lathem, but scholars have differed on whether it is actually his work.[31] Comparing the two manuscripts can offer points of evaluation that shed light on their artists.[32] At first glance, the images in the two manuscripts seem close in style. The figures move with a pleasing grace and a supple elasticity that is one of the most recognizable aspects of Van Lathem's work. Moreover, the articulation of the figures and their general disposition in interiors and against landscapes are clearly related to the style of Van Lathem. On closer observation, however, it can be seen that the execution of the illuminations in the Dülmen manuscript does not quite match Van Lathem's work. One of the most revealing comparisons is the depiction of battles at sea (lower half of fig. 23, plate 9).[33] The Dülmen scene features three ships centered and stacked diagonally in the water. A strip of water separates the boats from the front of the composition, and the boats are equidistant from both edges of the composition. The waves are represented as uniform eddies around the boats, curving in a homogeneous pattern around the prows. The soldiers are homogeneous as they battle one another. In the Getty scene, there is a sense of the confusion of combat up close and personal. The left-hand boat seems in danger of washing up over into the viewer's space, almost touching both the front and the left of the miniature's border,[34] with individual figures clearly visible. Soldiers fall over the sides of the boat and drown in the sea, as blood spreads in circles around the dead bodies. The real star of the scene, however, is the water itself, which rushes up the sides, undulating and splashing amid the action. The water also provides a medium for reflection in the Getty scene, where the shadows created by the boats are distinctly evident in a way that they are not in the Dülmen manuscript.

FIGURE 23

Workshop of Lieven van Lathem, *Battle before Nicosia; Gillion's Sons Attacked by Saracen Pirates*, from *Romance of Gillion de Trazegnies*, 1463. Dülmen, private collection, fol. 128 (detail)

FIGURE 24

Workshop of Lieven van Lathem, *Battle Scene; Gillion Defeating the Emir of Orbrie*, from *Romance of Gillion de Trazegnies*, 1463. Dülmen, private collection, fol. 51v (detail)

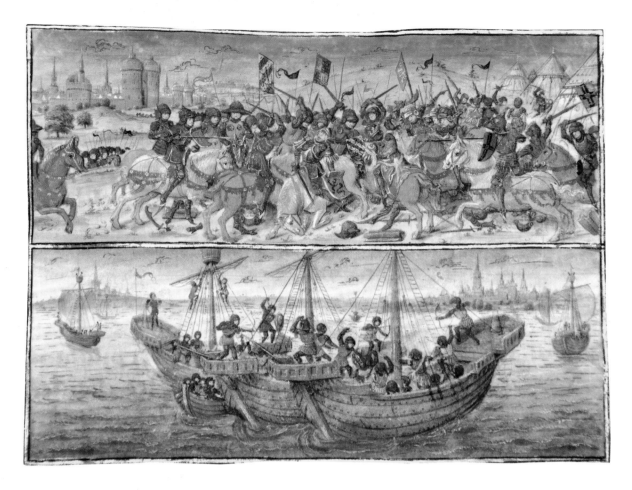

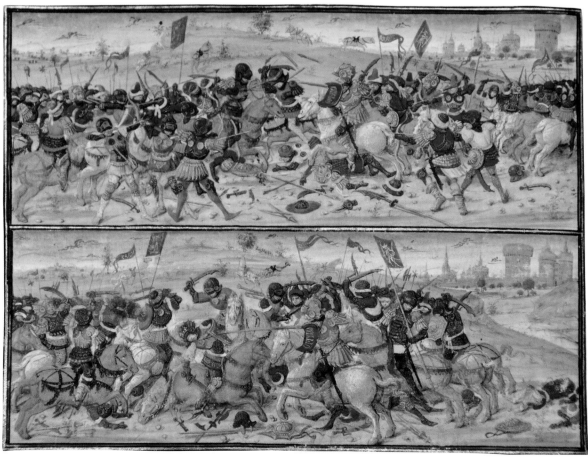

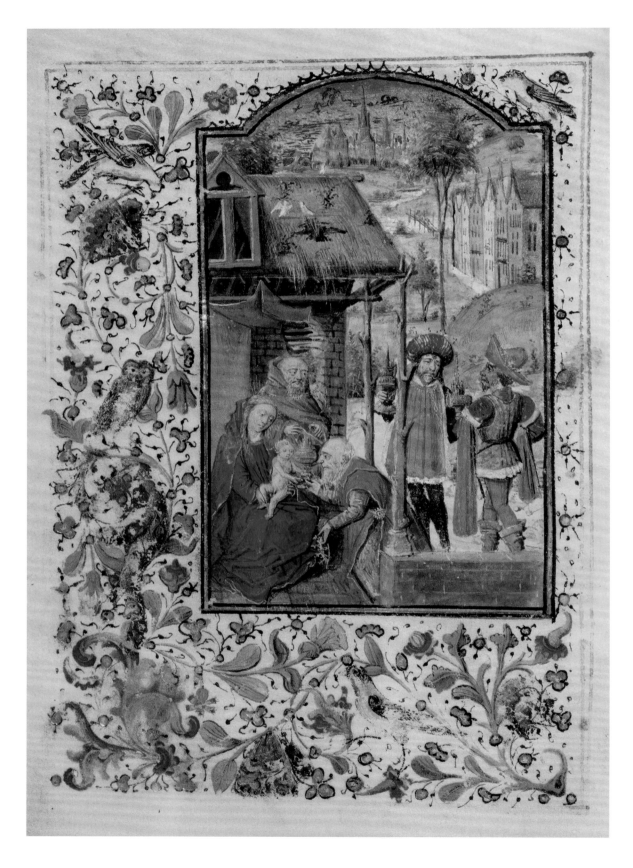

FIGURE 25

Lieven van Lathem, *The Adoration of the Magi*, from a book of hours, ca. 1465–80.
Paris, BnF, Ms. n.a.lat. 215, fol. 101v

Further compositional and stylistic differences between the two manuscripts are easily discernible in comparable miniatures (fig. 24, plate 42). The scenes in the Dülmen manuscript are more static, with a sense that the viewer is safely separated from the action. They have a panoramic effect that is absent from the Getty images. In the Getty manuscript, instead, the action scenes are pressed up against the picture plane, with an abrupt, dramatic disparity between the foreground and background. The landscapes in the Dülmen manuscript feature gentle rolling hills rather than the towering cliffs and atmospheric effects seen in the Getty manuscript. Moreover, there is a sameness to the figures participating in the action in the Dülmen manuscript, presented as a single melee, whereas the main characters in the Getty manuscript are individualized, even in battle scenes, and in most cases labeled with tiny script (plate 42; pp. 60–61).

The two manuscripts exhibit not only compositional and stylistic differences but also significant variations in format. The nine miniatures of the Dülmen manuscript are structured as a series of separate images in horizontal bands or multicompartment arrangements. This format is almost unheard-of at this period in Flemish manuscript illumination;[35] it is instead associated with much earlier manuscripts.[36] Because the *Gillion* story is supposed to be taking place in a bygone era, it is possible that this format was deliberately chosen to bring a sense of anachronism to the manuscript, enhancing the impression of the distant past already established by the text. In this regard it is interesting, as discussed above, that the Getty *Gillion* is also unusual in terms of its incorporation of historiated initials in a secular text, a practice more common in illuminated secular manuscripts of centuries past. Although it has been shown that their presence was an expedient solution to the problem of adding more narrative imagery to an already completed text, the use of historiated initials nonetheless created a sense of anachronism in keeping with the Dülmen manuscript. Neither multicompartment miniatures nor historiated initials are seen anywhere else in the secular productions of Van Lathem or any such manuscripts illuminated by his workshop. These distinctions set these two manuscripts apart, but at the same time, tie them together.

One additional element for discussion is the Dülmen manuscript's borders. Van Lathem's manuscripts are celebrated for their opulent borders, teeming with realistic flowers, romping animals, and lively figures. Every manuscript that Van Lathem was responsible for contains similar borders;[37] the main elements are evident even in the earliest manuscripts ascribed to him from before 1460.[38] The Dülmen manuscript features borders only along the outer side of the miniatures, with the coat of arms of Anthony of Burgundy surrounded by traditional vine scrolls and occasional sprays of flowers. By contrast, the Getty borders are bursting with life and vitality. They surround the miniatures on three sides, with either just a line or a narrow border of repeated flowers along the inside edge (plates 9, 42). This rather unusual configuration, fully utilizing only three sides, can be seen in other manuscripts by Van Lathem, both devotional and secular (fig. 25; see also fig. 13).[39] The borders in the Dülmen manuscript lack the lush feeling of the typical Van Lathem borders, making it again unlikely that Van Lathem himself was the painter of the Dülmen manuscript.

Nevertheless, Van Lathem must have been well aware of the Dülmen *Gillion,* and given the close correspondences between the manuscripts, it may well be that he was integral to its design. The similarities between the Dülmen and Getty manuscripts are both large and small. Stahuljak discusses some aspects of the related frontispieces (plate 1, fig. 5). The four moments depicted in the Dülmen *Gillion* frontispiece move from top to bottom in two vertical strips. In the top left image, the author-translator encounters the monks who tell him about the

existence of a volume relating the story of Gillion de Trazegnies. Beneath it, the author translates the book into French in his study. At the upper right, the story of Gillion begins with the marriage of Gillion and Marie. Below right, Gillion prays in an oratory on the left, while on the right, the childless couple look jealously at the fish family. The Getty frontispiece, by contrast, is conceived as a single, integrated continuous narrative that focuses solely on the discovery of Gillion's story.[40] Within a painstakingly detailed church interior, the triple tomb of Gillion and his wives is placed prominently before the viewer. In the background, the author, who is dressed in a red cap and blue *cotte*, hears the story from the abbot. Next to the tomb, the author appears again, conversing with the monks about the small volume in Italian that recounts Gillion's story. Finally, the author retires to his study in the background at right, where he eagerly translates the remarkable story into French to make it better known.

In the Getty manuscript, the actual story of Gillion and Marie as seen in the second column of the Dülmen frontispiece is deferred to the first three historiated initials (plates 2–4). In the twin images featuring the couple looking at the fish family, both castles are depicted in a shade of pink with a projecting room to the right and a towered portion to the left behind, leading to a drawbridge. In both images the couple is framed under a double-arched window above a set of two windows blocked by iron bars. Despite the fact that the Dülmen image with the castle is larger in size than the corresponding historiated initial in the Getty manuscript, the Getty image shows more attention to detail in the treatment of both the figures and the landscape. In the Dülmen manuscript, Marie and Gillion are separated by the column dividing the window into two. In the Getty manuscript, Gillion reaches around the column to touch Marie's hand, adding to the sense of the bond between the couple. Meanwhile, the castle itself is convincingly reflected in the shimmering water below, while the Dülmen manuscript does not include these naturalistic effects. Similarly, the backgrounds differ significantly in terms of handling. The Getty landscape recedes into the distance, with the added strip of grass at left and the flock of birds in the sky wheeling up in formation assisting in the illusion. By comparison, the landscape in the Dülmen manuscript seems more traditional.

While these differences in style highlight the attribution to different artists, there nonetheless remains a strong underlying relationship between the images. In addition to the images discussed in detail above, numerous other images closely link the two manuscripts.[41] In each case, an image from a multiple set in the Dülmen manuscript is separated from its larger context and isolated in the Getty volume. This pattern of borrowing from the Dülmen manuscript occurs throughout the Getty manuscript, not in the case of every one of the nine sets of miniatures in the Dülmen volume but with enough consistency to provide conclusive evidence of their close connection (see Appendix 2). The correspondences in color, disposition of major elements, and details make it virtually impossible that Van Lathem was not intimately familiar with the Dülmen manuscript. Since the scribe dated the manuscripts only one year apart, it is feasible that the Getty manuscript was being written out at the same time that the Dülmen manuscript was being illuminated. After all, Louis of Gruuthuse and Anthony of Burgundy were both in Bruges in 1463–64, as Stahuljak explains.[42] And because the manuscripts are related so closely, it seems likely that an artist in Van Lathem's workshop illuminated the Dülmen manuscript under his direction or that Van Lathem produced a set of preparatory sketches that were utilized for both manuscripts.[43] In any case, the correspondences between the two manuscripts provide a rationale for reconstructing some of the images missing from the Getty *Gillion*.

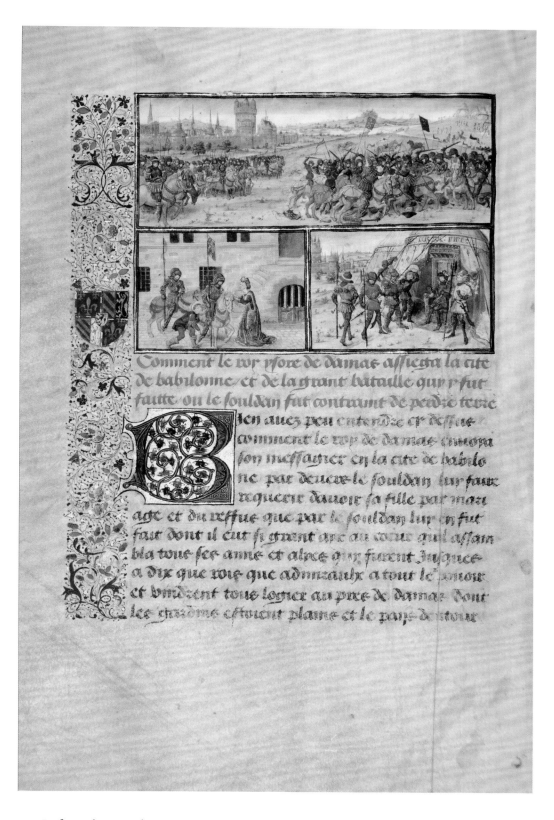

In four places in the Getty manuscript a missing historiated initial or miniature parallels a miniature that is present in the Dülmen manuscript (see Appendix 2 as well as the section of plates where the missing rubrics from the Getty manuscript are translated and the stories concerning the surrounding images are described). In these cases the imagery of the Dülmen manuscript can suggest what would have been in the Getty manuscript. The first place is the miniature on fol. 27v of the Dülmen manuscript (fig. 26). One panel depicts the story of King Ysore's attack on the sultan. When the battle goes badly for the sultan, his daughter,

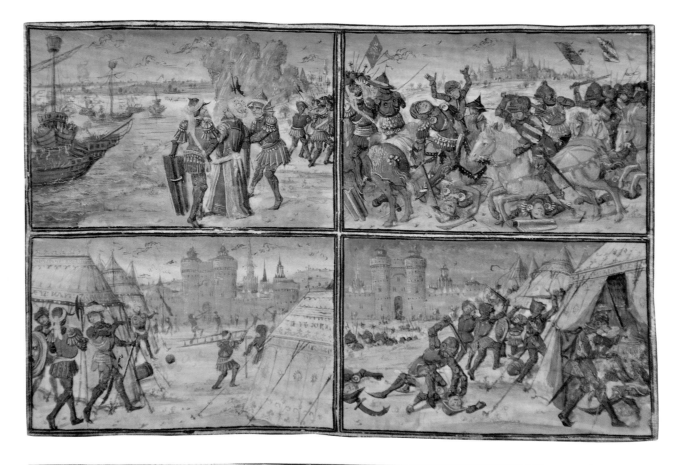

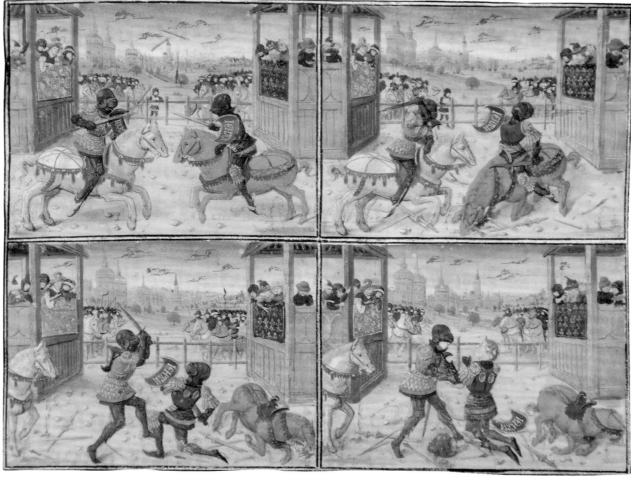

Gracienne, releases Gillion from prison so he can go to her father's aid. The third scene shows the sultan being brought before King Ysore in shackles. The Getty manuscript is missing a historiated initial for the chapter that describes Gillion being released by Gracienne (between fols. 29 and 30). It seems likely that the image of Gracienne beseeching Gillion's help as he is mounted on his horse is the dramatic moment that would have been transferred to the Getty volume to illustrate the same chapter. Likewise, fol. 109 in the Dülmen manuscript (fig. 27) corresponds to a missing leaf in the Getty manuscript (between fols. 107 and 108) where a large miniature would have been present. It is difficult to know which of the four scenes in the Dülmen manuscript would have been the basis for the missing Getty illumination, but since the missing rubric talked about the battle before Nicosia in Cyprus, in which Gillion's twin sons performed prodigious feats of arms, it is likely that there would have been another panoramic battle scene related to the one seen in the upper right-hand corner of the Dülmen folio, possibly with aspects of the other three scenes incorporated somewhere in the miniature (as is the case with fol. 49v, plate 17).[44] A similar battle scene is likely missing in the Getty manuscript between fols. 117 and 118, probably based on the upper register of the image on fol. 128 of the Dülmen manuscript, given that the rubric again concerns a battle (see fig. 23). The historiated initial following this missing folio in the Getty manuscript shows three ships engaged in a sea battle (plate 31), much like the lower register of the Dülmen manuscript. The last miniature that is possible to reconstruct would have originally appeared between fols. 159 and 160 of the Getty manuscript and corresponded to the miniature on fol. 177 of the Dülmen manuscript (fig. 28) depicting the battle between Gillion's two sons, who, hidden by their armor, are unaware that they are fighting each other. The historiated initial of the Getty manuscript on fol. 164v shows the denouement of the battle, when the brothers recognize each other (plate 39). So it is likely that the previous miniature would have been based on one of the three previous quadrants of the Dülmen image showing the battle in progress. Because the Getty manuscript contains many more images than the Dülmen manuscript, only where images missing from the Getty *Gillion* correspond to miniatures from the Dülmen copy is it possible to say with any degree of confidence what might be missing.

Dating the Getty *Gillion*

The date recorded at the end of the dedicatory prologue to the Getty manuscript is 1464, just one year after the recorded date of the Dülmen manuscript, and their proximity in time could explain their close relationship. However, although there is no question that the writing of the Getty manuscript was undertaken in 1464, various aspects of the visual program indicate that it may have been illuminated in 1464 or may have been set aside for a number of years before being completed, perhaps sometime after 1470.[45] Disconcertingly, good arguments exist on both sides of the dating question, and it is difficult to suggest a single unified theory that accounts for all the facts. However, an evaluation of all the information will suggest that the earlier date of around 1464 seems the more likely proposition.

The dedicatory prologue's date of 1464 provides a starting point for consideration of the dating of the manuscript's illumination. Because the writing was always completed before the illumination, the artist must have worked on the manuscript sometime in 1464 or after. Typically, the illumination was completed soon after the writing. If it had been put off, the patron, Louis of Gruuthuse, would have had to pay the scribe for the finished work and then kept the written-out sheets for more than half a decade before deciding to have them finished. He was likely inspired to commission the work based on seeing or witnessing the

FIGURE 27

Workshop of Lieven van Lathem, *King Bruyant Burning His Ships in Cyprus; Gillion's Sons Battling King Bruyant; The Siege of Nicosia; Battle Scene with Gillion's Sons*, from *Romance of Gillion de Trazegnies*, 1463. Dülmen, private collection, fol. 109 (detail)

FIGURE 28

Workshop of Lieven van Lathem, *Four Scenes of the Judicial Duel between Gillion's Sons*, from *Romance of Gillion de Trazegnies*, 1463. Dülmen, private collection, fol. 177 (detail)

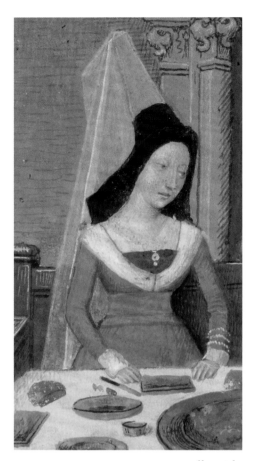

creation of the copy made for Anthony of Burgundy (Dülmen manuscript). As seen above, the two copies are intimately related on a number of levels, and if the manuscripts were being made in 1463 and 1464, and if they were both written out by David Aubert and illuminated in the workshop of Lieven van Lathem, then it becomes evident why their illumination schemes are so closely related. It may be that Van Lathem personally painted the illuminations on the Getty manuscript while simultaneously directing the work on the Dülmen copy, using similar compositional models for both.

In addition to this circumstantial evidence, which is based on a logistical model, there are also indications within the miniatures themselves that may help with dating: the costumes of the figures. As noted above, even though this text was describing events of a distant medieval past, the characters are dressed in contemporary Flemish fashion, which, as Margaret Scott has observed, changed just as rapidly as fashion today.[46] Fortunately in terms of dating the Getty manuscript, there were a number of significant changes in fashion around 1468–70.[47] Comparing two images, one from the *Gillion* manuscript and one from *The Visions of the Knight Tondal* [*Les Visions du chevalier Tondal*] (JPGM, Ms. 30), dated in the text to 1475, can help highlight these differences (plate 2, fig. 29). The women in the Getty *Gillion* wear dresses that are either loosely gathered in the front or feature slim belts. The garment of the woman in the Getty *Tondal* manuscript is tightly bound around the middle with a wide, fashionable sash. In the Getty *Gillion*, the women wear the tall steeple hats associated with the mid-1460s, noticeably without the black attachments called frontlets framing the face that came into fashion around 1468–70, as seen in figure 29. The garments of the women in the Getty *Gillion* also have long trains, a fashion abandoned in the 1460s (plates 2, 7, 27). For men's clothing, it is possible to compare the same image from the Getty *Gillion* to the *History of Jason* manuscript illuminated by Van Lathem, likely from after 1472 (see fig. 14). The rather simpler *cottes* of the men in the Getty *Gillion* contrast with the men in the second manuscript, who sport extra-long sleeves, slashed and then wound round the arms, with slashed doublet sleeves beneath, and white shirt sleeves on show beneath all that, as well as tall hats, styles associated with men's dress after about 1468–70 (see the male figure at far left in fig. 14). Costume elements worn by both men and women in images in the Getty *Gillion*, therefore, suggest a date closer to 1464 than after 1468–70.[48]

Given that the date recorded in the dedicatory prologue of the Getty *Gillion* makes sense both in the context of the date provided by the closely related Dülmen manuscript and the testimony offered by period clothing seen in the Getty manuscript, absent any other information, it would be natural to confirm the date of 1464. However, the evidence for dating the Getty *Gillion* to about 1470 or after is, in some ways, equally compelling. This argument results from a comparison with the same *Jason* manuscript considered above (see fig. 14). The complex narrative miniatures, the similar stylistic execution of the painting, and the closely comparable border styles suggest that the manuscripts were created at virtually the same time. A third manuscript also made for Louis, the *Secret of Secrets*, with a single miniature by Van Lathem (see fig. 13), shares all these features. Although neither the *Jason* nor the *Secrets* manuscripts are dated, the prologue to the *Jason* manuscript refers to Philip the Good in the past tense. Since Philip died in 1467, the manuscript must date after that time. In addition, it has been argued that the *Jason* text dates to after the death of Jean de Wavrin, a nobleman

FIGURE 29

Simon Marmion, *Tondal Suffers a Seizure at Dinner*, from *The Visions of the Knight Tondal*, Valenciennes, 1475. Los Angeles, JPGM, Ms. 30, fol. 7 (detail)

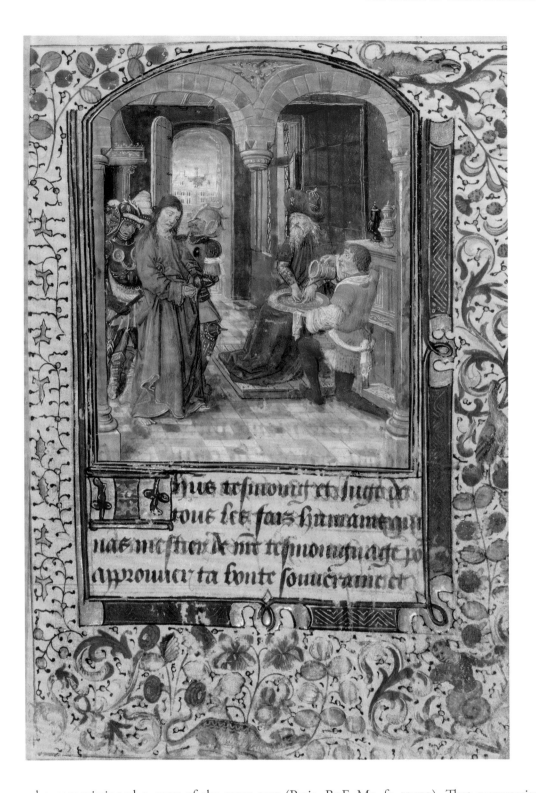

who commissioned a copy of the same text (Paris, BnF, Ms. fr. 12570). That manuscript breaks off about three-quarters of the way through the text and is completed in a different and hurried manner. It is thought that Wavrin's death sometime after 1471 (possibly as late as 1475)[49] caused this disruption. In turn, because the copy made for Louis of Gruuthuse seems to be based on Wavrin's manuscript, it has been suggested that Louis's *Jason* dates to around (or after) 1472 as well.[50] This dating would certainly be plausible given the costume that appears in its frontispiece (see above). The *Secrets* manuscript is then dated to the same period and, by inference, the Getty *Gillion*. It would seem reasonable that Louis of Gruuthuse might have worked very closely with Van Lathem in the years around or after 1470, perhaps

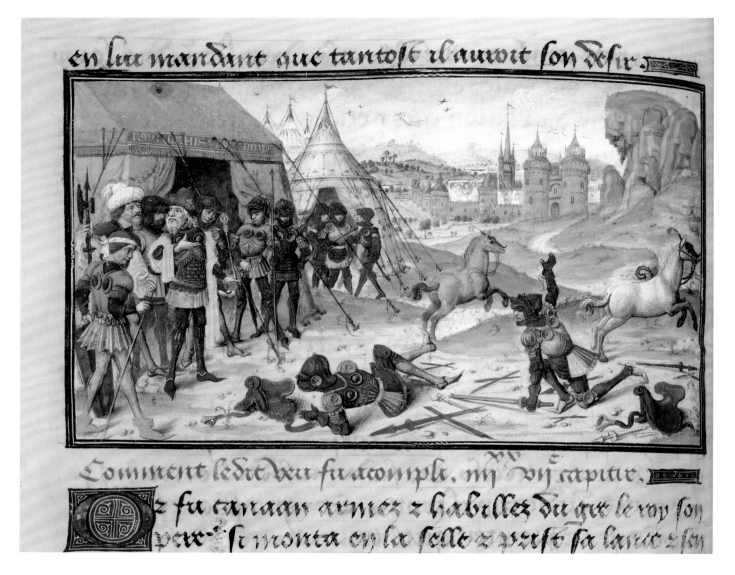

FIGURE 31

Lieven van Lathem, *Completion of the Vow of the Peacock*, from Jean Wauquelin, *Deeds and Conquests of Alexander*, before 1467. Paris, Petit Palais, Ms. Dutuit 456, fol. 94v (detail)

asking him to illuminate a written-out copy of the *Gillion* put aside for some reason, as well as the *Jason* and *Secrets* manuscripts. This logic would explain their correspondences and the overlap of patron and artist. Moreover, it is possible that the Getty *Gillion* was just having its decorated initials added at the beginning of the manuscript when the illumination was abandoned.[51] Then, when the manuscript was put into the hands of Van Lathem a number of years later, it was decided to change the scheme to include historiated initials rather than illuminated ones, based on Louis's ability to obtain the skills of one of the great narrative artists of the day.[52]

Despite the evidence that all three manuscripts should be dated around 1470–72, there are other aspects to consider. First is the fact that Van Lathem's style was fairly stable over the course of his career,[53] so that his manuscripts without any internal evidence for dating (such as being a commission by a patron with a known death date, such as Philip the Good) have been grouped by scholars together in the period 1470–80.[54] One useful comparison is the Prayer Book of Philip the Good painted by Van Lathem around 1462–65,[55] which contains a particular and unusual detail (fig. 30). The characteristic style of Van Lathem is evident, but above the scene is a two-arched stone entryway featuring an odd, columnless capital in the middle. It simply comes to a point and, where one would expect a column to descend, there is nothing. The same inexplicable columnless capital appears in the frontispiece to the Getty manuscript (plate 1). I know of no other examples in his works of the 1470s that feature this

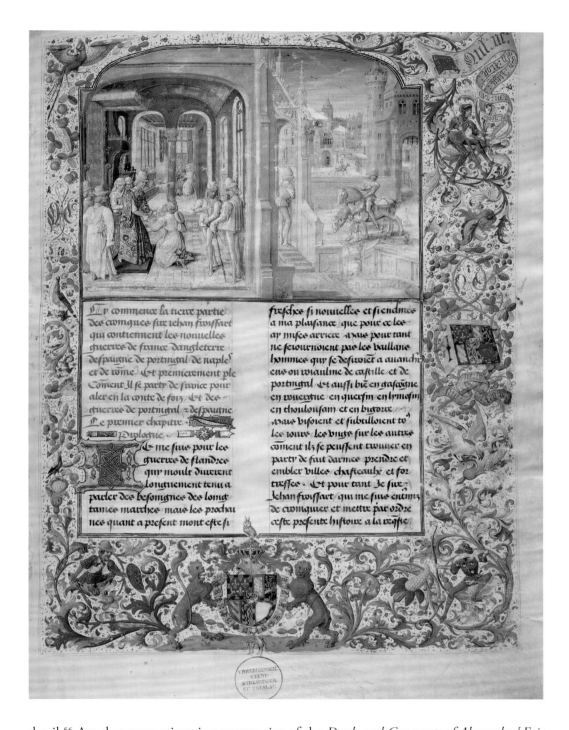

FIGURE 32

Lieven van Lathem, *The Presentation of a Book*, from Jean Froissart, *Chronicles*, ca. 1468–69. Berlin, Staatsbibliothek, SPK, Ms. Dep. Breslau 1, vol. 3, fol. 1

detail.[56] Another comparison is a manuscript of the *Deeds and Conquests of Alexander* [*Fais et conquests du noble roy Alexandre*] (Paris, Petit Palais, Ms. Dutuit 456) made for Philip the Good sometime before his death in 1467 and painted by Van Lathem (fig. 31), which is virtually identical in style to the Getty *Gillion*, including such aspects as a battle scene set in a dramatic landscape, inscribed tents, and facial types. Just slightly later is the four-volume copy of Froissart's *Chronicles* that Van Lathem illuminated for Anthony of Burgundy around 1468–69 (fig. 32). The composition of the frontispiece to volume 3 is clearly based on the same model as that for the frontispiece to the Getty *Gillion* (plate 1) and the *Jason* (see fig. 14). Although it is painted in a style referred to as semigrisaille, wherein part of the miniature is rendered in shades of gray and white mixed in with elements portrayed in full color,

the same, sure delicate figure style is in evidence, as well as the exuberant borders associated with both the *Gillion* and *Jason* manuscripts. Therefore, it seems more than possible that the Getty *Gillion* dates to the mid-1460s.

Unfortunately, there is a certain amount of conjecture in deciding on either date for the Getty *Gillion*. If the manuscript's images date to 1464, it is necessary to wonder why the commissions of Louis of Gruuthuse from Van Lathem would have been separated by so many years, as well as to explain the close stylistic and compositional links between the Getty *Gillion* and the two other manuscripts commissioned by Louis from Van Lathem around 1470–72.[57] If, however, the images date to 1470–72, it becomes necessary to introduce an odd lag between the writing of the Getty manuscript and its illumination.[58] In addition, it would be difficult to account for the seeming difference in dating between the dress depicted in the manuscripts. The latter choice, meanwhile, does not obviate the fact that the manuscript was commissioned by Louis of Gruuthuse in 1464, well before the dates usually associated with his collecting. It was clearly written and intended for illumination in 1464 whether the illuminations were completed then or not. In the end, the analysis becomes one of greatest likelihood against greatest complexity. More information helping to weigh the possibilities may come to light, but in the meantime, relying on the date of 1464 found in the Getty manuscript seems the more plausible of the choices.

Visual Narrative in the Getty *Gillion*

The most remarkable aspect of the illuminations in the Getty *Gillion* is the ambition and skill with which they visualize and enhance the dramatic story told in the text. In the eight surviving miniatures, Van Lathem adopted a number of different pictorial approaches, each deployed to best capture and interpret a particular point in the story. The historiated initials are often then intertwined with the miniatures to enhance the larger themes of the work as a whole. In both the miniatures and the initials, one notable aspect is the attention to the details of the story. It is clear that Van Lathem was deeply familiar with the text, choosing his visual narratives with care. As will be seen, these images were meant not merely to illustrate the tale but also to help shape the reader-viewer's experience of it.

The narrative approach in the first image of the Getty *Gillion* has already been briefly discussed in relation to the corresponding image from the Dülmen manuscript (plate 1, fig. 5). The story of the author-translator discovering the text of *Gillion de Trazegnies* is one of the few representatives of continuous narrative in the miniatures of the Getty manuscript.[59] It may indeed be that the quadripartite format encapsulating four distinct moments in the Dülmen manuscript provided the inspiration for the idea of incorporating several moments in the same image in the Getty *Gillion*. However, the rigid structure of the divided frontispiece in the Dülmen manuscript has been elided in the single, larger miniature in the Getty manuscript, with the chronology of moments treated fluidly in terms of space. First the author appears in a blue *cotte* and red hat talking to the abbot in the middle background of the image, inquiring about the tomb, which appears prominently in the foreground. A pair of gossipy monks stands to one side of the tomb, drawing attention to the unusual appearance of three figures carved on its surface. Then the author is seen again in almost the exact center of the miniature, holding the small Italian book that contains the original story. Then, in the far right background, he appears a final time, diligently translating the text into French. An inquisitive monk leaning on the parapet in the portico outside the church serves as a link between the two halves of the miniature. Van Lathem cleverly constructed the visual story as a series of rhythmic groupings

and structures that alternate between foreground and background, outside and inside, written and oral communication. The delicately painted faces mirror a variety of emotions, while the figures' naturalistic gestures and interactions create an effortless flow for the narrative. The focus of the Getty frontispiece solely on the story of the author is a marked change from the four moments chosen in the Dülmen manuscript, two from the story of the author, and two from the story of Gillion. By visually isolating the account of the discovery of the text from the story told within the discovered text, the Getty manuscript more closely reflects the actual text as it is presented in the manuscript. The author's prologue is presented from his perspective, in the first person, from the standpoint of the present, telling about the finding of a narrative from the past. It is completely distinct from the start of the actual story itself, in tone, perspective, and timing, and this distinction is reinforced by the frontispiece's directing attention to the author alone. The placing of a visual boundary between the author of the text and the story itself creates a frame for the rest of the manuscript. It also focuses attention on the creative process: just as the author was responsible for relaying the story that follows to readers, so the images performed a similar function.

An example of the artist's masterful narrative style in picking a single moment of overwhelming drama is the miniature that appears on fol. 150v (plate 37; detail on p. 62). King Haldin has become jealous of Gillion for being named head of the sultan's forces and desires to make trouble for him. He therefore accuses Gracienne of improper relations with Gillion and warns of the attendant possible terrible consequence in the eyes of her father of her abandoning Muhammad and converting to Christianity. In the miniature, the sultan sits enthroned at the center of the image. To the right, the evil King Haldin appears with sharp, unpleasant features, thrusting his finger forward and throwing down his gauntlet, accusing Gracienne and Gillion. On the left, Gracienne begins to kneel before the sultan, swearing to her innocence, while Gillion stands behind her with his hand drawn to his breast as if to say, incredulously, "Who, me?" The hatless figure behind Gracienne gestures toward Haldin, and this must be Gillion's faithful friend, Hertan, who will fight Haldin on behalf of Gracienne, since Haldin refuses to fight a Christian. The rubric that introduces this miniature does not discuss this emotional scene but describes the battle that follows it (see the translation accompanying plate 37), an anomaly among the rubrics, which usually reflect the contents of the miniature. The manuscript contains numerous other battle scenes, but Van Lathem decided here to deviate from yet another battle scene to focus instead on the interpersonal relations that create conflict. The opposing sides, the tension of the moment, and the reactions of the protagonists are all masterfully rendered.

In other miniatures, Van Lathem used subtle clues to imply multiple narrative moments in a single unified tableau. On fol. 134v, he depicted one of Gillion's twin sons battling a Saracen admiral named Lucion (plate 35). Just like his father, Gerard has fallen in love with a Saracen princess. Lucion, desiring the beautiful princess Natalie for himself, accuses her falsely of trying to poison her brother. Gerard agrees to fight Lucion to prove her innocence; if he fails, she will be burned at the stake. In the Dülmen manuscript, the events are depicted in a series of closely related tableaux (fig. 33).[60] In the Getty manuscript, Van Lathem let the story unfold in just one scene through carefully chosen details from each of the Dülmen scenes. At the center of the action are the two combatants. According to the text, Lucion had almost defeated Gerard when the young knight, inspired by the picture of herself that Natalie had ordered to be painted on his shield, cuts off Lucion's leg. The image depicts the two moments as one. Meanwhile, Natalie looks on from the left, where a pile of wood awaits

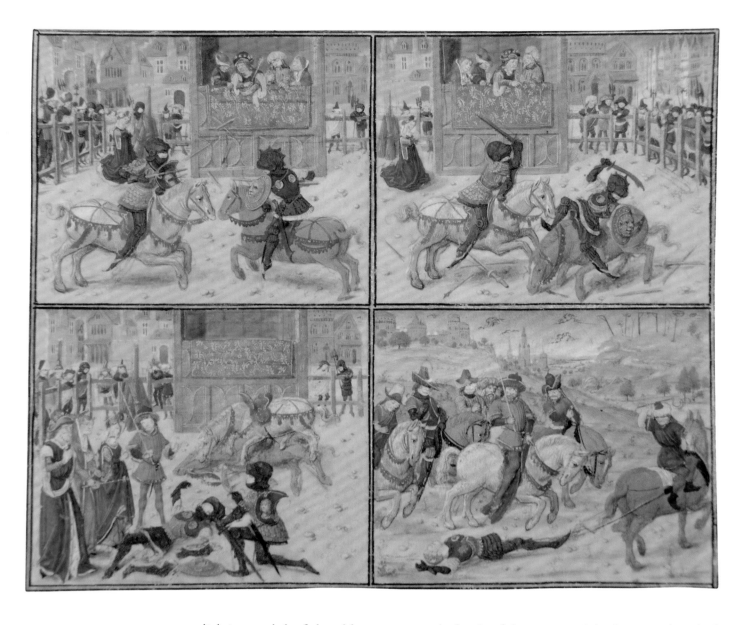

lighting, and the fighters' horses reenact the battle of their owners,[61] both events described as happening previous to the final battle. Van Lathem infused the scene with a sense of the fury of the contest. A look of agony is evident on the face of Lucion as he realizes that he has been vanquished by Gerard. Around the combatants are spectators avidly following the events, some leaning over a fence to get a better view. The border here also contributes to the overall power of the page. In the bottom border, a winged, bird-footed hybrid hunter blows a horn to urge on his dogs, one of whom attacks a stag in a position that mirrors the horses battling above. The miniature and the border together activate the entire page as a surface for meaningful decoration.

As in the case with the battle of Gerard and Lucion, Van Lathem often used the border as an extension of the themes of the miniature. Fol. 36v depicts a crucial moment when Gillion saves the sultan from King Ysore, thereby gaining the sultan's confidence and, at the same time, saving Gracienne from being seized by Ysore (plate 13; pp. iv, 102). Here, Van Lathem used a modified version of continuous narrative to tell the story. At center, Gillion frees the sultan from his bonds, while at left, Gillion and his troops interrupt the celebratory feast of Ysore and his men, and Gillion kills the king. Gracienne had disguised Gillion in the armor of the sultan for this battle, the same armor he wears when he kills Ysore. However, the text specifically states

that the sultan also did not recognize his savior until much later, after the battle, because of the obscuring armor. But in the miniature, Gillion appears *without* the armor as he frees the sultan. Therefore, Van Lathem not only inverted the order of the story (in a standard left to right reading, Gillion would kill Ysore before freeing the sultan, whereas in the text, the freeing precedes the killing: see the text accompanying plate 13) but also completely disregarded an important element of it. Given his deep familiarity with the text throughout, this inversion can only be purposeful. In the miniature, the sultan wears the same armor that can be seen on Gillion at left (the tiny letters indicating "Gillion" and "Sol[tan]" on their hauberks literally spell out the difference for the viewer), and he looks up into the face of Gillion with recognition and thankfulness as he is untied. For the artist, it was imperative that the sultan recognize his savior, Gillion, and that the viewer be witness to this moment. One of those viewers would be the manuscript's patron, Louis of Gruuthuse, and in order to invite his imagined participation in the action portrayed in this miniature, Van Lathem placed Louis's emblems, mottoes, and coat of arms (obscured by a later owner) in the surrounding border.[62] Besides the frontispiece, this is the only surviving miniature to be so adorned. Especially of note is the lion at left, obviously male, who wears the helm of Louis and carries his standard and shield. He appears to engage with the scene in the miniature, ready and eager to join the battle. The presence of the figure here is especially telling. As stated above and explored by Stahuljak in her essay, this is the moment when Gillion irrevocably commits himself to fighting in the East, a theme that will be again taken up at the end of this essay. The only other place where we can deduce that the shield of Louis appeared in the border is associated with one of the missing miniatures that would have originally been opposite fol. 107v (see fig. 20). Significantly, this image would have depicted the moment when Gillion's twin sons began their battles in the East, just as their father had. There were only two known narrative moments, then, that were paired in the reader-viewer's mind with the arms of Louis of Gruuthuse; both involve a commitment to warfare in the East.[63] This aspect will become important when considering the role of the manuscript within the collection of Louis of Gruuthuse.

The example mentioned above is just one instance of visual doubling that occurs throughout the manuscript. An important structuring element of the *Gillion* text is the way in which the story of Gillion is then echoed by the story of his sons, as Stahuljak points out. Other instances of doubling include the two wives, the twins, and the two Muslim princesses. In addition, the story of the twins is then sometimes echoed by an event concerning their father. As a pivotal plot strategy, doubling is also integral to the planning of the accompanying images.[64] While the missing folios make it impossible to do more than speculate (as above) about possible examples of visual doubling across miniatures, the addition of historiated initials most certainly enabled Van Lathem to carry out this scheme. A classic example is the capture of Gillion and then, later, his sons (plates 9, 31). As Stahuljak explains, these two scenes are purposefully similar to pair them in the reader-viewer's mind. Three boats appear in a similar configuration, with fighting happening in the crow's nests and men dying in the water. In both, the arms of Trazegnies are prominently displayed to identify the heroes. In an example of the twins' story providing a model for the father, consider the stories of the wrongly accused Saracen princesses (plates 35, 38). In the miniature, Gerard fights on behalf of Natalie to clear her from the charge of treason for supposedly wanting to poison her brother. In the initial, Hertan (representing Gillion) fights Haldin to help exonerate Gracienne from the suspicion of improper relations with Gillion. In both, the viewing platform with the accuser stands at center, with the princess and an altar below. The tents of the

combatants are cut off to frame the scenes on both sides. Early in the text, the twins' story echoes their father's on multiple levels, but then the natural order is reversed, proceeding instead from sons to father. The textual doubling is thus reinforced by the visual doubling.

The initials are also occasionally played off each other, helping to form completed thoughts, in a kind of variation on the doubling scheme. For example, on fol. 17, Gillion leaves Marie at home, holding her hands in a poignant good-bye (plate 7). On fol. 101v, Gillion arrives back in Cairo, greeted by Gracienne (plate 27). Gracienne is in almost the same position as Marie, visually replacing her and intimating how Gracienne will eventually replace Marie as Gillion's wife. A key distinguishing feature here, also seen elsewhere in the manuscript, is clothing. Marie and her lady-in-waiting wear clothing typical of Flanders at the time—turret hats with veils and dresses cinched by slim belts above the waist. Gracienne and her accompanying lady-in-waiting both sport turbans and long sleeves showing beneath a short-sleeved dress.[65] These simple indicators move the viewer from West to East, with Gillion serving as the link.[66]

At the end of the manuscript are two final examples of visual doubling. In the first, Gillion and Gracienne tenderly say farewell to the sultan in front of his castle (plate 43), a scene echoed by Gerard saying good-bye to the sultan at the very end of the text (plate 52). The castle is identical in each, the walls gray in front and peach in back, adjoining a low, pink crenellated wall. In the initial, Gerard, dressed in the same clothing in which he appeared previously, completes the kneeling posture he began in the earlier miniature. Even the man in the peaked hat appears in the background of both. In a final example, the entire manuscript is bridged by a doubling that links the beginning and end of the story. This doubling relates to the theme of the double wives, another strong example of textual twinning in the story. It has already been seen that the first miniature in the manuscript (plate 1) begins the story at the end, as it were, with the contemporary author finding the original Italian text concerning Gillion. The open time loop is brought to a close with the historiated initial on fol. 200v (plate 44), showing Marie and Gracienne as nuns at the celebration of Mass. In a touching detail, the women pray together in the same abbey in which they will shortly share a tomb—the tomb that is seen in the first miniature of the manuscript. This pairing across two hundred folios brings a strong sense of resolution to the visual narrative. The strategy of textual and visual doubling is used consistently and intentionally throughout the manuscript, but the tactic is especially important in the Getty *Gillion,* as it helps to form an intimate connection between the miniatures and the historiated initials, so that the initials work together with the larger images rather than seeming a separate, added afterthought. This treatment of the historiated initials makes them an essential part of the illumination scheme.

One aspect of the Getty *Gillion*'s illumination scheme that emerges from close study is that, unlike the Dülmen images, which focus primarily on battle scenes and panoramic sequences, the Getty *Gillion* is more intimate in approach.[67] The images often concentrate on relationships and on aspects of the romances and intrigues that are introduced in the text, with a greater emphasis on the role of passion and emotion in the story. Events that initiate narrative sequences as well as their consequences receive attention in the Getty *Gillion* in a way that they do not in the Dülmen manuscript, perhaps reflecting Van Lathem's special interest in and ability to depict interpersonal scenes. Van Lathem drew out the emotional aspects of the scenes he portrayed through techniques such as continuous narrative, single scenes with implied time lapses, and visual doubling. He was also creative in relating the historiated initials both to each other and to the larger miniatures, as well as in utilizing border spaces to comment on the

scenes depicted in the main images. All these elements work together to create a visual narrative that interacts with and enhances the textual one, and they make the Getty *Gillion* perhaps the most nuanced, accomplished, and ambitious of all of Van Lathem's secular works.

Van Lathem's Secular Manuscripts

Following examination of the various visual strategies employed by Van Lathem in the Getty *Gillion*, it will now be possible to consider how this manuscript compares to and complements his other secular works. Van Lathem is somewhat unusual among Flemish artists of the second half of the fifteenth century in that his body of works is divided between devotional and secular manuscripts. Many illuminators of the day seemed to specialize in either one type of book or the other; relatively few were equally devoted to both genres. Devotional books tended to be different in scale (smaller), subject matter (religious), and compositional reiteration (the frequent use of patterns) from secular manuscripts. Stories such as the life of the Virgin or of Christ were an integral part of a book of hours and other types of devotional books, repeated through thousands of manuscripts.[68] Secular books, by contrast, demanded a connected visual narrative to be sustained over the course of a manuscript. Often the narrative was being visualized for the first time, or it was among a very small number of examples. Artists such as Loyset Liédet, the Master of Margaret of York, the Master of Edward IV, and the Master of Anthony of Burgundy were known largely for their ability to create original images for these complex secular stories, although they occasionally worked on devotional projects too.[69] What differentiates Van Lathem's work from these illuminators is his extreme sensitivity, light touch, and captivating visualizations. In the numerous secular manuscripts that he illuminated, he adopted various solutions to the challenges of visual storytelling, altering his approach on a project-by-project basis, often based on the particularities presented by an individual text or plan.

Besides the Getty *Gillion*, Van Lathem produced significant series of secular illuminations in three other manuscripts: Jean Wauquelin, *Deeds and Conquests of Alexander* (Paris, Petit Palais, Ms. Dutuit 456), Jean Froissart, *Chronicles* (Berlin, Staatsbibliothek, SPK, Ms. Dep. Breslau 1, vols. 1–4), and Raoul Lefèvre, *History of Jason* (Paris, BnF, Ms. fr. 331), each produced for one of the great bibliophiles of the period.[70] The earliest in the group is *Deeds and Conquests of Alexander*, commissioned by Philip the Good and therefore dating to before his death in 1467.[71] In this manuscript of more than 150 miniatures, most were painted by Willem Vrelant and his workshop. A series of eleven miniatures, probably contained within a single gathering, were executed by Van Lathem (figs. 34, 35).[72] These are devoted to a portion of the text concerning the Vows of the Peacock, in which the noble members of Alexander's court take part in a feast to vow to fight against the king of India.[73] The miniatures by Van Lathem start with the fourth of twelve individual vows made by members of the court, with an additional two images devoted to the vows' completion. At first glance the nine vow scenes seem very similar, but on closer inspection it becomes clear that each reveals a slightly different view of the same setting. Van Lathem kept the narrative flowing by moving and weaving the viewer's perspective. Essentially he was faced with painting the same event over and over; he could have simply repeated the scene, varying the person taking the vow, but instead he cleverly changed the details so that each scene was subtly different while simultaneously reinforcing the fact that each participant was taking the same pledge. Confronted with the same problem, the artist of the previous two vow scenes chose to show the incident as an entirely different feast, complete with different guests and different architecture.[74] In

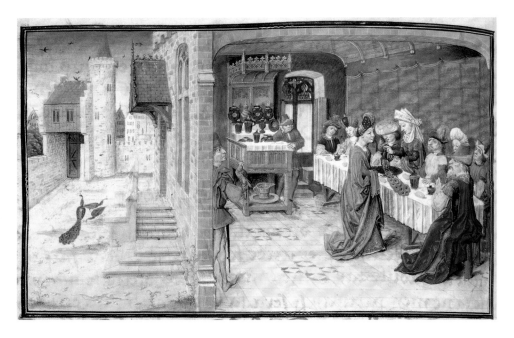

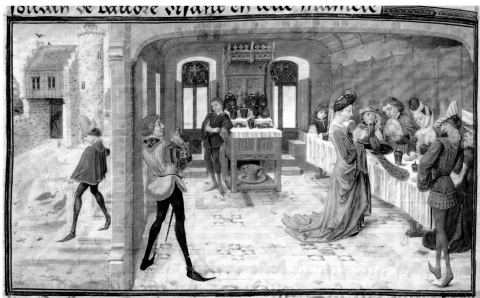

Van Lathem's miniatures, each scene literally moves down the table to the next guest to enact his or her vow so that the person sitting next to the vow taker is the one who stands up in the following miniature to pledge. But in order to add variety, Van Lathem moved the field of vision slightly to the left or right in every scene, showing more or less of the room or the outside courtyard, cutting off or revealing more of certain figures, and using the walls, windows, vaulted ceiling, and floor tiles to help emphasize the change in perspective. This approach to narrative is so unusual and elaborate that I can think of no other examples from this period.[75] It was an inventive solution to a particular challenge posed by the text. The last two miniatures painted by Van Lathem show the vows being put into action and therefore complete the vow concept created by the preceding miniatures (see fig. 31).

The copy of Froissart's *Chronicles* created by Van Lathem and his workshop for Anthony of Burgundy contains more than two hundred miniatures in four volumes.[76] The first volume has miniatures unrelated in style to Van Lathem,[77] but Van Lathem and his workshop were responsible for the other three volumes, mostly painted in a semigrisaille style (fig. 36; see also fig. 32).[78] The first volume gives a glimpse of what the visual narrative accompanying

FIGURE 34
Lieven van Lathem, *Vows of the Peacock*, from Jean Wauquelin, *Deeds and Conquests of Alexander*, before 1467. Paris, Petit Palais, Ms. Dutuit 456, fol. 87v (detail)

FIGURE 35
Lieven van Lathem, *Vows of the Peacock*, from Jean Wauquelin, *Deeds and Conquests of Alexander*, before 1467. Paris, Petit Palais, Ms. Dutuit 456, fol. 89v (detail)

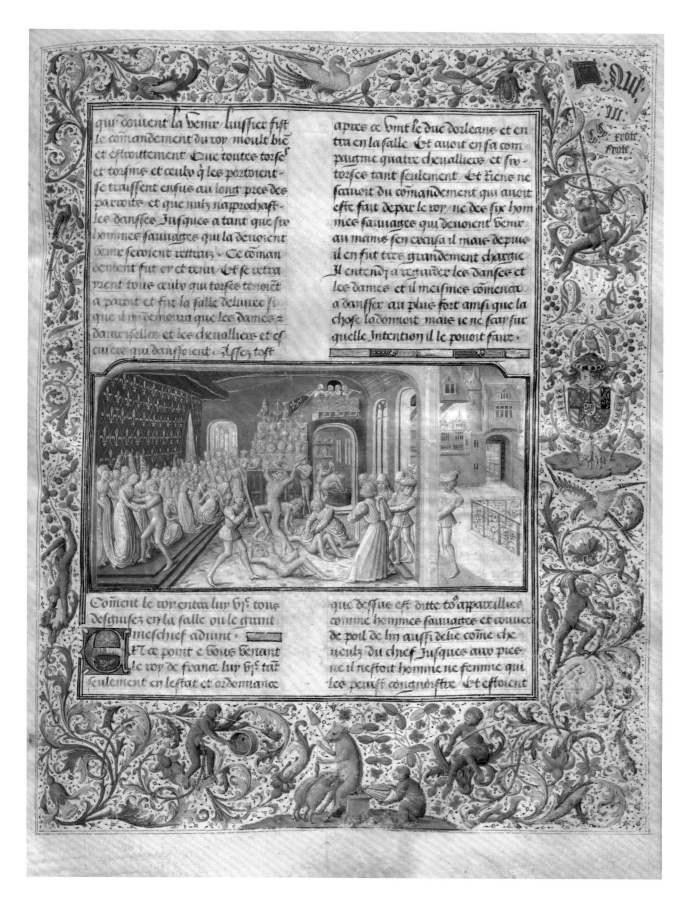

FIGURE 36

Lieven van Lathem, *The Ball of the Burning Men*, from Jean Froissart, *Chronicles*, ca. 1468–69.
Berlin, Staatsbibliothek, SPK, Ms. Dep. Breslau 1, vol. 4, fol. 156

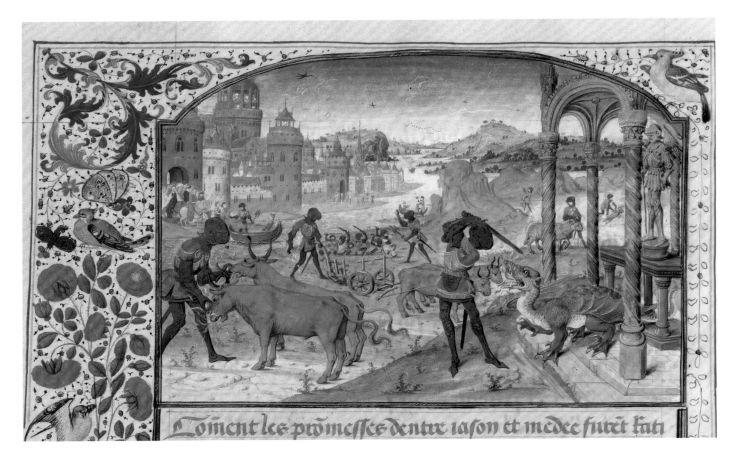

Coment les promesses dentre iason et medee furêt fati

FIGURE 37

Lieven van Lathem, *The Story of the Golden Fleece*, from Raoul Lefèvre, *History of Jason*, after 1472. Paris, BnF, Ms. fr. 331, fol. 106v (detail)

this historical text could be in the hands of less-talented artists. It becomes almost a litany of repetitive battle scenes, with little differentiation among them. In fact the images act almost solely as chapter dividers. The other three volumes show how an imaginative artist like Van Lathem could transform the task into an opportunity for drama. Images portray processions, treaty signings, crownings, and deaths in addition to battle scenes that convey a liveliness and momentousness lacking in volume 1.[79] When a dramatic event was called for, Van Lathem made the most of it (see fig. 36). The famous *Ball of the Burning Men* was an episode recounted in volume 4 of the *Chronicles*. In January 1393, the king of France and some of his courtiers dressed up as wild men in feathers for a performance at a feast. A carelessly lit torch resulted in the deaths of four men, but the king was miraculously saved. The Froissart volumes contain mostly one-column miniatures, with occasional two-column miniatures and full borders reminiscent of the large miniatures in the Getty *Gillion*. It is not surprising that the ball merited a two-column miniature. At the very center, a man on fire throws up his arms in despair. Horrified reactions ripple out from this figure. To the left, the king's face lights with relief as he escapes the flames, while a lady of the court just behind faints into the arms of her friends. To the right, a man coming in at the door turns to relay the news to another courtier standing outside. The figure who grabs attention, however, is the only one looking directly out at the viewer, near the center of the composition: the ill-fated man with the torch (the king's brother, Louis d'Orléans). The artist perfectly captures his expression of terror and guilt as he realizes that he has caused the panic and death surrounding him. Van Lathem's ability to define intense moments like this one is evident again and again in the abundant images of these volumes. Illustrating such a long text that concerns itself mostly with war required careful and imaginative planning to draw attention to the memorable events.

The last of the secular texts that Van Lathem illuminated is the story of Jason and the Golden Fleece.[80] The frontispiece of this manuscript utilizes the same basic composition as the Getty *Gillion* but with a more traditional subject (plate 1, see fig. 14). Instead of the ingeniously constructed narrative about the finding of the text featured in the Getty manuscript, the *Jason* manuscript features a more standard presentation scene of a type often found at the beginning of secular manuscripts. The action moves from the background, where the author composes the text, to the foreground, where he presents it to his patron. Many of the manuscript's other miniatures exhibit the type of continuous narrative seen in the Getty *Gillion*'s opening miniature, but taken to an extreme. For instance, on fol. 106v, the three tasks undertaken by Jason on Colchis to obtain the Golden Fleece are all represented. Jason, in fact, appears nine separate times in the miniature (fig. 37). Van Lathem made very little attempt to differentiate the scenes either spatially or chronologically. In fact, the nine repeated figures of Jason, dressed identically, almost form a visual pattern across the surface of the miniature, in layered concentric circles of increasing density, with two in the foreground, three in the middle ground, and four in the distance. Although this is an extreme example, the use of continuous narrative is a favored approach in the *Jason* manuscript, evident in the majority of the miniatures.

In each case, Van Lathem utilized a different and highly intelligent approach to visualize a particular text. Nevertheless, the Getty *Gillion* remains his most ambitious and carefully planned secular project, given the sophistication of the way the miniatures and the initials work together with the text to provide a unified visual program, which is at once complementary to and offers commentary on the text.

The Getty *Gillion* in the Collection of Louis of Gruuthuse

It has long been posited that the Getty *Gillion* finds a somewhat uncomfortable place within the collection of Louis of Gruuthuse. Its date of 1464 is half a decade before his great and prolific period of collecting began. It concerns Eastern subject matter, which heretofore has been seen to bear little relation to the other works commissioned by Louis, although Stahuljak in her essay somewhat negates this idea.[81] It also falls into the genre of historical romance, another anomaly within his collection.[82] However, if we look beyond the type of work and the subject matter to the pattern of interlinking artists, patrons, and manuscripts that surround the Getty *Gillion*, it may be seen that it does break a pattern in terms of Louis of Gruuthuse's patronage but in a very specific and overt way that is meaningful. It will, in fact, be suggested that the Getty *Gillion* was a turning point in Louis's history of collecting, a kind of "coming of age" statement of intent.

Very few among the more than one hundred works commissioned by Louis of Gruuthuse were completed before 1470, when his intense period of collecting seems to have started.[83] Only four illuminated manuscripts can with any certainty be dated to the 1450s and 1460s.[84] Two are ambitious productions painted by Willem Vrelant and his workshop in the years around 1455 to 1460. The first is a copy of Vincent of Beauvais's *Mirror of History* [*Miroir historial*] (Paris, BnF, Mss. fr. 308–11) with hundreds of miniatures in grisaille or semigrisaille, and the second is a *Moralized Bible* [*Bible moralisée*] with forty-four illuminations (Paris, BnF, Ms. fr. 897). Vrelant was often patronized by Philip the Good (Brussels, KBR, Mss. 9026, 9511; Paris, BnF, Ms. fr. 6449; Paris, Petit Palais, Ms. Dutuit 456). In the case of the *Moralized Bible*, the scheme of illumination was based on a copy probably made for Philip the Good (London, BL, Add. Ms. 15428), and another with almost the same scheme

of illumination was made for Anthony of Burgundy (The Hague, KB, Ms. 76 E 7).[85] The third manuscript in this pre-1470 grouping is an allegorical work called *The Twelve Ladies of Rhetoric* [*Douze dames de rhétorique*], which was painted by the Master of Anthony of Burgundy for Louis between 1464 and 1468 (Paris, BnF, Ms. fr. 1174).[86] It is one of three very closely related copies—the others made for Adolphe de Clèves (Munich, Bayerische Staatsbibliothek, Ms. Gall. 15) and for one of the text's authors, Jean de Montferrant (Cambridge, University Library, Ms. Nn. 3.2)—and it also shows a compositional affinity to a slightly later copy of the *Book of Good Customs* [*Livre des bonnes meurs*] made for Anthony of Burgundy (Paris, BnF, Ms. Smith-Lesouëf 73).[87] The fourth manuscript dating to the era before 1470 is a copy of the *Justification of France against England* [*Justification de la France contre l'Angleterre*], illuminated by the Master of the *Vraie Cronicque descoce* around 1464–67 (Paris, BnF, Ms. fr. 5058). This artist worked together with Vrelant and is associated with numerous volumes owned by Philip the Good (Paris, BnF, Ms. fr. 9002). The manuscript has only a frontispiece, closely allied to Philip the Good's copy of this rare text, also by the same artist (Brussels, KBR, Ms. 9469, 70). Therefore, for every manuscript established to have been commissioned by Louis before 1470, the texts, illuminations, and/or artists were closely allied with manuscripts made for either Philip the Good or Anthony of Burgundy.[88] In fact, there is little else that unites the early commissions of Louis, which are quite varied in subject matter. In the case of the Getty *Gillion*, the text was dedicated to Philip the Good, and the first known illuminated copy was commissioned by Anthony of Burgundy. The striking correlations between these three collections have often been noted, but without much additional study given to whether the pattern of influence flowed distinctly from one patron to another. Up to the time of the production of the Getty *Gillion*, Louis gave every evidence that he was happy to have manuscripts that mimicked those of a small, select set of patrons whom he aimed to emulate. The Getty *Gillion* was his first step forward out of that mold and into a new realm of his own devising in terms of text, iconography, and overt claims of ownership.[89]

A number of factors differentiate the Getty *Gillion* from Louis's other early commissions. First, it was commissioned from a scribe and an artist who had been employed as official artisans by Philip the Good. David Aubert was Philip's ducal secretary from 1463, and Lieven van Lathem was in the service of Philip from 1456 to 1459 and was engaged by both Philip and his son Charles, periodically afterward, for the rest of his career. Although Vrelant was favored by Philip and the Master of Anthony of Burgundy was regularly engaged by Anthony, these artists had carried no official rank in the ducal household; Aubert and Van Lathem did. Thus, Louis's choice of and ability to engage official ducal artisans (even though Van Lathem was no longer directly in the service of the duke in 1464) could be interpreted as a move up in the ranks, a means by which Louis allied himself more closely with the duke. In addition, as Stahuljak makes clear in her essay, the Getty *Gillion* was the first of Louis's manuscripts to contain a dedicatory prologue declaring his patronage; it celebrates all his roles and titles in a way that is absent from manuscripts he commissioned both before and after the Getty *Gillion*. Finally, it was the first manuscript of Louis's that responded to an aspect of his personal life: the years 1463–64 were largely devoted by the ducal court to preparations for a Crusade.[90]

Philip the Good deeply felt the disaster of the Crusade undertaken by his father, John the Fearless, in 1396. By 1451, and then further spurred by the fall of Constantinople to the

Ottomans in 1453, he was consolidating plans to mount a Crusade of his own.[91] The famous Feast of the Pheasant in 1454 was an important landmark in his preparations, with Crusading vows taken not only among the members of the Order of the Golden Fleece but also by powerful young members of his court, such as his bastard son, Anthony of Burgundy, and his knight, Louis of Gruuthuse. In the following ten years, Philip's attempts to fulfill his Crusading vow were continually thwarted by events ranging from European politics to papal health. But by 1463, serious arrangements were underway, and in 1464, Anthony was made head of the Crusading armies and sent by sea via France for final embarkation to the Holy Land.[92] It was in the midst of these events that the two illuminated copies of the *Romance of Gillion de Trazegnies* were commissioned by two of the most influential members of Philip's court.

Stahuljak has convincingly described different emphases in the two manuscripts, reflecting the differing positions of the two men: Anthony's manuscript foregrounds the sons, particularly Gerard, while Louis's manuscript concentrates largely on Gillion as hero. Also, as already noted above, Anthony's manuscript privileges battle scenes, while Louis's manuscript shifts the focus to chivalric events, romance, and emotion-laden moments.[93] Considering that Anthony was heavily engaged in preparations for the Crusade by 1463, when his manuscript was being produced (although he had not yet been named head of the troops, he nevertheless would have certainly known that his role in the coming endeavor would be significant), the emphasis on battle scenes in the East certainly makes sense. Louis's own commitment to the Crusade can be seen in the appearance of his coat of arms and emblems on the two folios in which Gillion and then his two sons irrevocably pledge themselves to fighting in the East. The lion in the border of fol. 36v (plate 13), representing Louis, seems eager to literally leap into the fray. It is likely, however, that in 1464 Louis believed he would remain in Flanders, continuing his administrative duties and supporting the Crusade from behind the lines.[94] As Stahuljak theorizes, Louis at this point in his career may have been more intent on celebrating his recent election as a knight of the Order of the Golden Fleece (1461) and his elevation to the position of governor general of Holland, Zeeland, and Frisia (1463) than in the idea of departing on Crusade. Support for this premise can be found in the Getty *Gillion*'s dedicatory prologue. All of Louis's titles are mentioned, but, in addition, special prominence is given to the newly acquired title of governor general of Holland, Zeeland, and Frisia, recognized as coming by the favor of "my most feared lord Philip, by the grace of God Duke of Burgundy and Brabant" (fol. 8). Louis himself later commissioned an actual history of the Crusades (Paris, BnF, Ms. fr. 68) that is singularly lackluster in its illuminations.[95] It may well be that Louis found a true account of the Crusades, with its frequent recounting of failures and its harsh historical reality, less appealing than a displaced account of successful battles and thrilling adventures in the East.

The *Gillion* manuscript was therefore a perfect vehicle for Louis's various needs on multiple levels. It linked him closely to Philip's Crusading fervor via Anthony, who was in command of the fleet, while at the same time also feeding Louis's burgeoning interest in lavish manuscripts. The scribe and artist of Louis's manuscript were also closely connected to the creation of Anthony's manuscript, made only the year before. The commission of the *Gillion* manuscript fits into Louis's pattern of ordering manuscripts closely related to commissions made for Philip and Anthony. But in the case of the Getty *Gillion*, there are significant differences in the ambition of the project. The text is not simply a copy of the one found in Anthony's manuscript but an extended version, with almost every paragraph receiving

135

extra attention. Likewise, even before the illumination program was increased by an extensive series of historiated initials, fourteen large miniatures exceeded Anthony's nine. In its extended form, the *Gillion* owned by Louis was undeniably more lavish than Anthony's copy, significantly augmented from the model. Again, this enhancement could be interpreted as an indication that the Getty *Gillion* represents Louis's assay into a new phase in his collecting, one that was more ambitious than the collections being formed by his friends and fellow courtiers. As Stahuljak notes, Louis may well have seen Anthony's copy in 1463 in Bruges and determined that, instead of the bland copy he was usually happy with, he would commission something better, more elaborate, in every way superior to the exemplar owned by his friend Anthony. It may even be that while Anthony was embarking for the Holy Land to fight in Philip's Crusade, Louis was expecting to be in Flanders keeping the momentum for the Crusade alive and well. A beautiful, lavish manuscript showing a true Burgundian hero finding success, love, and honor in the Holy Land would be no poor ally.

The Genius of Visual Narrative

One of the most interesting aspects of Van Lathem's work is that in four of his five large-scale secular projects, the themes of the narratives were related to the idea of Crusading in the East.[96] His earliest project involved producing a small number of miniatures for the *Abridged Chronicles of Jerusalem* [*Les Chroniques de Jherusalem abregiés*] (Vienna, ÖNB, Cod. 2533),[97] an elaborate commission undertaken by Philip the Good in 1455, after the Feast of the Pheasant. In 1463–64 Van Lathem was involved with the two copies of the *Romance of Gillion de Trazegnies* for courtiers occupied with Philip's Crusade that have served as the focus of this essay. Next, before 1467, Van Lathem painted a series of miniatures concerning the Vows of the Peacock in an *Alexander* manuscript, an event seen as a historical model for the famed Feast of the Pheasant.[98] Finally, around 1470, again for Louis, he painted an elaborate *Jason* manuscript, whose story provided the basis for the Order of the Golden Fleece, founded in part to disseminate chivalric and Crusading ideals.[99] Although it is conceivable that the recurring theme is simply happenstance, it is also possible that Van Lathem became associated with projects dealing with Eastern themes that inspired Crusading ideals and was sought after for his skills in rendering this kind of subject matter. His affinity for depicting exoticism and emotion, which he interpreted as a combination particular to the East, made the commission a perfect concurrence between the talents of the artist and the desires of the patrons. Especially evident in the case of the Getty *Gillion*, Van Lathem's talent lay in his ability to evoke an ideal vision of the East, full of foreign allusions and opportunities for glory, yet safely ensconced in the familiarity of a Western setting, featuring cities that look like Bruges, Christian morals adhered to by both the Western knights and the "good" Saracens they encountered, and, above all, a sense of genealogical destiny. Illuminations such as those painted by Van Lathem in the Getty *Gillion* created romanticized heroes to serve as exemplars bridging the tension between the East and the West. For Louis, the exotic East was brought to life in the person of Gillion, who served simultaneously as his vicarious representative on Crusade, his perfected counterpart in the chivalric arts, and his entry into a powerful and lifelong addiction to collecting sumptuous manuscripts, none which ever perhaps quite equaled his prized *Romance of Gillion de Trazegnies*.

NOTES

1. De Schryver 1957.

2. De Schryver 2008, 31–44.

3. For information on Van Lathem and his career, see Dogaer 1987, 133–36; van Elslande 1992; Wolf 1996; Kren in Kren and McKendrick 2003, 239; de Schryver 2008, 44–55; Hans-Collas and Schandel 2009, 78; Kren in Bousmanne and Delcourt 2011, 287–89. Wijsman 2010 is also a key resource in all aspects of northern Netherlandish and Flemish illumination study in this period. The accompanying online catalogue of manuscripts (http://www.cn-telma.fr/luxury-bound/index/ [accessed March 15, 2015]) was invaluable in preparing a bibliography and completing research for this essay. Further references on all the manuscripts mentioned in this essay can be located in Wijsman's online catalogue.

4. There is a tendency to date the vast majority of Louis's secular manuscript commissions to the decade between 1470 and 1480 (Hans-Collas and Schandel 2009, 321–28), but this essay will provide some evidence on dating that may indicate a revision of this assumption is merited. Because this question reaches beyond the scope of the current study, all manuscripts associated with Louis are dated here from 1460 to 1490 unless otherwise noted.

5. Kren in Kren and McKendrick 2003, 239; Kren in Bousmanne and Delcourt 2011, 289.

6. In this image, Jean, the eldest son, who will stay in Hainaut to carry on the family name, appears on his father's right dressed in Western clothes, while Gerard, the younger son, who will return eventually to the Holy Land, appears on his father's left, dressed in the exotic clothing associated with the East.

7. McKendrick in Kren and McKendrick 2003, 73; Hedeman in Morrison and Hedeman 2010, 69–85.

8. Every detail in Van Lathem's narratives is carefully thought out. In this image, a good example is the archway through which the travelers will pass. The sculpted scene in its top shows Moses with the tablets of the law. Moses represents the Old Law in Christianity and was often considered a prophetic counterpart to Muhammad in Islam. Therefore his presence on the gate through which Gracienne's entourage will pass on her way to the West and Christianity aptly symbolizes both physical and spiritual departure.

9. The artist may have portrayed the text in a slightly different way from what the author intended. On the love between Gillion and Marie as presented in the text, see Stahuljak, "A Romance between the East and the West," 97.

10. The Breslau Froissart (Berlin, Staatsbibliothek, SPK, Ms. Dep. Breslau 1, vols. 1–4, ca. 1468–69), made for Anthony of Burgundy, contains more illuminations by Van Lathem and his workshop, but the Getty *Gillion* is more cohesive in its conception and consistent in its execution.

11. Morgan and Panayotova 2009, 112–15; Wolf 1996, 131–32. Although Morgan and Panayotova as well as Wolf attribute the book to Van Lathem's own hand, de Schryver (2008, 107–12) attributes it to a member of Van Lathem's workshop.

12. Wolf 1996. Wolf's entire thesis revolves around Van Lathem and this manuscript, but de Schryver (2008, 103) again attributes it to a member of Van Lathem's workshop.

13. The later Book of Hours of Mary of Burgundy, from around 1470–75 (Vienna, ÖNB, Cod. 1857), uses this same format. See the facsimile with commentary by Eric Inglis (Inglis 1995) and Kren in Kren and McKendrick 2003, 137–41.

14. Scot McKendrick was kind enough to suggest three other secular manuscripts with historiated initials. A careful examination of the more than one thousand northern Netherlandish and Flemish secular manuscripts catalogued by Hanno Wijsman (with some searching help gratefully received from that author) indicates that less than twenty secular manuscripts of this period feature narrative historiated initials, although a larger number feature a single historiated initial to introduce the text or texts. None of those twenty is a romance.

15. McKendrick in Kren and McKendrick 2003, 242.

16. The manuscript was originally foliated in red at the upper right of each page in Roman numerals (only the front of each folio receives a number, as opposed to pagination, where both the front and back of each page receive a number). At some point after the thirty-three folios were removed, the manuscript was foliated again in pencil in the upper right with Arabic numerals. Because this modern foliation does not account for the missing pages, the foliations in red ink and pencil do not match. The continuous pencil foliation is the one followed throughout this volume.

17. On rubrics and chapter lists in relation to illumination in secular texts, see Timelli 2004; Quéruel 2000.

18. Vincent 2010.

19. Between fols. 29 and 30, 448 words are missing; between fols. 57 and 58, 405 words are missing; between fols. 83 and 84, 435 words are missing; between fols. 195 and 196, 555 words are missing; between fols. 197 and 198, 531 words are missing.

20. Between fols. 117 and 118, 328 words are missing; between fols. 214 and 215, 355 words are missing; between fols. 231 and 232, 273 words are missing.

21. There is a missing folio between fols. 107 and 108. Stahuljak has determined that at this point the Getty manuscript combines into a single chapter text that takes up four chapters in the Dülmen manuscript, so it is impossible to say how much text is missing.

22. Two of these were places that had already been suggested based on the number of missing words (between fols. 117 and 118 and between fols. 214 and 215).

23. Eleven boxes can be found corresponding to: fol. 21; missing folio between fols. 23 and 24; fol. 49v (the marking here is small and difficult to discern; it may or may not be a box); missing folio between fols. 107 and 108; missing folio between fols. 117 and 118; fol. 134v; fol. 150v; missing folio between fols. 159 and 160; fol. 177; fol. 188v; and missing folio between fols. 214 and 215. This use of boxes as indicators is an unusual method that I have not otherwise seen in manuscripts. It may be that the boxes were added when it was decided to enhance the program with historiated initials, as marking the chapters that already had a miniature would provide a way to count how many chapters would need additional illumination.

24. It is unclear why three boxes are missing, corresponding to the first (extant, fol. 9) and last (missing, between fols. 231 and 232) miniatures, and the one on fol. 36v (extant). Since many of the boxes are quite faint and visible only under magnification, it is possible that some have faded beyond perception. I thank Nancy Turner for her help in examining the table of contents in various lights, which unfortunately still revealed no additional evidence.

25. Boxes appear for leaves missing between fol. 23 and 24, 107 and 108, and 117 and 118. There is a missing image between fols. 159 and 160, along with numerous folios of text (see Appendix 3). With the appearance of a box next to one of the missing folios we can now conclude that a folio between fols. 159–60 was accorded a large miniature.

26. I have been unable to suggest the reasoning for removing this particular set of images; they seem to share nothing in terms of subject matter that unites them.

27. See the map of missing miniatures in Appendix 3, especially those following fols. 117, 214, and 231. By contrast, bifolios that are missing containing more than one image include the gathering following gathering 3, as well as gatherings 4 and 27. Inexplicable are the missing folios from gatherings 21 and 22 and from gathering 28, where a number of text pages were taken as well as a single folio with an image.

28. McKendrick in Kren and McKendrick 2003, 241. Dibdin (1817, cciv) describes a binding that matches the current binding. Given that the leaves would probably not have been removed by the Dukes of Devonshire, it is likely that the loss of folios would have happened during an earlier rebinding. I thank James Towe, archivist and librarian at Chatsworth, for his opinion that the binding likely dates from the time of the sixth Duke of Devonshire.

29. Ham 1932, 66; Laffitte 1997, 246.

30. See Stahuljak, "A Romance between the East and the West," 89–90. Marc Gil was kind enough to consider the question of David Aubert as scribe, examining the Getty *Gillion*'s script in comparison with other manuscripts. He sees no reason why the Getty *Gillion* should not be given to Aubert's hand despite the lack of an actual signature. As Stahuljak notes, if it was not Aubert himself, it must have been someone working under his supervision.

31. Wolf (1996, 155–66) argued for Van Lathem himself; Delaissé (1959, no. 240) was the first to mention Dreux Jean in conjunction with the manuscript, followed by McKendrick (in Kren and McKendrick, 2003, 242) and Chrystèle Blondeau (cited in Vincent 2010, 69). The two latter scholars were working from photographs and not from the original, and thus both were hesitant to make a definitive judgment. Hanno Wijsman also looked at reproductions of the images of the Dülmen manuscript, and his impression was that the style corresponds better to Dreux Jean than that of Van Lathem.

32. I thank both Thomas Kren and Scot McKendrick for personal discussions in 2014 regarding the artist of the Dülmen manuscript, based on comparing detailed images of the Getty *Gillion* to new photography of the Dülmen manuscript. Kren shared that he thinks the images in the Dülmen manuscript are largely the work of the Van Lathem workshop. McKendrick agreed that the images have an overall close relationship to Van Lathem's work and concluded that the execution indicates a workshop production. He noted, for example, that the color palette used by the Dülmen manuscript's artist is quite different from that used by Van Lathem. For other comparisons of the two illumination schemes, see Wolf 1996, 154–82; Vincent 2010, 65–75.

33. These two scenes do not represent the same moment in the text, but nevertheless both concern conflicts on the water. The Getty manuscript represents Gillion being captured by the sultan's army after leaving Jerusalem, and the Dülmen manuscript shows Jean and Gerard being overcome by Saracens on leaving Cyprus.

34. Scot McKendrick has also pointed out that in other images in the Getty manuscript, structures are cut off at the sides, and foreground figures are cut off or touching the frame. These compositional details are lacking in the Dülmen manuscript.

35. One example of multicompartment miniatures in other Flemish manuscripts of the period is the frontispiece to a manuscript of the acts of mercy made for Margaret of York (Brussels, KBR, Ms. 9296, fol. 1) and another for a French copy of the *History of the Destruction of Troy* [*Historia destructionis Troiae*] (Brussels, KBR, Ms. 9571-72,

fol. 4v). I thank Scot McKendrick for drawing my attention to the latter. In each case, however, these miniatures were frontispieces in manuscripts otherwise lacking miniatures. Hanno Wijsman kindly indicated two other manuscripts with similar treatments: Jena, Thüringer Universitäts- und Landesbibliothek, Mss. El. f. 91, El. f. 95–96. All four of these manuscripts date to the period around 1460–80. Interestingly, the first of these last two mentioned manuscripts features multicompartment miniatures of the mid-fifteenth century illustrating a text written out in the early fifteenth century, so it may indeed potentially be a case of intentional anachronism, and the second features rectangular miniatures divided by diamond-shaped gold bars, with the sectioned-off outer corners sometimes devoted to additional scenes. As Wijsman notes, this novel solution is not closely related to the treatment of the Dülmen miniatures. I know of no other manuscript from this period that utilizes this format throughout a volume.

36. For a discussion of multicompartment miniatures in earlier illumination, see Morrison in Morrison and Hedeman, 2010.

37. Manuscripts to which Van Lathem only contributed miniatures without being responsible for the overall plan, such as Paris, Petit Palais, Ms. Dutuit 456 (before 1467), in which he painted only 11 of the more than 150 miniatures, do not feature his distinctive borders.

38. For example, the borders by Van Lathem in The Hague, Museum Meermanno, Ms. 10 F 50, completed sometime around 1450–60. Boon 1964.

39. Paris, BnF, Ms. n.a.lat. 215 is a devotional book with these three-sided borders. The manuscript has been dated variously as ca. 1465 or 1470–80. Wolf 1996, 316, 280–82; de Schryver 2008, 48, 53n24; Marrow in Alexander, Marrow, and Sandler 2005, 270n4.

40. Scot McKendrick points out that the composition used for the Getty frontispiece and its corollary in the *History of Jason* manuscript (see fig. 14) was adapted by the Rambures Master as early as 1470. McKendrick in Kren and McKendrick 2003, 255.

41. Of the nine miniatures in the Dülmen manuscript, seven feature compositions related to either miniatures or historiated initials in the Getty manuscript.

42. See Stahuljak, "A Romance between the East and the West," 79–80.

43. I thank Thomas Kren for suggesting this latter possibility. There are many examples of the use of drawings as workshop models in devotional manuscripts but virtually no evidence for the same practice in the secular realm (Kren 2005; Heyder 2014), although shared visual models are certainly a known feature in secular manuscript illumination. McKendrick in Kren and McKendrick 2003, 65–66.

44. The burning ships in the harbor (see upper left quadrant of fig. 27), for instance, is just the kind of dramatic detail that Van Lathem reveled in.

45. McKendrick in Kren and McKendrick 2003, 242.

46. Scott 1980, 171–89.

47. The following observations were kindly shared with me by Margaret Scott via lengthy personal correspondence in 2014.

48. These changes in fashion are evident by referring to the images in Van Buren 2011, 198–225.

49. Naber 1987, 290; McKendrick in Kren and McKendrick 2003, 280n2.

50. Pinkernell 1971; Pinkernell 1973. I thank Megan McNamee for her help in parsing out Pinkernell's argument. McKendrick (in Kren and McKendrick 2003, 243) and Hans-Collas and Schandel (2009, 81–82) date the Paris *Jason* to around 1470.

51. The serious Crusading efforts undertaken by Philip the Good were broken off abruptly in late 1464, a disruption that would perhaps provide a reason for the illumination of the manuscript to be abandoned, but in the 1470s there was no renewed attempt at Crusading or any other evident reason for the manuscript's completion at that time.

52. The latter was originally suggested by McKendrick in Kren and McKendrick 2003, 242.

53. For example, the few illuminations by Van Lathem in a manuscript from around 1455 (*Abridged Chronicles of Jerusalem* [*Les Chroniques de Jherusalem abregiés*], Vienna, ÖNB, Cod. 2533) have many of the same stylistic features seen in his later works.

54. See note 4 above.

55. Wolf 1996, 126–30, 275–79; Bousmanne and Delcourt 2011, 270.

56. Also note the green and red marble columns that flank the scene, similar as well to the alternating green and red columns seen at the left and back of the Getty frontispiece. The floor of the hall in Philip's manuscript is virtually identical to the lower left scene of the Dülmen frontispiece (see fig. 5).

57. It was quite a common practice for collectors of this period to borrow manuscripts from one another, and it is possible that Louis borrowed Anthony's copy around 1470 for the sole purpose of having Van Lathem refresh himself with the illumination scheme.

58. One would also think that if Louis put aside the manuscript for a period and then had it illuminated around 1470–72, he would have also taken the opportunity to update the prologue. After all, Aubert was readily available since he was employed by Louis to write out the *Jason* and *Secrets* manuscripts. If it was after 1467, it would be appropriate, as Stahuljak points out, to mention Philip the Good in the past tense as other manuscripts do, and if it were as late as 1472, Louis almost certainly

would have wished to include his title as Earl of Winchester. The fact that scribes other than Aubert were hired to rewrite the portions of text around the historiated initials remains problematic whether the illumination was done in 1464 or in ca. 1470–72, as at both of those points, Aubert was employed by Louis.

59. In another example, fol. 49v (plate 17) concentrates on a battle scene with Gillion fighting King Hector, but a secondary scene in the background also shows Gillion attacking the emir of Orbrie.

60. This miniature was stolen from the Dülmen manuscript in the 1950s by a dishonest scholar, and when it resurfaced with a German dealer in 1975, the original owner bought it back. Sadly, the folio had been cut down to the border of the miniature. The reacquired leaf now resides with the manuscript in Dülmen. I thank the keeper of the Dülmen archives for sharing this story.

61. The battle of horses reflecting that of their riders goes back to an old tradition told in the bestiary. See London, BL, Royal Ms. 12 F.XIII (ca. 1230), fol. 42v.

62. I thank Nancy Turner for examining these coats of arms under the microscope. It seems that the four coats of arms in the corners representing Louis's possessions have been modified, with their distinctive aspects either removed or painted over.

63. As noted in Appendix 1, there are other places where Louis's coat of arms may have appeared in a decorative initial, but the use of the coat of arms, device, and motto in the borders has a much more dramatic impact than simply in the initials, which were likely not painted by Lieven van Lathem.

64. On the concept of visual doubling in earlier French secular manuscripts, see Hedeman in Morrison and Hedeman 2010, 79–84.

65. On the use of exotic costume by Van Lathem in the related *History of Jason* manuscript, see Van Buren 2008.

66. Lucy Moorkerjee suggested in personal communications that the change of costume rather than scenery (i.e., the buildings and landscape remain distinctly Flemish throughout) might also reflect the origins of this narrative in live performances (see Vincent 2010, 81), where a change of costume between scenes could be an easy indicator of movement in the story from East to West.

67. Also noted by Vincent 2010, 74–75.

68. Certain aspects germane to Van Lathem's style, working methods, and abilities are just as evident in his devotional works as in his secular manuscripts. For Van Lathem's iconographic innovations in the Trivulzio Hours, see Rudy 2013.

69. McKendrick in Kren and McKendrick 2003, 223–26. In addition, unlike many of his contemporaries, Van Lathem did not seem to operate a large workshop trained to produce miniatures in his style. Most miniatures assigned to Van Lathem's "workshop" either appear in manuscripts that he also participated in (such as the Breslau Froissart or the Prayer Book of Charles the Bold) or that he seems to have directly supervised (perhaps including the Dülmen *Gillion*). Some manuscripts, such as the Sachsenheim Prayer Book (Stuttgart, Württembergische Landesbibliothek, Cod. Brev. 162), have been ascribed to a workshop member, but there is disagreement on this subject. Wolf 1996, 34–95. Nevertheless, a "Van Lathem style" is not found in dozens of other manuscripts.

70. Van Lathem produced less than half a dozen miniatures for a manuscript of the *Abridged Chronicles of Jerusalem* (Vienna, ÖNB, Cod. 2533), about 1455; one miniature for a manuscript of the *Secrets of Secrets* (Paris, BnF, Ms. fr. 562), about 1470–75; and one miniature for a copy of the history of Rome (*Romuleon*, after 1468, Brussels, KBR, Ms. 9055). *The Miracles of the Virgin* (Paris, BnF, Ms. fr. 9199) contains an extensive series of narrative illuminations painted in grisaille, but their nature as individual vignettes is quite different from the connected secular narratives discussed here.

71. See Wolf 1996, 201–6, 283–89; Bousmanne 1997, 200–204, 297–99; Hans-Collas and Schandel 2009, 24, 78; Blondeau 2009, 90–99, 327–28, and passim; Wijsman 2010, 202, 233, 248, 251; Bousmanne and Delcourt 2011, 110n19, 239, 256, 287.

72. The manuscript is too tightly bound to complete a collation, but the eleven images are all contained within eight folios, so it may well be a single gathering. No catchwords are visible in this part of the manuscript, but there is a catchword exactly eight folios after the last folio with a miniature by Van Lathem, so it seems a good possibility that it is a single gathering. (Catchwords are the first word of the next gathering, placed at the bottom of the last verso of each gathering so that the gatherings could easily be kept in the correct order before the manuscript was bound.) A further three miniatures by Van Lathem found on fols. 127–133 (also within one gathering) concern the Restoration of the Peacock, a sequel to the Vows of the Peacock section that he illuminated on fols. 87–94.

73. For the tradition, see Leo 2013.

74. The group of four vow scenes that precede those by Van Lathem are by Willem Vrelant's workshop (Bousmanne 1997, 297–99; Bousmanne and Delcourt 2011, 256). Two show completely different feasts underway while the other two are simply mirror images of each other.

75. Interestingly, Stahuljak and I noticed a slightly different version of this approach in the Getty *Gillion*. The initial on fol. 13 (plate 4) showing Gillion praying in his castle is visualized as a 90-degree turn from the initial on fol. 11v (plate 3). It is as if the viewer has turned the corner to see a different side of the castle. Gillion and

Marie leaning over to watch the fish are the fixed points around which the viewer has pivoted.

76. See Lindner 1912; Wolf 1996, 191–201, 241–48; Hans-Collas and Schandel 2009, 58, 78, 84, 157, 164; Bousmanne and Delcourt 2011, 285–90, 320, 380.

77. The miniatures of volume 1 have been linked to Loyset Liédet. Dogaer 1987, 112; Charron and Gil 1999, 91, 99; Hans-Collas and Schandel 2009, 58.

78. The miniatures in volume 3 are painted in pastel shades, almost like a moderate step in between semigrisaille and full color, giving them an ethereal, whimsical character.

79. See, for example, the Battle of Nicopolis (vol. 4, fol. 229v).

80. See Pinkernell 1973; Wolf 1996, 182–91, 271–72; Martens 1992, 115, 116; McKendrick in Kren and McKendrick 2003, 243; Hans-Collas and Schandel 2009, 79–82; Bousmanne and Delcourt 2011, 111n29, 122, 124n28, 125n52, 287, 292, 406.

81. Stahuljak, "A Romance between the East and the West," 81–83.

82. I thank Hanno Wijsman for pointing out that Louis's copies of texts like *Guiron le Courtois* (Paris, BnF, Ms. fr. 358–63) and *Perceforest* (Paris, BnF, Ms. fr. 345–48) might also be considered historical romances, but they address heroes of the time of Alexander and Arthur, unlike the (seemingly) real Gillion de Trazegnies, who was a high medieval (closer in time) and regional (closer in geography) hero.

83. During this period, Gruuthuse may have also been acquiring older manuscripts through purchase or gift. For an in-depth discussion of the library as well as a complete list of the known manuscripts, see Hans-Collas and Schandel 2009. For discussions of the Gruuthuse library, see Baurmeister and Laffitte 1992, 193–95; Vale 1995; Lemaire 1996; Laffitte 1997; Quéruel 2006; Wijsman 2010, 355–69. Wijsman (2010, 219–55, 277) also gives helpful overviews of the libraries of Philip the Good and of Anthony of Burgundy. On Anthony's library, see van den Bergen-Pantens 1993; van den Bergen-Pantens 1996. On Philip the Good's library, also see Delaissé 1959; Bousmanne and coeditors, *La librarie des ducs de Bourgogne*, 4 vols., 2000–2009; Bousmanne and Delcourt 2011. On dating Louis's collection, see n. 4 above.

84. Here I will discuss only the manuscripts datable before 1464. A full list of manuscripts with probable dates is given in Hans-Collas and Schandel 2009, 321–28. There are two additional manuscripts in that list given with an approximate date of third quarter of the fifteenth century, one of which is Parisian in origin and was not commissioned by Louis, and the other is a little-studied manuscript in Turin that I have not had the opportunity to see (Paris, BnF, Ms. fr. 133, and Turin, Biblioteca Nazionale Universitaria, L.I. 10). A third manuscript, of *The Life and Passion of Our Lord Jesus Christ* (unknown location, Sotheby's, London, December 6, 2001, lot 67), must date after 1461 because of the appearance of Louis's arms with the Order of the Golden Fleece and has traditionally been seen as coming early in the career of the Master of the Harley Froissart. McKendrick in Kren and McKendrick 2003, 261. Although devotional in nature, it provides several interesting parallels with the Getty *Gillion*, as it too features historiated initials, and the artist has been posited by McKendrick as working for Louis both in this early period and then again around 1470 (McKendrick in Kren and McKendrick 2003, 261–62, 245), as I am arguing for Lieven van Lathem. This manuscript is also closely related to a copy of the same text made for Philip (Brussels, KBR, Mss. 9081–82). Yann Sordet (in Cockshaw 2000, 234–36) points out that a manuscript in Paris (Bibliothèque Sainte-Geneviève, Mss. 809–11) lacks the collar of the Order of the Golden Fleece around the arms of Louis of Gruuthuse, which might suggest the manuscript dates to before 1461, but the artist of the manuscript has been identified as the Master of the *Chroniques d'Angleterre*, who seems to have mostly been active after 1470. Hans-Collas and Schandel 2009, 183–84; Bousmanne and Delcourt 2011, 323–25.

85. Hans-Collas and Schandel 2009, 39.

86. The Master of Anthony of Burgundy, so-called for the numerous works this artist undertook at the behest of Anthony of Burgundy, was an artist favored by Louis. Another manuscript, a copy of the *Book of the Properties of Things* [*Livre des propriétés des choses*] (Paris, BnF, Ms. fr. 134), also illuminated by the Master of Anthony of Burgundy for Louis, was produced sometime between 1467 and 1475 (Hans-Collas and Schandel 2009, 96), so it does not necessarily fit within the date range under discussion but nonetheless shows his preference for this artist. Philip the Good owned a copy of the *Book of the Properties of Things* from the fourteenth century (Brussels, KBR, Ms. 9094), but it is not known whether Louis's copy was influenced by the compositions in Philip's copy.

87. Hans-Collas and Schandel 2009, 96.

88. Louis's *Mirror of History* is a notable exception since neither its illuminations nor the text is related to a similar manuscript owned by Philip or Anthony, but it was an unusual example in any case because Louis apparently acquired the manuscript with three of its four volumes written out around 1400 but not decorated, and he engaged Vrelant to finish it. Hans-Collas and Schandel 2009, 24–36.

89. See Stahuljak, "A Romance between the East and the West," 77–81.

90. The link between the Getty *Gillion* and the contemporary political situation regarding the East is discussed in Sotheby's 2012, 53.

91. For Philip's Crusading ambitions, see Vaughan 1970, 358–72; Paviot 2003, 59–238.

92. For more details, see Stahuljak, "A Romance between the East and the West," 64–67, 71–81.

93. Vincent (2010, 74–75) attributes this difference in emphasis to Anthony's greater status at the Burgundian court and therefore his liking for grandiose, crowded scenes.

94. We have no archival information regarding whether Louis was called upon to actively participate in the Crusade, but there is no indication that he ever left Flanders to join the effort.

95. Hans-Collas and Schandel 2009, 50–52; Donovan 2013, 115–59. Donovan specifically argues a contradistinction between the illuminations of the Getty *Gillion* and Louis's copy of the *Book of Heraclius* text, which is a history of the Crusades. On the probable comparative cost of these two manuscripts, see Stahuljak, "A Romance between the East and the West," 79.

96. The fifth project, Froissart's *Chronicles*, made at the behest of Anthony of Burgundy, does in part address the Crusades. The Battle of Nicopolis from Philip's father's Crusade in 1396, for example, is one of the few scenes to receive a two-column miniature in volume 4 (fol. 229v). The *Secret of Secrets* manuscript also obliquely deals with Eastern subject matter, though not related to the Crusades, but it contains only a single frontispiece miniature by Van Lathem. Hans-Collas and Schandel 2009, 83–85.

97. Wolf (1996, 308) argues that Van Lathem was responsible for miniatures on fols. 12, 12v, 15 (middle), and 15v. De Schryver (2008, 136; also see 103–5, 144, 148n25) does not commit to particular miniatures but says only, "Van Lathem was himself associated with the execution of the *Chroniques*." Having only seen reproductions, I would be inclined to agree with Wolf's assessment. This manuscript was not discussed above in the section concerning Van Lathem's secular projects because the limited number of miniatures he executed for this manuscript and the way they are integrated into the leaves suggest that he was not responsible for the planning of the miniatures' subjects or placements. See also Pächt, Jenni, and Thoss 1983, 61–77; Wolf 1996, 306–9; Bousmanne and Delcourt 2011, 88n8, 107, 188, 191, 198, 200, 220; Moodey 2012, 175–208.

98. On the Feast of the Pheasant, see Moodey 2012, 125–48.

99. On the Order of the Golden Fleece, see Vaughan 1970, 161–63; Paviot 1996; Haggh 2013.

Appendix 1

Description of the Manuscript

Los Angeles, JPGM, Ms. 111 (2013.46)

Written by David Aubert (act. 1456–79) or collaborator in 1464, perhaps in Bruges, for Louis of Gruuthuse (ca. 1422/27–November 24, 1492), lord of Gruuthuse, prince of Steenhuijs, Earl of Winchester, governor general of Holland, Zeeland, and Frisia; illumination by Lieven van Lathem (ca. 1438–1493), in 1464, perhaps in Antwerp or Bruges

Tempera colors, gold, and ink on parchment, bound in blind-tooled tan morocco featuring the arms of the sixth Duke of Devonshire over pasteboard, with green silk doublures and gilt edges (binding is early nineteenth century, before 1817); iii + 237 + iii folios, 8 half-page miniatures with three- or four-sided borders, 44 historiated initials. Binding: 38.9 x 28 x 9.4 cm (15⁵⁄₁₆ x 11 x 3¹¹⁄₁₆ in.); page: 37 x 25.5 cm (14⁹⁄₁₆ x 10¹⁄₁₆ in.); justification: 24.3 x 15.8 cm (9⁹⁄₁₆ x 6¼ in.); one column with 27 lines of *bastarda* in French; original foliation in red above right-hand side of the text block of rectos, modern foliation in pencil in top right-hand corner of rectos (this publication follows the latter)

Heraldry: Escutcheons with the arms of Gruuthuse or his possessions, fols. 9 (arms in initial overpainted by the arms of France), 21 (arms in initial probably overpainted), 36v (arms held by lion overpainted; other arms modified), 150 (arms in initial overpainted); *bombard* (personal device of Louis of Gruuthuse) in border, fols. 9, 36v; *Plus est en vous* (personal motto of Louis of Gruuthuse) on banner held by helmed lion wearing the collar of the Order of the Golden Fleece in border, fol. 36v

Provenance: Louis of Gruuthuse; Louis XII, king of France (1462–1515) [Blois inventory of 1518, no. 97]; William George Spencer Cavendish, sixth Duke of Devonshire (1790–1858), by descent to Peregrine Andrew Morny Cavendish, twelfth Duke of Devonshire (b. 1944); his sale, Sotheby's, London, December 5, 2012, lot 51; J. Paul Getty Museum

Appendix 2

Comparison of the Dülmen *Gillion* Miniatures to Illuminations in the Getty *Gillion*

Dülmen Miniature Subjects	Getty Illumination Subjects
1. *The Author Hearing the Story of Gillion*; *The Author Translating the Story*; *The Wedding of Gillion and Marie*; *Gillion Praying and Marie Gazing at Carp*, fol. 1 (fig. 5)	*The Author Hearing the Story of Gillion de Trazegnies*, fol. 9 (plate 1); Initial *D*: *The Wedding of Gillion and Marie*, fol. 10v (plate 2); Initial *A*: *Gillion and Marie Gazing at a Mother Carp and Her Offspring*, fol. 11v (plate 3); Initial *Q*: *Gillion and Marie Gazing at Carp and Gillion Praying*, fol. 13 (plate 4)
2. *A Battle before the Walls of Cairo*; *Gracienne Sending Gillion and His Companion Hertan to Rescue the Sultan*; *King Tarsus Delivering the Captured Sultan to King Ysore*, fol. 27v (fig. 26)	Initial *B*: *A Battle before the Walls of Cairo*, fol. 27 (plate 10); (missing folio in Getty *Gillion*); Initial *V*: *King Tarsus Capturing the Sultan*, fol. 31v (plate 11)
3. *Battle Scene*; *Gillion Defeating the Emir of Orbrie*, fol. 51v (fig. 24)	*Gillion Defeating King Hector and Gillion Fighting with the Emir of Orbrie*, fol. 49v (plate 17)
4. *Gillion Duels with the Emir of Orbrie*; *Gillion Kills the Emir*; *The Army of the Emir Flees*; *Gillion Brings the Head of the Emir to Gracienne*, fol. 54v (fig. 6)	Initial *A*: *Gillion Defeating the Army of the Emir of Orbrie*, fol. 54v (plate 18)
5. *King Bruyant Burning His Ships in Cyprus*; *Gillion's Sons Battling King Bruyant*; *The Siege of Nicosia*; *Battle Scene with Gillion's Sons*, fol. 109 (fig. 27)	(missing folio in Getty *Gillion*)
6. *The Constable of Cyprus Is Led to His Hanging and Gillion's Sons Rescuing the Constable*; *The Sons of Gillion Attack the Encampment of King Bruyant and the Constable Sails to Rhodes*; *The Arrival of the Grand Master of Rhodes into Cyprus*, fol. 117v (fig. 7)	Initial *Q*: *Gillion's Sons Attacking the Encampment of King Bruyant*, fol. 113 (plate 29); Initial *Q*: *Military Aid Arriving in Cyprus*, fol. 115 (plate 30)
7. *Battle before Nicosia*; *Gillion's Sons Attacked by Saracen Pirates*, fol. 128 (fig. 23)	(missing folio in Getty *Gillion*); Initial *A*: *Gillion's Sons Attacked by Saracen Pirates*, fol. 120 (plate 31)
8. *Three Scenes of the Judicial Duel between Gillion's Son Gerard and the Emir Lucion*; *The Emir Lucion Being Dragged to the Gallows*, fol. 152 (fig. 33)	*A Judicial Duel between Gillion's Son Gerard and the Emir Lucion*, fol. 134v (plate 35); Initial *Q*: *The Emir Lucion Being Dragged to the Gallows*, fol. 147 (plate 36)
9. *Four Scenes of the Judicial Duel between Gillion's Sons*, fol. 177 (fig. 28)	(missing folio in Getty *Gillion*); Initial *G*: *Gillon's Sons Recognizing Each Other*, fol. 164v (plate 39)

Appendix 3

Diagram of Gatherings

A manuscript is constructed as a series of gatherings (or quires), each of which is composed of a number of folded sheets (bifolios) nested one into another. Usually four such bifolios were stacked together and folded to form a single gathering, and then that gathering stacked alongside numerous others to sew into a binding. This arrangement can be reconstructed through careful study even after the manuscript is bound. I thank Nancy Turner for her expertise in helping to map this diagram of the gatherings of the Getty *Gillion*.

The gatherings are numbered sequentially; the superscript numbers indicate the current number of folios in the gathering. The Arabic numerals in the first column indicate the modern foliation. The second column indicates the original foliation in Roman numerals. Brackets indicate a missing folio or illumination. Recto/verso indicates on which side of the folio an illumination appears; recto/verso is indicated for missing illuminations where it was possible to make a determination.

Gathering 1[8]

1		
2		
3		
4		
5		
6		
7		
8		

Gathering 2[8]

9	ii	large miniature (recto)
10	iii	historiated initial (verso)
11	iiii	historiated initial (verso)
12	v	
13	vi	historiated initial (recto)
14	vii	historiated initial (recto)
15	viii	historiated initial (verso)
16	ix	

Gathering 3[7]

17	x	historiated initial (recto)
18	xi	
19	xii	historiated initial (recto)
20	xiii	
21	xiiii	large miniature (recto)
22	xv	
23	xvi	
	[xvii]	[missing historiated initial]

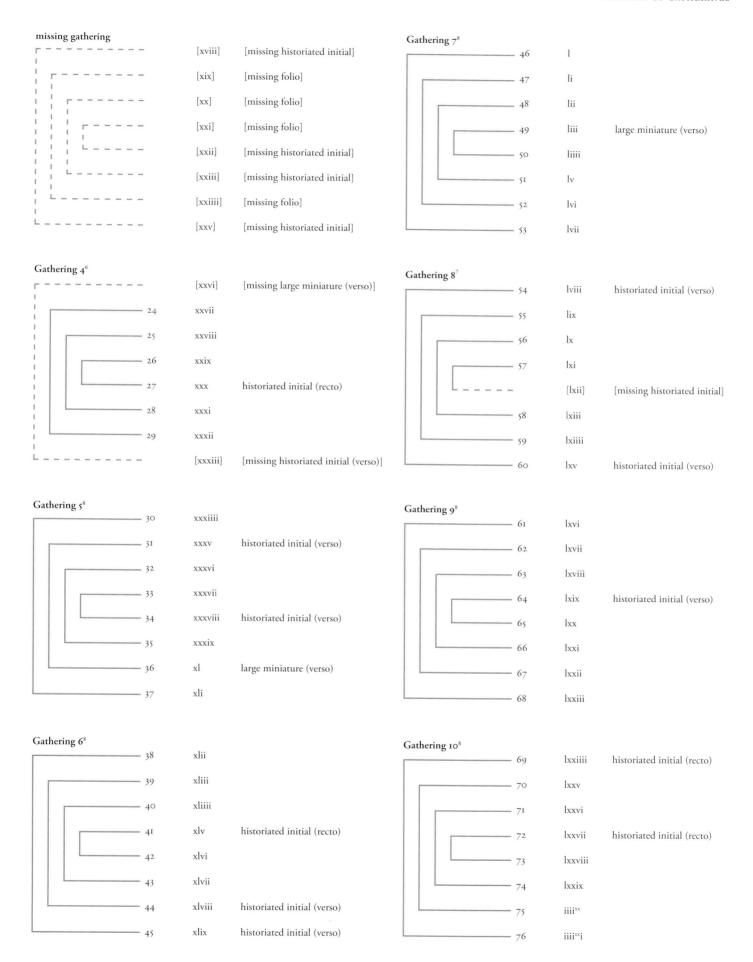

missing gathering

	[xviii]	[missing historiated initial]
	[xix]	[missing folio]
	[xx]	[missing folio]
	[xxi]	[missing folio]
	[xxii]	[missing historiated initial]
	[xxiii]	[missing historiated initial]
	[xxiiii]	[missing folio]
	[xxv]	[missing historiated initial]

Gathering 4⁶

	[xxvi]	[missing large miniature (verso)]
24	xxvii	
25	xxviii	
26	xxix	
27	xxx	historiated initial (recto)
28	xxxi	
29	xxxii	
	[xxxiii]	[missing historiated initial (verso)]

Gathering 5⁸

30	xxxiiii	
31	xxxv	historiated initial (verso)
32	xxxvi	
33	xxxvii	
34	xxxviii	historiated initial (verso)
35	xxxix	
36	xl	large miniature (verso)
37	xli	

Gathering 6⁸

38	xlii	
39	xliii	
40	xliiii	
41	xlv	historiated initial (recto)
42	xlvi	
43	xlvii	
44	xlviii	historiated initial (verso)
45	xlix	historiated initial (verso)

Gathering 7⁸

46	l	
47	li	
48	lii	
49	liii	large miniature (verso)
50	liiii	
51	lv	
52	lvi	
53	lvii	

Gathering 8⁷

54	lviii	historiated initial (verso)
55	lix	
56	lx	
57	lxi	
	[lxii]	[missing historiated initial]
58	lxiii	
59	lxiiii	
60	lxv	historiated initial (verso)

Gathering 9⁸

61	lxvi	
62	lxvii	
63	lxviii	
64	lxix	historiated initial (verso)
65	lxx	
66	lxxi	
67	lxxii	
68	lxxiii	

Gathering 10⁸

69	lxxiiii	historiated initial (recto)
70	lxxv	
71	lxxvi	
72	lxxvii	historiated initial (recto)
73	lxxviii	
74	lxxix	
75	iiiixx	
76	iiiixxi	

143

Gathering 11⁷

77	iiiiˣˣii	
78	iiiiˣˣiii	historiated initial (verso)
79	iiiiˣˣiiii	
80	iiiiˣˣv	
81	iiiiˣˣvi	
82	iiiiˣˣvii	historiated initial (recto)
83	iiiiˣˣviii	
[iiiiˣˣix]	[missing historiated initial]	

Gathering 12⁸

84	iiiiˣˣx	historiated initial (verso)
85	iiiiˣˣxi	
86	iiiiˣˣxii	
87	iiiiˣˣxiii	
88	iiiiˣˣxiiii	
89	iiiiˣˣxv	
90	iiiiˣˣxvi	
91	iiiiˣˣxvii	

Gathering 13⁸

92	iiiiˣˣxviii	
93	iiiiˣˣxix	
94	c	
95	ci	historiated initial (recto)
96	cii	
97	ciii	
98	ciiii	
99	cv	

Gathering 14⁸

100	cvi	
101	cvii	historiated initial (verso)
102	cviii	
103	cix	
104	cx	
105	cxi	historiated initial (recto)
106	cxii	
107	cxiii	

Gathering 15⁷

[cxiiii]	[missing large miniature (recto)]	
108	cxv	
109	cxvi	
110	cxvii	
111	cxviii	
112	cxix	
113	cxx	historiated initial (recto)
114	cxxi	

Gathering 16⁷

115	cxxii	historiated initial (recto)
116	cxxiii	
117	cxxiiii	
[cxxv]	[missing large miniature (recto)]	
118	cxxvi	
119	cxxvii	
120	cxxviii	historiated initial (recto)
121	cxxix	

Gathering 17⁸

122	cxxx	
123	cxxxi	
124	cxxxii	historiated initial (recto)
125	cxxxiii	
126	cxxxiiii	
127	cxxxv	
128	cxxxvi	historiated initial (verso)
129	cxxxvii	

Gathering 18⁸

130	cxxxviii	
131	cxxxix	
132	cxl	historiated initial (verso)
133	cxli	
134	cxlii	large miniature (verso)
135	cxliii	
136	cxliiii	
137	cxlv	

Gathering 19⁸

138 — cxlvi
139 — cxlvii
140 — cxlviii
141 — cxlix
142 — cl
143 — cli
144 — clii
145 — cliii

Gathering 23⁸

162 — clxxviii
163 — clxxix
164 — ciiii^xx — historiated initial (verso)
165 — ciiii^xxi
166 — ciiii^xxii
167 — ciiii^xxiii
168 — ciiii^xxiiii — historiated initial (verso)
169 — ciiii^xxv

Gathering 20⁸

146 — cliiii
147 — clv — historiated initial (recto)
148 — clvi
149 — clvii
150 — clviii — large miniature (verso)
151 — clix
152 — clx
153 — clxi — historiated initial (recto)

Gathering 24⁸

170 — ciiii^xxvi — historiated initial (verso)
171 — ciiii^xxvii
172 — ciiii^xxviii
173 — ciiii^xxix
174 — ciiii^xxx
175 — ciiii^xxxi
176 — ciiii^xxxii
177 — ciiii^xxxiii — large miniature (recto)

Gathering 21⁶

154 — clxii
155 — clxiii
156 — clxiiii
157 — clxv
158 — clxvi
159 — clxvii
[clxviii] — [missing folio]
[clxix] — [missing folio]

Gathering 25⁸

178 — ciiii^xxxiiii
179 — ciiii^xxxv
180 — ciiii^xxxvi
181 — ciiii^xxxvii
182 — ciiii^xxxviii
183 — ciiii^xxxix
184 — cc
185 — cci

Gathering 22²

[clxx] — [missing folio]
[clxxi] — [missing folio]
[clxxii] — [missing folio]
[clxxiii] — [missing large miniature]
[clxxiv] — [missing folio]
[clxxv] — [missing folio]
160 — clxxvi
161 — clxxvii

Gathering 26⁸

186 — ccii
187 — cciii
188 — cciiii — large miniature (verso)
189 — ccv
190 — ccvi
191 — ccvii
192 — ccviii
193 — ccix

Gathering 27⁶

194	ccx	
195	ccxi	
[ccxii]		[missing historiated initial (recto)]
196	ccxiii	
197	ccxiiii	
[ccxv]		[missing historiated initial (recto)]
198	ccxvi	
199	ccxvii	

Gathering 28²

200	ccxviii	historiated initial (verso)
[ccxix]		[missing folio]
[ccxx]		[missing folio]
[ccxxi]		[missing folio]
[ccxxii]		[missing historiated initial]
[ccxxiii]		[missing folio]
[ccxxiiii]		[missing folio]
201	ccxxv	

Gathering 29⁸

202	ccxxvi	
203	ccxxvii	
204	ccxxviii	historiated initial (recto)
205	ccxxix	
206	ccxxx	
207	ccxxxi	
208	ccxxxii	historiated initial (recto)
209	ccxxxiii	

Gathering 30⁷

210	ccxxxiiii	historiated initial (recto)
211	ccxxxv	
212	ccxxxvi	
213	ccxxxvii	
214	ccxxxviii	historiated initial (verso)
[ccxxxix]		[missing large miniature (verso)]
215	ccxl	
216	ccxli	

Gathering 31⁸

217	ccxlii	
218	ccxliii	historiated initial (verso)
219	ccxliiii	
220	ccxlv	
221	ccxlvi	
222	ccxlvii	
223	ccxlviii	
224	ccxlix	historiated initial (verso)

Gathering 32⁷

225	ccl	
226	ccli	
227	cclii	
228	ccliii	historiated initial (recto)
229	ccliiii	
230	cclv	
231	cclvi	
[cclvii]		[missing large miniature (verso)]

Gathering 33⁶

232	cclviii	
233	cclix	
234	cclx	
235	cclxi	historiated initial (recto)
236	cclxii	
237	cclxiii	

Inventory of Original Images

Total number of extant large miniatures: 8

Total number of extant historiated initials: 44

Total number of missing large miniatures: 6

Total number of missing historiated initials: 11

Total number of original images: 69

(14 large miniatures; 55 historiated initials)

References

List of Abbreviations

BL: British Library, London

BnF: Bibliothèque nationale de France, Paris

JPGM: J. Paul Getty Museum, Los Angeles

KB: Koninklijke Bibliotheek, The Hague

KBR: Koninklijke Bibliotheek van België (Bibliothèque Royale de Belgique),

Brussels

ÖNB: Österreichische Nationalbibliothek, Vienna

Staatbibliothek, SPK: Staatsbibliothek zu Berlin, Stiftung Preußischer

Kulturbesitz, Berlin

Primary Sources

Bagatii 1948
Bagatti, Bellarmino, ed. *Visit to the Holy Places of Egypt, Sinai, Palestine, and Syria in 1384, by Frescobaldi, Gucci & Sigoli*. Translated by Theophilus Bellorini and Eugene Hoade. Jerusalem: Franciscan Press, 1948.

Beaune and d'Arbaumont 1884
Beaune, Henri, and J. d'Arbaumont, eds. *Mémoires d'Olivier de La Marche, maître d'hôtel et capitaine des gardes de Charles le Téméraire*. Vol. 2. Paris: Librairie Renouard, 1884.

Blanchard 1995
Blanchard, Joël, ed. Antoine de la Sale, *Jehan de Saintré*. Paris: Livre de poche, 1995.

Buchon 1826
Buchon, J.A., ed. Mathieu d'Escouchy, *Chroniques* in *Chroniques d'Enguerrand de Monstrelet*. Vols. 10–11. Paris: Verdière, 1826.

Chalon 1837
Chalon, R. *La Chronique du bon chevalier messire Gilles de Chin*. Mons: Typ. de Hoyois-Derely, 1837.

Debrie and Garnier 1976
Debrie, René, and Pierre Garnier, eds. *La Romance du Sire de Créqui: Une énigme littéraire picarde*. Amiens: C.R.D.P., 1976.

De Lettenhove 1967
De Lettenhove, Kervyn, ed. Jean Froissart, *Chroniques*. In *Oeuvres de Froissart*. Vol. 15. Repr. ed. Osnabrück: Biblio, 1967 [1st ed. 1867–77].

Guiette 1940
Guiette, Robert, ed. *Croniques et conquestes de Charlemaine*. 2 vols. Brussels: Palais des Académies, 1940.

Horgan 1985
Horgan, Frances. "A Critical Edition of the "Romance of Gillion de Trazegnies" from Brussels Bibliothèque Royale Ms. 9629." PhD diss., Cambridge University, 1985.

Lalande 1985
Lalande, Denis, ed. *Le livre des fais du bon messire Jehan le Maingre, dit Boucicaut, Mareschal de France et Gouverneur de Jennes*. Geneva: Droz, 1985.

Potvin 1878
Potvin, Charles, ed. Guillebert de Lannoy, *Œuvres de Ghillebert de Lannoy, voyageur, diplomate et moraliste*. Louvain: Impr. De P. et J. Lefever, 1878.

Seigneuret 1966
Seigneuret, Jean-Charles, ed. *Le Roman du Comte d'Artois*. Geneva: Droz, 1966.

Stuip 1993
Stuip, René, ed. *Histoire des Seigneurs de Gavre*. Paris: H. Champion, 1993.

Tucco-Chala 1972–73
Tucco-Chala, Pierre, ed. "Le voyage de Pierre Barbatre à Jérusalem en 1480." *Annuaire-Bulletin de la Société de l'histoire de France* (1972–73): 75–172.

Vincent 2010
Vincent, Stéphanie, ed. *Le Roman de Gillion de Trazegnies*. Textes vernaculaires du Moyen Âge 11. Turnhout: Brepols, 2010.

Wolff 1839
Wolff, O. L. B. *Histoire de Gillion de Trasignyes et de Dame Marie, sa femme*. Paris and Leipzig: Desforges, Brockhaus et Avenarius, 1839.

Secondary Sources

Akbari 2009
Akbari, Suzanne Conklin. *Idols in the East: European Representations of Islam and the Orient, 1100–1450*. Ithaca, NY: Cornell University Press, 2009.

Alexander 1992
Alexander, Jonathan J. G. *Medieval Illuminators and Their Methods of Work*. New Haven: Yale University Press, 1992.

Alexander, Marrow, and Sandler 2005
Alexander, Jonathan J. G., James H. Marrow, and Lucy Freeman Sandler. *The Splendor of the Word: Medieval and Renaissance Illuminated Manuscripts at the New York Public Library*. Exh. cat. New York: New York Public Library; London and Turnhout: Harvey Miller Publishers, 2005.

Barrois 1830
Barrois, Joseph. "Inventaire de la librairie qui est en la maison à Bruges, vers 1467 à Gand en 1485, à Bruxelles en 1487." In *Bibliothèque protypographique, ou, Libraries des fils du roi Jean, Charles V, Jean de Berri, Philippe de Bourgogne et les siens*, 123–226. Paris: Treuffel et Würtz, 1830

Baurmeister and Laffitte 1992
Baurmeister, Ursula, and Marie-Pierre Laffitte. *Des livres et des rois: La bibliothèque royale de Blois*. Paris: Bibliothèque nationale de France, 1992.

Bayot 1903
Bayot, Alphonse. *Le Roman de Gillion de Trazegnies*. Louvain and Paris: Typ. C. Peeters, 1903.

Blockmans et al. 2013
Blockmans, Wim, et al., eds. *Staging the Court of Burgundy: Proceedings of the Conference "The Splendor of Burgundy."* Turnhout: Brepols, 2013.

Blondeau 2009
Blondeau, Chrystèle. *Un conquérant pour quatre ducs: Alexandre le Grand à la cour de Bourgogne*. Paris: Institut national d'histoire de l'art, 2009.

Boon 1964
Boon, K. G. "Nieuwe gegevens over de Meester van Katharina van Kleff en zijn atelier." *Bulletin van de Koninklijke Nederlandische Oudheidkundige Bond*, ser. 6, 17 (1964): 241–54.

Bouchet 2009
Bouchet, Florence. "Le lecteur à l'œuvre: L'avènement du lecteur dans le discours auctorial (France, XIVe–XVe siècles)." *Poétique* 159 (2009): 275–85.

Bousmanne 1997

Bousmanne, Bernard. *"Item a Guillaume Wyelant aussi enlumineur": Willem Vrelant, un aspect de l'enluminure dans les Pays-Bas méridionaux sous le mécénat des ducs de Bourgogne Philippe le Bon et Charles le Téméraire.* Turnhout: Brepols, 1997.

Bousmanne and Delcourt 2011

Bousmanne, Bernard, and Thierry Delcourt, eds. *Miniatures flamandes, 1404–1482.* Exh. cat. Brussels and Paris: Bibliothèque royale and Bibliothèque nationale de France, 2011.

Bousmanne and van Hoorebeeck 2000

Bousmanne, Bernard, and Céline van Hoorebeeck, eds. *La librairie des ducs de Bourgogne: Manuscrits conservés à la Bibliothèque royale de Belgique.* Vol. 1, *Textes liturgiques, ascétiques, théologiques, philosophiques et moraux.* Turnhout: Brepols, 2000.

Bousmanne, Johan, and van Hoorebeeck 2003

Bousmanne, Bernard, Frédérique Johan, and Céline van Hoorebeeck, eds. *La librairie des ducs de Bourgogne: Manuscrits conservés à la Bibliothèque royale de Belgique.* Vol. 2, *Textes didactiques.* Turnhout: Brepols, 2003.

Bousmanne, van Hemelryck, and van Hoorebeeck 2006

Bousmanne, Bernard, Tania van Hemelryck, and Céline van Hoorebeeck. *La librairie des ducs de Bourgogne: Manuscrits conservés à la Bibliothèque royale de Belgique.* Vol. 3, *Textes littéraires.* Turnhout: Brepols, 2006.

Bousmanne, van Hemelryck, and van Hoorebeeck 2009

Bousmanne, Bernard, Tania van Hemelryck, and Céline van Hoorebeeck, eds. *La librairie des ducs de Bourgogne: Manuscrits conservés à la Bibliothèque royale de Belgique.* Vol. 4, *Textes historiques.* Turnhout: Brepols, 2009.

Brown-Grant 2008

Brown-Grant, Rosalind. *French Romance of the Later Middle Ages: Gender, Morality, and Desire.* Oxford: Oxford University Press, 2008.

Brown-Grant 2012

Brown-Grant, Rosalind. "Narrative Style in Burgundian Prose Romances of the Later Middle Ages." *Romania* 130 (2012): 355–406.

Buettner 2001

Buettner, Brigitte. "Past Presents: New Year's Gifts at the Valois Courts, ca. 1400." *Art Bulletin* 83 (2001): 598–625.

Caron 2003

Caron, Marie-Thérèse. *Les vœux du faisan, noblesse en fête, esprit de croisade: Le manuscrit français 11594 de la Bibliothèque nationale de France.* Turnhout: Brepols, 2003.

Caron and Clauzel 1997

Caron, Marie-Thérèse, and Denis Clauzel. *Le banquet du faisan.* Arras: Artois Presses Université, 1997.

Charron and Gil 1999

Charron, Pascale, and Marc Gil. "Les enlumineurs des manuscrits de David Aubert." In Quéruel 1999, 81–100.

Cockshaw 1996

Cockshaw, Pierre, ed. *L'Ordre de la Toison d'or, de Philippe le Bon à Philippe le Beau, 1430–1505.* Turnhout: Brepols, 1996.

Cockshaw 2000

Cockshaw, Pierre, ed. *Les Chroniques de Hainaut, ou les ambitions d'un prince bourguignon.* Turnhout: Brepols, 2000.

Coleman 1996

Coleman, Joyce. *Public Reading and the Reading Public in Late Medieval England and France.* Cambridge: Cambridge University Press, 1996.

Constable 2012

Constable, Giles, ed. and trans. Introduction to *How to Defeat the Saracens,* by William of Adam, 1–19. Washington, D.C.: Dumbarton Oaks Research Library and Collection, 2012.

Contamine and Paviot 2008

Contamine, Philippe, and Jacques Paviot, eds. Introduction to *Une epistre lamentable et consolatoire* by Philippe de Mézières, 9–96. Paris: La Société de l'Histoire de France, 2008.

Cornish 2011

Cornish, Alison. *Vernacular Translation in Dante's Italy: Illiterate Literature.* Cambridge: Cambridge University Press, 2011.

Dakhlia 2008

Dakhlia, Jocelyne. *Lingua franca: Histoire d'une langue métisse en Méditerranée.* Arles: Actes Sud, 2008

De Barthélemy 1884

De Barthélemy, Anatole. "Chartes de départ et de retour des comtes de Dampierre-en-Astenois, IVe et Ve croisades." *Archives de l'Orient Latin* 2 (1884): 2:184–89.

De Gruben 1996

De Gruben, Françoise. "Les chapitres de la Toison d'or à l'époque bourguignonne (1430–1477)." In Cockshaw 1996, 80–83.

Delaissé 1959

Delaissé, L. M. J. *Le siècle d'or de la miniature flamande: Le mécénat de Philippe le Bon; Exposition organisée à l'occasion du 400e anniversaire de la fondation de la Bibliothèque royale de Philippe II à Bruxelles, le 12 avril 1959.* Exh. cat. Brussels, 1959.

Delaville le Roulx 1886

Delaville le Roulx, Joseph Marie Antoine. *La France en Orient au XIVe siècle: Expéditions du Maréchal Boucicaut.* 2 vols. Paris, 1886.

Delsaux and van Hemelryck 2014

Delsaux, Olivier, and Tania van Hemelryck. *Les manuscrits autographes en français au Moyen Âge.* Turnhout: Brepols, 2014.

De Schryver 1957

De Schryver, Antoine. "Lieven van Lathem, een onbekende grootmeester van de Vlaamse miniatuurschilderkunst." In *Handelingen van het XXIIe Vlams Filologencongres,* 338–42. Leuven: Uitgegeven door De Vlaamsche Philologencongressen, 1957.

De Schryver 2008

De Schryver, Antoine. *The Prayer Book of Charles the Bold.* Los Angeles: J. Paul Getty Museum, 2008.

De Smedt 2000

De Smedt, Raphaël, ed. *Les Chevaliers de l'Ordre de la Toison d'or au XVe siècle: Notices bio-bibliographiques.* 2nd rev. ed. New York: P. Lang, 2000.

Dibdin 1817

Dibdin, T. F. *The Biographical Decameron; or, Ten Days Pleasant Discourse upon Illuminated Manuscripts and Subjects Connected with Early Engraving, Typography, and Bibliography.* London: W. Bulmar, 1817.

Dogaer 1987

Dogaer, Georges. *Flemish Miniature Painting in the 15th and 16th Centuries.* Amsterdam: B. M. Israël, 1987.

Donovan 2011

Donovan, Erin K. "A *Livre d'Eracles* within the Library of the Fifteenth-Century Flemish Bibliophile, Louis de Bruges: Paris, BnF Ms. fr. 68 in Context." In *Collections in Context: The Organization of Knowledge and Community in Europe,* edited by Karen L. Fresco and Anne D. Hedeman, 191–207. Columbus: Ohio State University Press, 2011.

Donovan 2013

Donovan, Erin K. "Imagined Crusaders: The *Livre d'Eracles* in Fifteenth-Century Burgundian Collections." PhD diss., University of Illinois, Urbana-Champaign, 2013.

Doutrepont 1906

Doutrepont, Georges. *Inventaire de la "librairie" de Philippe le Bon (1420).* Brussels: Kiessling et cie, 1906.

Doutrepont 1909

Doutrepont, Georges. *La littérature française à la cour des ducs de Bourgogne: Philippe le Hardi, Jean sans Peur, Philippe le Bon, Charles le Téméraire.* Paris: Honoré Champion, 1909.

Doutrepont 1939

Doutrepont, Georges. *Les Mises en prose des épopées et des romans chevaleresques du XIVe et XVe siècle.* Brussels: Palais des académies, 1939.

Ferlampin-Acher 2012
Ferlampin-Acher, Christine, trans. Introduction to *Guillaume de Palerne*, 7–112. Paris: Garnier Classiques, 2012.

Gardette 2003
Gardette, Philippe. "Jacques de Helly, figure de l'entre-deux culturel au lendemain de la défaite de Nicopolis." *Erytheia* 24 (2003): 111–24.

Gaucher 1994
Gaucher, Elisabeth. *La biographie chevaleresque: Typologie d'un genre (XIIIe–XVe siècle).* Paris: H. Champion, 1994.

Gaullier-Bougassas 2003
Gaullier-Bougassas, Catherine. *La tentation de l'orient dans le roman médiéval: Sur l'imaginaire médiéval de l'autre.* Paris: Champion, 2003.

Gaullier-Bougassas 2011
Gaullier-Bougassas, Catherine. *Les Vœux du Paon de Jacques de Longuyon: Originalité et rayonnement.* Paris: Kincksieck, 2011.

Gil 1994
Gil, Marc. "Le mécénat littéraire de Jean V de Créquy, conseiller et chambellan de Philippe le Bon." *Eulalie* 1 (1994): 69–95.

Haemers 2007
Haemers, Jelle. "Philippe de Clèves et la Flandre: La position d'un aristocrate au cœur d'une révolte urbaine (1477–1492)." In Haemers, van Hoorebeeck, and Wijsman 2007, 21–83.

Haemers, Van Hoorebeeck, and Wijsman 2007
Haemers, Jelle, Céline van Hoorebeeck, and Hanno Wijsman, eds. *Entre la ville, la noblesse et l'état: Philippe de Clèves (1456–1528), homme politique et bibliophile.* Turnhout: Brepols, 2007

Haggh 2013
Haggh, Barbara. "Between Council and Crusade: The Ceremonial of the Order of the Golden Fleece in the Fifteenth Century." In Blockmans et al. 2013, 51–58.

Ham 1932
Ham, Edward Billings. "Le Manuscrit de *Gillion de Trazignies* à Chatsworth." *Romania* 58 (1932): 66–77.

Hans-Collas and Schandel 2009
Hans-Collas, Ilona, and Pascal Schandel. *Manuscrits enluminés des anciens Pays-Bas méridionaux.* Vol. 1, *Manuscrits de Louis de Bruges.* Paris: Bibliothèque nationale de France, 2009.

Hans-Collas and Wijsman 2009
Hans-Collas, Ilona, and Hanno Wijsman. "Le Livre d'heures et de prières d'Agnès de Bourgogne, duchesse de Bourbon." *Art de l'enluminure* 29 (2009): 20–47.

Heyder 2014
Heyder, Joris. "Corporate Design Made in Ghent/Bruges? On the Extensive Reuse of Patterns in Late Medieval Flemish Illuminated Manuscripts." In *Usage of Models in Medieval Book Painting*, edited by Monika Müller, 167–201. Newcastle upon Tyne: Cambridge Scholars, 2014.

Inglis 1995
Inglis, Eric. *The Hours of Mary of Burgundy: Codex Vindobonensis 1857, Vienna, Österreichische Nationalbibliothek.* London: Harvey Miller, 1995.

Johan 2009
Johan, Frédérique. "Les artisans du livre sous les gouvernements de Philippe le Bon et de Charles le Téméraire: En marge d'un projet d'édition de sources." In *Miscellanea in memoriam Pierre Cockshaw (1938–2008)*, edited by Frank Daelemans and Ann Kelders, 2:223–38. Brussels: Archives et bibliothèques de Belgiques, 2009.

Korteweg 2007
Korteweg, Anne. "La bibliothèque de Philippe de Clèves: Inventaire et manuscrits parvenus jusqu'à nous." In Haemers, van Hoorebeeck, and Wijsman 2007, 183–221.

Kren 2005
Kren, Thomas. "The Importance of Patterns in the Emergence of the New Style of Flemish Manuscript Illumination after 1470." In *Manuscripts in Transition: Recycling Manuscripts, Texts, and Images*, edited by Brigitte Dekeyzer and Jan van der Stock, 357–77. Leuven: Uitgeverij Peeters, 2005.

Kren and McKendrick 2003
Kren, Thomas, and Scot McKendrick, eds. *Illuminating the Renaissance: The Triumph of Flemish Manuscript Painting in Europe.* Exh. cat. Los Angeles: J. Paul Getty Museum, 2003.

Laffitte 1997
Laffitte, Marie-Pierre. "Les manuscrits de Louis de Bruges, chevalier de la Toison d'or." In *Le Banquet du Faisan*, edited by Marie-Thérèse Caron and Denis Clauzel, 243–55. Arras: Artois Presses Université, 1997.

Lalande 1988
Lalande, Denis. *Jean II, le Meingre, dit Boucicaut (1366–1421): Étude d'une biographie héroique.* Geneva: Droz, 1988.

Lemaire 1996
Lemaire, Claudine. "La bibliothèque de Louis de Gruuthuse." In Cockshaw 1996, 206–8.

Lemaire and de Schryver 1981
Lemaire, Claudine, and Antoine de Schryver. "De bibliotheek van Lodewijk van Gruuthuse." In *Vlaamse kunst op perkament* 1981, 207–77.

Leman 2010
Leman, Victorien. "Les armoiries monumentales des Créquy au château de Fressin." *Bulletin historique du Haut-Pays* 76 (2010): 33–40.

Leman and Watelle 2009
Leman, Victorien, and Maxence Watelle. "De cire et d'histoire: Les sceaux de la famille de Créquy (XIIe–XVIe siècle)." *Dossiers généalogiques* 25 (2009): n.p.

Leo 2013
Leo, Domenic. *Images, Texts, and Marginalia in a "Vows of the Peacock" Manuscript (New York, Pierpont Morgan Library MS G24).* Boston: Brill, 2013.

Lindner 1912
Lindner, Arthur. *Der Breslauer Froissart: Festschrift des Vereins für Geschichte der bildenden Künste zu Breslau, zum fünfzigjahrigen Jubilaeum verfasst im Auftrage des Vereins.* Berlin: Kommissions-Verlag von Meisenbach, 1912.

Marchandisse 2006
Marchandisse, Alain. "Jean de Wavrin, un chroniqueur entre Bourgogne et Angleterre, et ses homologues bourguignons face à la Guerre des deux roses." *Le Moyen Age* 3 (2006): 507–27.

Martens 1992
Martens, Maximiliaan P. J. *Lodewijk van Gruuthuse: Mecenas en Europees Diplomaat, ca. 1427–1492.* Bruges: Stichting Kunstboek, 1992.

McDougall 2012
McDougall, Sara. *Bigamy and Christian Identity in Late Medieval Champagne.* Philadelphia: University of Pennsylvania Press, 2012.

Moodey 2012
Moodey, Elizabeth J. *Illuminated Crusader Histories for Philip the Good of Burgundy.* Turnhout: Brepols, 2012.

Morgan and Panayotova 2009
Morgan, Nigel, and Stella Panayotova, et al. *A Catalogue of Western Book Illumination in the Fitzwilliam Museum and the Cambridge Colleges.* Pt. 1, vol. 2, *The Meuse Region, Southern Netherlands.* Turnout: Harvey Miller, 2009.

Morrison and Hedeman 2010
Morrison, Elizabeth, and Anne D. Hedeman. *Imagining the Past in France: History in Manuscript Painting, 1250–1500.* Exh. cat. Los Angeles: J. Paul Getty Museum, 2010.

Morse 1980
Morse, Ruth. "Historical Fiction in Fifteenth-Century Burgundy." *Modern Language Review* 75 (1980): 48–64.

Naber 1987
Naber, Antoinette. "Jean de Wavrin, un bibliophile du quinzième siècle." *Revue du Nord* 59 (1987): 281–93.

Naber 1990a

Naber, Antoinette. "Les goûts littéraires d'un bibliophile de la cour de Bourgogne." In *Courtly Literature: Culture and Context*, edited by Keith Busby and Erik Kooper, 459–64. Amsterdam: John Benjamins, 1990.

Naber 1990b

Naber, Antoinette. "Les manuscrits d'un bibliophile bourguignon du XVe siècle, Jean de Wavrin." *Revue du Nord* 72 (1990): 23–48.

Newett 1907

Newett, M. Margaret, ed. Introduction to *Canon Pietro Casola's Pilgrimage to Jerusalem in the Year 1494*, 1–113. Manchester: Manchester University Press, 1907.

Nuttall 2004

Nuttall, Paula. *From Flanders to Florence: The Impact of Netherlandish Painting, 1400–1500*. New Haven: Yale University Press, 2004.

Nuttall 2013

Nuttall, Paula. *Face to Face: Flanders, Florence, and Renaissance Painting*. San Marino, CA: Huntington Library, Art Collections, and Botanical Gardens, 2013.

Pächt, Jenni, and Thoss 1983

Pächt, Otto, Ulrike Jenni, and Dagmar Thoss. *Die illuminierten Handschriften und Inkunabeln der Österreichischen Nationalbibliothek: Flämische Schüle I*. Vienna: Verlag der Österreichischen Akademie der Wissenschaften, 1983.

Pastoureau 1996

Pastoureau, Michel. "Un nouvel ordre de chevalerie." In Cockshaw 1996, 65–66.

Pastoureau 2009

Pastoureau, Michel. *L'art héraldique au Moyen Âge*. Paris: Seuil, 2009.

Paviot 1995

Paviot, Jacques. *Politique navale des ducs de Bourgogne, 1384–1482*. Villeneuve-d'Ascq: Presses Universitaires de Lille, 1995.

Paviot 1996

Paviot, Jacques. "L'Ordre de la Toison d'or et la Croisade." In Cockshaw 1996, 71–74.

Paviot 1999

Paviot, Jacques. "David Aubert à la cour de Bourgogne." In Quéruel 1999, 11–18.

Paviot 2003

Paviot, Jacques. *Les ducs de Bourgogne, la croisade et l'Orient: Fin XIVe siècle–XVe siècle*. Paris: Presses de l'Université de Paris-Sorbonne, 2003.

Pinkernell 1971

Pinkernell, Gert, ed. Introduction to *L'Histoire de Jason, ein Roman aus dem fünfzehnten Jahrhundert*, by Raoul Lefèvre, 7–120. Frankfurt a/M: Athenäum, 1971.

Pinkernell 1973

Pinkernell, Gert. "Die Handschrift B.N., MS Fr. 331 von Raoul Lefevres *Histoire de Jason* und das Wirken des Miniaturisten Lieven van Lathem in Brügge." *Scriptorium* 27, no. 2 (1973): 295–301.

Plumet 1959

Plumet, Jules. *Les Seigneurs de Trazegnies au Moyen Âge: Histoire d'une célèbre famille noble du Hainaut (1100–1500)*. Mont-Sainte-Geneviève, 1959.

Quéruel 1999

Quéruel, Danielle, ed. *Les manuscrits de David Aubert*. Paris: Presses de l'Université de Paris-Sorbonne, 1999.

Quéruel 2000

Quéruel, Danielle. "La naissance des titres: rubriques, enluminures et chapitres dans les mises en prose du XVe siècle." In *A plus d'un titre: Les titres des œuvres dans la littérature française du Moyen Âge au XXe siècle; Actes du colloque (18 et 19 mai 2000)*, edited by Claude Lachet, 49–60. Lyon: C.E.D.I.C., 2000.

Quéruel 2006

Quéruel, Danielle. "Du mécénat au plaisir de lire: L'exemple de quelques seigneurs bourguignons et en particulier de Louis de la Gruthuyse." *Cahiers du léopard d'or* 11 (2006): 197–211.

Régnier-Bohler 1999

Régnier-Bohler, Danielle. "David Aubert et le conte des deux frères: *L'Histoire d'Olivier de Castille et Artus d'Algarbe*." In Quéruel 1999, 53–68.

Richard 2003

Richard, Jean. "Les prisonniers de Nicopolis." In *Francs et Orientaux dans le monde des croisade*, 75–83. Aldershot: Ashgate, 2003.

Roncaglia 1965

Roncaglia, Aurelio. "La letteratura franco-veneta." In *Storia della letteratura italiana II: Il Trecento*, 727–59. Milano: Garzanti, 1965.

Rudy 2013

Rudy, Kathryn. "The Trivulzio Hours, the Ghent Altarpiece, and the Mass as Devotional Subject." In Blockmans et al. 2013, 301–23.

Schandel 1997

Schandel, Pascal. "Le Maitre de Wavrin et les miniaturistes Lillois a l'époque de Philippe le Bon et de Charles le Téméraire." PhD diss., Université des sciences humaines de Strasbourg, 1997.

Schandel 2002–3

Schandel, Pascal. "*Histoire des Seigneurs de Gavre*." *Art de l'Enluminure* 3 (December 2002–February 2003): 4–16.

Scott 1980

Scott, Margaret. *Late Gothic Europe, 1400–1500*. Atlantic Highlands, NJ: Humanities Press, 1980.

Sotheby's 2012

Sotheby's. *Three Renaissance Masterworks from Chatsworth*. Sale cat. London: Sotheby's, 2012.

Sterchi 2004

Sterchi, Bernhard. "Hugues de Lannoy, auteur de l'*Enseignement de vraie noblesse*, de l'*Instruction dun jeune prince* et des *Enseignements paternels*." *Le Moyen Âge* 110 (2004): 79–117.

Straub 1986–87

Straub, Richard E. F. "Contribution à l'étude de l'activité littéraire de David Aubert: Les manuscrits." *Romanica vulgaria: Quaderni* 10–11 (1986–87): 233–68.

Straub 1995

Straub, Richard E. F. *David Aubert, escripvain et clerc*. Amsterdam: Rodopi, 1995.

Straub 1997

Straub, Richard E. F. "L'activité littéraire de David Aubert." In *Le moyen français: philologie et linguistique; Approches du texte et du discours; Actes du VIIe colloque international sur le moyen français (Nancy, 5–6–7 septembre 1994)*, edited by Bernard Combettes and Simone Monsonégo, 143–50. Paris: Didier Érudition, 1997.

Timelli 2004

Timelli, Maria. "Pour une 'défense et illustration' des titres de chapitres: Analyse d'un corpus de romans mis en prose au XVe siècle." In *Du roman courtois au roman baroque: Actes du colloque des 2–5 juillet 2002*, edited by Emmanuel Bury and Francine Mora, 209–32. Paris: Les Belles Lettres, 2004.

Timelli et al. 2014

Timelli, Maria, Barbara Ferrari, Anne Schoysman, and François Suard. *Nouveau répertoire de mises en prose (XIVe–XVIe siècle)*. Paris: Classiques Garnier, 2014.

Tolan 2002

Tolan, John V. *Saracens: Islam in the Medieval European Imagination*. New York: Columbia University Press, 2002.

Vale 1995

Vale, Malcolm. "An Anglo-Burgundian Nobleman and Art Patron: Louis de Bruges, Lord of la Gruthuyse and Earl of Winchester." In *England and the Low Countries in the Late Middle Ages*, edited by Caroline Barron and Nigel Saul, 115–31. New York: St. Martin's Press, 1995.

Van Buren 2008

Van Buren, Anne H. "Van Lathem's Costumes." In *Invention: Northern*

Renaissance Studies in Honor of Molly Faries, edited by Julien Chapuis, 94–103. Turnhout: Brepols, 2008.

Van Buren 2011
Van Buren, Anne. *Illuminating Fashion: Dress in the Art of Medieval France and the Netherlands, 1325–1515*. Exh. cat. New York: Morgan Library and Museum, 2011.

Van den Bergen-Pantens 1993
Van den Bergen-Pantens, Christiane. "Héraldique et bibliophilie: Le cas d'Antoine, Grand Bâtard de Bourgogne (1421–1504)." In *Miscellanea Martin Wittek: Album de codicologie et de paléographie offert à Martin Wittek*, edited by Anny Raman and Eugène Manning, 323–54. Paris: Editions Peeters, 1993.

Van den Bergen-Pantens 1996
Van den Bergen-Pantens, Christiane. "Antoine, Grand Bâtard de Bourgogne, bibliophile." In Cockshaw 1996, 198–200.

Van der Linden 1940
Van der Linden, Herman. *Itinéraires de Philippe le Bon, duc de Bourgogne (1419–1467) et de Charles, comte de Charolais (1433–1467)*. Brussels: Palais des Académies, 1940.

Van Elslande 1992
Van Elslande, Rudy. "Lieven van Lathem, een onbekende belangrijke kunstenaar uit de 15de eeuw." *Jaarboek van de Heemkring Scheldeveld* 21 (1992): 127–69.

Van Praet 1831
Van Praet, Joseph. *Recherches sur Louis de Bruges, seigneur de la Gruthuyse*. Paris: De Bure frères, 1831.

Vaughan 1970
Vaughan, Richard. *Philip the Good: The Apogee of Burgundy*. Harlow: Longmans, 1970.

Visser-Fuchs 2002
Visser-Fuchs, Livia. "Warwick and Wavrin: Two Case Studies on the Literary Background and Propaganda of Anglo-Burgundian Relations in the Yorkist Period." PhD diss., University College London, 2002.

Visser-Fuchs 2006
Visser-Fuchs, Livia. "The Manuscript of the *Enseignement de Vraie Noblesse* Made for Richard Neville, Earl of Warwick, in 1464." In *Medieval Manuscripts in Transition: Tradition and Creative Recycling*, edited by Geert Claessens and Werner Verbeke, 337–62. Mediaevalia Lovaniensia Series 1, Studia 36. Leuven: Leuven University Press, 2006.

***Vlaamse kunst op perkament* 1981**
Vlaamse kunst op perkament: Handschriften en miniaturen te Brugge van de 12de tot de 16de eeuw. Exh. cat. Bruges: Gruuthusemuseum, 1981.

Wagner 1959
Wagner, Anthony R. "The Swan Badge and the Swan Knight." *Archaeologia; or Miscellaneous Tracts Relating to Antiquity, Society of Antiquaries of London* 97 (1959): 127–38.

Wijsman 2007
Wijsman, Hanno. "Politique et bibliophilie pendant la révolte des villes flamandes des années 1482–1492: Relations entre les bibliothèques de Philippe de Clèves, Louis de Gruuthuse et la Librairie de Bourgogne." In Haemers, van Hoorebeeck, and Wijsman 2007, 245–78.

Wijsman 2010
Wijsman, Hanno. *Luxury Bound: Illustrated Manuscript Production and Noble and Princely Book Ownership in the Burgundian Netherlands, 1400–1550*. Turnhout: Brepols, 2010. [online at: http://www.cn-telma.fr/luxury-bound/index/ (accessed March 15, 2015)]

Willard 1996
Willard, Charity Cannon. "Patrons at the Burgundian Court: Jean V de Créquy and His Wife, Louise de la Tour." In *The Search for a Patron in the Middle Ages and the Renaissance*, edited by David G. Wilkins and Rebecca L. Wilkins, 55–62. Lewiston, NY: E. Mellen Press, 1996.

Willard 1997
Willard, Charity Cannon. "Louis de Bruges, lecteur de Christine de Pizan." *Cahiers de recherches médiévales* 4 (1997): 191–95.

Wolf 1996
Wolf, Eva. *Das Bild in der spätmittelalterlichen Buchmalerei: Das Sachsenheim-Gebetbuch im Werk Lieven van Lathems*. Hildesheim: Georg Olms, 1996.

Web Sources
(all accessed March 15, 2015)

ARLIMA (Les Archives de littérature du Moyen Âge): http://www.arlima.net/
Créquy genealogy: http://famille.de.crequy.com/sommaire.htm
Créquy genealogy: http://racineshistoire.free.fr/LGN/PDF/Crequy.pdf
Getty *Gillion* (images): http://www.getty.edu/art/collection/objects/132644/lieven-van-lathem-david-aubert-roman-de-gillion-de-trazegnies-flemish-1464/
La Romance du sire de Créqui: http://www.crequy.com/la_romance_de_raoul.htm
Les Enluminures (image database of manuscripts in municipal French libraries): http://www.enluminures.culture.fr/documentation/enlumine/fr/
Mandragore (BnF, manuscript images website): http://mandragore.bnf.fr/jsp/rechercheExperte.jsp
Pseudo-Aristotle, *Le secret des secrets*: http://www.sites.univ-rennes2.fr/celam/cetm/S2.htm#4
Wijsman, Hanno, Luxury Bound (online list of Flemish manuscripts): http://www.cn-telma.fr/luxury-bound/index/

Index

Page numbers in *italics* refer to illustrations.

Acre, 56, 68, 70–71
Agincourt, Battle of, 72, 88
Alexander, king, 129, 139n82
Alexandria, 70
Amaury (character), 32, 33, *33*, 34, 53, 70–71, 89
Amédée VI, Count of Savoy, 64
Amiens, Bibliothèque municipale, Ms. 483 (*Book of Heraclius*), 87
Anthony of Burgundy, *72*
 coat of arms, 115
 and Gerard character, 73, 76
 Gillion copy owned by (*see* Dülmen, private collection)
 library and manuscript commissions, 72, 82, 90, 104, 123, 130, 134, 137n10, 139n96
 Louis of Gruuthuse as close associate of, 103, 136
 as military commander, 65, 72, 73, 79, 135
Antwerp, 5
Arnaud, Baculard d', 87
Arras, Treaty of, 64, 72
Artois, 64, 81, 84, 88
Aubert, David
 as ducal scribe and secretary, 81, 83, 85, 89, 134
 Dülmen *Gillion*, signature on, 65, 79, 89
 as Getty *Gillion*'s scribe, 81, 90, 112, 120, 137n30, 138n58
 and *Gillion* romance's authorship, 90–91
 as Louis's scribe on other projects, 90, 138n58

Bajazet I, Sultan, 67, 88
Baldwin, Count of Hainaut, 68
Baldwin, Count of Hainaut (character), 18, 19, *19*, 20, *20*, 33, 55, 67, 68, 86, 97
Beauvais, Vincent de, 78, 133
Berlin, Staatsbibliothek, Ms. Dep. Breslau 1 (Froissart, *Chronicles*), 90, 104, 123–24, *123*, 129, 130, *131*, 132, 137n10, 138n69, 139n96
Book of Heraclius [*Livre d'Eracles*], 79, 82, 85, 87, 88, 100n44, 139n95
Boucicaut, Marshal, 7n16, 67, 88, 89
Broquière, Bertrandon de la, 68, *69*, 82, 97
Bruges, 3, 5, 64, 73, 79, 81, 84, 89–90, 92, 100n38, 116, 136
Bruges Master of 1482, 78, 100n41
Brun, Gilles le, 68
Brussels, 89

Brussels, Bibliothèque royale de Belgique
 Ms. 9026 (Breviary of Philip the Good), 133
 Ms. 9055 (*Romuleon*), 138n70
 Ms. 9066 (*Chronicles and Conquests of Charlemagne*), 83, 85, 90, 93, *93*, 95
 Mss. 9081-82 (*The Life and Passion of Our Lord Jesus Christ*), 139n84
 Ms. 9094 (*Book of the Properties of Things*), 139n86
 Ms. 9243 (*Chronicles of Hainaut*), 80, 81
 Ms. 9296 (*Blessed will be the Merciful*), 137n35
 Ms. 9469, 70 (*Justification of France against England*), 134
 Ms. 9511 (Breviary of Philip the Good), 133
 Ms. 9571-72 (*History of the Destruction of Troy*), 137n35
 Ms. 9629 (*Romance of Gillion de Trazegnies*), 6, 7n15, 82, 83
 Ms. 9631 (*Gérard de Nevers*), 82, 83, 101n55
 Ms. IV 1187 (*Romance of Gillion de Trazegnies*), 6, 68, 101n126
Bruyant, King of Slavonia (character), 38, *38*, 40, *75*, *118*
Burgundian Low Countries, 1–2, 3, 5, 63–65, 72–73, 84. *See also specific cities, regions, and rulers*
Byzantine Empire, x, 6

Cairo, 6, 22, 24, *24*, 25, *25*, 28, *28*, *30*, 31, 32, *32*, 34, *34*, 35, *35*, 37, *37*, 47, 49, *49*, 50, *51*, 52, 53, 55, 56, 71, 98–100, 105, *117*, 128
Cambridge, Fitzwilliam Museum, Ms. 143 (book of hours), 106, 137n11
Cambridge, University Library, Ms. Nn. 3.2 (*The Twelve Ladies of Rhetoric*), 134
Cambron Abbey, 53, 54, 68
Camus, Philippe, 82, 89, 90
Champagne, 21, 68, 70
Charles the Bold, Duke of Burgundy, 3, 65, 72, 81, 85, 104, 134
Charles VII, King of France, 64
Childebert, King, 68
Christine de Pizan, 82, 83
Chronicles [*Chroniques*] by Jean Froissart. *See* Froissart, Jean
Chronicles of Hainaut [*Chroniques de Hainaut*], 80, 81, 83, 85, 100n38
Clèves, Adolphe de, 72, 134
Clèves, Philippe de, 6, 71, 72, 81
Constantinople, 2, 6, 64, 68, 70, 88, 135
Count of Artois, [*Comte d'Artois*], 7n16, 81, 91
Courcy, Jean de, 78

Créquy, Jean V de, 83, 84–88, *86*, *87*, 88, 89, 90, 91, 95, 101n74
Créquy Master, *87*
Crete, 15, 39
Crusades
 and dating of *Gillion* romance, 7
 Gillion romance as extolling ideals of, 65, 67, 73, 78, 99
 and Godfrey of Bouillon, 86–87
 and historicity of *Gillion* romance, 68, 70, 89
 and lavish commissions of *Gillion* manuscripts, 72–73, 77–79, 135
 Nicopolis, Battle of, 66, 67, 88–89
 Philip the Good's endeavors, 2, 5, 64–65, 73, 79, 81, 82, 88, 134–36, 138n51
 Venice as embarkation port for, 70, 91
Cyprus, 7, 22, 28, 37, *37*, 38, *38*, 39, *39*, 40, 63, 64, 65, 67, 68, 70, *75*, 77, 88, 99, *118*
 Famagusta, 38
 Kyrenia, 15, 39
 Nicosia, 37, 38, 39, *113*, *118*, 119

Damascus. *See* Ysore, King of Damascus
Deeds and Conquests of Alexander [*Fais et conquests du noble roy Alexandre*] (*see* Paris, Petit Palais, Ms. Dutuit 456)
Devonshire, Dukes of, 1, 112, 137n28
Dibdin, Thomas Frognall, 1
Dubrovnik, 15, 40, *40*, 55, *55*, 76
Dülmen, private collection, *Romance of Gillion de Trazegnies*
 Anthony of Burgundy's ownership of, 6, 65, 71–81, 103, 112, 116, 139n93
 author-translator, depictions of, 82, 84, 92, 124–25
 Crusade ideals in, 65, 67, 73
 dating of, 6, 65, 79, 89, 116
 dedicatory prologue, 73, 78, 81
 Getty *Gillion* compared with, 108–9, 112, 115–17, 119, 128, 141
 illuminations from, *74*, *75*, *113*, *117*, *118*, *126*
 and Jena *Gillion*, 90
 Van Lathem's role in illumination of, 90, 103, 112, 115, 116, 120, 137nn31–32
 Louis's viewing or borrowing of, 81, 120, 136, 138n57
 personalization of manuscript, 71, 73, 75–77, 135
 theft of miniature from, 138n60
 Vincent's edition as based on, 100n11

Edward III, King of England, 64
Edward IV, King of England, 3, 78
Egypt. *See* Cairo
Egypt, sultan of (character), 6, 7, 22, *23*, 24, *24*, 25, *25*, 26, 27, 29, *29*, 33, *33*, 35, 37, *46*, 47, 48, 52, 53, 55, 56, *56*, 57, 59, *59*, 99–100, 105, *117*, 125–28

Fabur, King of Moriane (character), 34, 35, *35*, 36, *36*, 41, *41*, 48, 49, 50, *51*, 76
Fais et conquests du noble roy Alexandre. See Deeds and Conquests of Alexander
Feast of the Pheasant, 3, 64–65, 73, 84, 135, 136, 139n98
Fez, king of (character), 34, 35, 49, *49*, 50, *108*
Fillastre, Guillaume, 82
Flanders, 1–3, 5, 63–65, 68, 72–73, 79, 81–82, 92, 135, 136, 139n94
Frisia, 3, 63, 77–78, 82, 135
Froissart, Jean, 78, 90, 104, 123, 129, 130, 132, 139n96

Gaza, 56, 71
Genoa, 70, 91
Gerard de Trazegnies (character), 22, 32, *32*, 36, *36*, 37, *37*, 38, *38*, 39, *39*, 40, *40*, 42, 43, 44, 48, *48*, 50, 53, 55, *55*, 57, *57*, 58, *58*, 59, *59*, 73, *75*, 75–76, *113*, *118*, 119, 125–26, *126*, 127, 137n6
Gérard de Nevers , 7n16, 82, 83, 101n55
Germain, Jean, 64
Ghent, 3, 5, 65, 72, 104
Gilles de Chin, 6, 7n16, 7n18, 81, 85–86, 88, 101n65
Godfrey of Bouillon, 86–87
Gracienne (character), 22, 24, 25, 27, 28, 32–35, 37, *37*, *46*, 47–50, 52, 53–54, *54*, *75*, 76, 97–99, 105, *117*, 125–28

Hague, Koninklijke Bibliotheek. *See* The Hague
Hainaut, 1, 6, 16, 19, 20, *20*, 32, 33, 53, 57, 59, 63, 67, 81–82, 83, 85, 100n38, 105
Haldin, King (character), *46*, 47, 48, *48*, 125, 127
Hamal, Arnould de, 84
Hector of Salerno, King (character), *30*, 31
Heilly de Créquy, Jacques de, 67, 83, 88–89, 101n92
Henry V, King of England, 83
Hertan (character), 24, 25, *25*, *26*, 27, 28, *28*, 29, 31, 32, 33, 35, 36, *36*, 37, *47*, *48*, 50, 53, 67, 99, *117*, 125, 127
Holland, 3, 63, 77–78, 82, 135
History of Jason [*Histoire de Jason*] (*see* Paris, Bibliothèque nationale de France, Ms. fr. 331)
Holy Land, 64, 68, 71, 81, 84, 88, 91, 136, 137n6
Hours of Mary of Burgundy. *See* Vienna, Österreichische Nationalbibliothek, Cod. 1857
Hundred Years' War, 5, 63–64, 72, 88

Isabel of Portugal, 64
Isidore du Ny, 85
Italy
 Ferrara, 55
 Florence, 92
 Genoa, 70, 91
 Lombardy, 21, 70
 Milan, 55
 Naples, 70
 Pavia, 55

Rome, 21, 37, 70, 72, 76, 81, 99
Venice, 55, 59, 63, 70–71, 91

Jacqueline of Bavaria, 63
Jacques de Lalaing, 6, 7n16, 84, 101n65
Jacques de Longuyon, 82, 100n9
Jaffa, 70–71
Jean de Trazegnies (character), 22, 32, *32*, 36, *36*, 37, *37*, 38, *38*, 39, *39*, 41, *41*, 48, *48*, 50, 53, 55, 73, *75*, 75–76, 86, 100, *113*, *118*, 119, 127, 137n6
Jean d'Arras, 88
Jean d'Avesnes, 7n16, 82, 83, 101n55
Jena, Thüringer Universitäts-und Landesbibliothek, Ms. El. f. 91 (*Aristoteles*), 138n35
 Ms. El. f. 92 (*Romance of Gillion de Trazegnies*), 6, 7n15, 71, 90
 Ms. El. f. 95–96 (*Bible historiale*), 138n35
Jerusalem, 2, 19, 20, 37, 56, 63, 64, 70, 71, 86, 100n21
John the Fearless, Duke of Burgundy (formerly Count of Nevers), 64, 67, 88, 135
Joinville, Jean de, 68

Knights Hospitaller, 38, 64, 70

Lannoy, Guillebert de, 83–84
La Sale, Antoine de, 7n16, 82, 91
Lathem, Lieven van
 author-translator depictions, 84, 92–96, 116
 biography, 104
 as ducal artisan, 104, 134
 Dülmen *Gillion*, role in illumination of, 90, 103, 112, 115, 116, 120, 137nn31–32
 and Getty *Gillion's* codicology, 106, *107*
 as Getty *Gillion's* illuminator, 90, 104, 105, 112, 120
 and Getty *Gillion's* visual narrative, 124–29
 Gillion Defeating the King of Fez, *108*
 Gillion Receiving the Pope's Blessing, *106*
 illuminations by,
 Berlin, Staatsbibliothek, Ms. Dep. Breslau 1 (Froissart, *Chronicles*), *123*, *131*
 Dülmen *Gillion*, (workshop), *74*, *75*, *113*, *117*, *118*, *126*
 Los Angeles, J. Paul Getty Museum. Ms. 37 (Prayer Book of Charles the Bold) *106*
 Paris, Bibliothèque nationale de France , Ms. fr. 331 (Lefèvre, *History of Jason*), *94*, *132*
 Paris, Bibliothèque nationale de France , Ms. fr. 562 (Pseudo-Aristotle, *Secret of Secrets*), *95*
 Paris, Bibliothèque nationale de France , Ms. n.a. fr. 16428 (Prayer Book of Philip the Good), *121*
 Paris, Bibliothèque nationale de France , Ms. n.a.lat. 215 (book of hours), *114*
 Paris, Petit Palais, Ms. Dutuit 456 (Wauquelin, *Deeds and Conquests of Alexander*), *123*, *130*
 Louis of Gruuthuse's hiring of, 2, 90, 96, 104
 and Northern Renaissance, 7
 personalization of images for patrons, 76–77
 secular manuscripts, overview of, 129–30, 132–33, 136
Livre d'Eracles. See Book of Heraclius
Lefèvre, Raoul, 78, 82, 85, 129

Le Prévost, Hubert, 100n41
Le Tavernier, Jean, 68, *69*, 93, *93*, 95, 97
Liédet, Loyset, 129, 139n77
Lille, 64–65, 72, 73, 89
Lombardy, 21, 70
London, British Library
 Add. Ms. 15428 (*Moralized Bible*), 134
 Royal Ms. 12 F.XIII (bestiary), 138n61
Lords of Gavre,, 7n16, 81–82, 91
Los Angeles, J. Paul Getty Museum
 Ms. 30 (*The Visions of the Knight Tondal*), 120, *120*
 Ms. 37 (Prayer Book of Charles the Bold), 104, 105, *106*, 138n69
 Ms. 111 (*Romance of Gillion de Trazegnies*), Aubert's role in production of, 81, 90–91, 112, 120, 137n30; author-translator, depictions of, 84, 92–96, 116, 124–25; codicology of, 15, 103, 106–12, 142–43; dating of, 6, 65, 79, 90, 100n40, 116, 119–24; description summary, 140; Dülmen *Gillion* compared with, 108–9, 112, 115–17, 119, 128, 141; exhibition history, 1, 7n3; Van Lathem as illuminator of, 90, 104–5, 112, 120; patron, overview of, 3; personalization of manuscript, 71, 76–77, 135; provenance of, 1, 5, 112, 140. *See also Romance of Gillion de Trazegnies* (text); *and specific characters and places*
Louis IX, Saint, King of France, 68
Louis d'Orléans, 132
Louis of Gruuthuse, *4*
 Anthony of Burgundy as close associate of, 103, 136
 Aubert's work for, on other projects, 90, 138n58
 biography, 3
 coat of arms, 5, 79, 100n38, 109–10, 127, 135, 138nn62–63, 139n84
 Crusading vow, 2, 3, 65, 73, 77, 78–79, 135
 family members, 78, 100n41
 Gillion copy owned by (*see* Los Angeles, J. Paul Getty Museum, Ms. 111)
 Gillion's appeal to, 2, 63, 71, 77–79, 134–36
 library and manuscript commissions, 2, 3, 5, 7n8, 72, 78–79, 82, 90, 96, 104, 120–24, 133–36, 137n4, 139n84
 service to England, 3, 5, 77, 78
Louis XI, King of France, 65, 73
Louis XII, King of France, 5
Lucena, Vasco de, 85
Lucion, Emir (character), *42*, 43, 44, *44*, *45*, 125–26, *126*, 127

Mansel, Jean, 85
Mansion, Colard, 78
Margaret of Austria, 72, 83, 85
Margaret of York, 3, 129, 137n35
Marie d'Ostrevant (character), 18, *18*, 19, *19*, 20, *20*, 22, 32, 33, 35, 36, *36*, 53, 54, *54*, 68, *74*, 86, 97, 99, 105, 116, 128, 138n75
Marmion, Simon, 120, *120*
Mary of Burgundy, 3, 104, 137n13
Master of Anthony of Burgundy, 129, 134, 139n86
Master of Edward IV, 129
Master of Margaret of York, 129

Master of the *Chroniques d'Angleterre*, 100n38, 100n40, 139n84

Master of the Dresden Prayer Book, *66*

Master of the *Vraie Cronicque descoce*, 134, 138n74

Master of the Harley Froissart, 139n84

Master of Wavrin, 82, 83

Maximilian, Archduke of Austria, 3, 72, 104

Memling, Hans, *72*

Mézières, Philippe de, 85, 88

Mobrant, King of (character), 47

Montferrant, Jean de, 134

Morgan, King of Slavonia (character), 40, *40*, 43, 44, 48, 49, 55, 76

Moriane 15, 35, 39

Morocco, 63, 64

Munich, Bayerische Staatsbibliothek, Ms. Gall 15 (*The Twelve Ladies of Rhetoric*), 134

Murad I, Sultan, 67, 88

Nancy, Battle of, 3, 65

Natalie (character), 40, 43, 44, 55, 76, 125–26, 127

Nevers, Count of. *See* John the Fearless, Duke of Burgundy

Nicolas V, Pope, 64

Nicopolis, Battle of, *66*, 67, 88–89, 139n96

Olive, Abbey of, 16, *17*, 53, 54, *54*, 84, 99, 101n126, 128

Orbrie, emir of (character), 28, *30*, 31, 32, *32*, 34, *75*, *113*

Order of the Golden Fleece, 3, *4*, 5, 18, 19, 64–65, 72, 73, 81, 82, 83, 84, 86, *86*, 95, 100n38, 104, 135, 136, 139n84

Paris, Bibliothèque de l'Arsenal
 Ms. 4790 (*Grand Equestrian Armorial of the Golden Fleece*), 87
 Ms. 5089 (*Abridged Chronicles of Emperors*), 81, 83

Paris, Bibliothèque nationale de France
 Ms. fr. 68 (*Book of Heraclius*), 79, 82, 100n44, 135, 139n95
 Mss. fr. 74–85 (Wavrin, *Chronicles of England*), 78
 Ms. fr. 133 (*Concerning Famous Women*), 139n84
 Ms. fr. 134 (*Book of the Properties of Things*), 139n86
 Ms. fr. 279 (*Chronicle of Baudouin d'Avesnes*), 82
 Mss. fr. 308–11 (Vincent of Beauvais, *Mirror of History*), 78, 133, 139n88
 Mss. fr. 345-48 (*Perceforest*), 139n82
 Mss. fr. 358-63 (*Guiron le Courtois*), 139n82
 Ms. fr. 331 (Lefèvre, *History of Jason*), 78, 90, *94*, 96, 104, 120–24, 129, *132*, 133, 136, 138n40, 138n58
 Ms. fr. 562 (Pseudo-Aristotle, *Secret of Secrets*), 78, 90, *95*, 96, 104, 120–22, 138n58, 138n70, 139n96
 Ms. fr. 897 (*Moralized Bible*), 78, 133–34
 Ms. fr. 1174 (*The Twelve Ladies of Rhetoric*), 134
 Ms. fr. 1837 (*Pénitance d'Adam*), 78, 100n41
 Ms. fr. 2643–46 (Froissart, *Chronicles*), *66*, 78
 Ms. fr. 4199 (*Miracles of the Virgin*), 138n70
 Ms. fr. 5058 (*Justification of France against England*), 134
 Ms. fr. 6449 (*Life of Saint Catherine*), 133
 Ms. fr. 9002 (*Chronographia*), 134

Ms. fr. 9087 (De la Broquière, *Voyage in the Land of Outremer*), 68, *69*, 97

Ms. fr. 12570 (*History of Jason*), 121

Ms. fr. 12574 (Camus, *History of Olivier de Castille*), 89, 90, 91

Ms. n.a.fr. 16428 (Prayer Book of Philip the Good), 104, *121*, *122–23*

Ms. n.a.lat. 215 (book of hours), *114*, 115, 138n19

Ms. Smith-Lesouëf 73 (*Book of Good Customs*), 134

Paris, Bibliothèque Sainte-Geneviève, Mss. 809-811 (*Chronicles of Hainaut*), 139n84

Paris, Petit Palais, Ms. Dutuit 456 (Wauquelin, *Deeds and Conquests of Alexander*), 122, 123, 129, *130*, 133, 138n37

Philip the Bold, Duke of Burgundy, 67, 88

Philip the Good, Duke of Burgundy
 Aubert as scribe of, 81, 83, 85, 89, 134
 bastard sons of, 72
 and communal reading, *80*, 81
 Crusading endeavors, 2, 5, 64–65, 73, 79, 81, 82, 88, 134–36, 138n51
 father's experiences battling Ottomans, 67
 geopolitical concerns of, 63–65, 70
 Getty *Gillion*'s dedication to, 16, 83, 134, 138n58
 and *Gillion* romance's authorship, 83–84, 85
 and *Jason* manuscript's date, 121
 van Lathem's artistic work for, 104, 134
 library and manuscript commissions, 5–6, 63, 83, 85, 90, 100n1, 101n55, 101n74, 123, 129, 133–34, 136
 Louis of Gruuthuse's service to, 2–3, 77–78
 Order of Golden Fleece founded by, 18, 64
 presentation scenes with, 68, *69*, 93, *93*, *94*, *95–96*

Philip VI, King of France, 70

Picardy, 73, 84

Pierre I, King of Cyprus, 70

Pius II, Pope, 65, 72, 73, 81

Prayer Book of Charles the Bold. *See* Los Angeles, J. Paul Getty Museum, Ms. 37

Prayer Book of Philip the Good. *See* Paris, Ms. n.a.fr. 16428

Rambures Master, 138n40

Ramla, 56

Rhodes, 38, 39, 63, 64, 70, *75*, 82

Rolin, Nicolas, 93

Romance of Gillion de Trazegnies (text)
 authorship of, 2, 83–91
 Crusading ideals extolled in, 65, 67, 73, 78, 99
 geopolitics of, 63–65, 67
 historicity of, 5, 67–68, 70–71, 89
 literary influences and analogues, 6, 7n16, 70, 81–83, 84, 85, 87–88, 91, 139n82
 manuscript copies, overview of, 6–7, 7n13, 71
 map of places related to, 8–9
 plot summary, 12–14
 as translation from Italian, 91–92, 96
 See also specific characters and places

Rome, 21, 37, 70, 72, 76, 81, 99. *See also* Italy

Savoy, 21, 64, 70

Sachsemheim Prayer Book. *See* Stuttgart, Württembergische Landesbibliothek, Cod. Brev. 162

Secret of Secrets [*Secret des secrets*] (*see* Paris, Bibliothèque nationale de France, Ms. fr. 562)

Slavonia , 15, 39, 40

Sluis, 64, 73, 81

Sotheby's, London, Dec. 6, 2000, lot 67 (*The Life and Passion of Our Lord Jesus Christ*), 139n84

Stuttgart, Württembergische Landesbibliothek, Cod. Brev. 162 (Sachsenheim Prayer Book), 106, 137n12, 138n69

Suso, Henry, 100n41

Syria, 63, 68, 70–71, 83–84, 98

Tarsus, King (character), 25, *25*, *117*

The Hague, Koninklijke Bibliotheek
 Ms. SMC1 (Trivulzio Hours), 138n68
 Ms. 76 E 7 (*Moralized Bible*), 134
 Ms. 76 E 10 (*Statutes, Ordonnances, and Armorial of the Order of the Golden Fleece*), *4*, 86

Torzelo, Giovanni, 82

Trazegnies, 18, 19, 21, 22, 37, 39, 50, 55, 57, 58, 68, 75–76, 84, 100, 100n31, 127

Trazegnies, Gilles II de, 68, 100n16

Trazegnies, Jean IV de, 6, 68, 101n126

Trazegnies, Otto II de, 68

Tripoli, 34, *34*, 35, *35*, 36, 41, *41*, 48, 63, 76

Tunis, king of (character), 50

Turin, Biblioteca Nazionale Universitaria, L.I. 10, 139n84

Valerius Maximus, 78

Venice, 55, 59, 63, 70–71, 91. *See also* Italy

Vienna, Österreichische Nationalbibliothek
 Cod. 1857 (Hours of Mary of Burgundy), 104, 137n13
 Cod. 2533 (*Abridged Chronicles of Jerusalem*), 136, 138n53, 138n70, 139n96

Vrelant, Willem, *80*, 129, 133–34, 138n74, 139n88

Wauquelin, Jean, 83, 85, 100n38

Wavrin, Jean de, 6, 71, 72, 78, 81–83, 85, 101n55, 121

Wavrin, Waleran de, 64, 81

William of Adam, 82, 101n56

Ysore, King of Damascus (character), 24, *24*, 25, *25*, 26, 27, 28, 31, 34, 36, *117*, 126–27

Zeeland, 3, 63, 77–78, 82, 135